D1430582

EDITED BY
PHYLLIS FREEMAN
ERIC HIMMEL
EDITH PAVESE
ANNE YAROWSKY

HARRY N. ABRAMS, INC., PUBLISHERS, NEW YORK

DESIGNER: TINA DAVIS SNYDER

LIBRARY OF CONGRESS CATALOGING IN PUBLICATION DATA
MAIN ENTRY UNDER TITLE:

NEW ART.

1. ART, MODERN—20TH CENTURY—THEMES, MOTIVES.
2. AVANT-GARDE (AESTHETICS)—HISTORY—20TH CENTURY—
THEMES, MOTIVES. I. FREEMAN, PHYLLIS. II. HARRY N.
ABRAMS, INC.
N6493 1980.N48 1984 709'.04 84-2959
ISBN 0-8109-2287-8 (PBK.)

LIST OF ARTISTS

VITO ACCONCI
JOHN AHEARN
LAURIE ANDERSON
GIOVANNI ANSELMO
RICHARD ARTSCHWAGER
ALICE AYCOCK
LUIS CRUZ AZACETA
JENNIFER BARTLETT
GEORG BASELITZ
JEAN MICHEL BASQUIAT
LYNDA BENGLIS
JAMES BIEDERMAN
JONATHAN BOROFSKY
RICHARD BOSMAN
TROY BRAUNTUCH
JAMES BROWN
ROGER BROWN
CHRIS BURDEN
JONATHAN BURKE
SCOTT BURTON
DEBORAH BUTTERFIELD
LOUISA CHASE

SANDRO CHIA
CHRISTO
FRANCESCO CLEMENTE
TONY CRAGG
ENZO CUCCHI
AGNES DENES
DAVID DEUTSCH
MARTHA DIAMOND
MARTIN DISLER
JOHN DUFF
CYNTHIA EARDLEY
JONATHAN ELLIS
JACKIE FERRARA
ERIC FISCHL
JANET FISH
LUIS FRANGELLA
JANE FREILICHER
JEDD GARET
GÉRARD GAROUSTE
GILBERT & GEORGE
GREGORY GILLESPIE
NANCY GRAVES
RODNEY ALAN GREENBLAT
JAN GROOVER
DIETER HACKER
RICHARD HAMBLETON
KEITH HARING
HOWARD HODGKIN
JENNY HOLZER
BRYAN HUNT
JÖRG IMMENDORFF
NEIL JENNEY
BILL JENSEN
STEVE KEISTER
ANSELM KIEFER
KEN KIFF
KOMAR AND MELAMID
BARBARA KRUGER
STEPHEN LACK
LOIS LANE
CHRISTOPHER LE BRUN
RICHARD LONG
ROBERT LONGO
MARKUS LÜPERTZ
ROBERT MAPPLETHORPE
MICHAEL MAZUR
MARIO MERZ
MELISSA MILLER

MARY MISS
MALCOLM MORLEY
ROBERT MOSKOWITZ
ELIZABETH MURRAY
PAUL NARKIEWICZ
NIC NICOSIA
JIM NUTT
TOM OTTERNESS
MIMMO PALADINO
ED PASCHKE
A. R. PENCK
JUDY PFAFF
SIGMAR POLKE
KATHERINE PORTER
LOUIS RENZONI
JUDY RIFKA
DOROTHEA ROCKBURNE
SUSAN ROTHENBERG
DAVID SALLE
SALOMÉ
JIM SANBORN
KENNY SCHARF
JULIAN SCHNABEL
RICHARD SERRA
JOEL SHAPIRO
CINDY SHERMAN
TODD SILER
CHARLES SIMONDS
MICHAEL SINGER
NED SMYTH
JOAN SNYDER
KEITH SONNIER
PAT STEIR
GARY STEPHAN
DONALD SULTAN
MARK TANSEY
RICHARD TUTTLE
GER VAN ELK
EMO VERKERK
JOHN WALKER
JEFF WALL
WILLIAM WEGMAN
NEIL WELLIVER
WILLIAM WILEY
JACKIE WINSOR
DAVID WOJNAROWICZ
JOE ZUCKER
RHONDA ZWILLINGER

EDITORS' NOTE

Convinced that, as responsible art-book publishers, we have an obligation to chronicle the events of the art world, we have compiled this record of the art of the 1980s so far, presented in a format and style designed to reach the widest possible audience. We call this compilation *NEW ART*, knowing that the question of what is "new" is as controversial as what is "art."

Unpredictability is a given in art. But change was once exclusively in the hands of the avant-garde; today the establishment co-opts new trends so swiftly that it is often hard to define what is avant-garde. In effect, change now is generated by smaller and more disparate groups. Not surprisingly, this has led to a multiplicity of trends in varying stages of development. No longer is there a dominant style or even a dominant artist.

For the first time since the triumph of Abstract Expressionism, there has been room on the art scene in America for European innovators. While the successors of Abstract Expressionism—Pop, Op, and Photorealism, also considered American inventions—monopolized the attention of the art world here, European artists had little impact. But with the recent fragmentation of art into subtly distinctive subcategories of style, the work of German and Italian Neo-Expressionists and Transguardists and British vernacular artists has charged the U.S. art scene with the force of a hungry bull facing a skilled matador.

We have restricted our outlook to work that has been exhibited in the United States, and evaluated its impact in the 1980s. Many younger European artists first exhibited here in the last few years, although their work was already known in Europe. But we have also included the art of some well-established figures whose work has taken off in new directions in the years since 1980, or has altered the consciousness of viewers in these years.

For almost three-quarters of a century, the gallery system has prevailed in this country. Works were occasionally shown in premises presided over by artists, but for most artists, work reached the public eye through galleries. And museums, too, relied on galleries to serve as a source of new art. At present, with thousands of artists competing for attention, the gallery system flourishes, but by utilizing techniques of public relations and media hype, it often leapfrogs acceptance by museums and critics and reaches out directly to the TV and magazine public. We have sifted out the one-season wonders thereby created from those with an authentic talent.

That many of the artists we have chosen are shown in New York galleries is a function of the inescapable fact that it is in New York that art with a nationwide or international standing must be shown sooner or later. To be sure, there are strong regional schools in many parts of the country, but we have imposed the criterion that a work selected must have some resonance coast to coast and border to border.

Finally, we have tried to avoid subjectivity and hewed to nonjudgmental reporting. We believe that our selection of 118 artists spans the qualitative and typological range of art now, and reflects the vitality and high spirits of the new art.

ACKNOWLEDGMENTS

The editors and publisher would like to thank the following individuals, without whose assistance this book would not have been possible: Bonnie Arffa and Carol Lee Corey, M. Knoedler & Co.; Macon Asbury, Delahunty Gallery; Ricky Barnett, Hal Bromm Gallery; Douglas Baxter, Paula Cooper Gallery; Ted Bonin, Brooke Alexander, Inc.; Mary Boone and Frances Chaves, Mary Boone Gallery; Roger A. Bultot, O.K. Harris Works of Art; Carol Celentano, Phyllis Kind Gallery; John Cheim, Robert Miller Gallery; Jeanne-Claude Christo; Arch Connelly, Executive Gallery; Ann Cook, Willard Gallery; Betty Cuningham, Hirschl & Adler Modern; Lawrence L. DiCarlo, Fischbach Gallery; Bella Fishko and Gerry Levin, Forum Gallery; Richard Flood, Barbara Gladstone Gallery; Xavier Fourcade and Jill Weinberg, Xavier Fourcade, Inc.; Peter C. Freeman, Blum Helman Gallery; Allan Frumkin, Allan Frumkin Gallery; Andrea Gewitsch; Barbara Goldner, Ronald Feldman Fine Arts; Marian Goodman, Marian Goodman Gallery; Patricia Hamilton; Terry Hubscher, Marlborough Gallery; Fredericka Hunter and Kathleen Crain, Texas Gallery; Curt Klebaum, Castelli Feigen Corcoran; Michael R. Klein and Andy Gessner; Monique Knowlton, Monique Knowlton Gallery; Gracie Mansion, Gracie Mansion Gallery; Maryjo Marks, Leo Castelli Gallery; Barbara Mathes, Barbara Mathes Gallery; Elizabeth McDonald and Doug Milford, Piezo Electric Gallery; Renée Conforte McKee, David McKee Gallery; Fran Nelson and Mary Trasko, Max Protetch Gallery; David Nolan, Sonnabend Gallery; Ann Philbin, Grace Borgenicht Gallery; Frances Redell and Kristen Holcomb, John Weber Gallery; Janelle Reiring and Helene Winer, Metro Pictures; Joyce Pomeroy Schwartz, Works of Art for Public Spaces; Charles Smith, General Electric Corporation; Holly Solomon and Anita Grossman, Holly Solomon Gallery; Alexandra Sutherland, Tony Shafrazi Gallery; Edward Thorp, Edward Thorp Gallery; Joan Washburn, Washburn Gallery; Angela Westwater and Julia Blaut, Sperone Westwater; and Susan Wilharm, Annina Nosei Gallery.

VITO ACCONCI

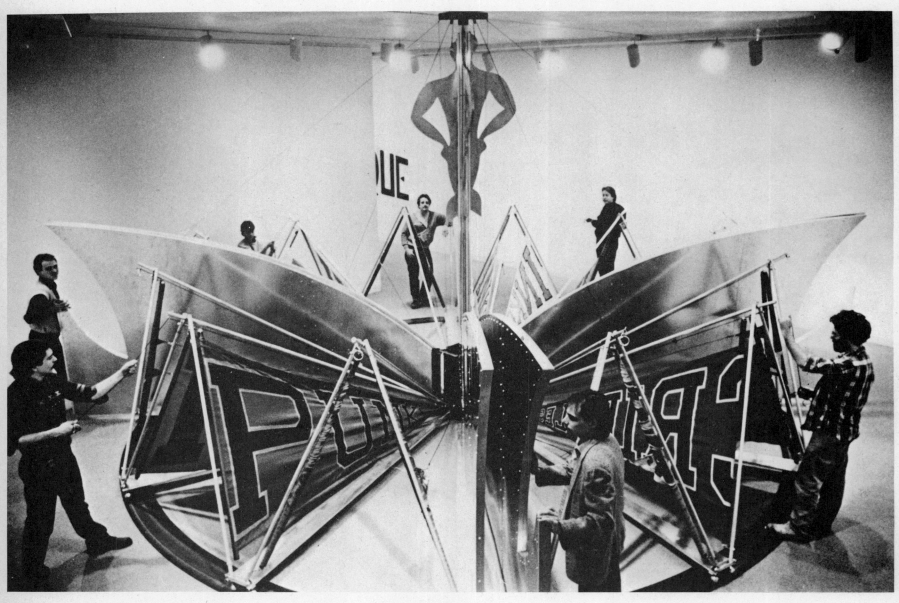

VITO ACCONCI
FAN CITY (DETAIL). 1981
COURTESY THE ARTIST AND MICHAEL KLEIN, INC.

▶
VITO ACCONCI
RAISING THE DEAD (AND GETTING LAID AGAIN). 1980
COURTESY THE ARTIST AND MICHAEL KLEIN, INC.

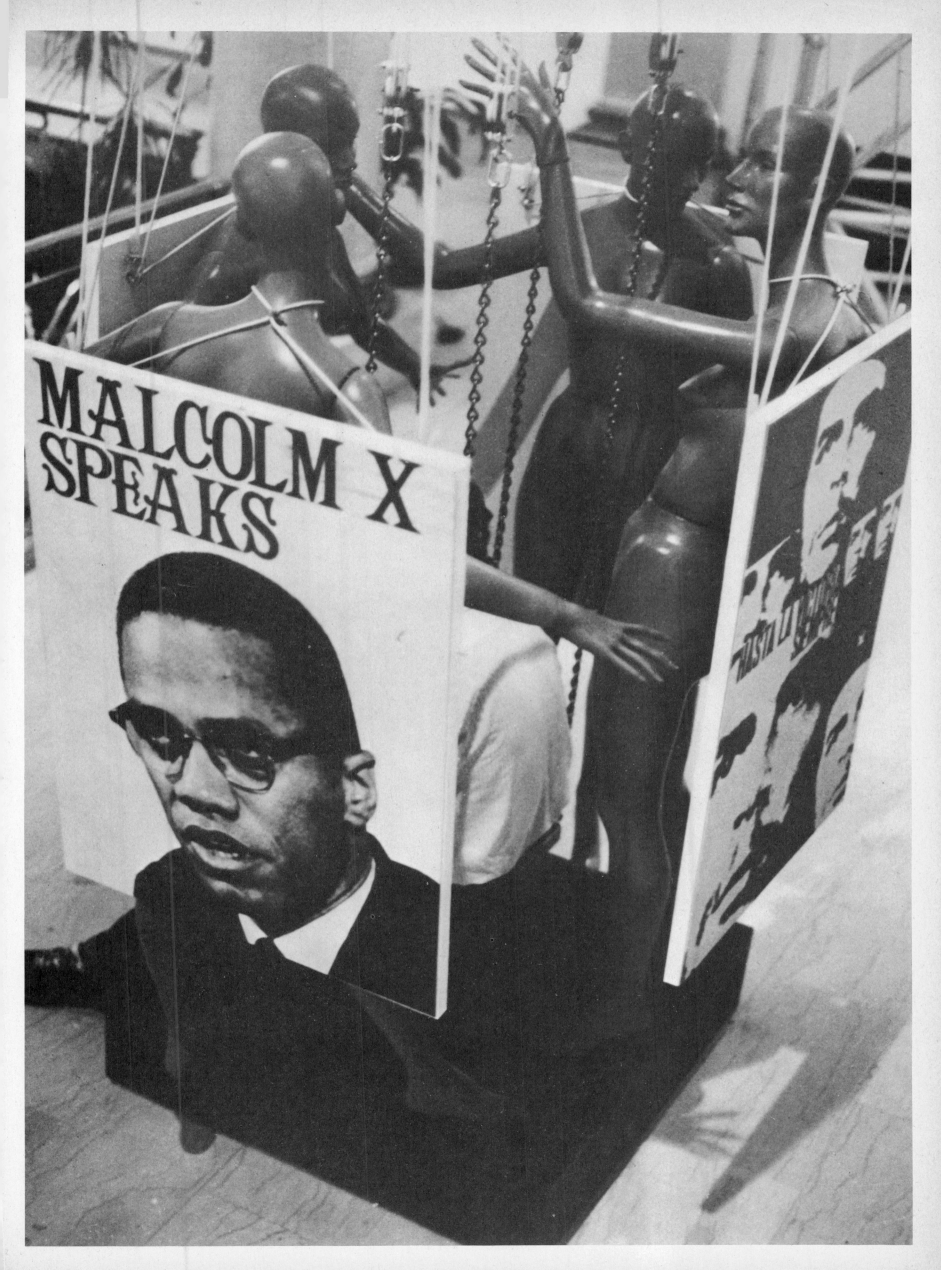

JOHN AHEARN

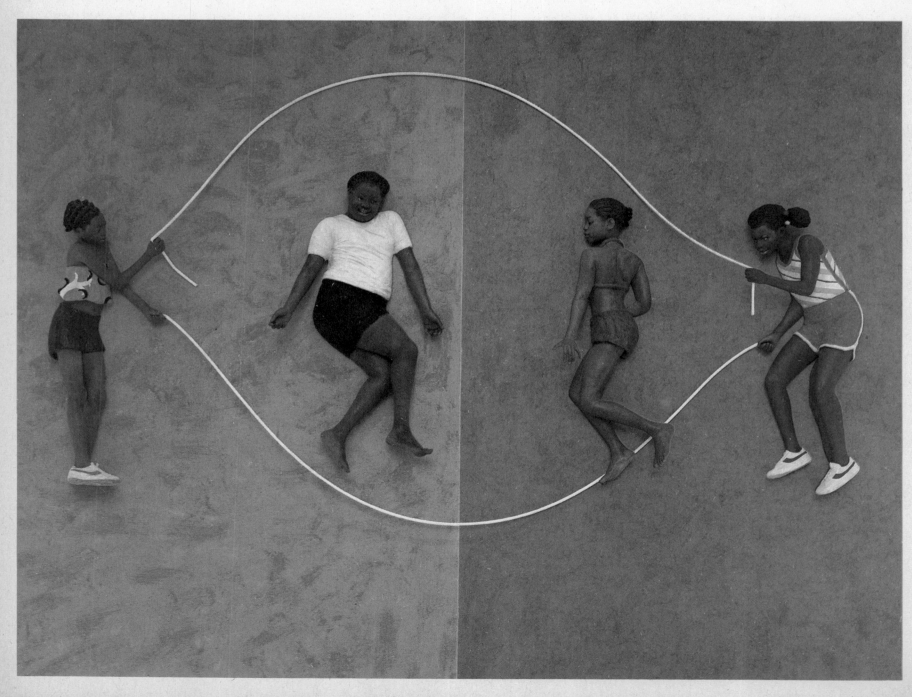

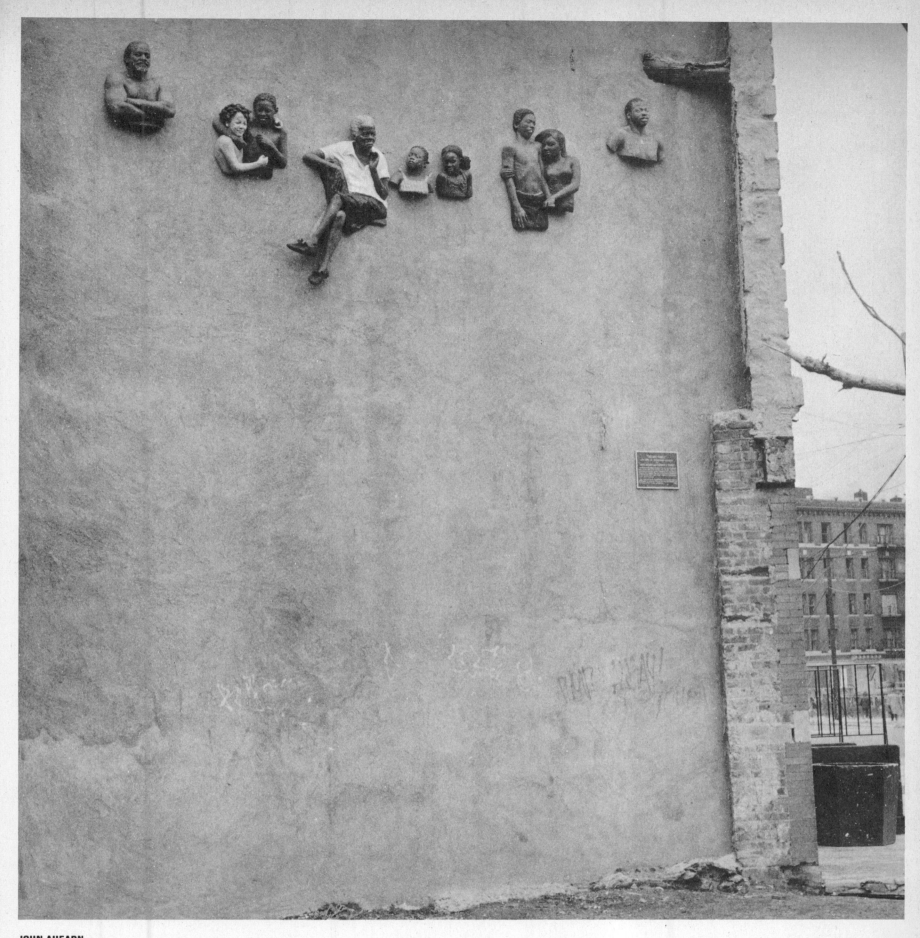

JOHN AHEARN
WE ARE FAMILY. 1982
PAINTED CAST FIBERGLAS
PERMANENT INSTALLATION, 877 INTERVALE AVENUE, SOUTH BRONX, NEW YORK
COURTESY BROOKE ALEXANDER, INC., NEW YORK

◄ **JOHN AHEARN**
DOUBLE DUTCH AT KELLY STREET I (DETAIL). 1981–82
APPROXIMATELY 54 x 54 x 12", PAINTED CAST FIBERGLAS
INSTALLATION, 74TH AMERICAN EXHIBITION, THE ART INSTITUTE OF CHICAGO, 1982
COURTESY BROOKE ALEXANDER, INC., NEW YORK

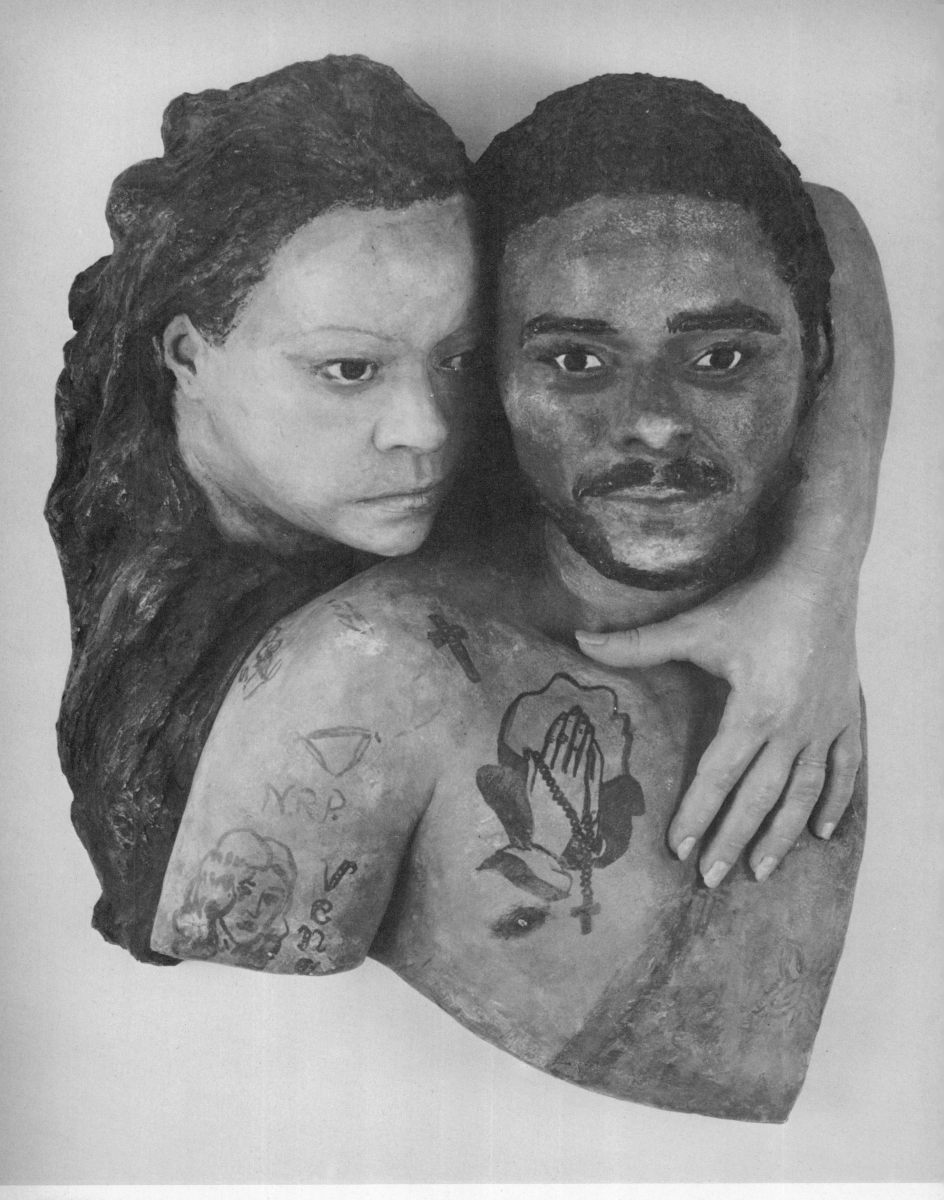

JOHN AHEARN
NORMA AND MARIO. 1981
PAINTED CAST PLASTER, 24 x 16 x 8"
COURTESY BROOKE ALEXANDER, INC., NEW YORK

LAURIE ANDERSON
DARK DOGS/AMERICAN DREAMS. 1980
INSTALLATION OF PHOTOGRAPHS WITH ACCOMPANYING TAPE RECORDINGS IN CASSETTES,
HOLLY SOLOMON GALLERY, NEW YORK

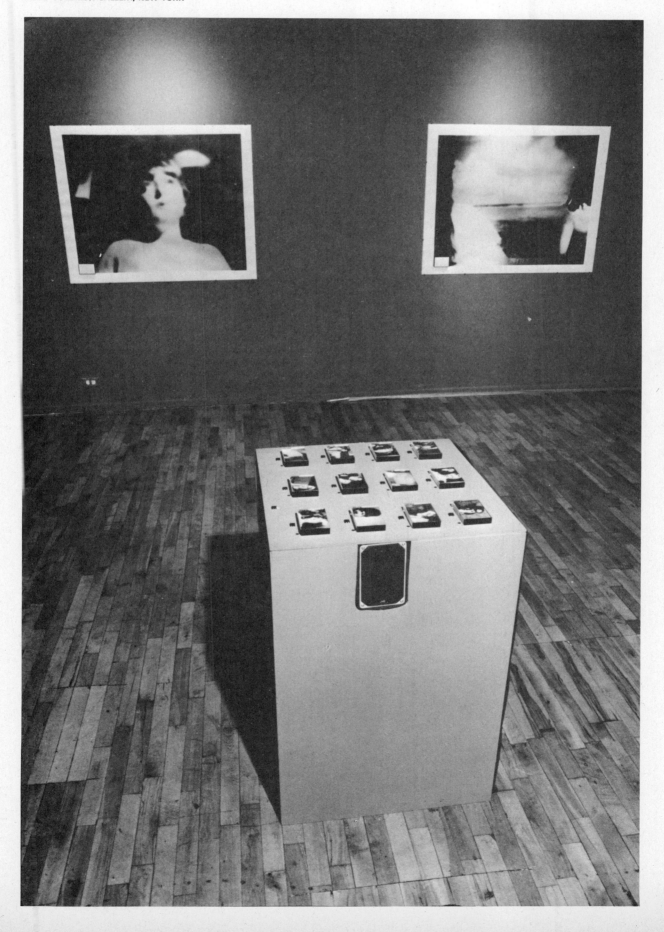

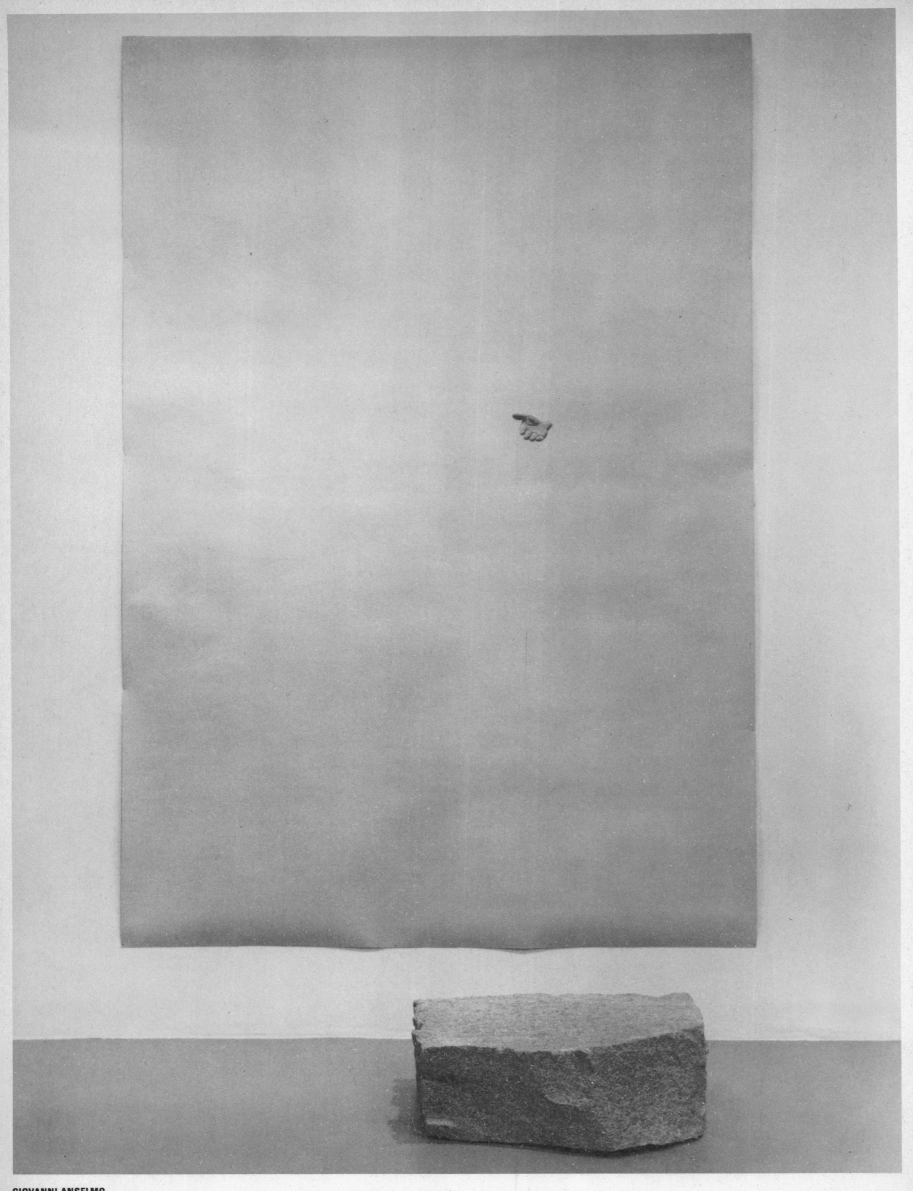

GIOVANNI ANSELMO
PANORAMA. FEBRUARY, 1984
GRANITE AND PENCIL ON PAPER, 120 x 80"
INSTALLATION, MARIAN GOODMAN GALLERY, NEW YORK

GIOVANNI ANSELMO

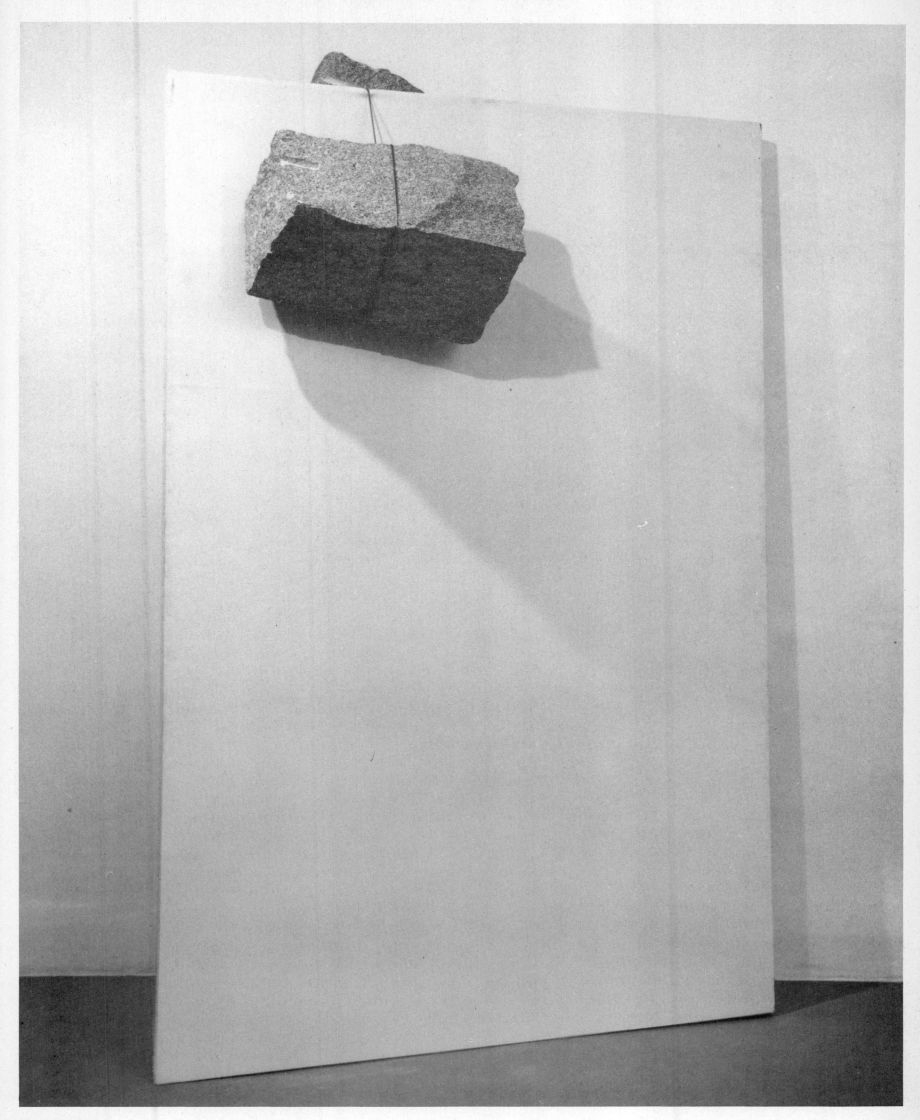

GIOVANNI ANSELMO
UNTITLED PAINTING. FEBRUARY, 1984
GRANITE ON CANVAS, 90 x 59"
INSTALLATION, MARIAN GOODMAN GALLERY, NEW YORK

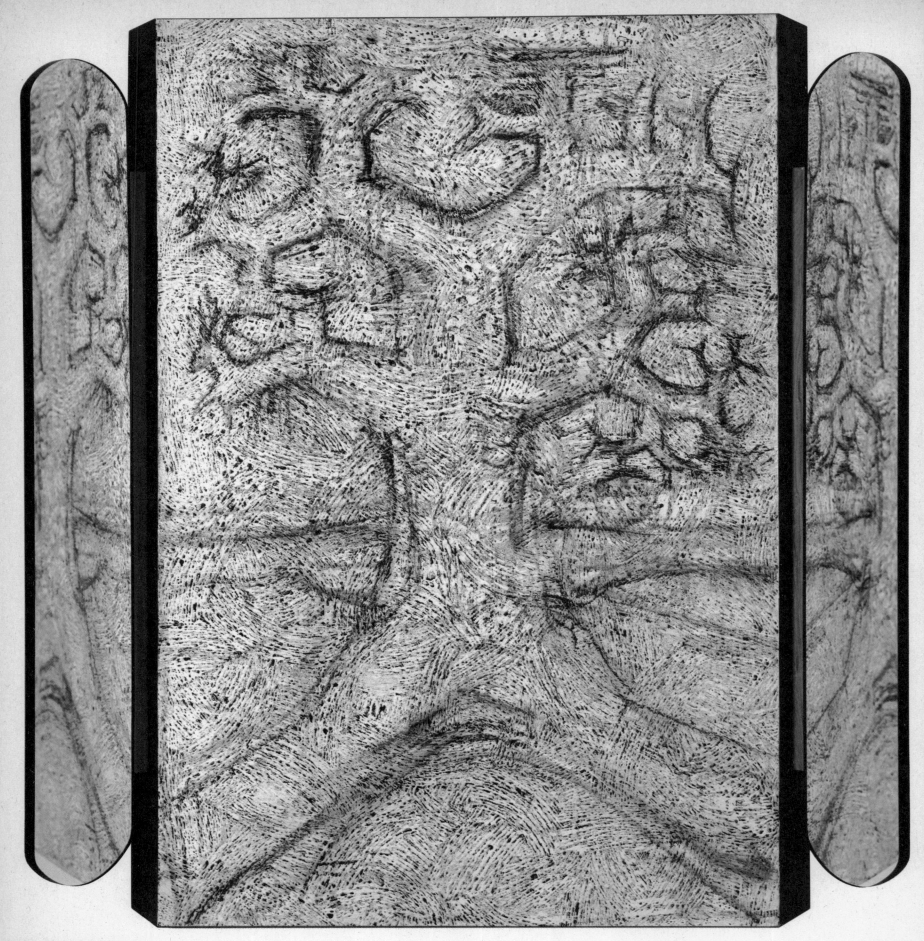

RICHARD ARTSCHWAGER
TREE WITH 2 MIRRORS. 1981
ACRYLIC AND CHARCOAL ON CELOTEX, MYLAR MIRRORS, PAINTED WOOD, 35⅛ x 31 x 8¾"
COURTESY LEO CASTELLI GALLERY, NEW YORK

RICHARD ARTSCHWAGER

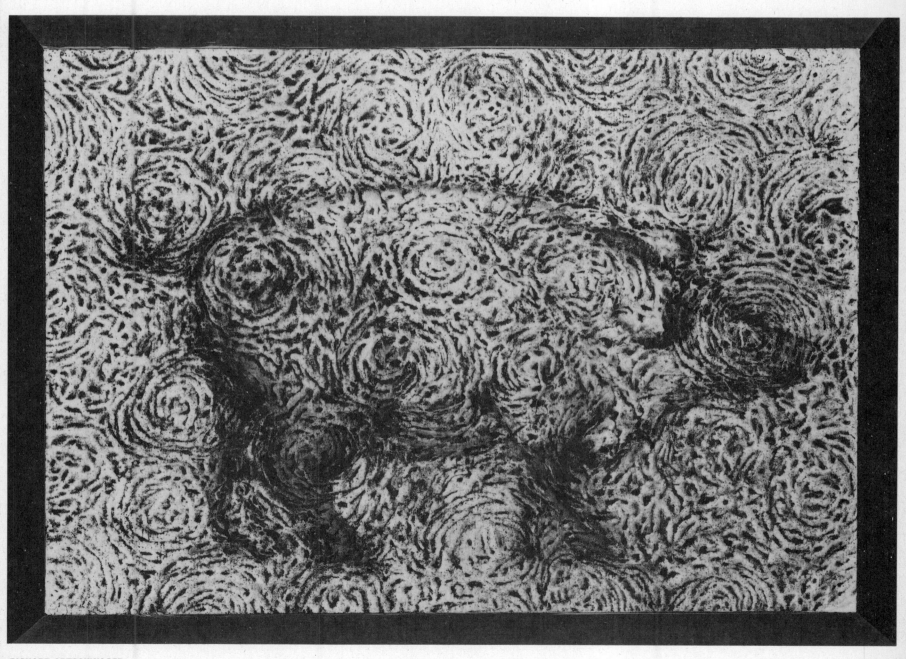

RICHARD ARTSCHWAGER
PIG. 1981
ACRYLIC AND CHARCOAL ON CELOTEX, PAINTED WOOD, 14 x 18¼ x 3¾"
COURTESY LEO CASTELLI GALLERY, NEW YORK

ALICE AYCOCK

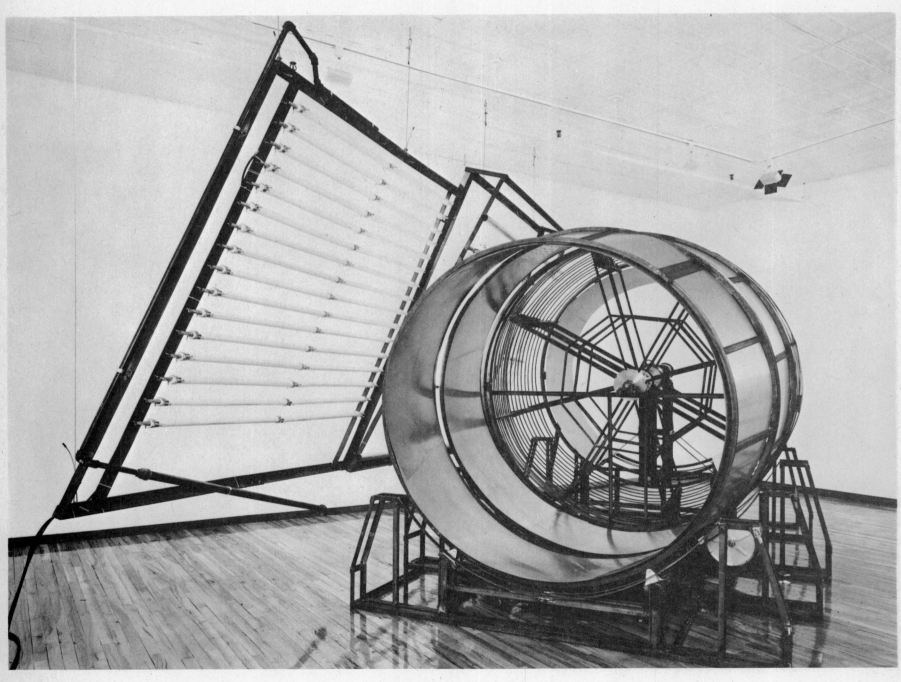

ALICE AYCOCK
THE SAVAGE SPARKLER. MAY, 1981
PLATTSBURG COLLEGE COLLECTION, PLATTSBURG, NEW YORK

▶
ALICE AYCOCK
GAME OF FLIERS. 1980
INSTALLATION, WASHINGTON, D.C.

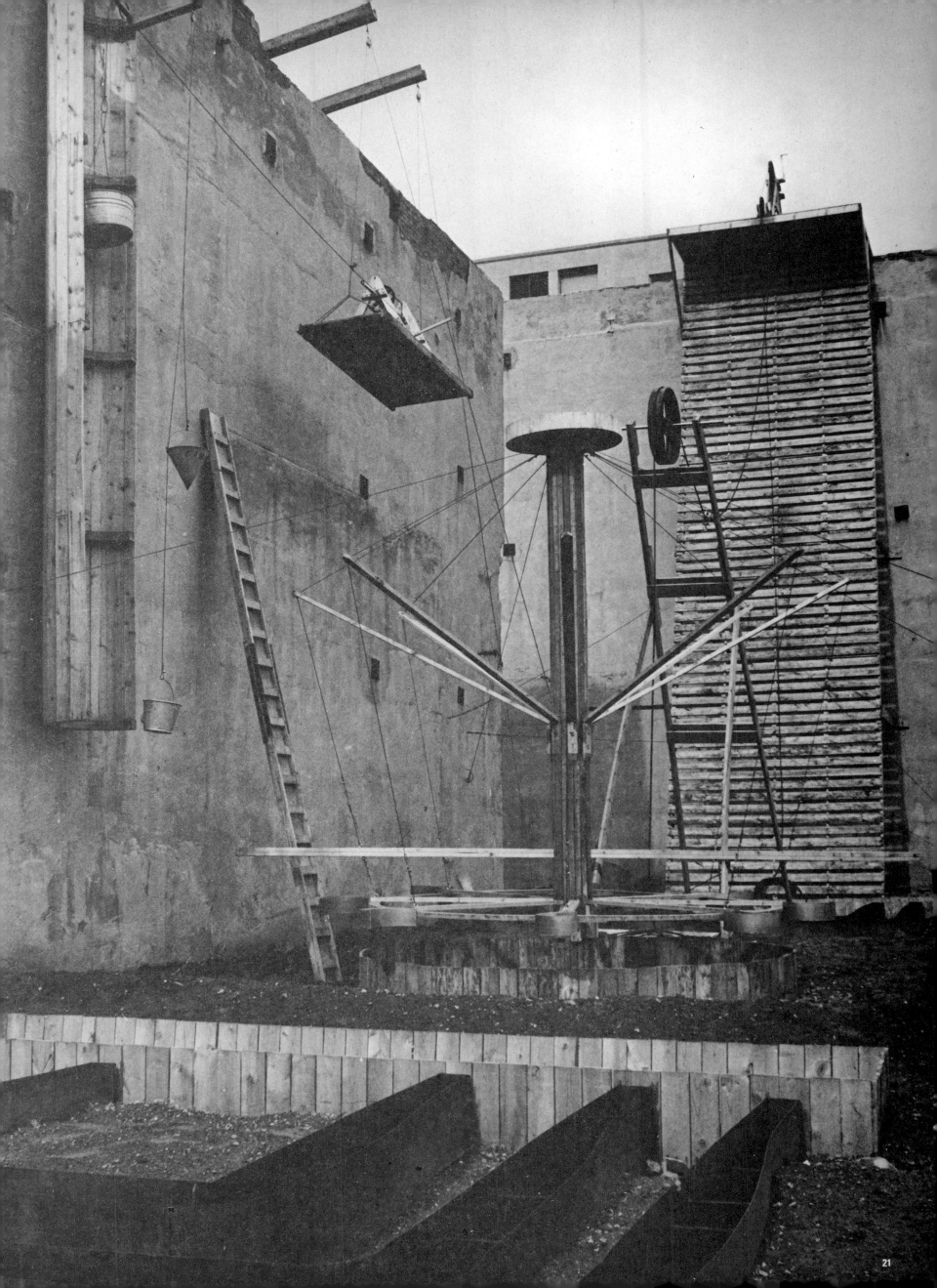

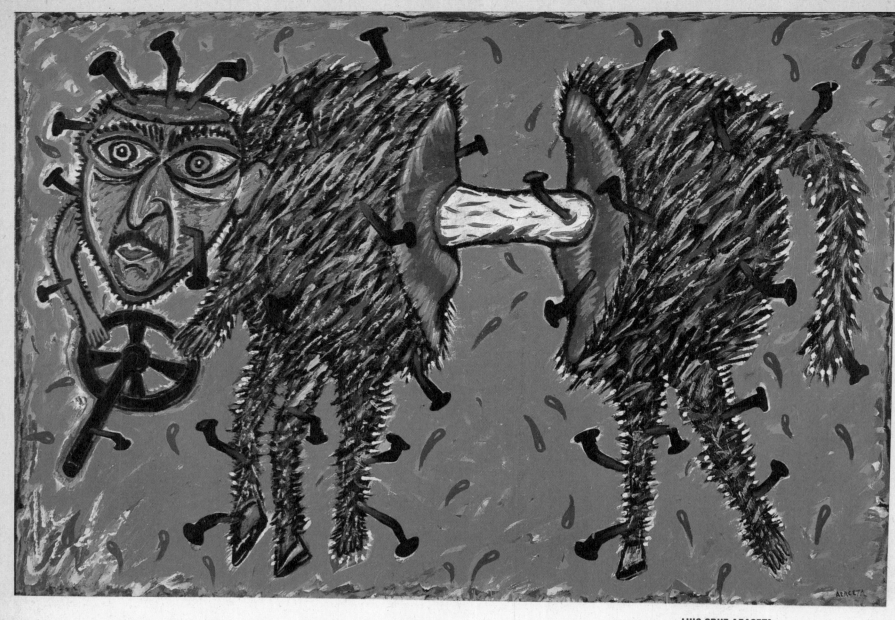

LUIS CRUZ AZACETA
TRAVELER. 1983
ACRYLIC ON CANVAS, 66 x 96"
COURTESY ALLAN FRUMKIN GALLERY, NEW YORK

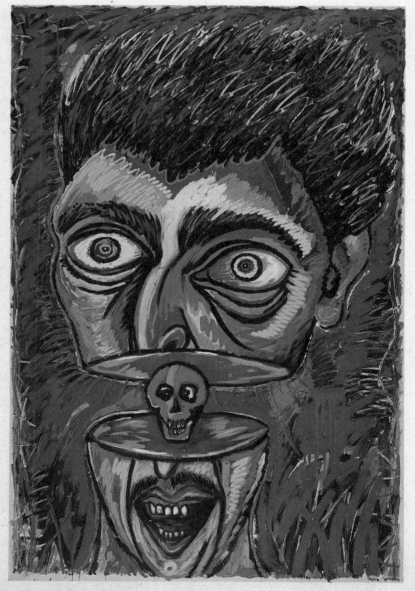

LUIS CRUZ AZACETA

LUIS CRUZ AZACETA
SPLIT HEAD. 1983
ACRYLIC ON CANVAS, 95 x 62"
COURTESY ALLAN FRUMKIN GALLERY, NEW YORK

JENNIFER BARTLETT
BOY. 1983
OIL ON CANVAS, EACH PANEL 7 x 5'
COLLECTION THE NELSON-ATKINS MUSEUM OF ART, KANSAS CITY, MISSOURI
GIFT OF THE FRIENDS OF ART

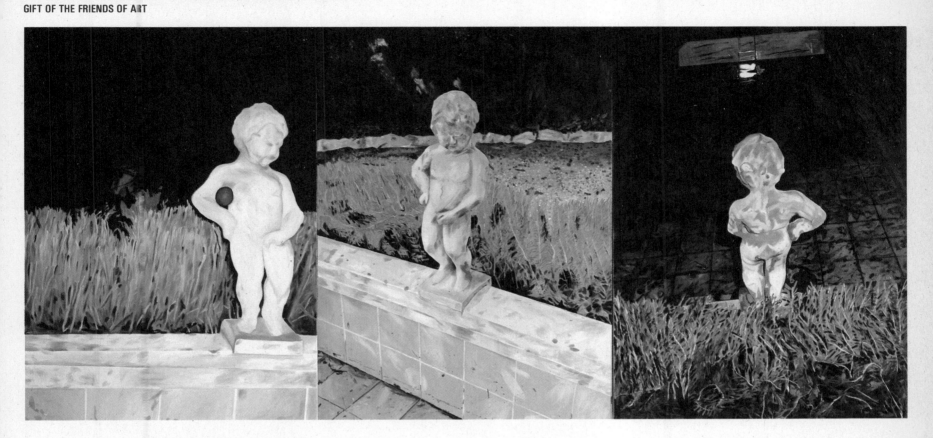

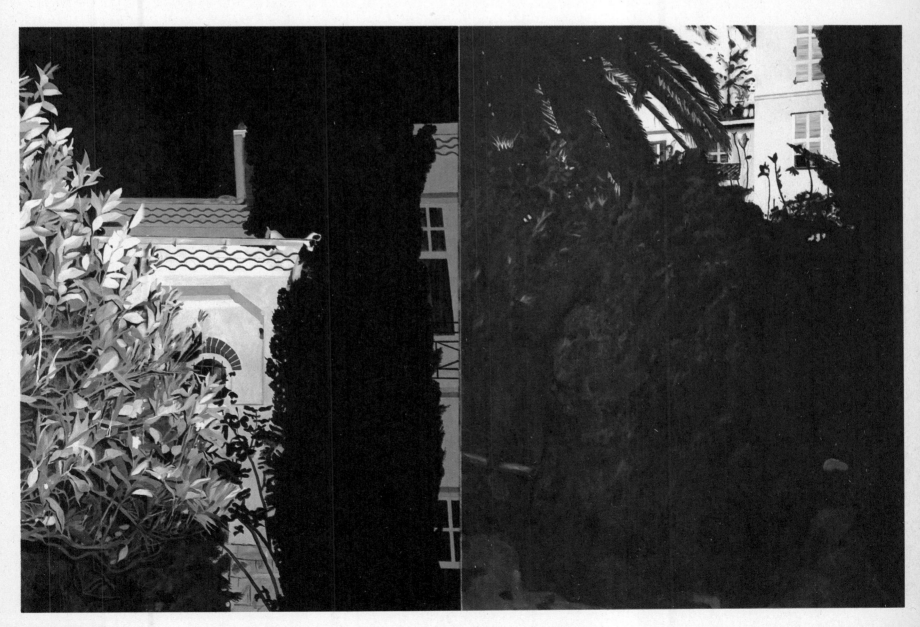

JENNIFER BARTLETT
HOUSE. 1983
OIL ON CANVAS, EACH PANEL 7 x 5'
COLLECTION THE EDWARD R. BROIDA TRUST, NEW YORK

GEORG BASELITZ

GEORG BASELITZ
FRAU AM STRAND. 1981
OIL ON CANVAS, 78½ x 98½"
PRIVATE COLLECTION

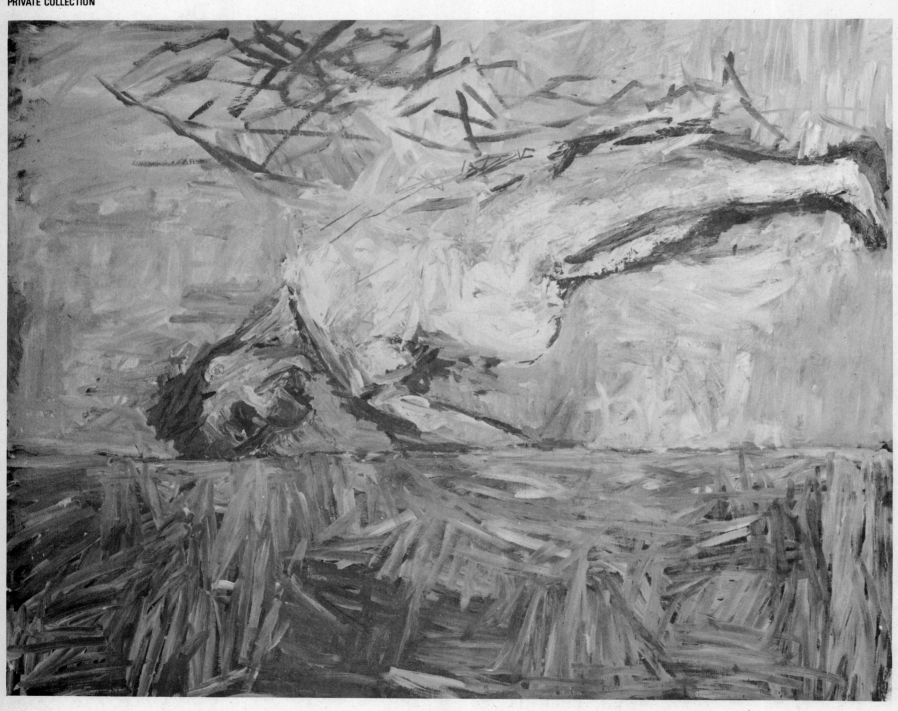

GEORG BASELITZ
THE GIRLS FROM OLMO. 1981
OIL ON CANVAS, 98½ x 98½"
COLLECTION MUSÉE NATIONAL D'ART MODERNE
CENTRE GEORGES POMPIDOU, PARIS

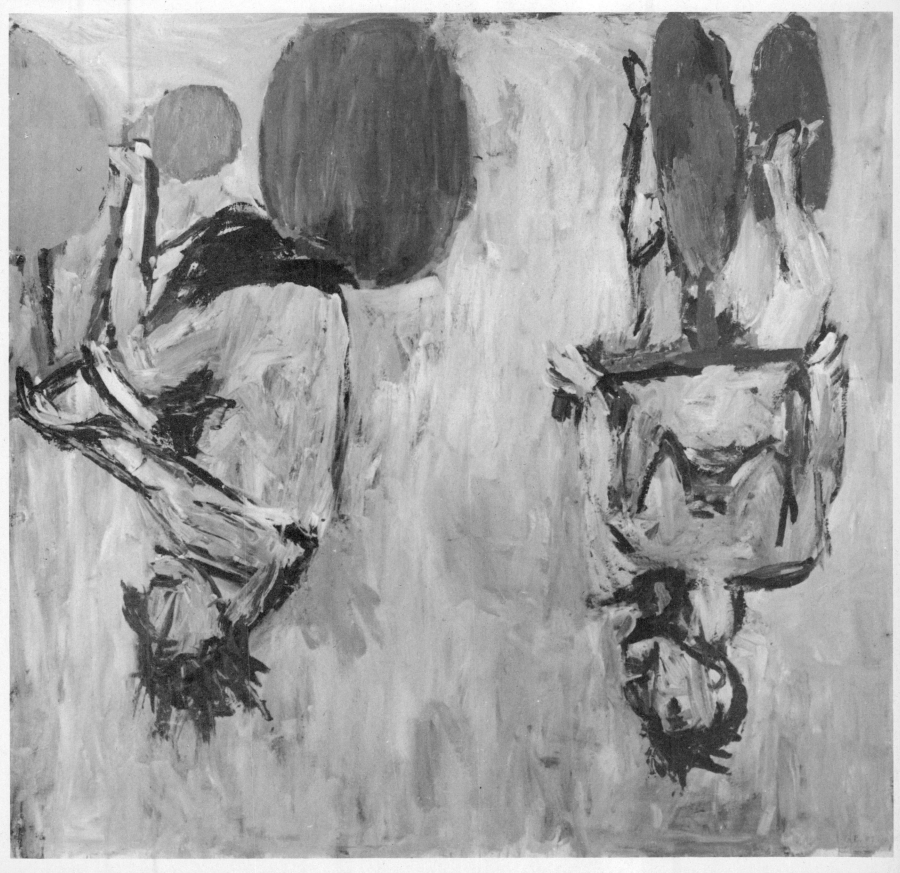

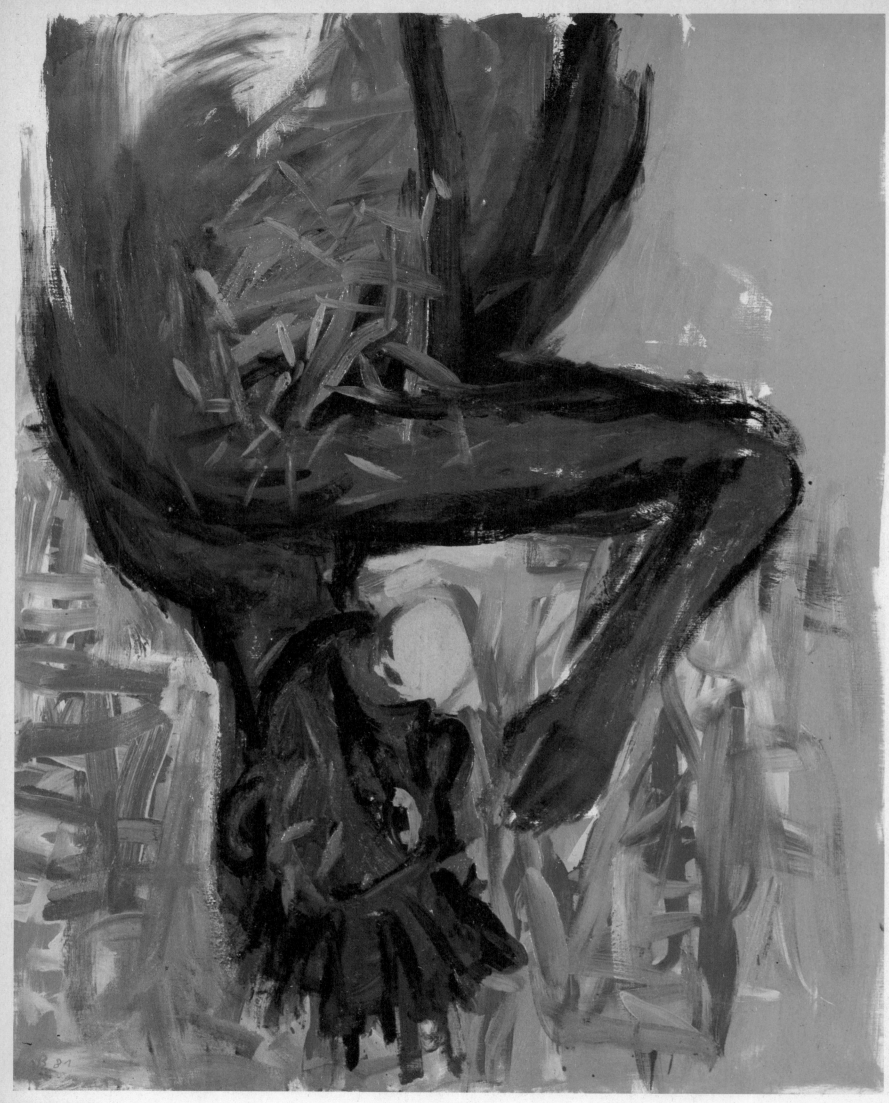

GEORG BASELITZ
ORANGEATER. 1981
OIL ON CANVAS, 57½ x 45"
COLLECTION PHOEBE CHASON, NEW YORK

LYNDA BENGLIS
PAVO. 1982
BRONZE, WIRE, ZINC, PATINATED COPPER, 33½ x 31 x 16"
COLLECTION DANIEL G. ROMUALDEZ III, NEW YORK

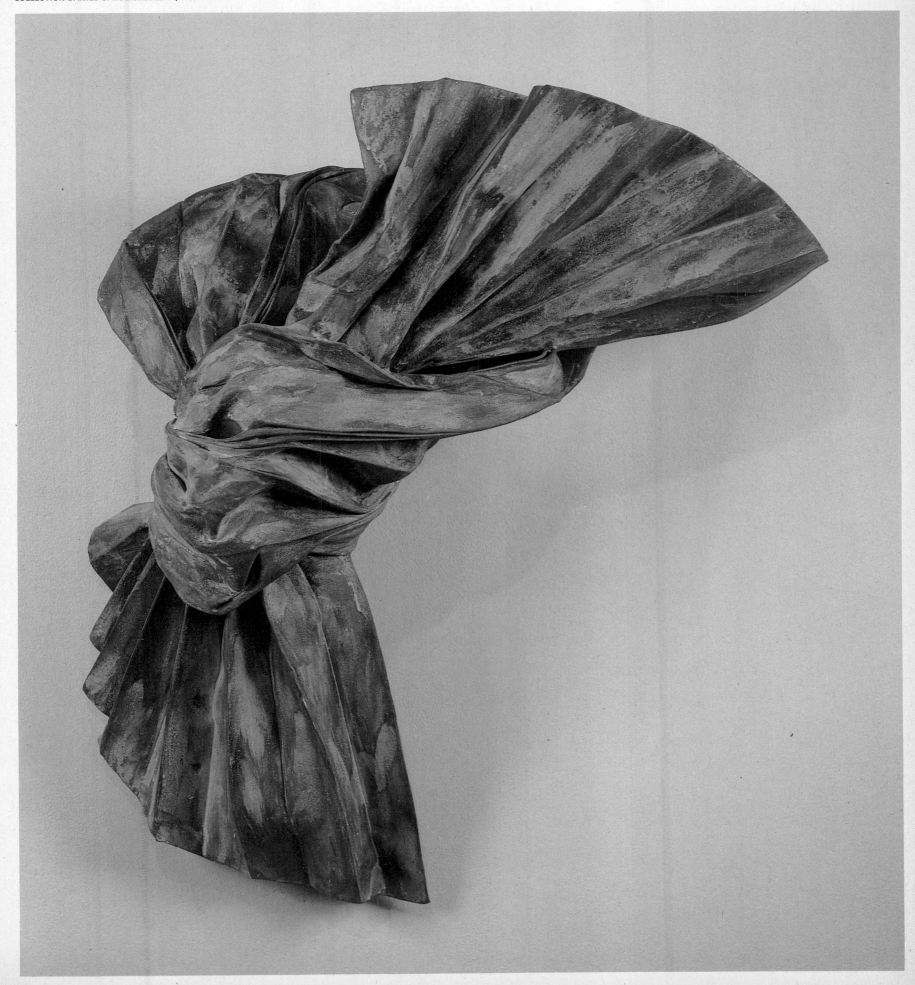

JEAN MICHEL BASQUIAT

JEAN MICHEL BASQUIAT
REVISED UNDISCOVERED GENIUS OF THE MISSISSIPPI DELTA. 1983
ACRYLIC ON CANVAS, 78 x 156¼"
COLLECTION OLIVER STAHEL, ZURICH

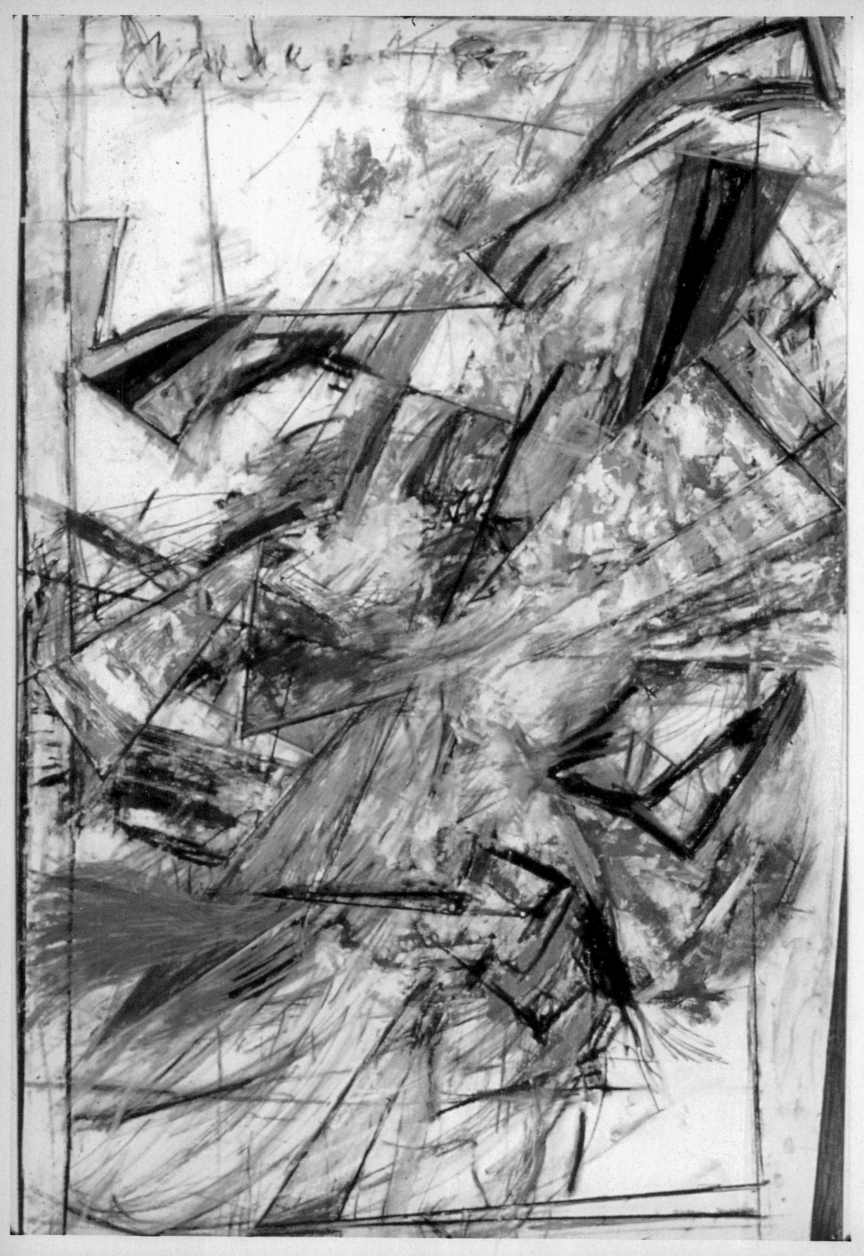

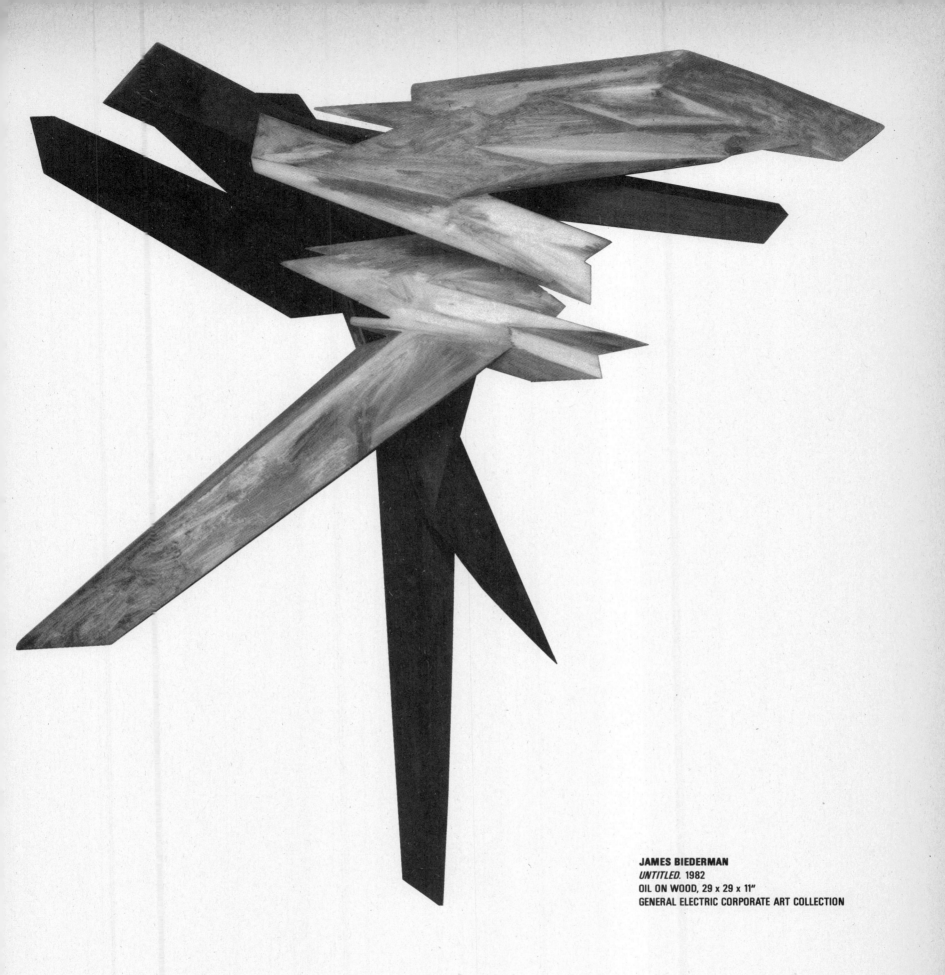

JAMES BIEDERMAN
UNTITLED. 1982
OIL ON WOOD, 29 x 29 x 11"
GENERAL ELECTRIC CORPORATE ART COLLECTION

JAMES BIEDERMAN

◀

JAMES BIEDERMAN
UNTITLED. 1982
MIXED MEDIUMS ON PAPER, 63½ x 41½"
COLLECTION DOLORES CYNTHIA SMITHIES, NEW YORK

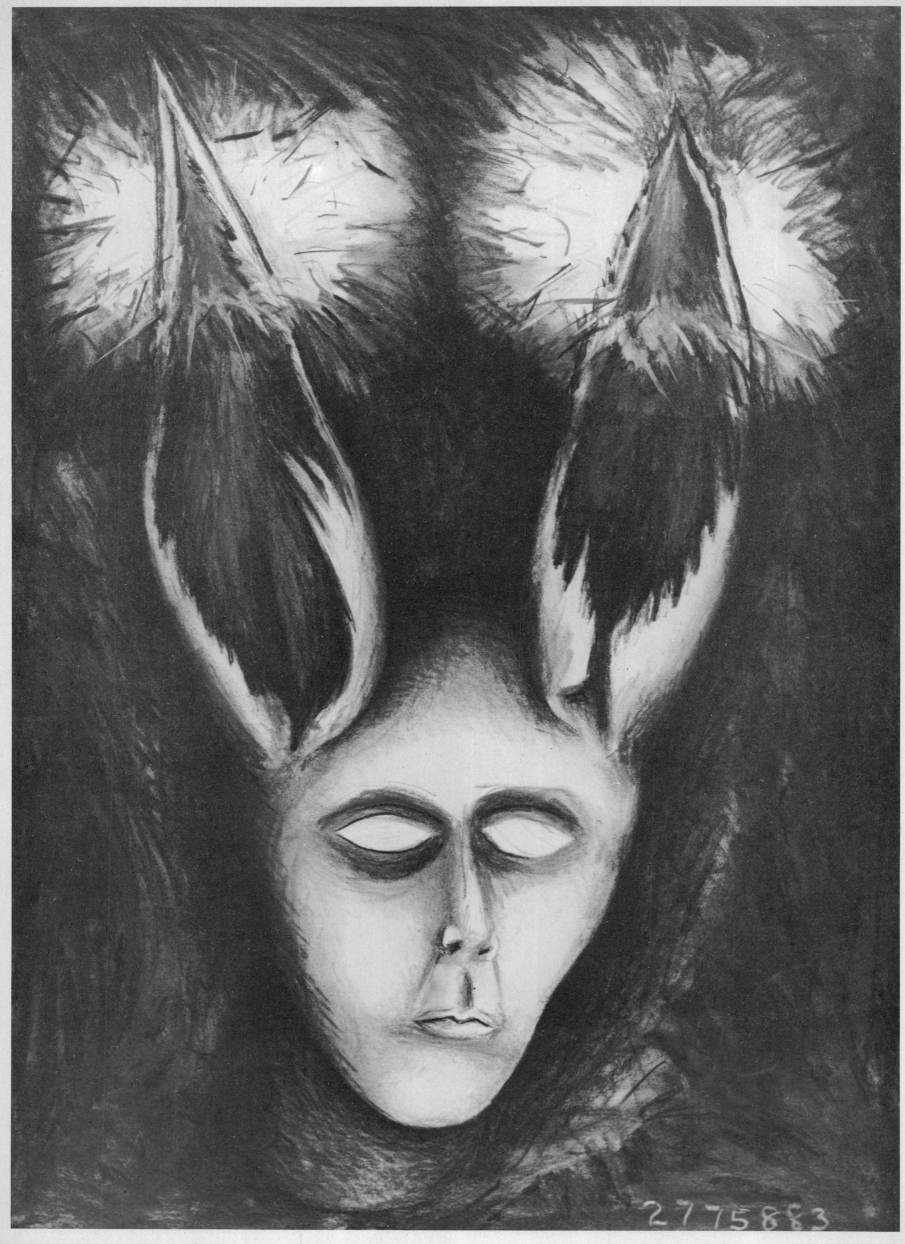

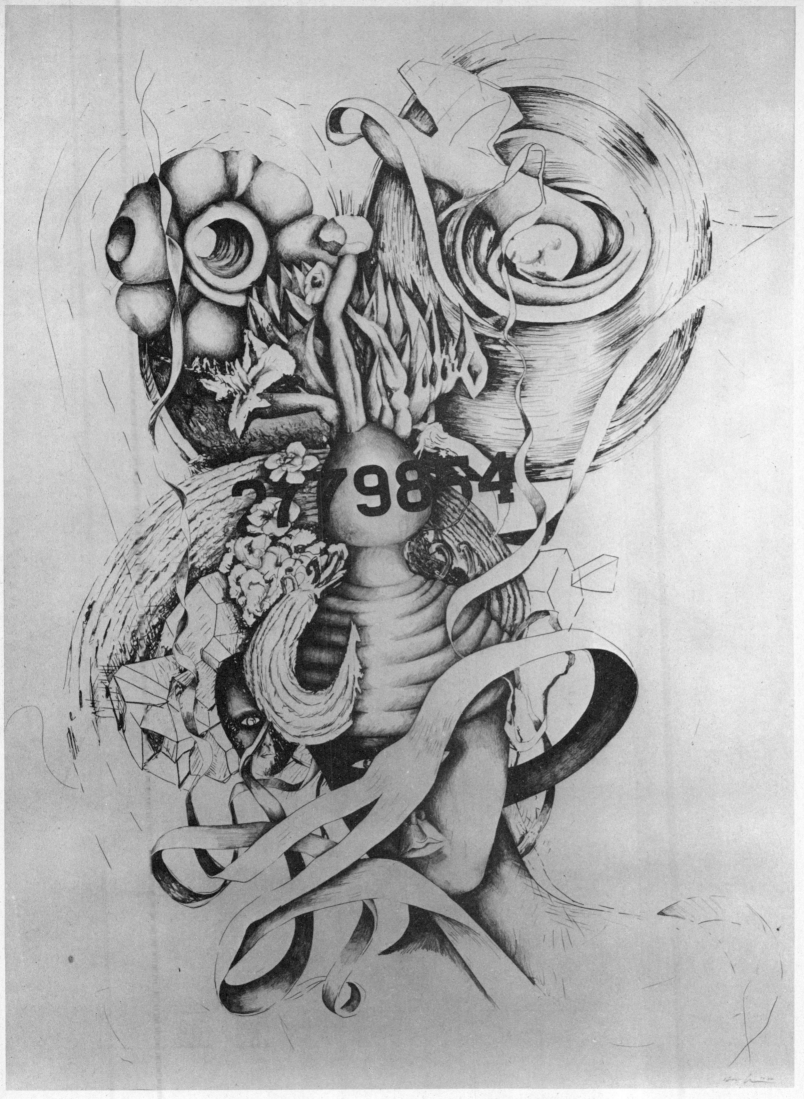

JONATHAN BOROFSKY
HEAD AT 2,779,854. 1978–82
PENCIL, ACRYLIC ON PAPER WITH AUTOMATIC
RHEOSTATING DEVICE AND LIGHT BULB, 84¼ x 57½"
MR. AND MRS. HARRY W. ANDERSON COLLECTION, ATHERTON, CALIFORNIA

◄

JONATHAN BOROFSKY
UNTITLED AT 2,775,883. 1982
PASTEL ON PAPER, 28½ x 20⅛"
COLLECTION JOEL AND ANNE EHRENKRANZ

JONATHAN BOROFSKY

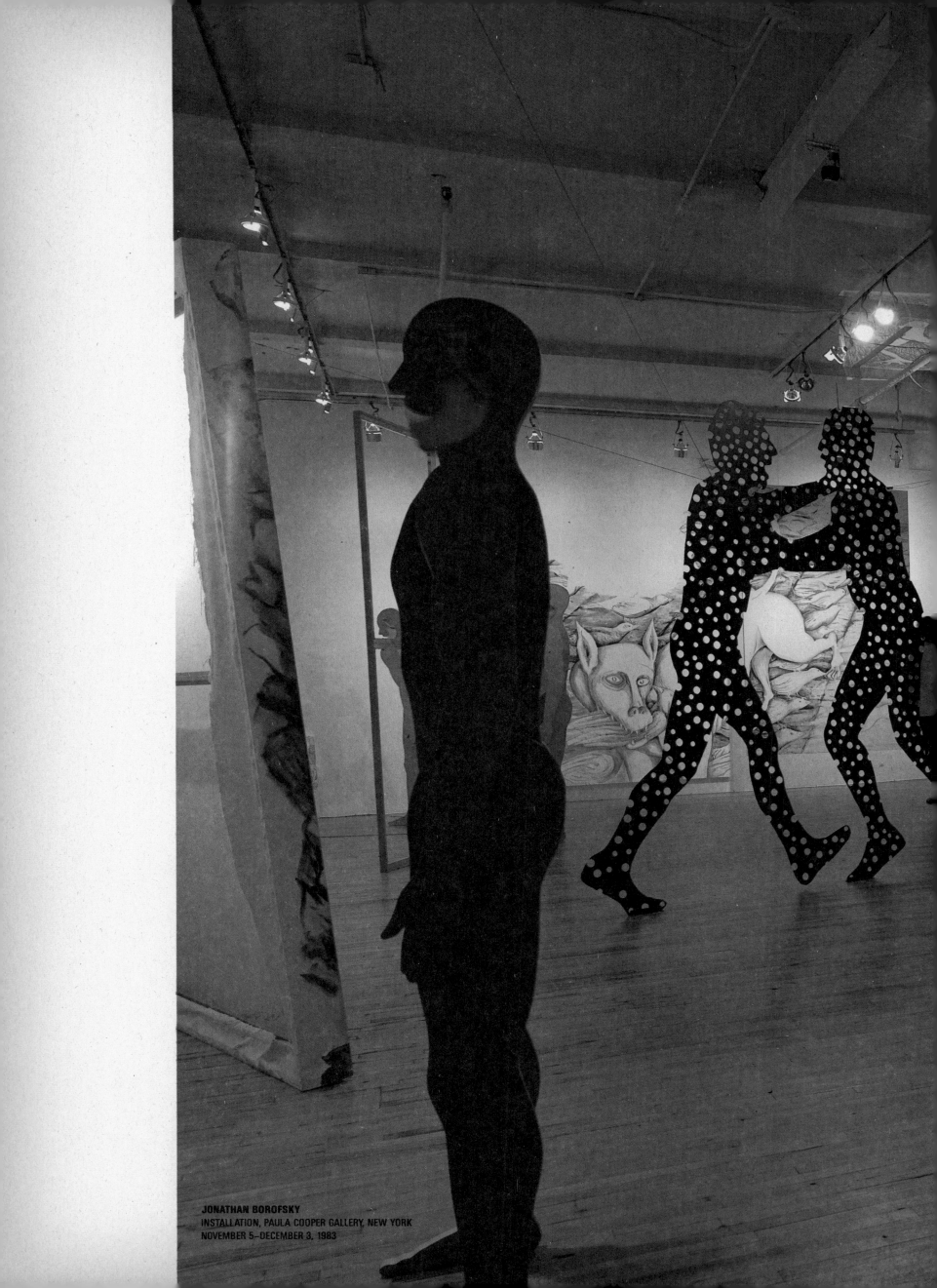

JONATHAN BOROFSKY
INSTALLATION, PAULA COOPER GALLERY, NEW YORK
NOVEMBER 5–DECEMBER 3, 1983

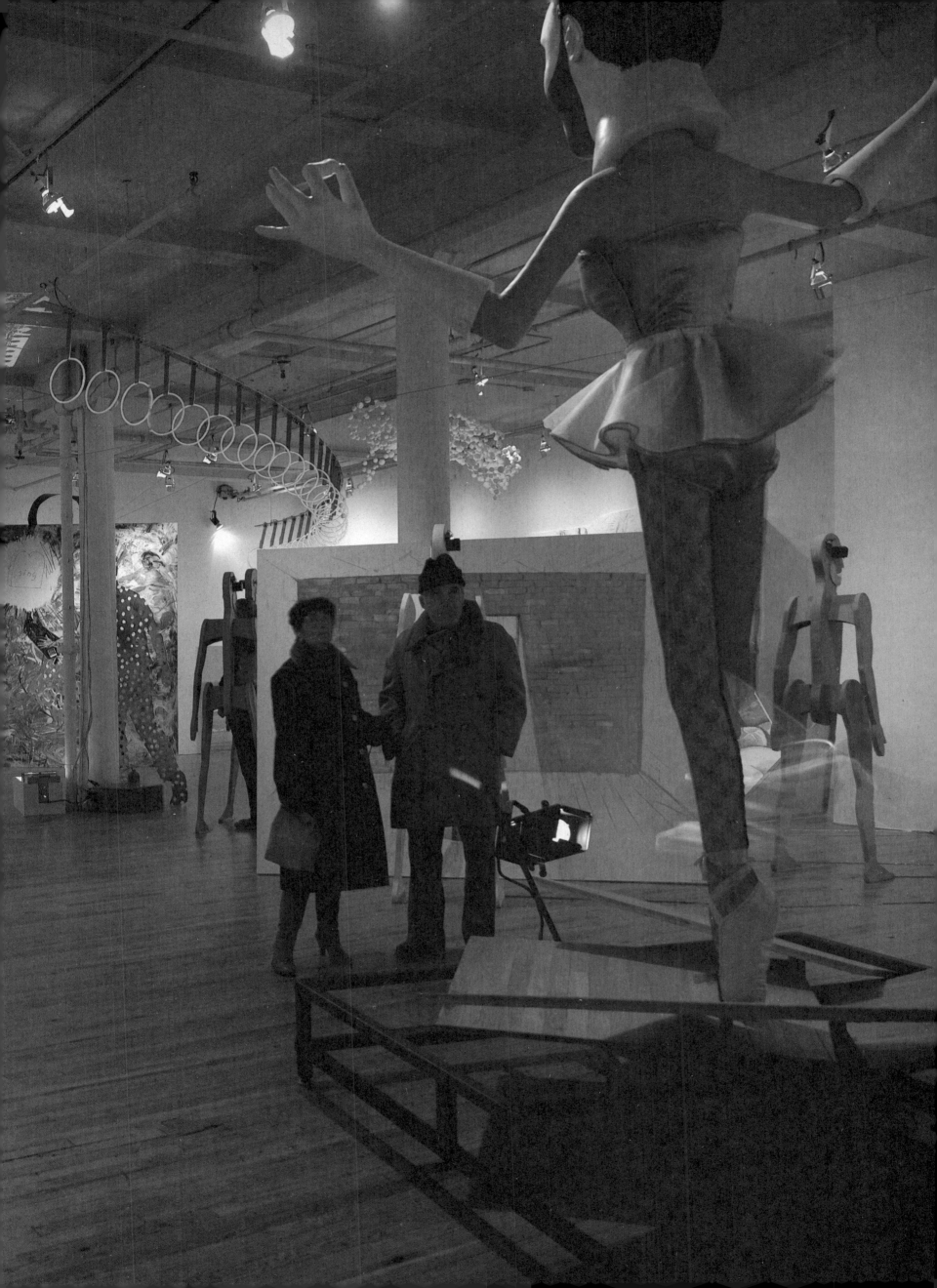

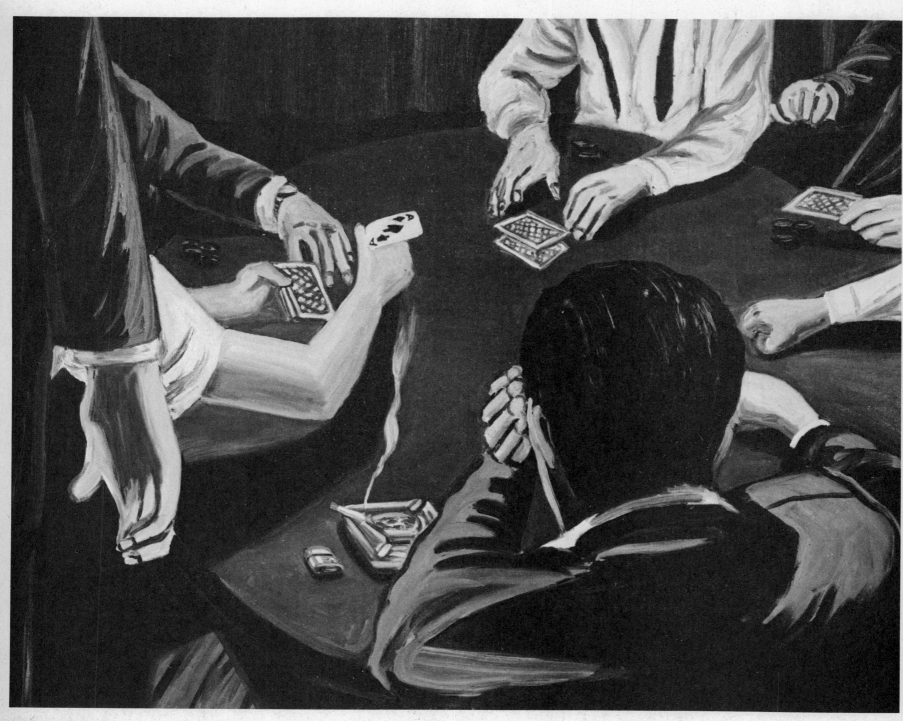

RICHARD BOSMAN
THE CARD PLAYERS. 1982
OIL ON CANVAS, 66 x 84"
COLLECTION DR. AND MRS. JOSEPH GOSMAN

▶
RICHARD BOSMAN
LEAP. 1983
OIL ON CANVAS, 72 x 48"
COLLECTION MR. AND MRS. JOHN BOWES

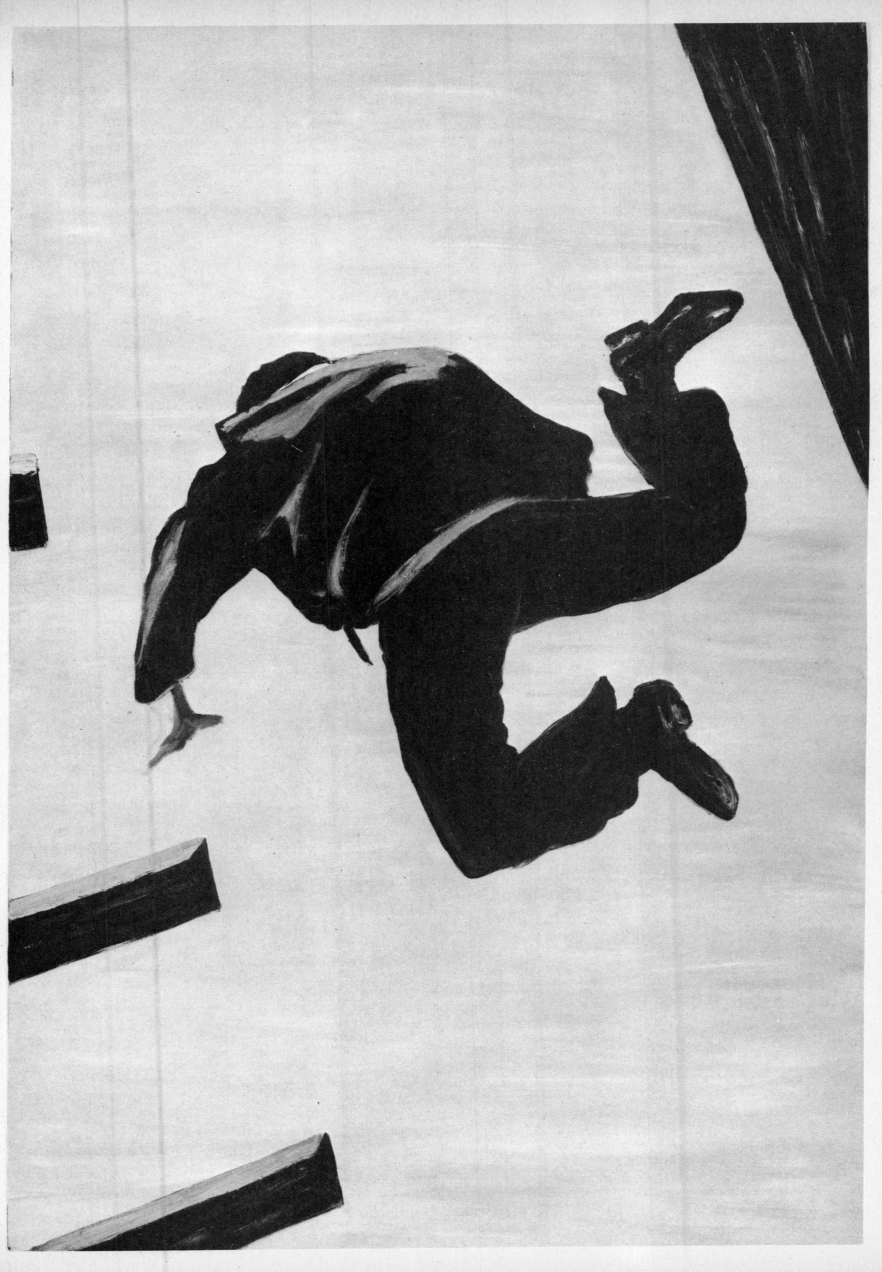

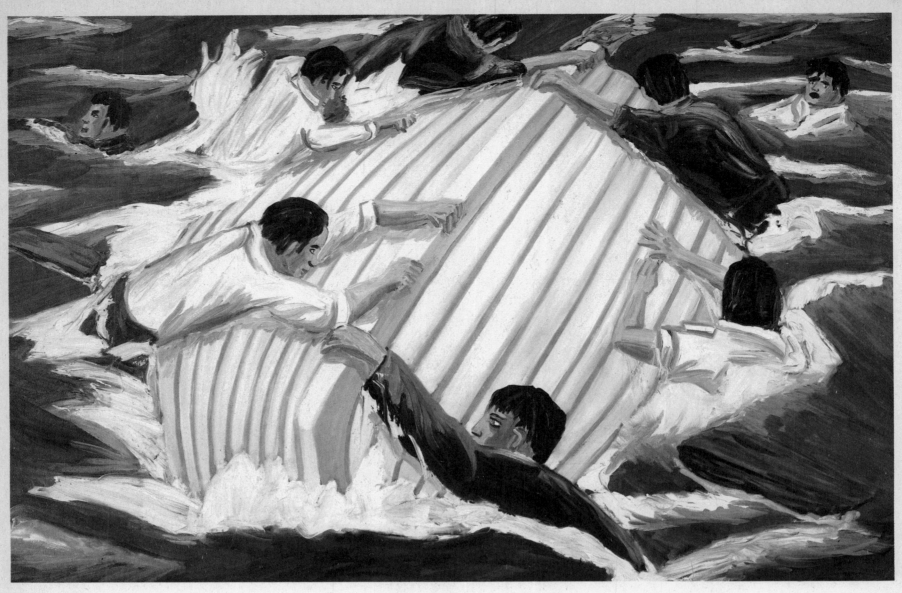

RICHARD BOSMAN
CAPSIZED. 1982
OIL ON CANVAS, 72 x 108"
THE METROPOLITAN MUSEUM OF ART, NEW YORK
GIFT OF MR. AND MRS. WILSON NOLEN, 1983

TROY BRAUNTUCH
UNTITLED. 1981
PENCIL ON PAPER, 46 x 63"
COLLECTION JANET AND MICHAEL GREEN, LONDON

JAMES BROWN

JAMES BROWN
LARGE HEAD III. 1983
TEMPERA ON WOOD AND CARDBOARD, 67 x 63"
COLLECTION CAMUFFO, VENICE

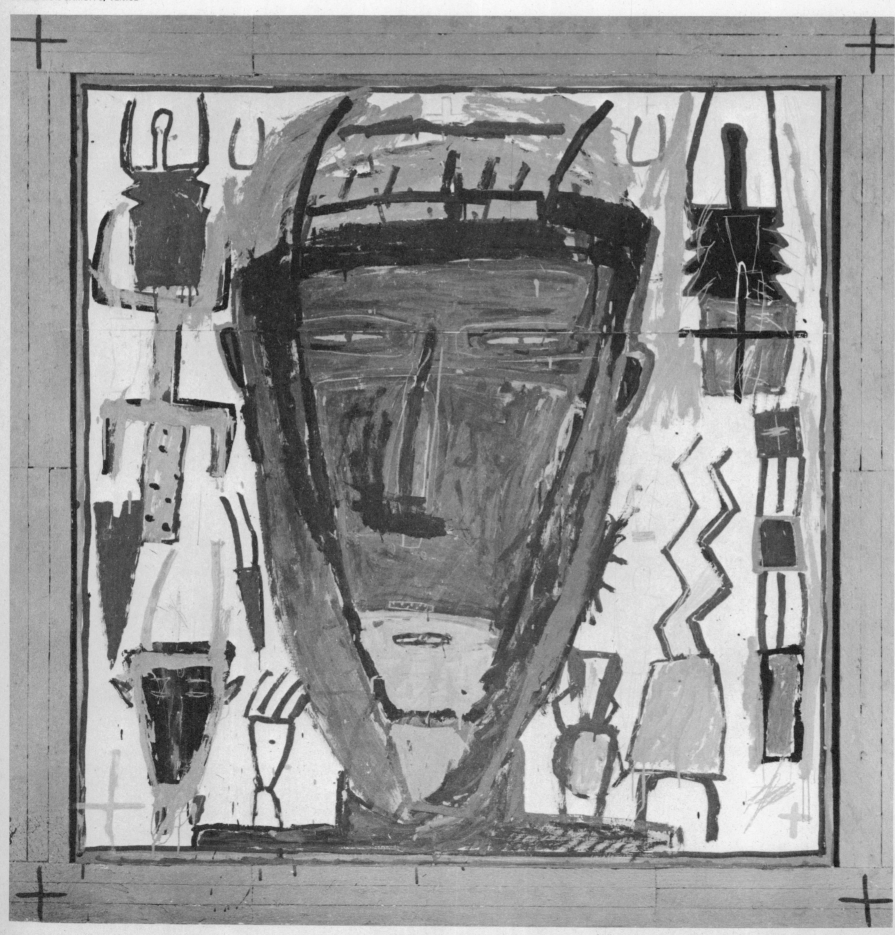

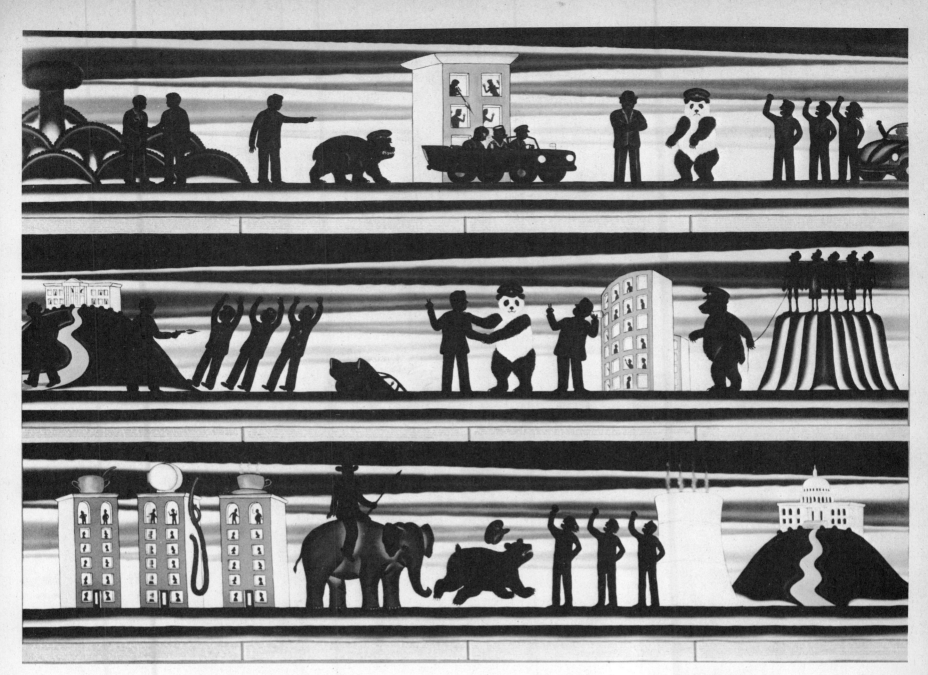

ROGER BROWN
THE MODERN STORY OF LIFE: A CIVICS DIATRIBE. 1982
OIL ON CANVAS, 72¼ x 96"
THE METROPOLITAN MUSEUM OF ART, NEW YORK
GEORGE D. HEARN FUND, 1983

ROGER BROWN

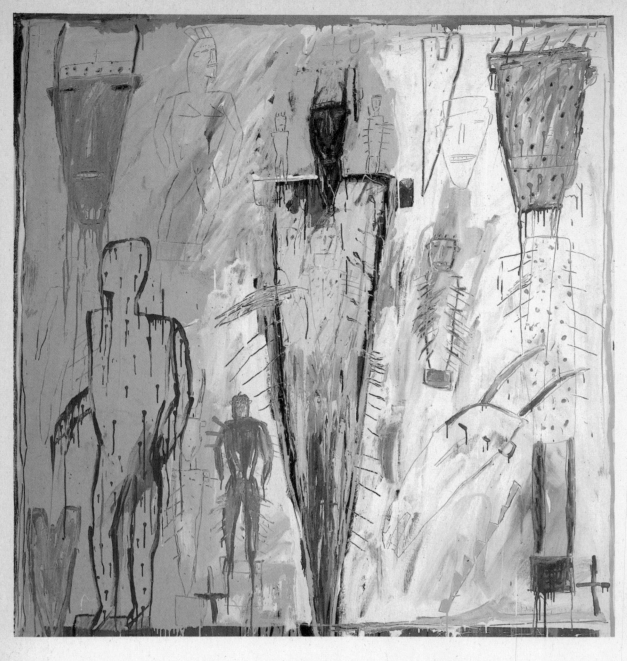

JAMES BROWN
WOODEN SPIKE FIGURE. 1983
OIL AND ENAMEL AND PENCIL ON CANVAS, 84 x 78"
COURTESY TONY SHAFRAZI GALLERY, NEW YORK

ROGER BROWN
VIETNAM COMMEMORATIVE. 1983
OIL ON CANVAS, 84 x 144"
ON ANONYMOUS LOAN TO THE MUSEUM OF FINE ARTS, BOSTON

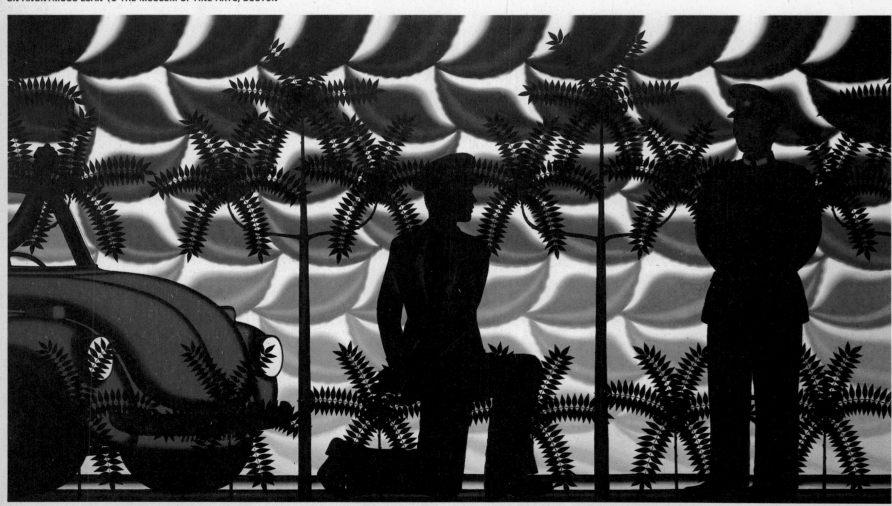

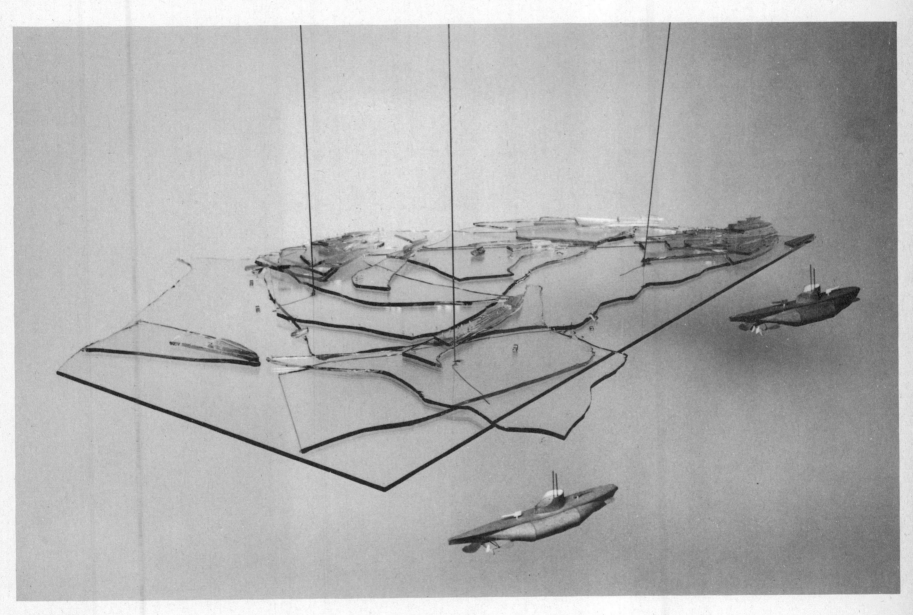

CHRIS BURDEN
THE GLASS SHIP. 1983
¼" PLATE GLASS, SILICONE AND LEAD SOLDIERS
52" LONG, 39" WIDE, 2½" HIGH
COURTESY RONALD FELDMAN FINE ARTS, NEW YORK

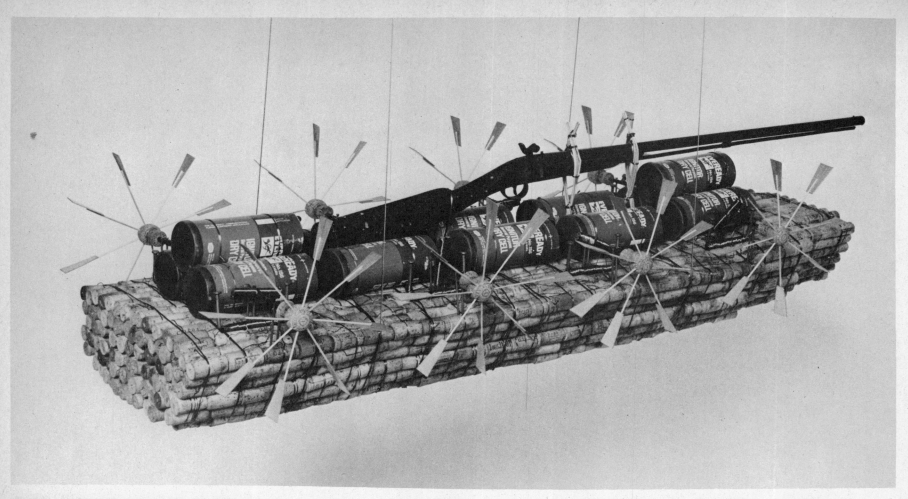

CHRIS BURDEN. *THE SHIP-O-CORKS.* 1983. 2,700 WINE BOTTLE CORKS, CHILD'S 19TH-CENTURY SHOTGUN, 12 DRAY BATTERIES, 8 PADDLE WHEELS, BAMBOO, COPPER WIRE, NAILS AND ELECTRICAL TAPE 55 x 18 x 10½". COLLECTION JOHN ALEXANDER, NEW YORK

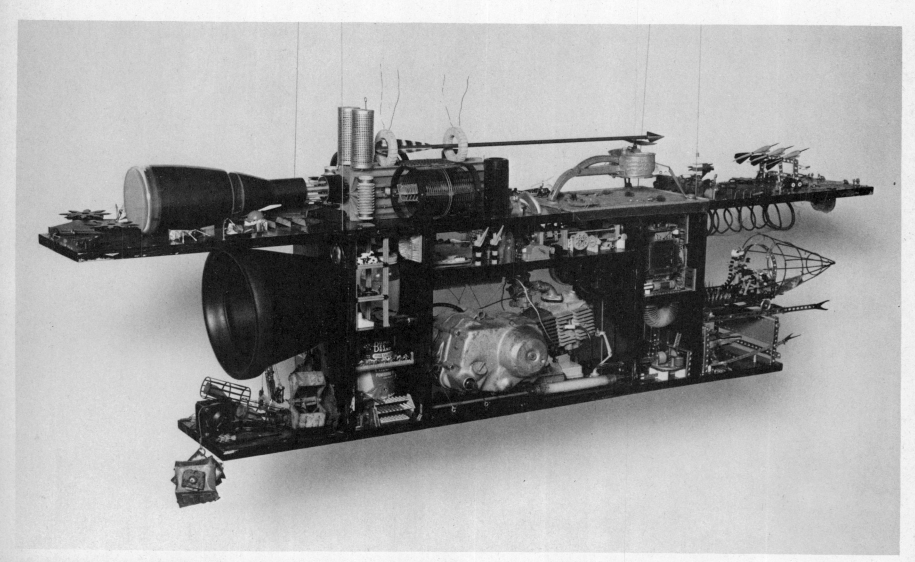

CHRIS BURDEN. *THE SANTA MARIA.* 1982. WOOD, TOYS, PAINT, MOTORCYCLE ENGINE AND ELECTRONIC PARTS. 75½" LONG, 15¼" WIDE, 30" HIGH
COLLECTION MARILYN OSHMAN LUBETKIN, HOUSTON, TEXAS

▶ **JONATHAN BURKE**

JONATHAN BURKE
CHINATOWN. 1980–81
OIL ON CANVAS, 24 x 36"
COLLECTION THE ARTIST

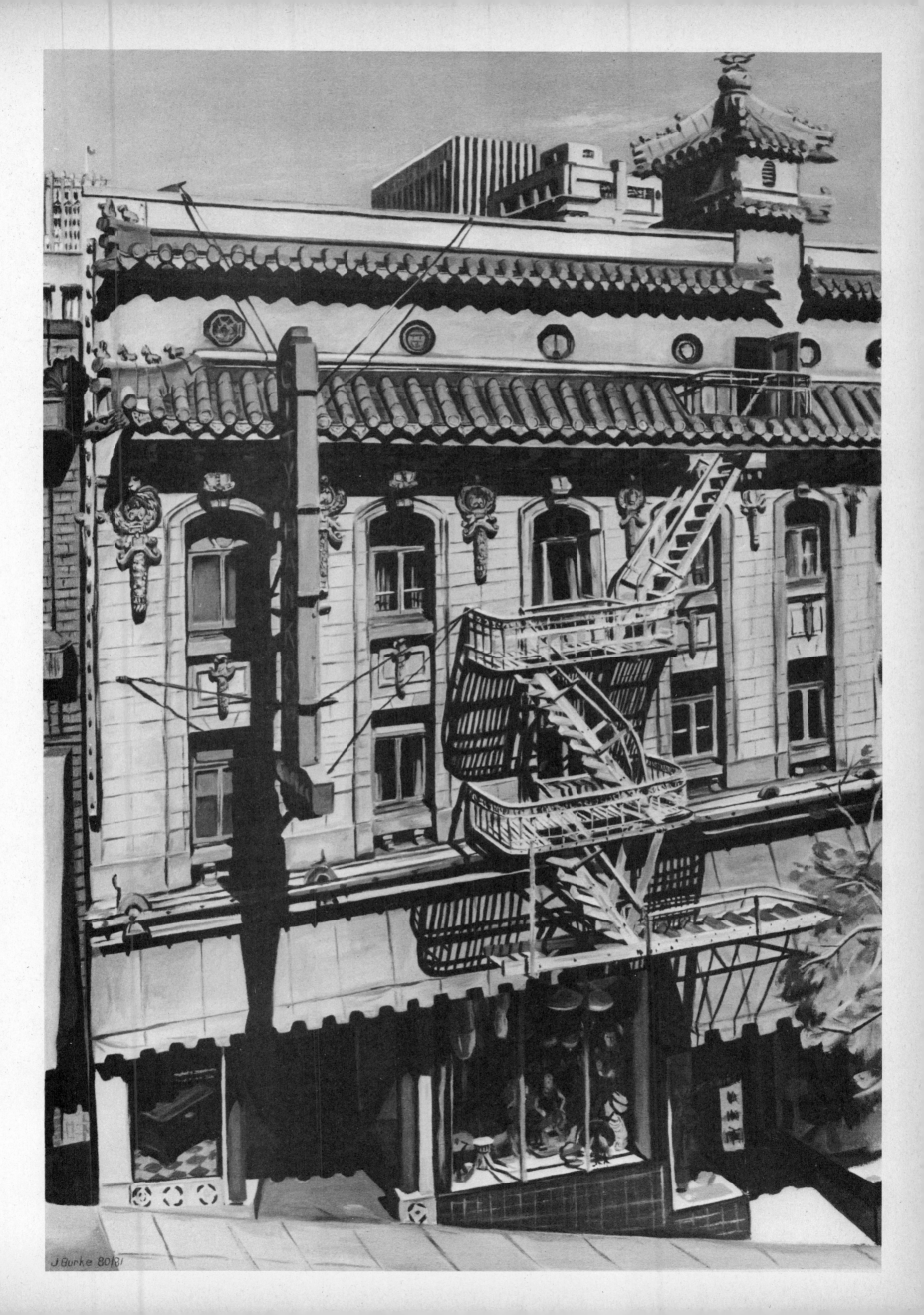

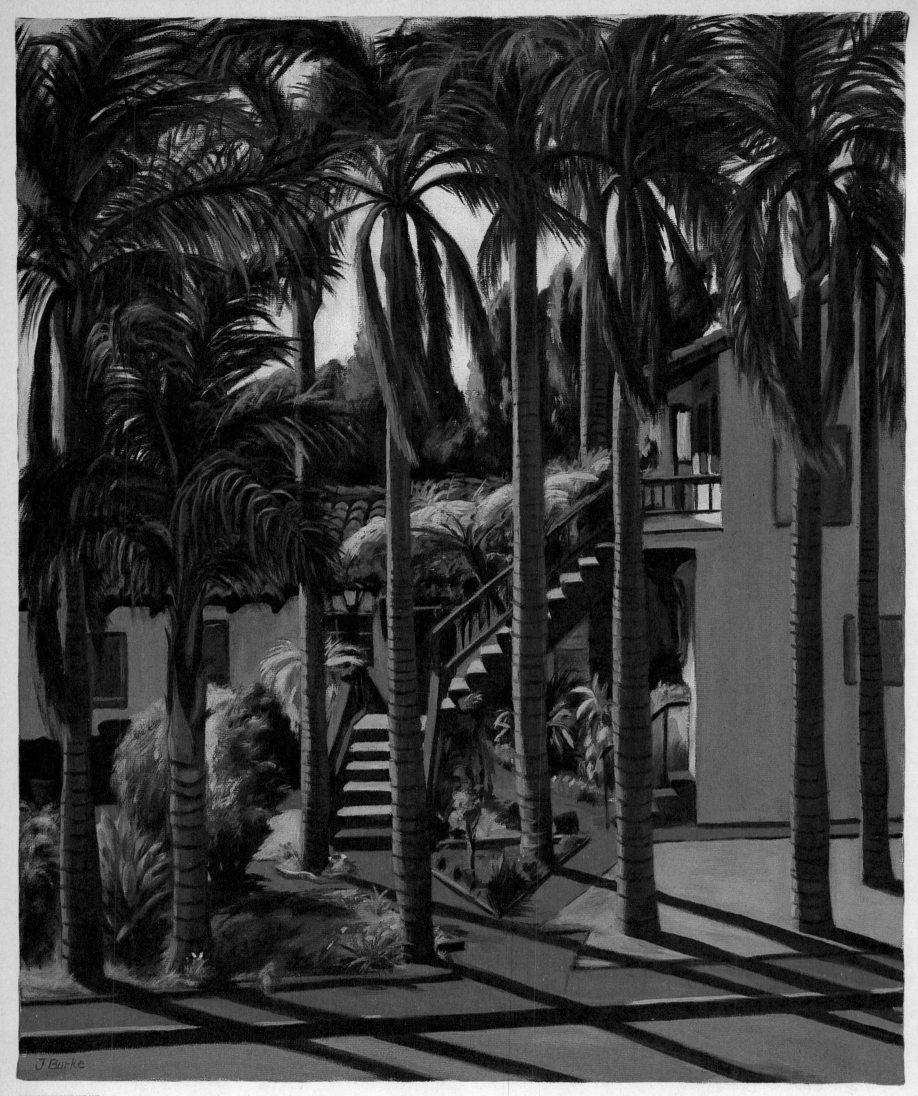

JONATHAN BURKE
AFTERNOON PALMS I. 1982
OIL ON CANVAS, 16 x 20"
PRIVATE COLLECTION

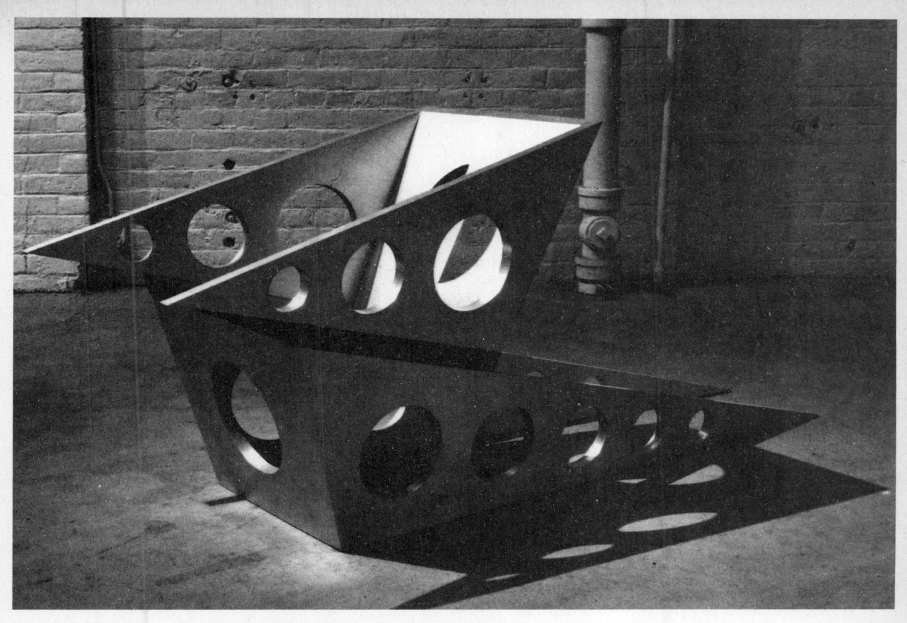

SCOTT BURTON. *ALUMINUM CHAIR.* 1980–81. ALUMINUM, 30 x 23½ x 70". COLLECTION RAYMOND LEARSY, NEW YORK

SCOTT BURTON
GRANITE SETTEE. 1983–84. OVERALL DIMENSIONS, 36 x 65¼ x 35". DALLAS MUSEUM OF ART. PURCHASE THROUGH A GRANT FROM THE NATIONAL ENDOWMENT FOR THE ARTS WITH MATCHING FUNDS FROM ROBERT K. HOFFMAN, THE ROBLEE CORPORATION, LAURA L. CARPENTER, NANCY M. O'BOYLE, AND AN ANONYMOUS DONOR

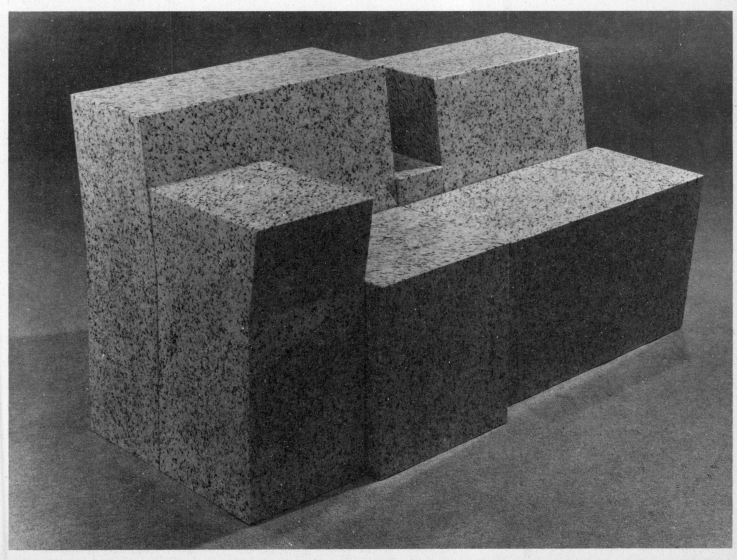

SCOTT BURTON

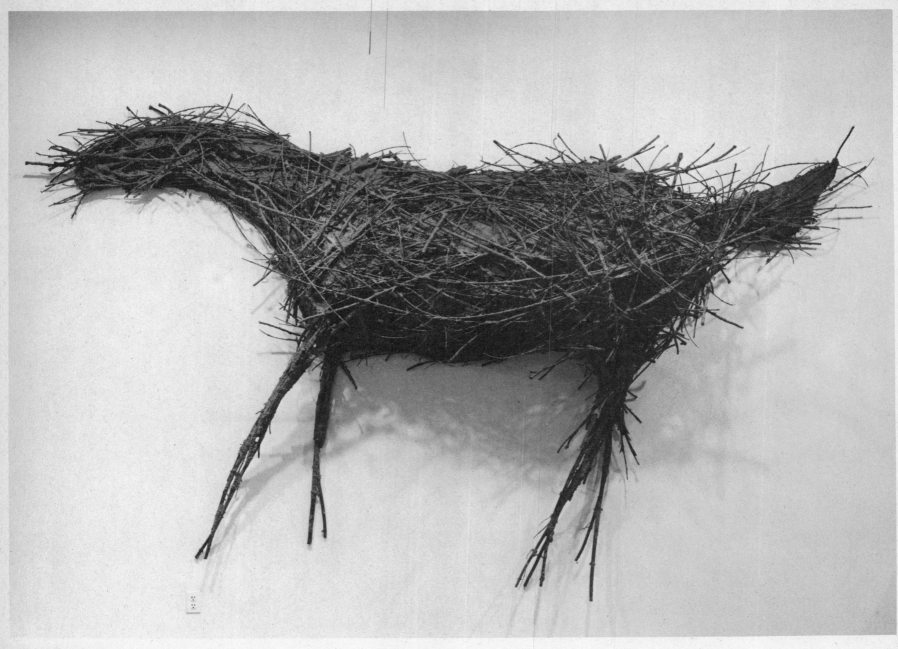

DEBORAH BUTTERFIELD
LARGE HORSE. 1981
PAPER, STICKS ON WIRE ARMATURE, C. 8' HIGH
COLLECTION J. B. SPEED MUSEUM, LOUISVILLE, KENTUCKY

DEBORAH BUTTERFIELD

DEBORAH BUTTERFIELD
HORSES. FUSED ALUMINUM ON STEEL ARMATURE, LIFESIZE
INSTALLATION, O. K. HARRIS WORKS OF ART, NEW YORK, APRIL 3–24, 1982

DEBORAH BUTTERFIELD
BUNDLED HORSE #4. 1982
WOOD, WIRE, 27 x 34 x 13"
PRIVATE COLLECTION
COURTESY O. K. HARRIS WORKS OF ART, NEW YORK

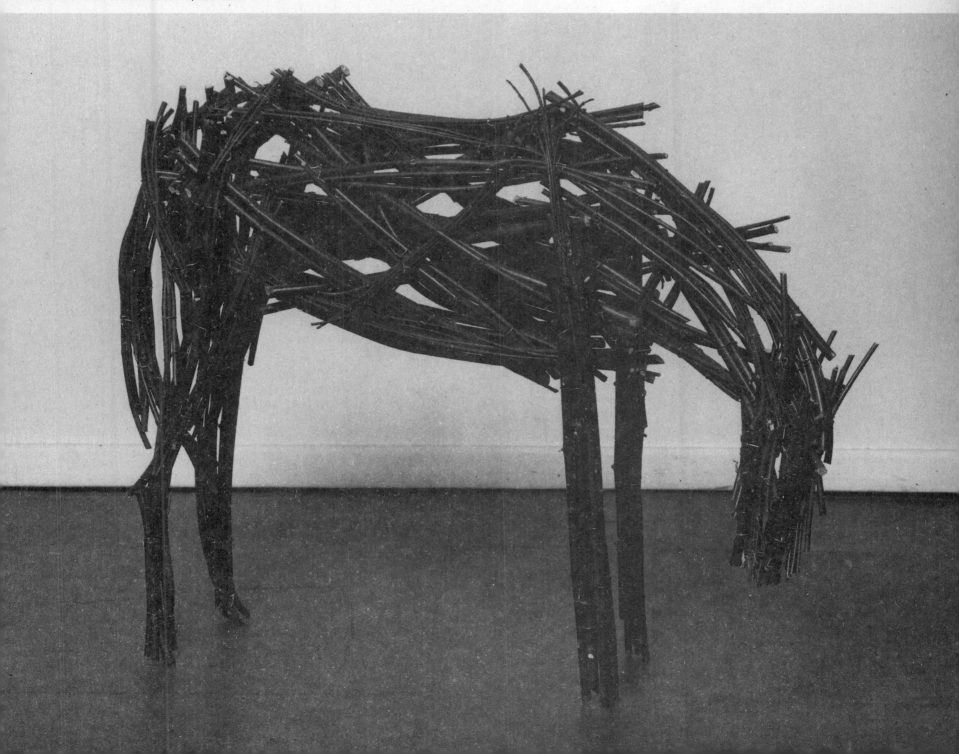

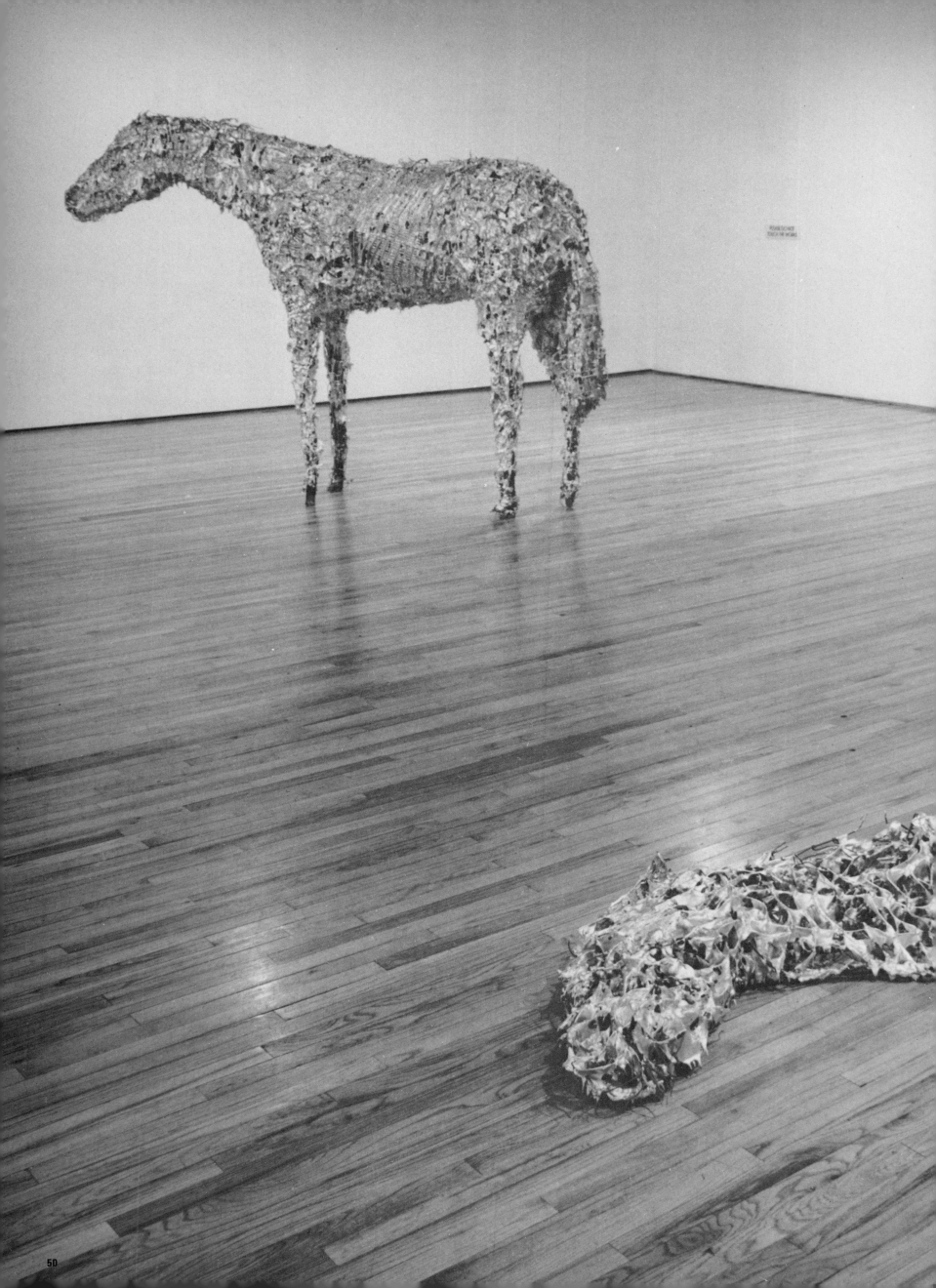

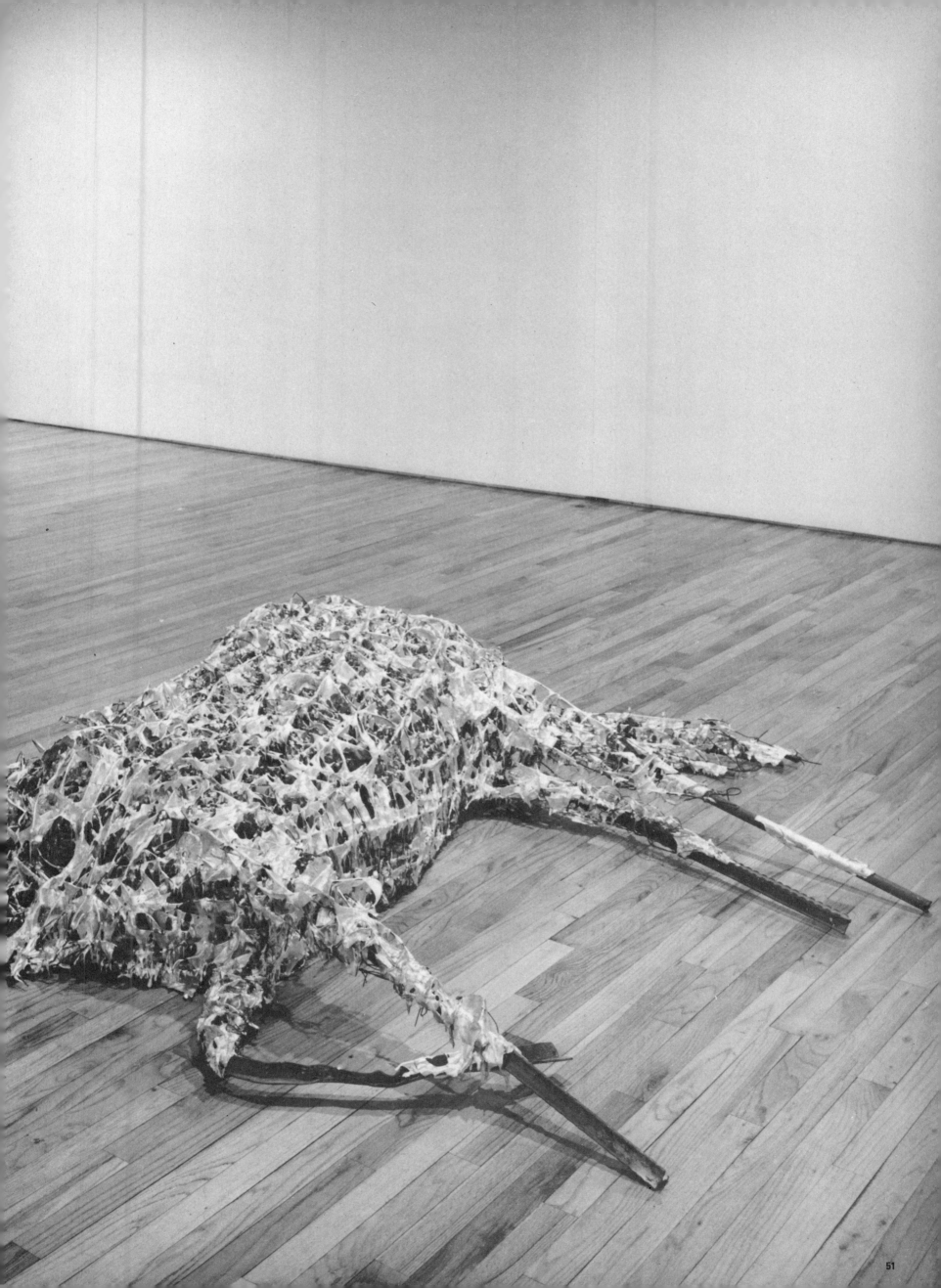

LOUISA CHASE

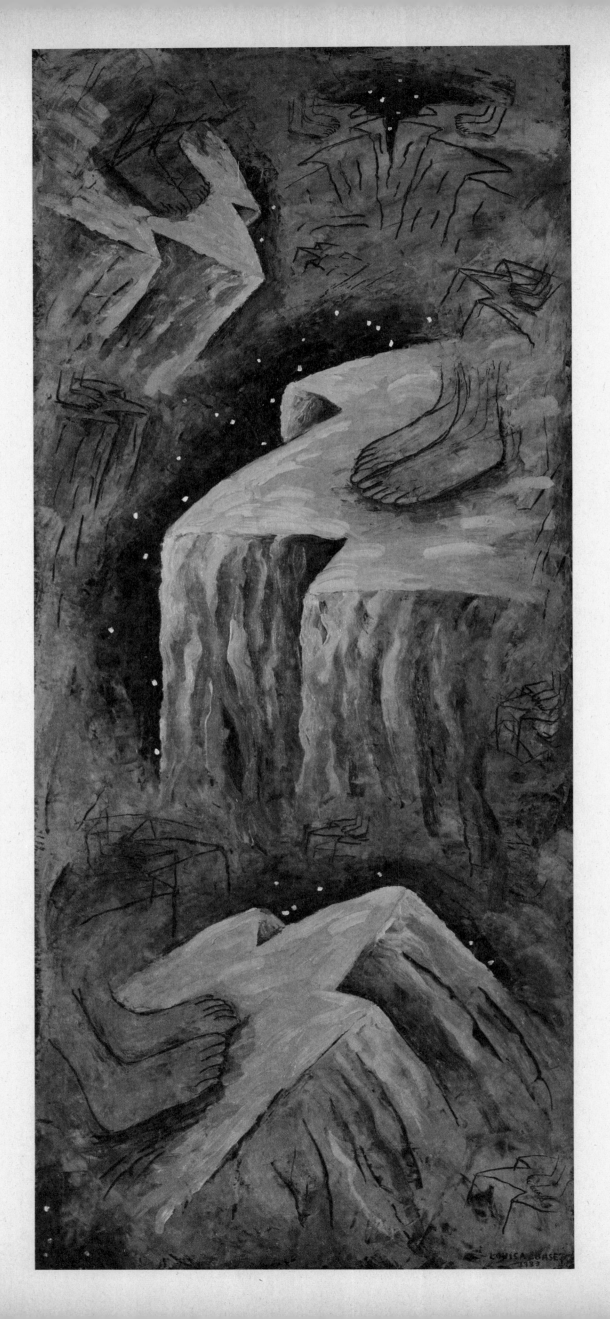

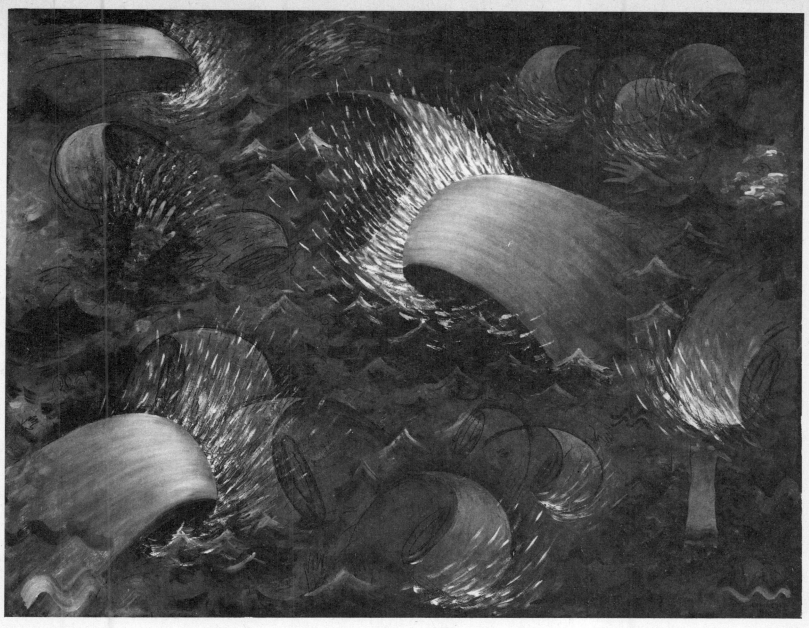

LOUISA CHASE
RED SEA. 1983
OIL ON CANVAS, 84 x 108"
COLLECTION MR. AND MRS. ROBERT SHAPIRO, NEW YORK

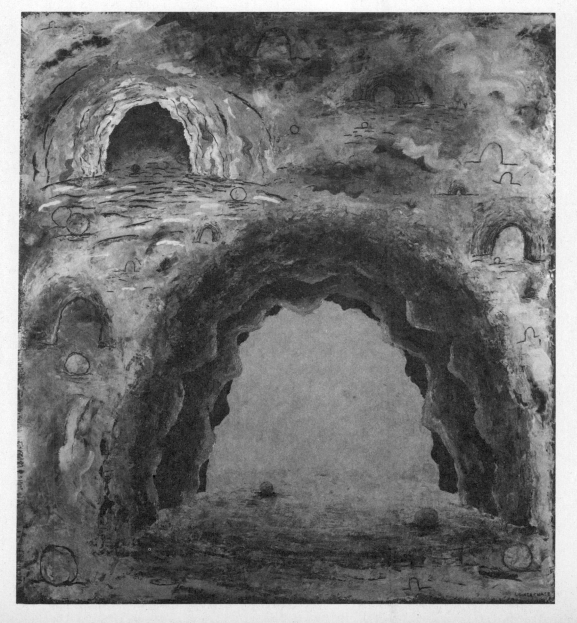

LOUISA CHASE
PINK CAVE. 1983
OIL ON CANVAS, 84 x 72"
THE METROPOLITAN MUSEUM OF ART, NEW YORK
EDITH C. BLUM FUND, 1983

SANDRO CHIA

SANDRO CHIA
THREE BOYS ON A RAFT. 1983
OIL ON CANVAS, 97 x 111"
COLLECTION PAINE WEBBER INC.
COURTESY SPERONE WESTWATER, NEW YORK

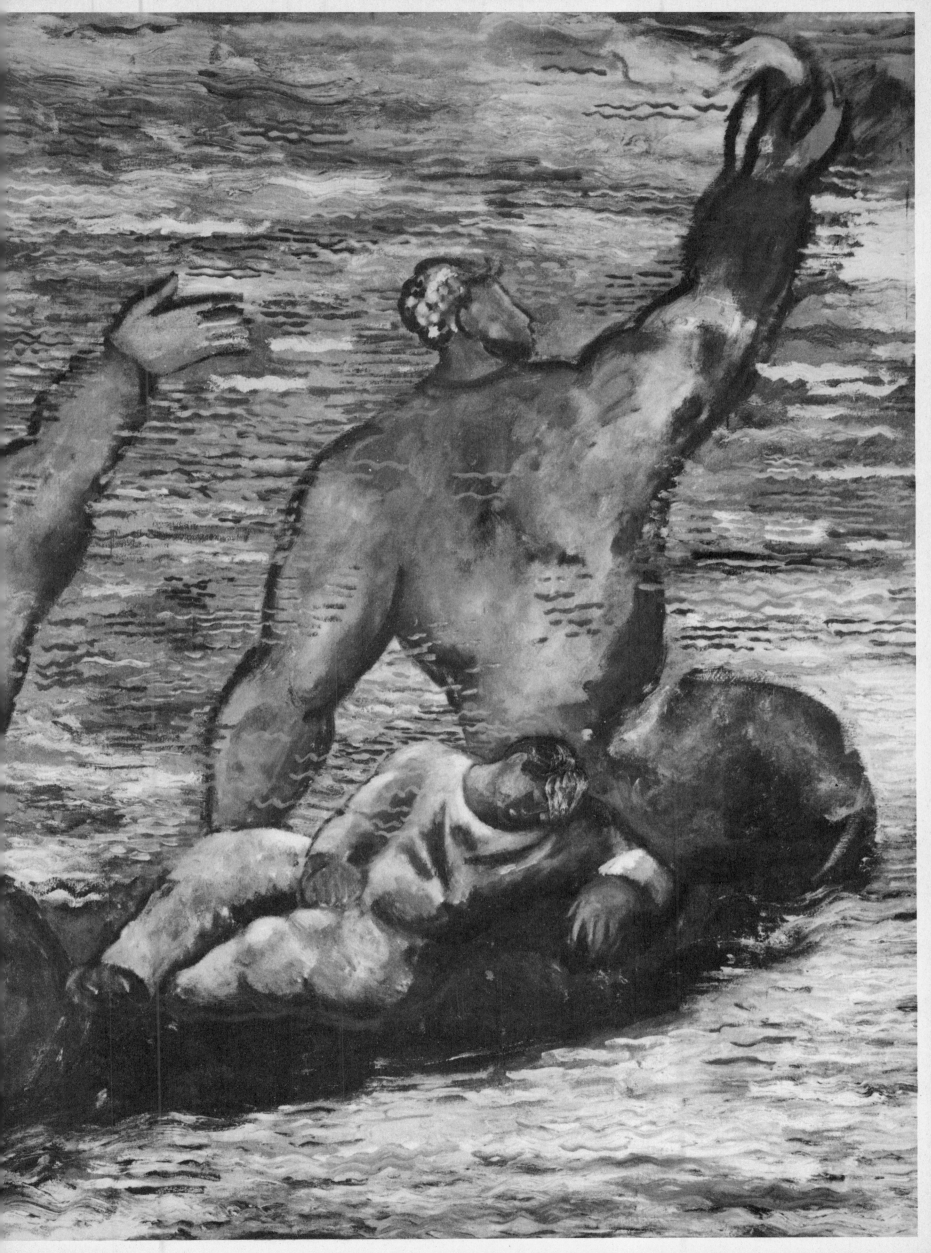

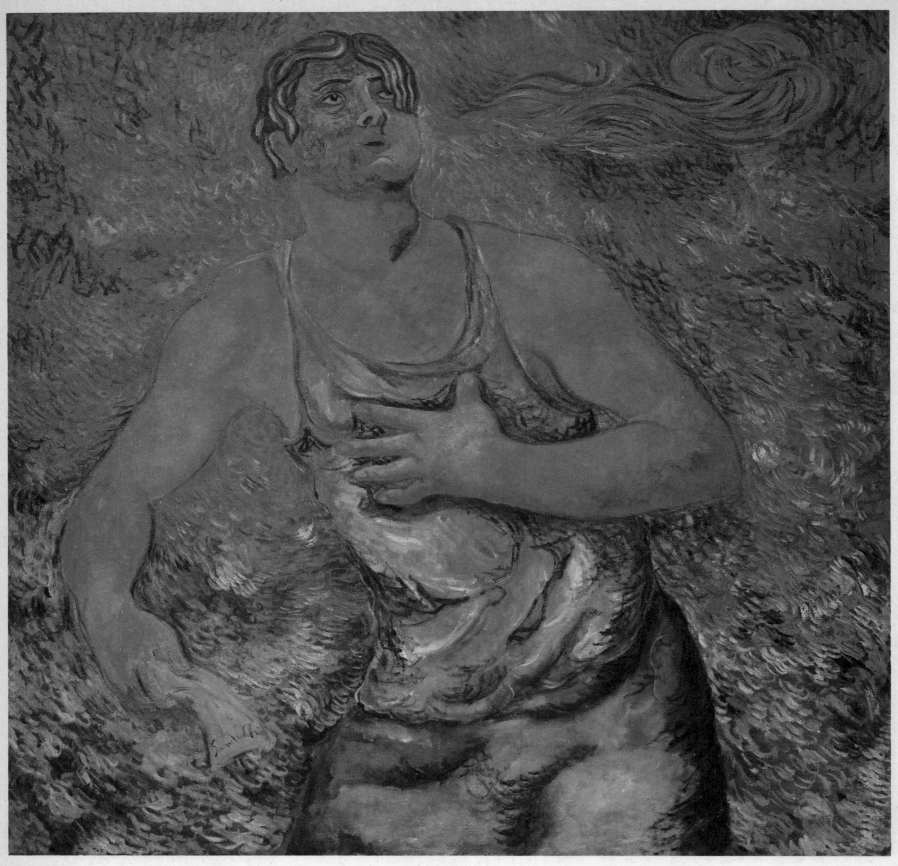

SANDRO CHIA
POETIC DECLARATION. 1983
OIL ON CANVAS, 96 x 96"
COLLECTION GERALD S. ELLIOTT, CHICAGO
COURTESY SPERONE WESTWATER, NEW YORK

CHRISTO

CHRISTO
SURROUNDED ISLANDS. BISCAYNE BAY, GREATER MIAMI, FLORIDA, 1980–83
PHOTO: JEANNE-CLAUDE CHRISTO
COPYRIGHT CHRISTO/C.V.J. CORPORATION

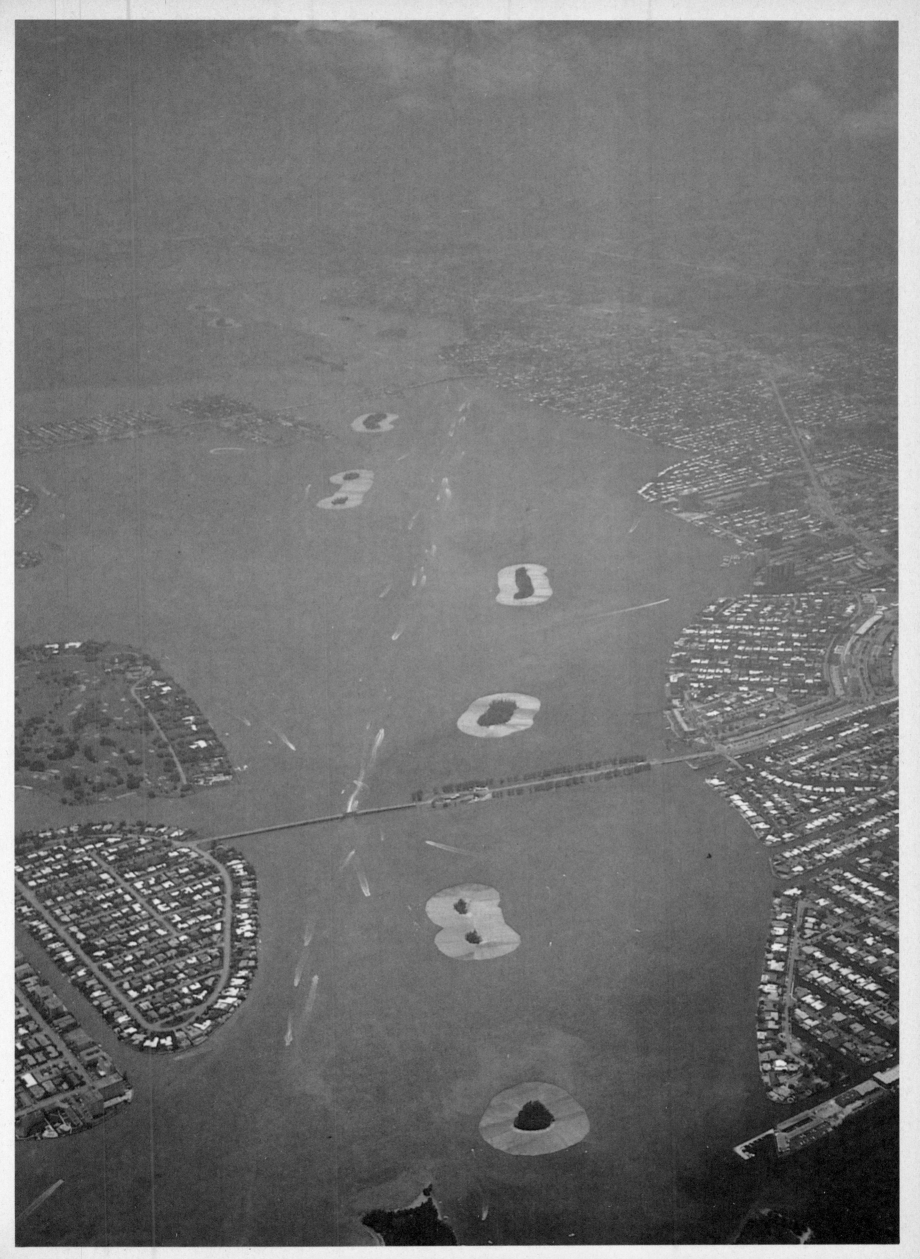

FRANCESCO CLEMENTE

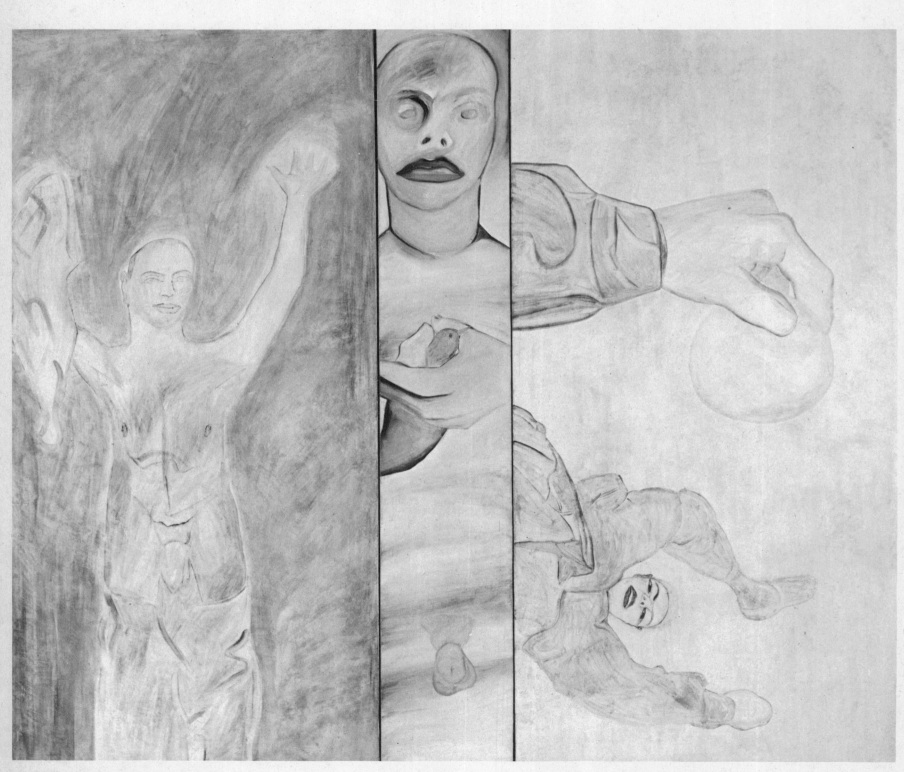

FRANCESCO CLEMENTE
CONVERSION TO HER. 1983
FRESCO ON STYROFOAM AND FIBERGLAS PANEL, 96 x 112½ x 2½"
COLLECTION THE MUSEUM OF MODERN ART, NEW YORK
COURTESY SPERONE WESTWATER, NEW YORK

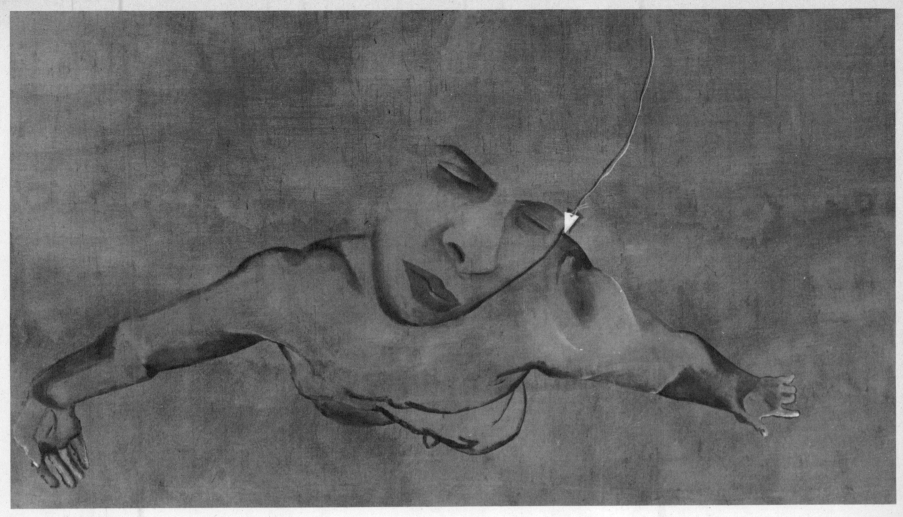

FRANCESCO CLEMENTE
SEMEN. 1983
OIL ON LINEN, 93 x 156"
PRIVATE COLLECTION, VENEZUELA
COURTESY SPERONE WESTWATER, NEW YORK

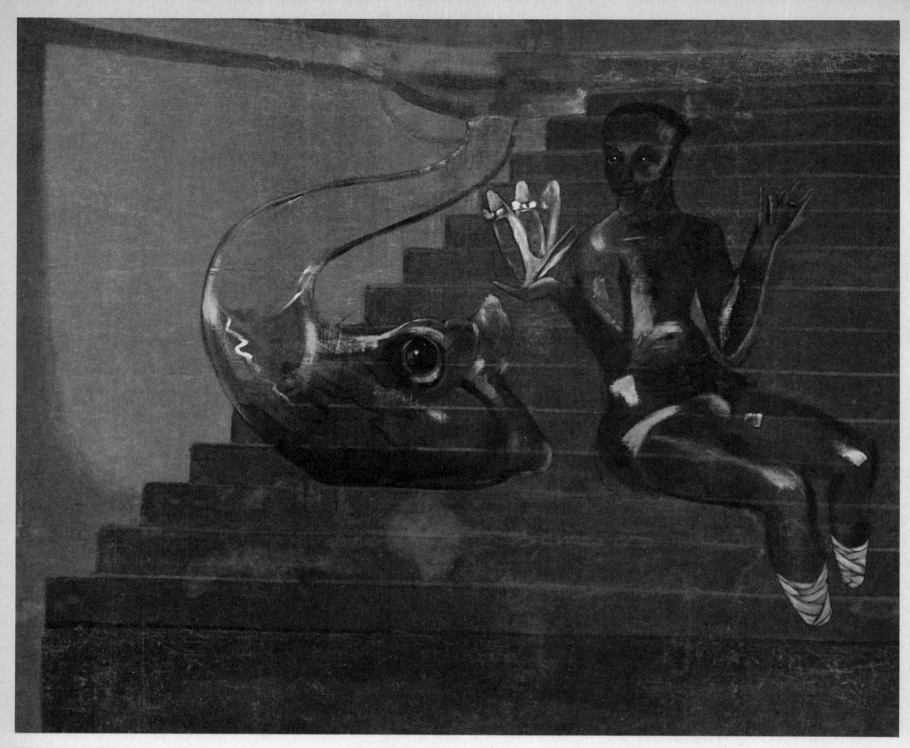

FRANCESCO CLEMENTE
FRIENDSHIP. 1983.
ACRYLIC AND OIL ON CANVAS, 84 x 100"
COURTESY MARY BOONE GALLERY, NEW YORK

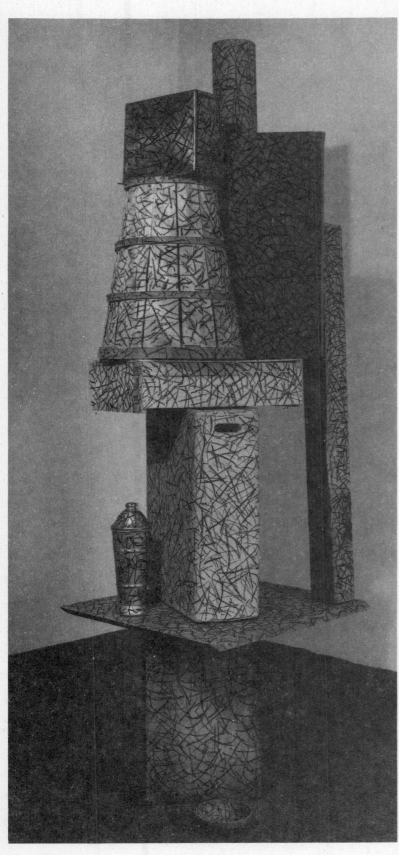

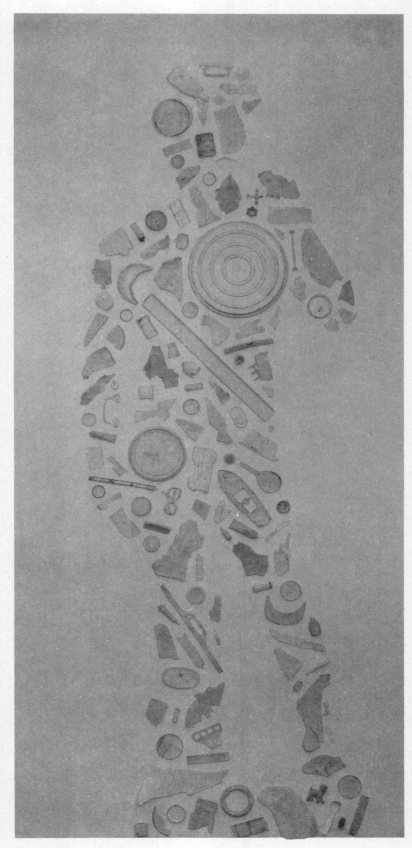

TONY CRAGG
DRAWN OBJECTS "WAITING." 1983
86½ x 26 x 28"
COLLECTION GERALD S. ELLIOTT, CHICAGO

TONY CRAGG
DAVID. 1984
PRIVATE COLLECTION

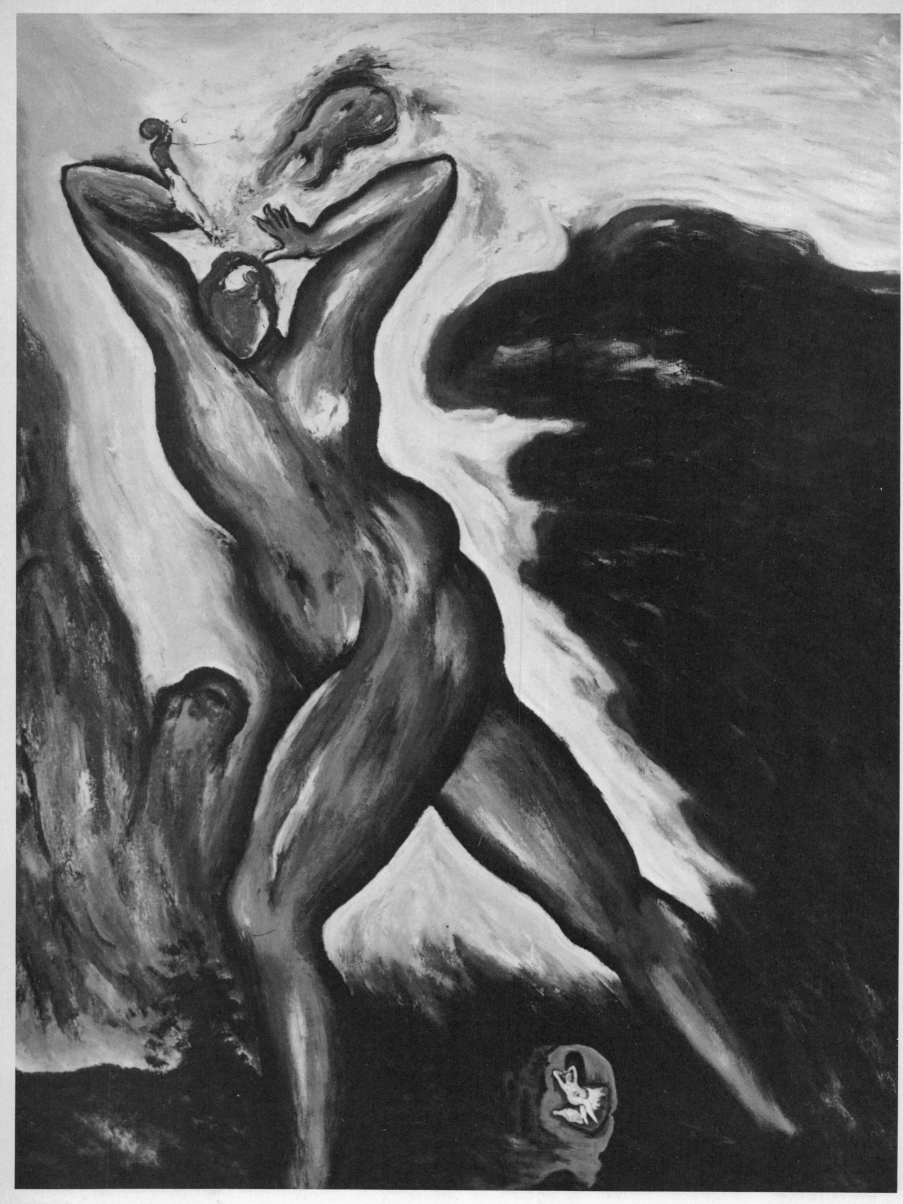

ENZO CUCCHI
LO ZINGARO. 1982
OIL ON CANVAS, 117 x 84"
COURTESY SPERONE WESTWATER, NEW YORK

ENZO CUCCHI
PAESAGGIO BARBARO. 1983
OIL ON CANVAS, 51 x 62¾"
COLLECTION ANGELA WESTWATER, NEW YORK
COURTESY SPERONE WESTWATER, NEW YORK

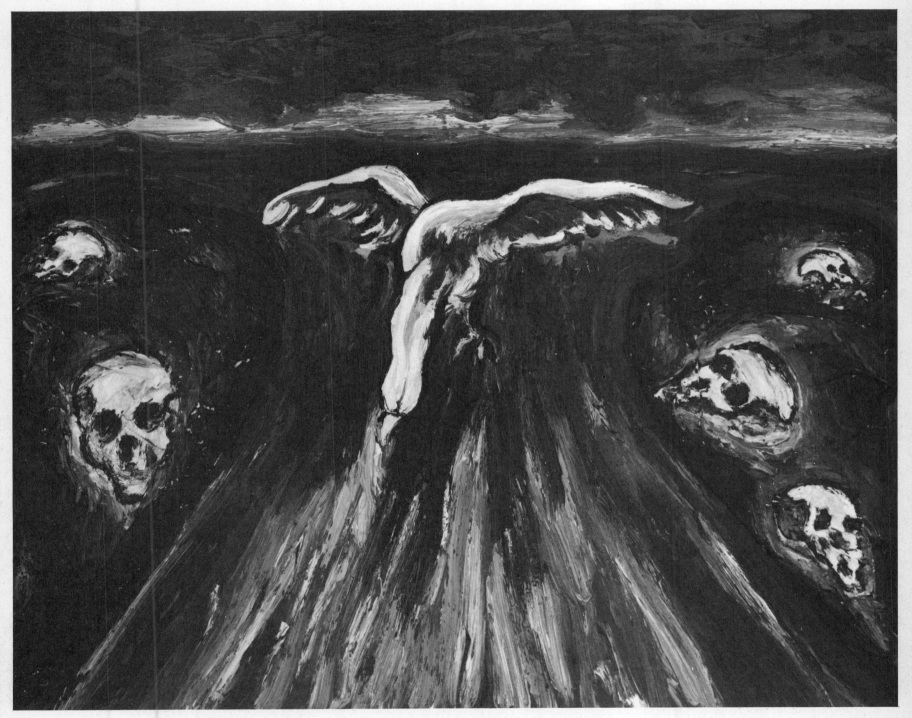

AGNES DENES
WHEATFIELD—A CONFRONTATION—
BATTERY PARK LANDFILL, DOWNTOWN MANHATTAN—
1.8 ACRES OF WHEAT, SUMMER 1982
© 1982 AGNES DENES

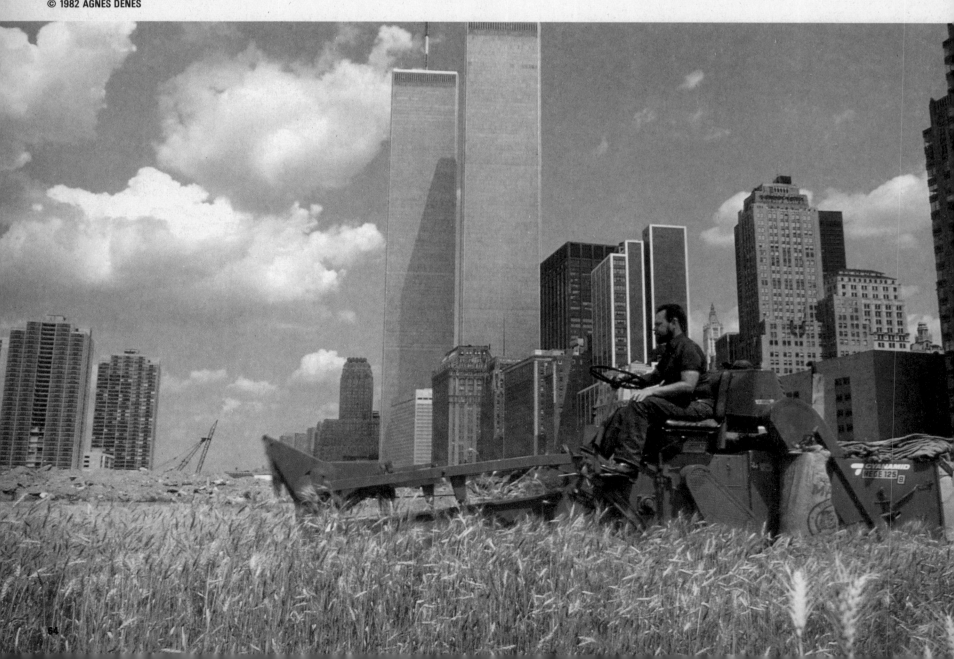

DAVID DEUTSCH
UNTITLED. 1982
ACRYLIC ON CANVAS, 75 x 75"
PRIVATE COLLECTION, LONDON

DAVID DEUTSCH
UNTITLED. 1982
INK ON PAPER ON CANVAS, 74 x 234"
PRIVATE COLLECTION

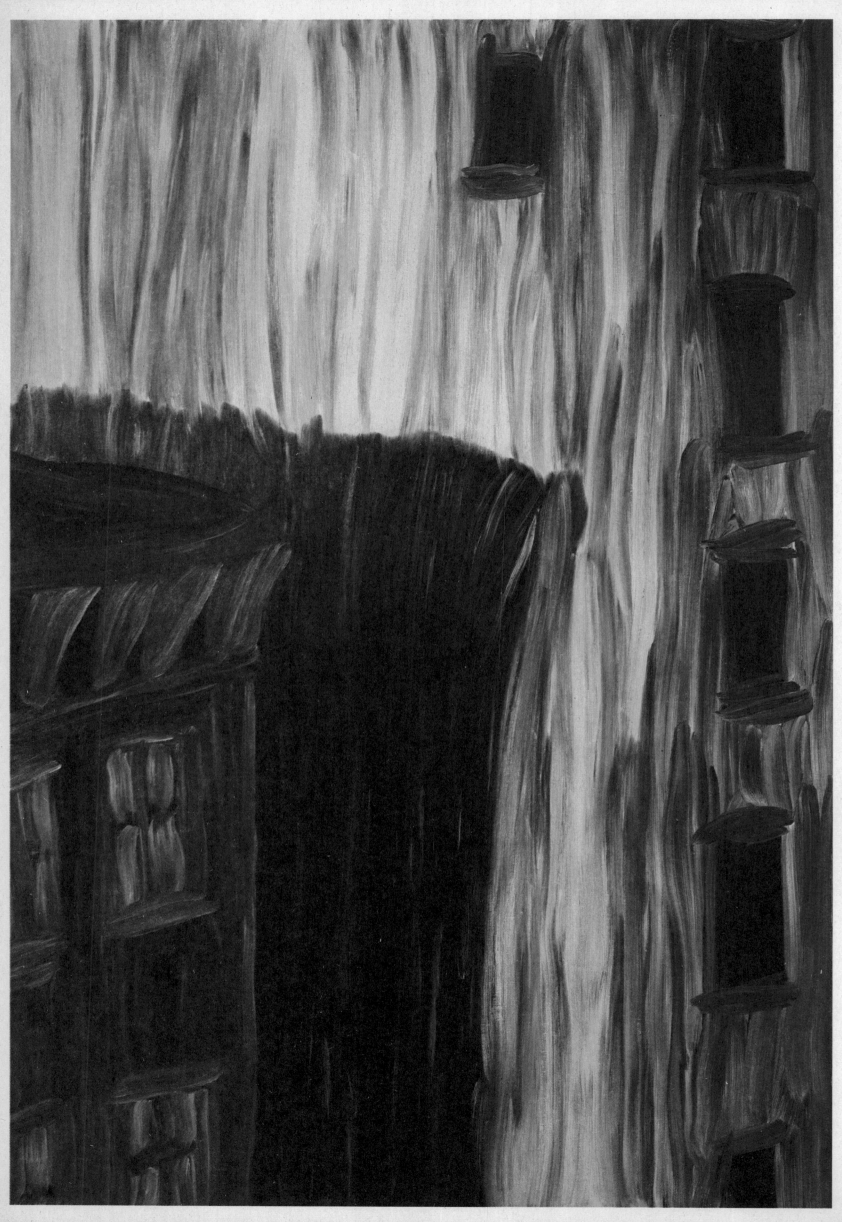

JOHN DUFF

JOHN DUFF
ORACLE. 1983
WOOD ON FIBERGLAS WITH OIL AND ALUMINUM PAINT ON REVERSE,
72¼ x 12⅞ x 19¾"
COURTESY BLUM HELMAN GALLERY, NEW YORK

◀

MARTHA DIAMOND
PARADE. 1982
OIL ON CANVAS, 84 x 56"
COLLECTION BROOKE AND CAROLYN ALEXANDER

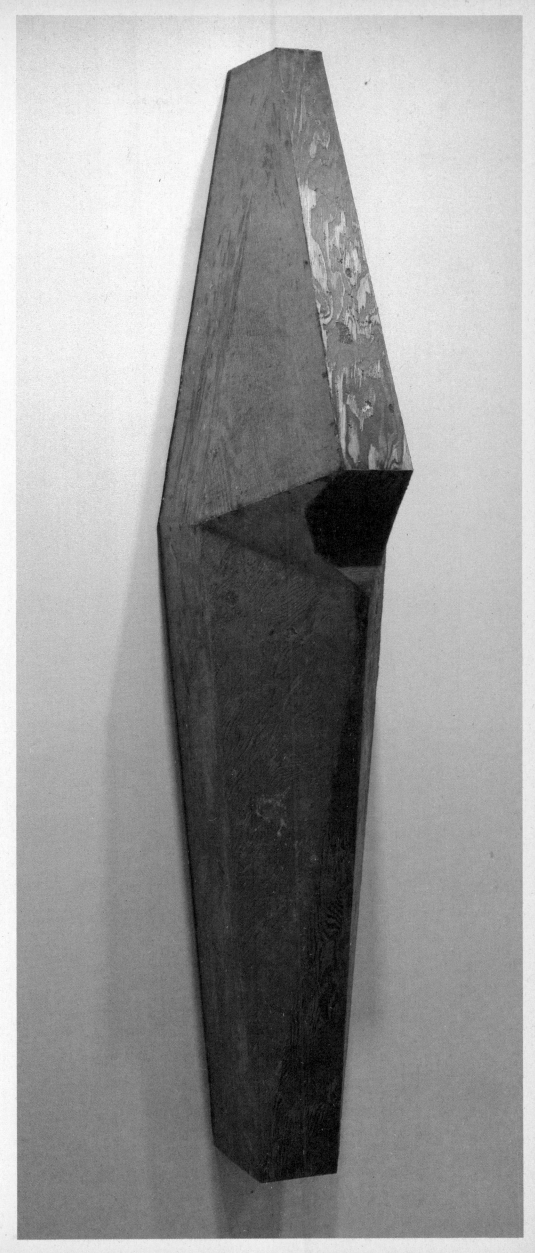

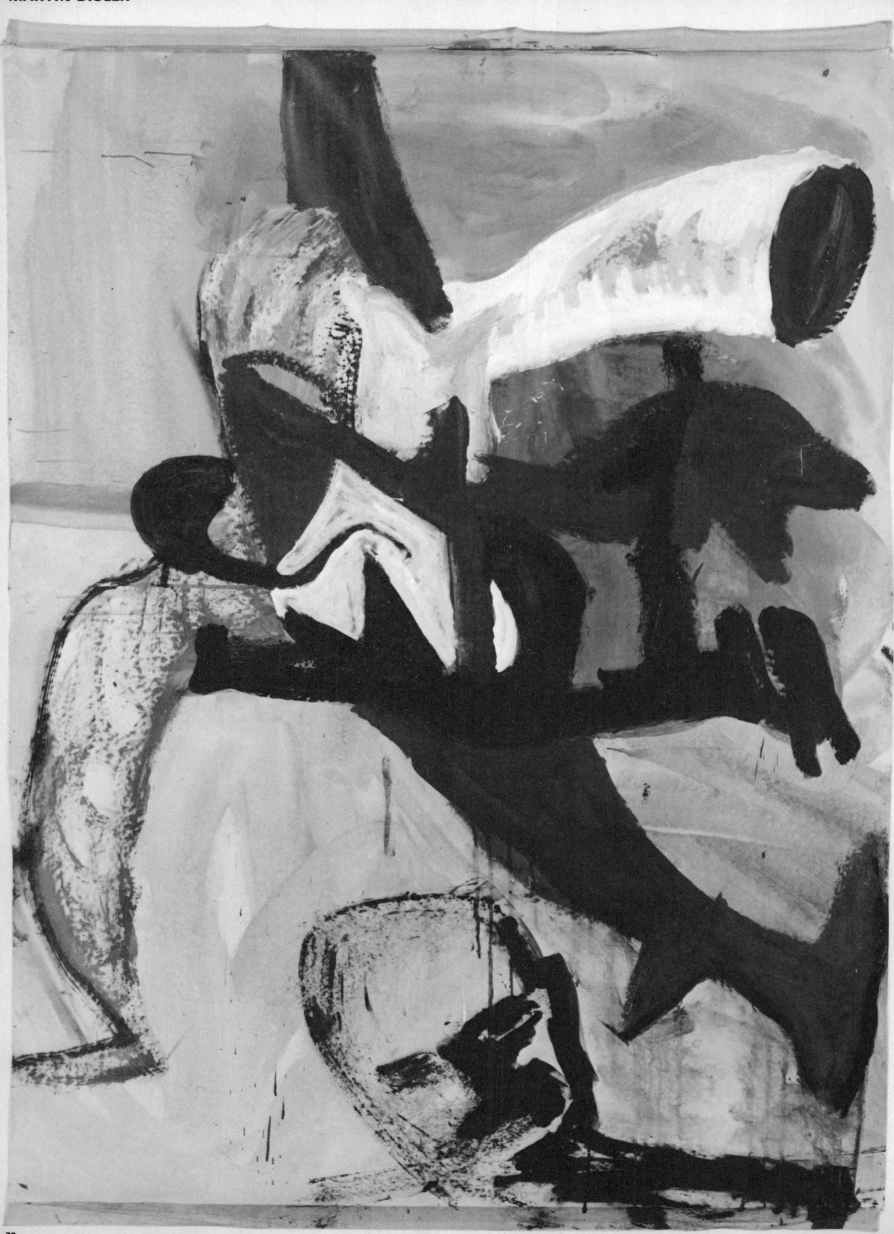

CYNTHIA EARDLEY

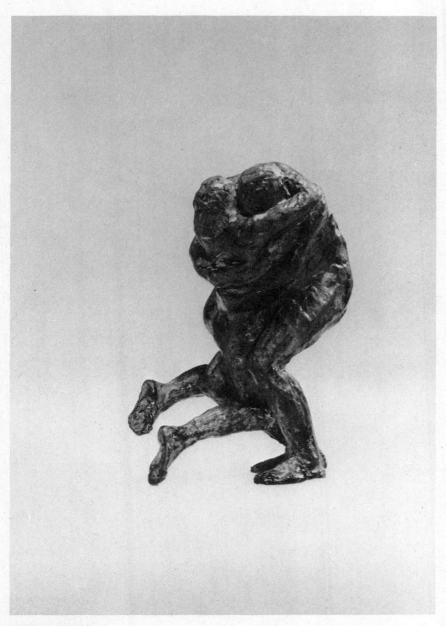

CYNTHIA EARDLEY
THE LOVERS. 1983
BRONZE, 4 x 2½ x 2″
COURTESY MONIQUE KNOWLTON GALLERY, NEW YORK

◄
MARTIN DISLER
UNTITLED. 1981
ACRYLIC ON CANVAS, 82⅝ x 70⅞″
COLLECTION ERIC FRANCK, GENEVA

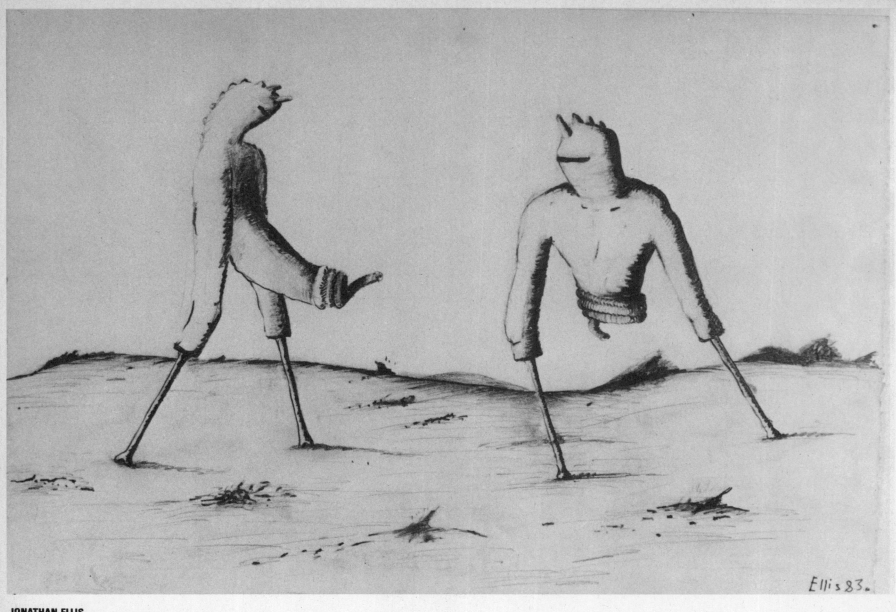

JONATHAN ELLIS
PLAYING AT NATURAL SELECTION. 1983
PENCIL ON PAPER, 17 x 23"
COURTESY EXECUTIVE GALLERY, NEW YORK

JONATHAN ELLIS

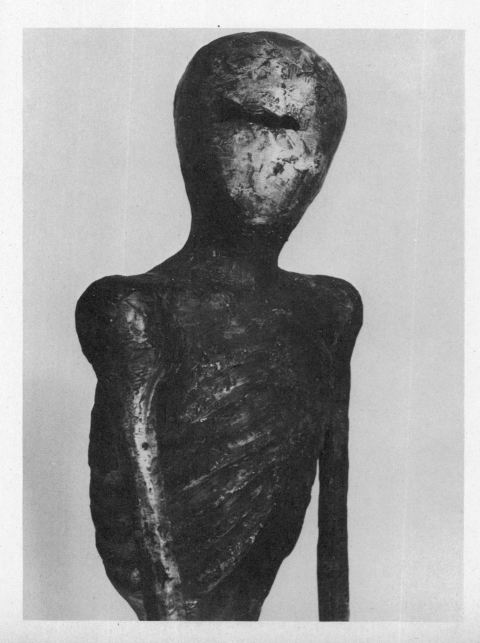

JONATHAN ELLIS
THE BRUNT OF A DREAM (DETAIL). 1983
OIL PAINT ON PLASTER OVER METAL ARMATURE, 71 x 36 x 29"
COURTESY EXECUTIVE GALLERY, NEW YORK

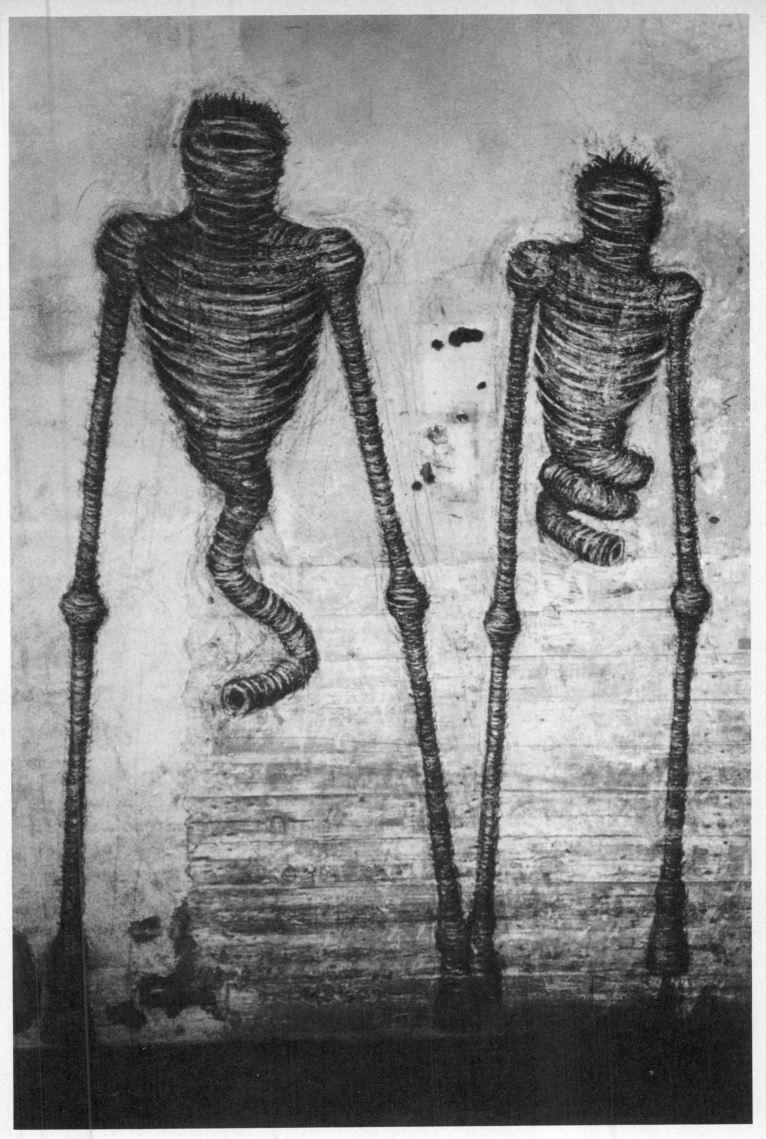

JONATHAN ELLIS
DEFINE YOUR PERIMETERS. 1983
CHARCOAL ON WALL, 92 x 63"
INSTALLATION, TERMINAL NEW YORK, 1983
COURTESY EXECUTIVE GALLERY, NEW YORK

JACKIE FERRARA

JACKIE FERRARA
LAUMEIER PROJECT, ST. LOUIS. 1981
CEDAR, 16'4" x 21'8" x 19'
COURTESY MAX PROTETCH GALLERY, NEW YORK

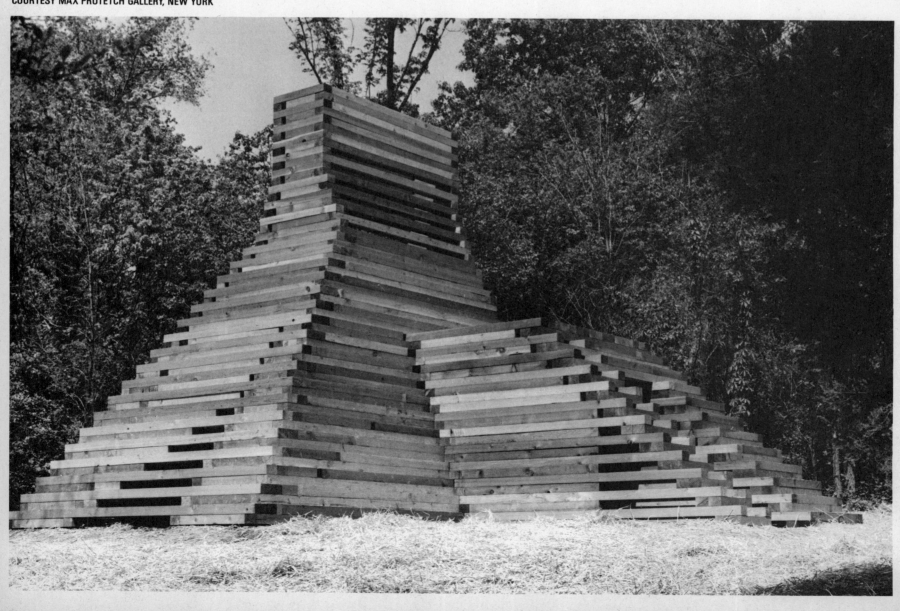

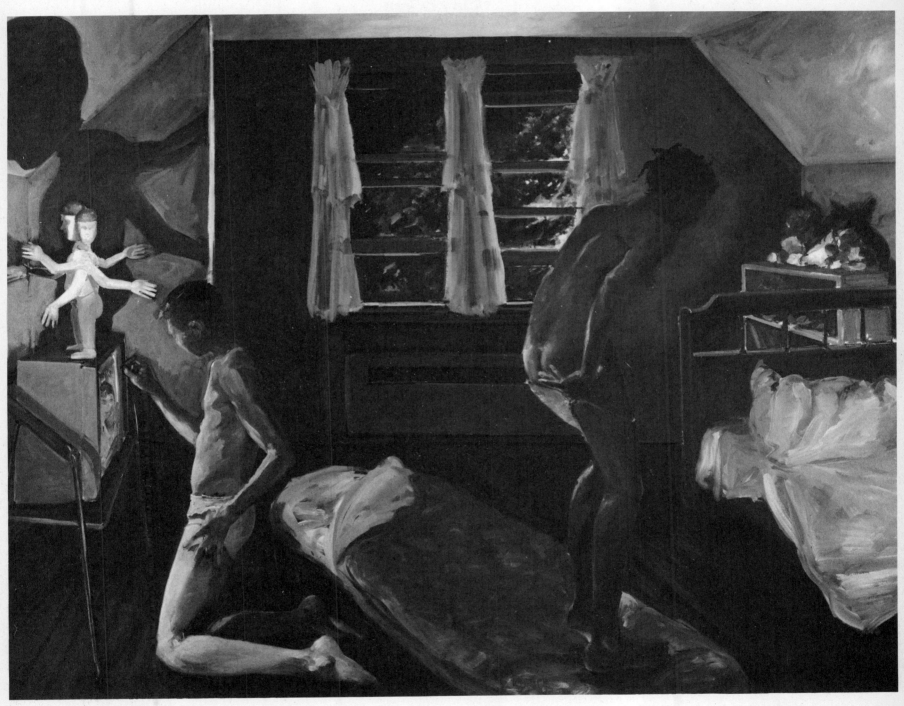

ERIC FISCHL
SLUMBER PARTY. 1983
OIL ON CANVAS, 84 x 108"
COLLECTION ED DOWNE, NEW YORK

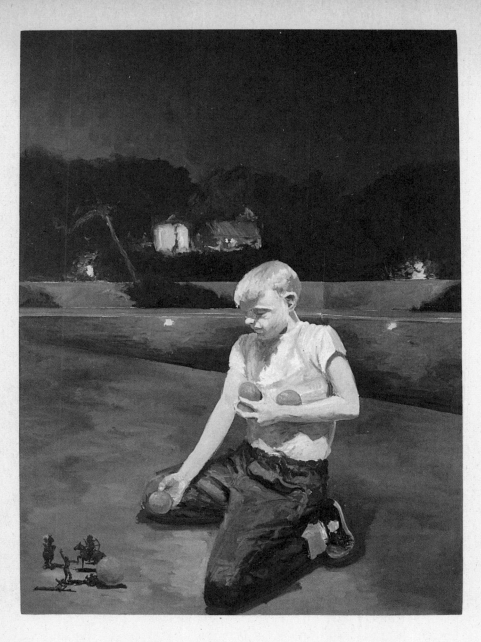

ERIC FISCHL
BEST WESTERN. 1983
OIL ON CANVAS, 108 x 78"
THE SPEYER FAMILY COLLECTION, NEW YORK

ERIC FISCHL
MASTER BEDROOM. 1983
OIL ON CANVAS, 84 x 108"
COLLECTION BARRY LOWEN, LOS ANGELES

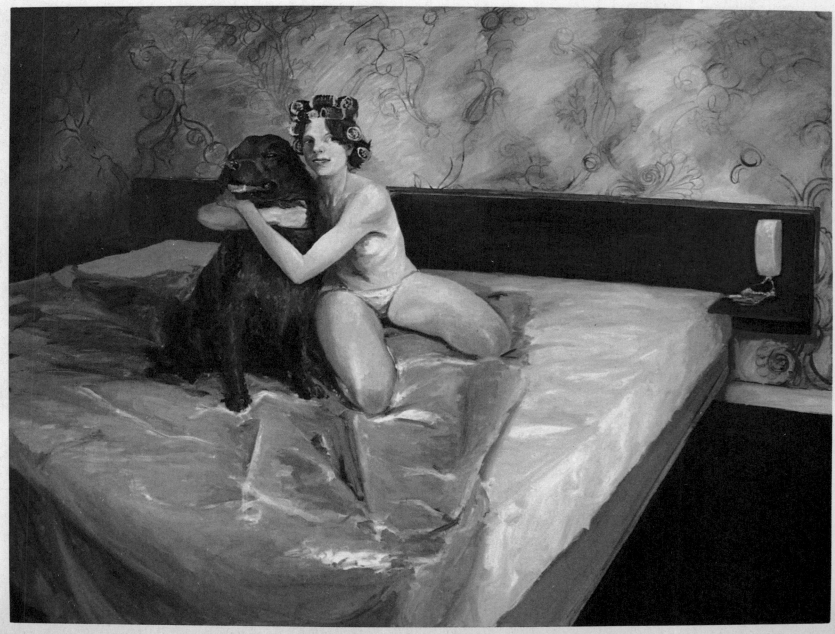

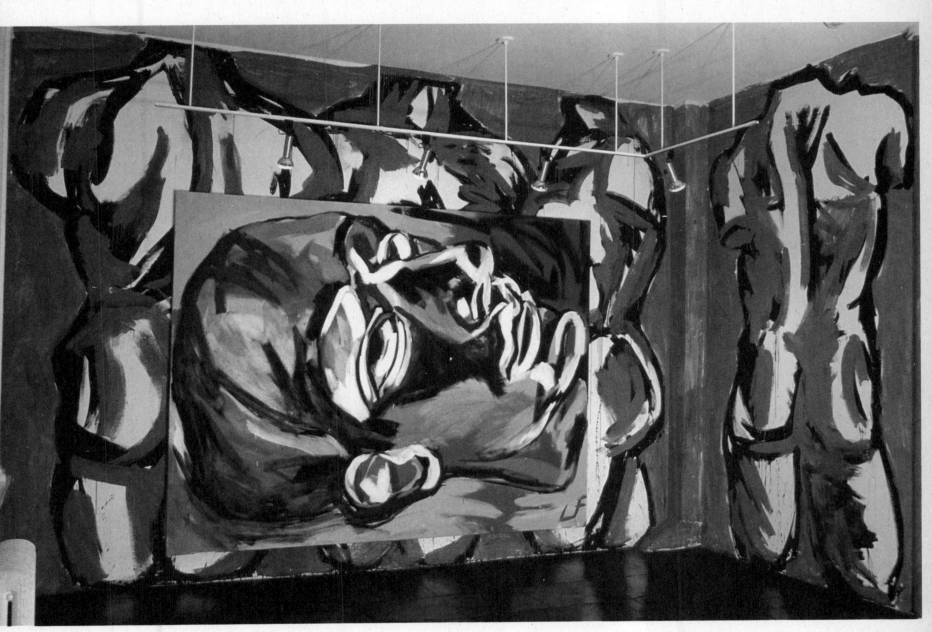

LUIS FRANGELLA
DREAMER. 1983
OIL ON CANVAS, 108 x 135", ON TEMPERA WALL PAINTING
INSTALLATION, HAL BROMM GALLERY, SEPTEMBER, 1983
COURTESY HAL BROMM GALLERY, NEW YORK

JANE FREILICHER

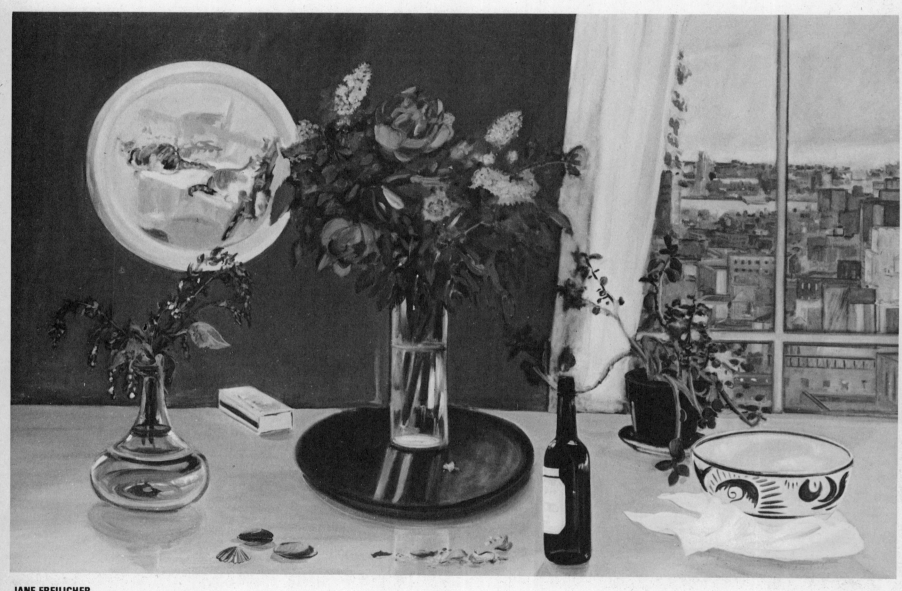

JANE FREILICHER
WINDOWS, FLOWERS, SHERRY BOTTLE, ETC. 1981–82
OIL ON CANVAS, 40 x 60"
COURTESY FISCHBACH GALLERY, NEW YORK

▶
JANET FISH
KARA. 1983
OIL ON CANVAS, 70 x 60"
COLLECTION THE ARTIST

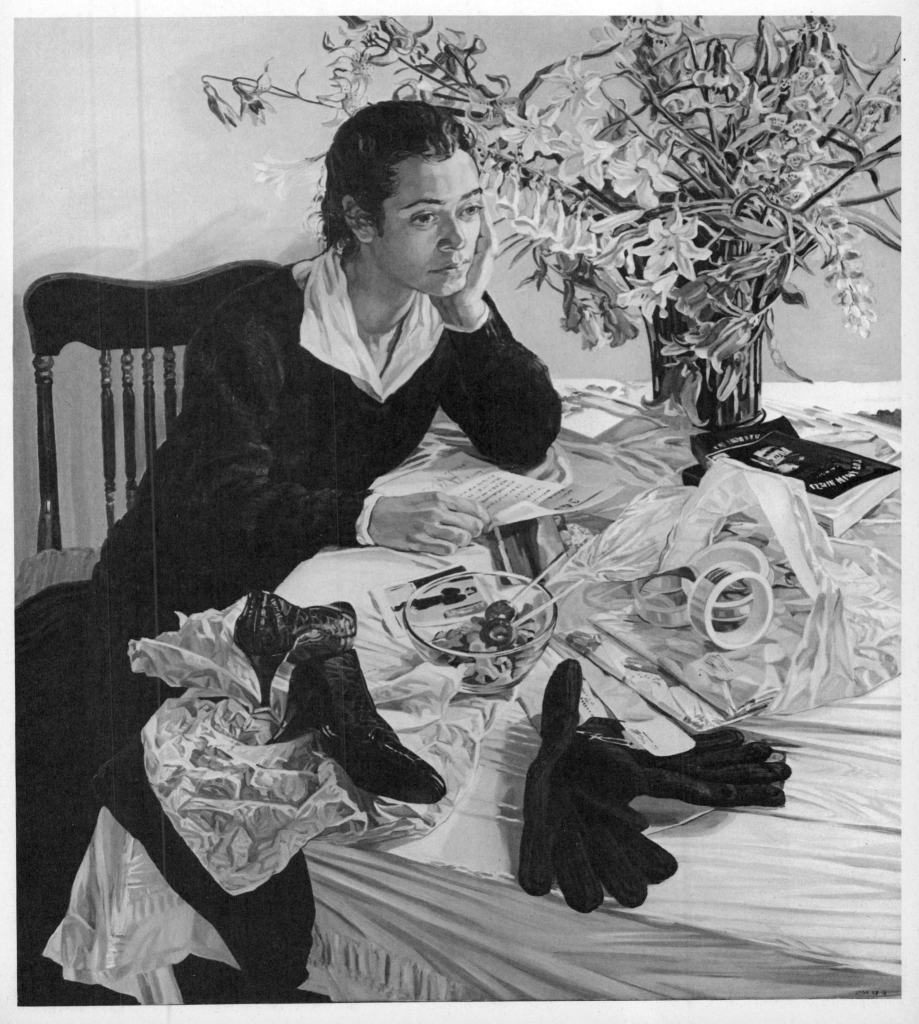

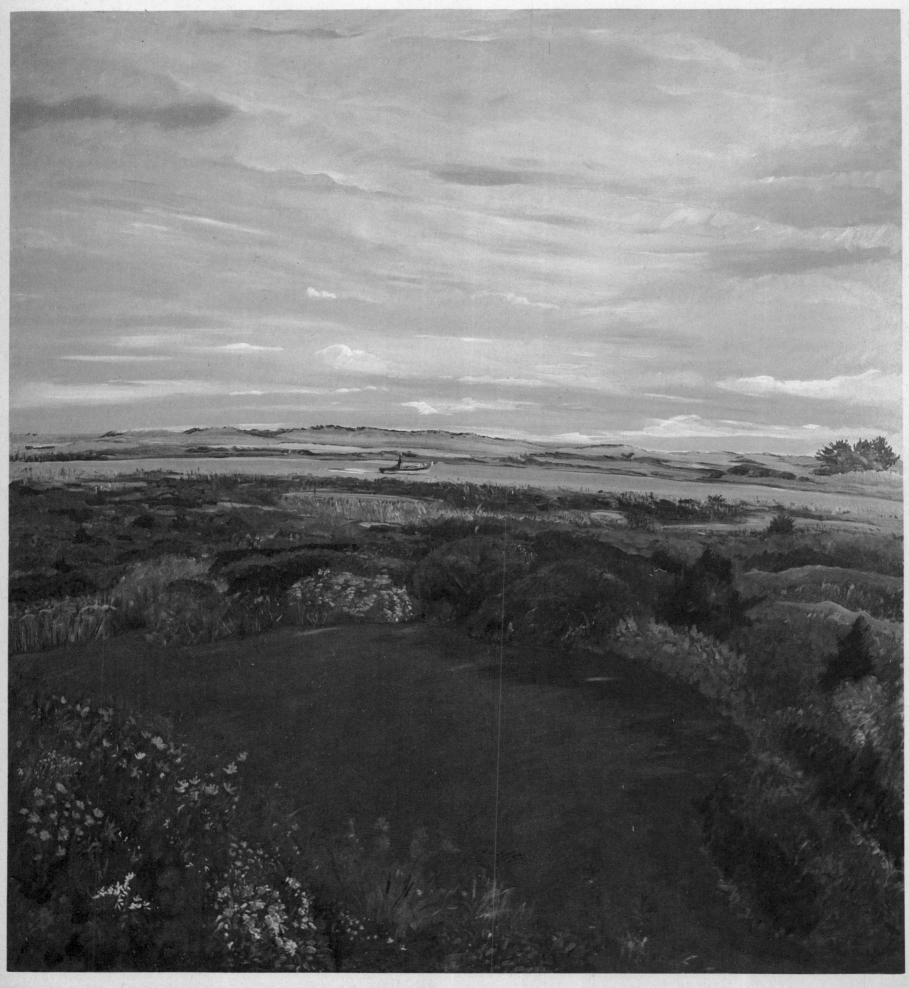

JANET FISH
RASPBERRIES AND GOLDFISH. 1981
OIL ON CANVAS, 72 x 64"
THE METROPOLITAN MUSEUM OF ART, NEW YORK. PURCHASE,
THE CAPE BRANCH FOUNDATION AND LILA ACHESON WALLACE GIFTS, 1983

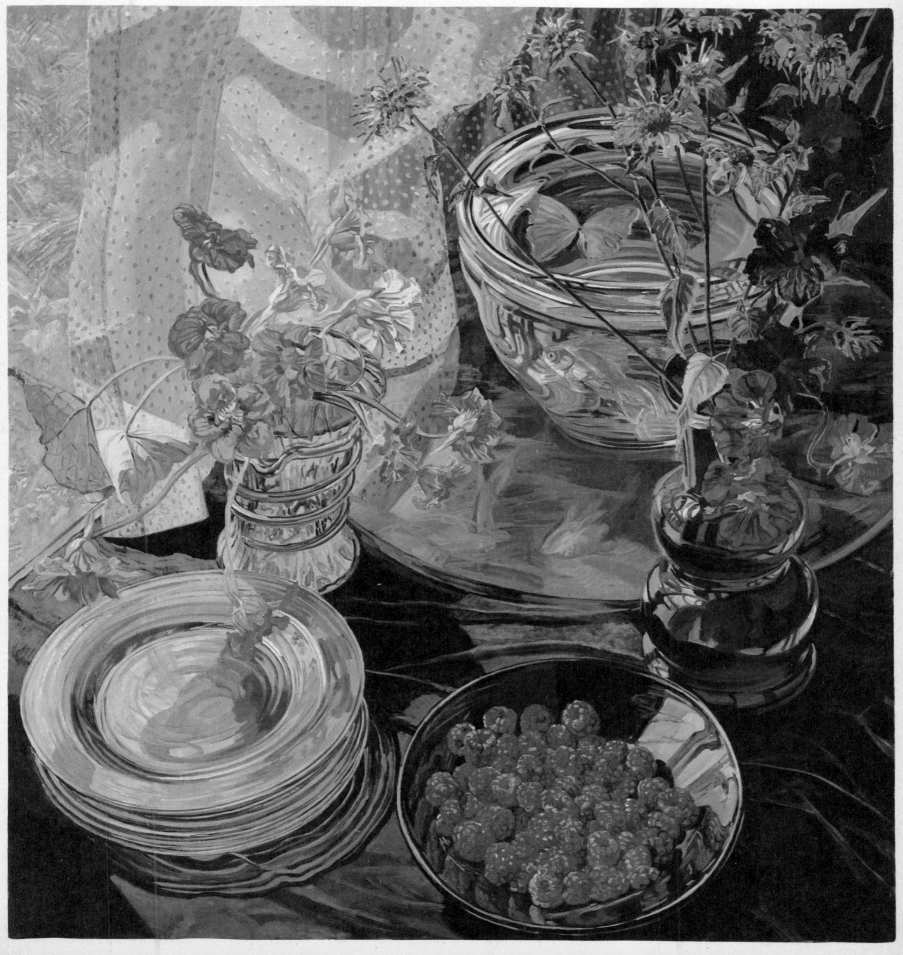

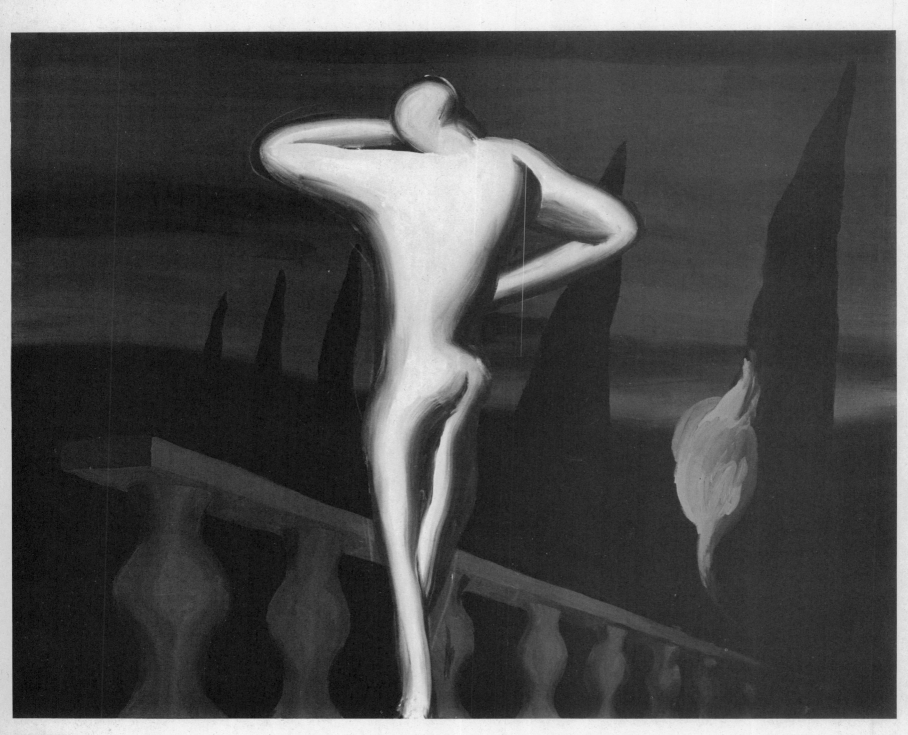

JEDD GARET
THE HERO OF REDWORLD. 1983
ACRYLIC ON CANVAS, 84 x 105"
COLLECTION DR. DONALD M. LEVY, MILWAUKEE, WISCONSIN

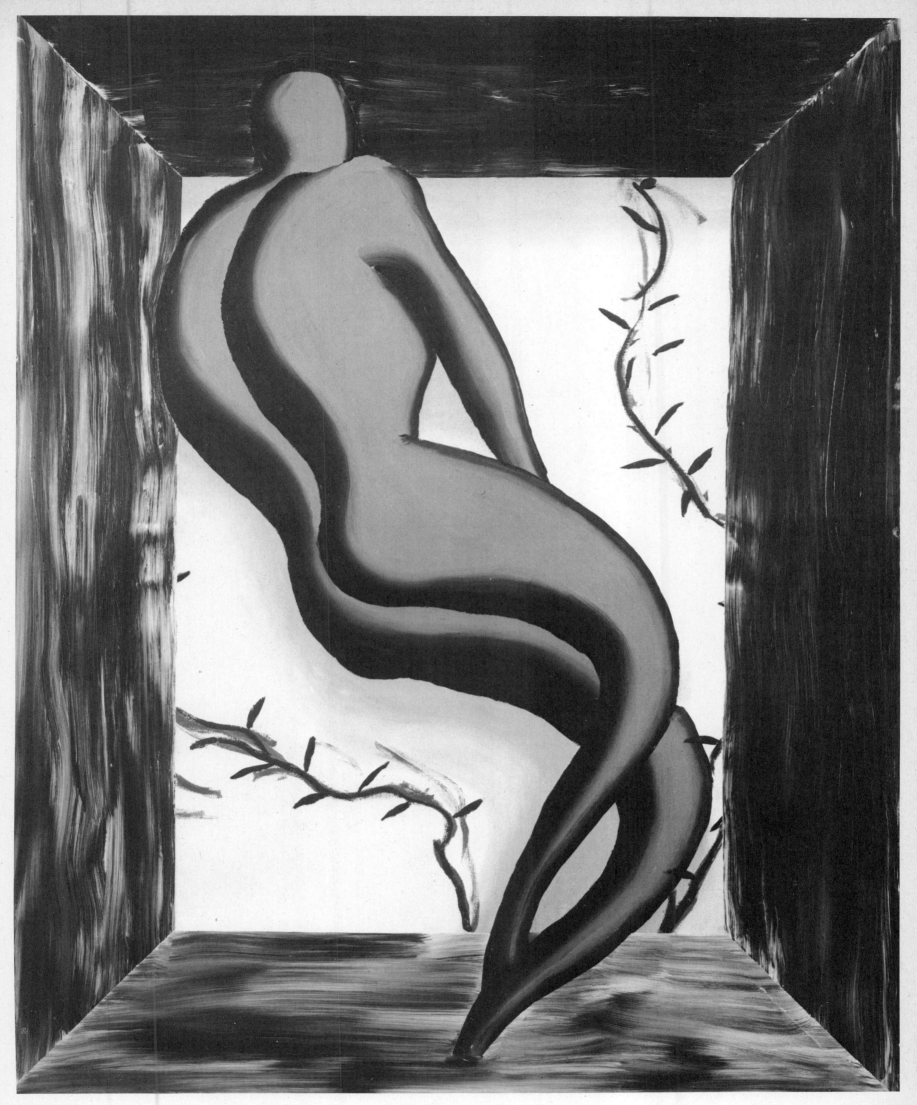

JEDD GARET
PICTURE. 1981. ACRYLIC ON CANVAS, 73 x 57"
COLLECTION PAINE WEBBER INC.

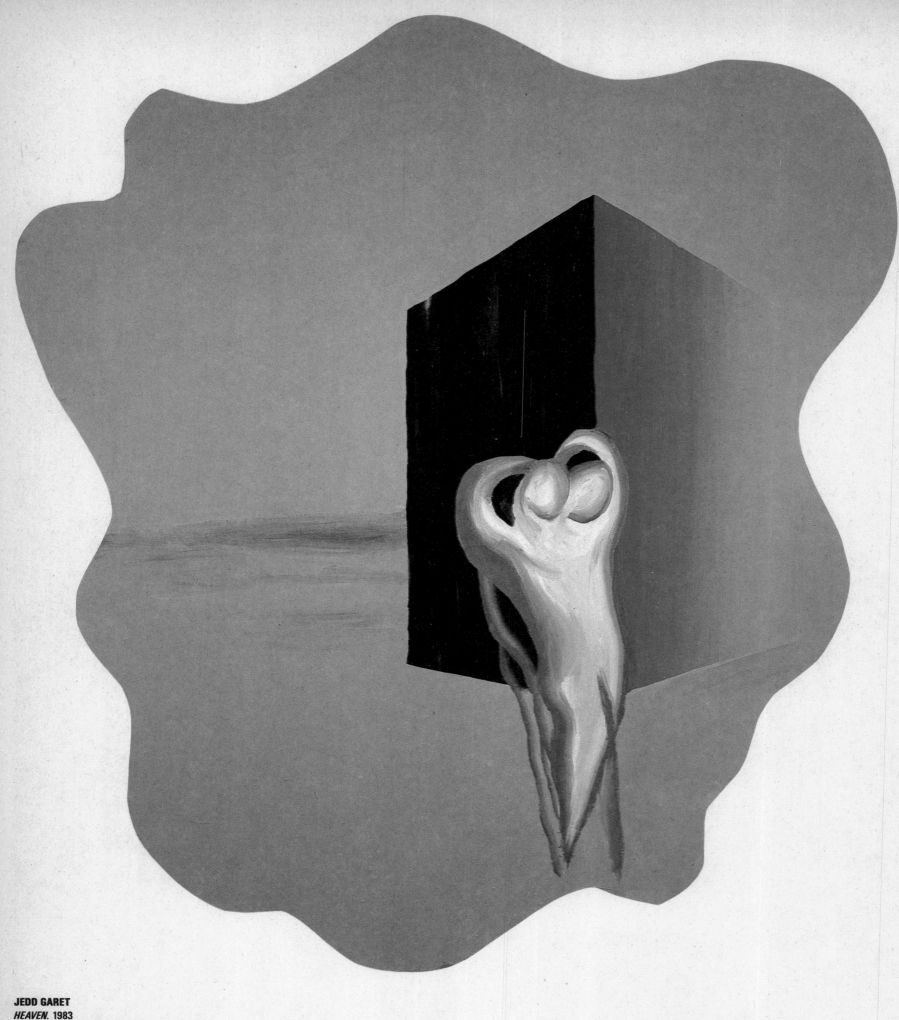

JEDD GARET
HEAVEN. 1983
ACRYLIC ON SHAPED CANVAS, 106 x 94"
COURTESY ROBERT MILLER GALLERY, NEW YORK

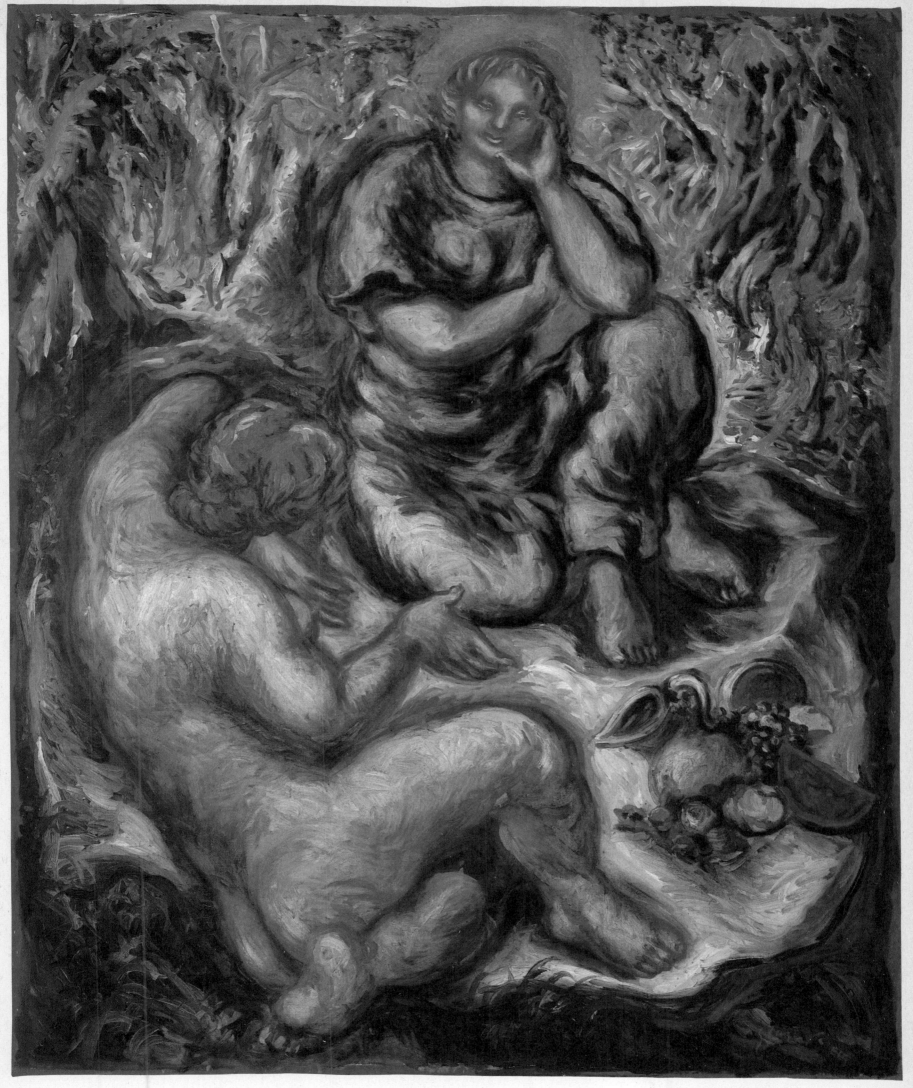

GÉRARD GAROUSTE
DÉJEUNER SUR L'HERBE. 1982
OIL ON CANVAS, 64⅝ x 52"
COLLECTION RICHARD EKSTRACT, NEW YORK
COURTESY SPERONE WESTWATER, NEW YORK

GÉRARD GAROUSTE

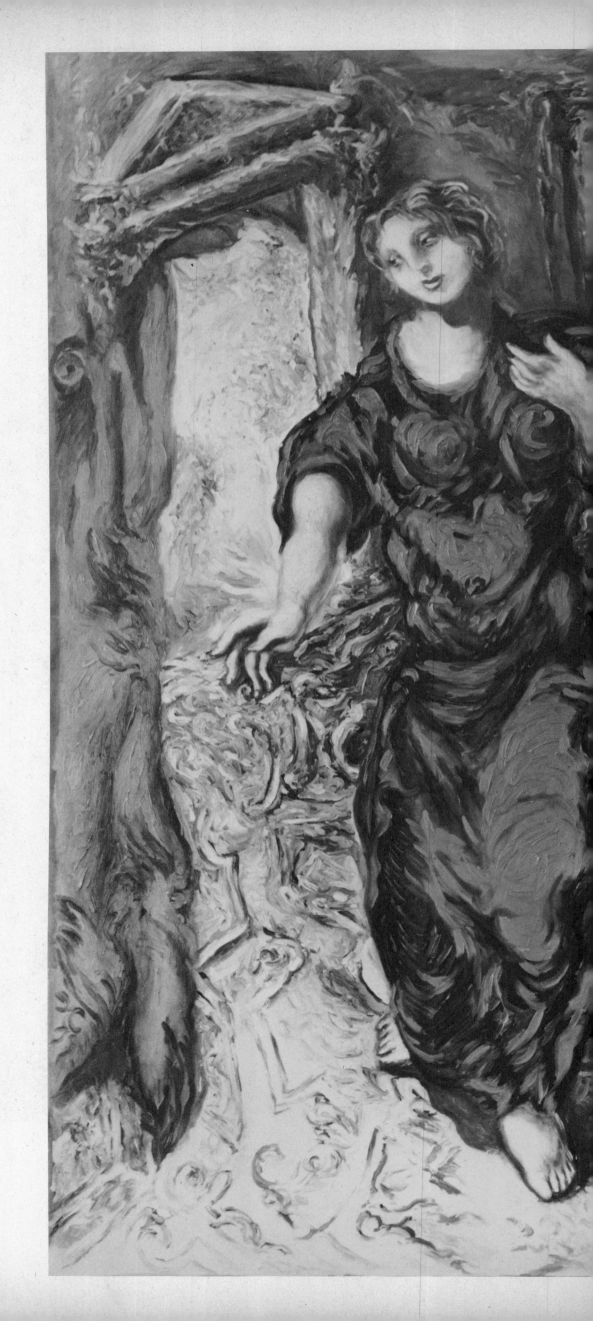

GÉRARD GAROUSTE
LA CHAMBRE ROUGE. 1982
OIL ON CANVAS, 98⅜ x 116″
COURTESY LEO CASTELLI, NEW YORK

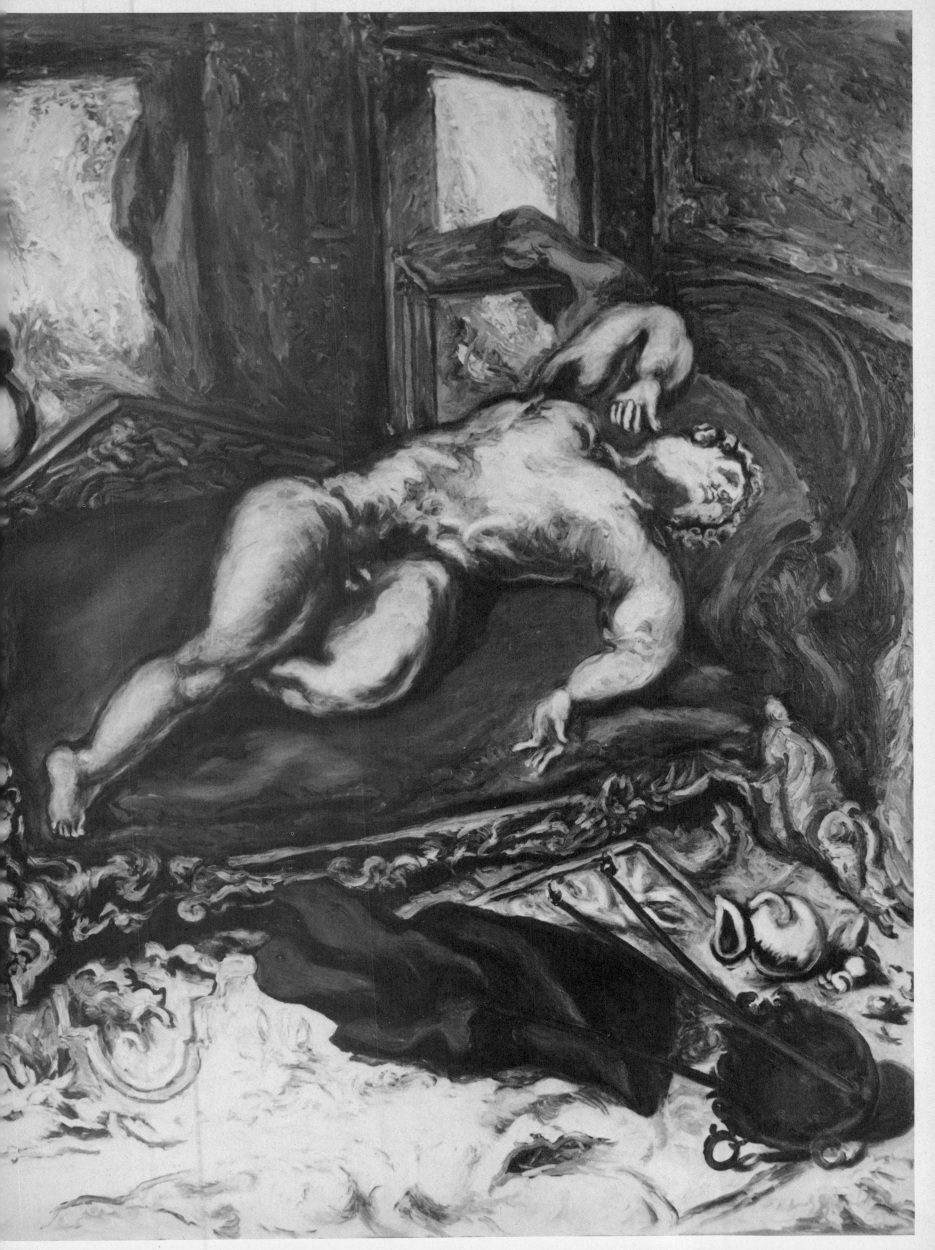

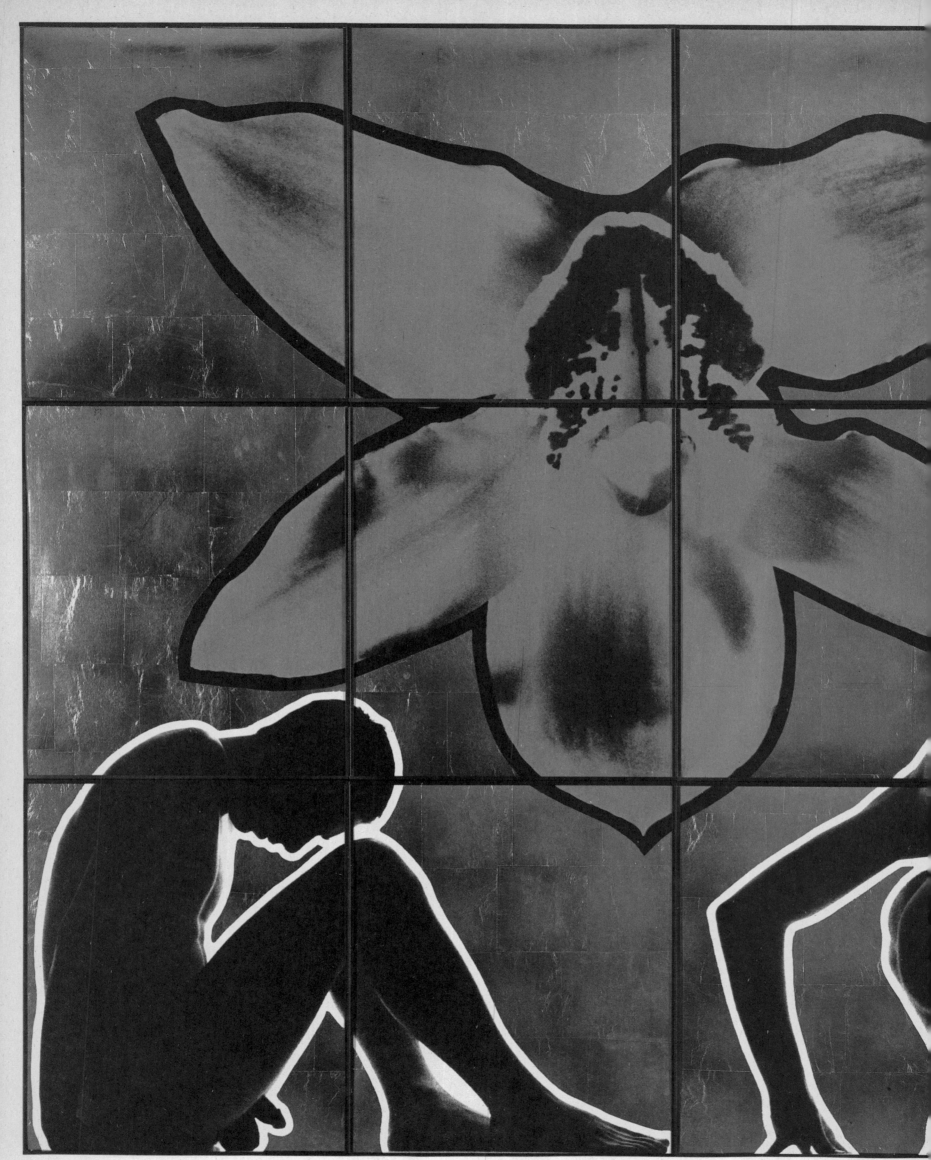

GILBERT & GEORGE
NAKED BEAUTY. 1982
71¼ x 98¾"
COLLECTION SHERRY AND WILLIAM FABRIKANT, NEW YORK

GILBERT & GEORGE

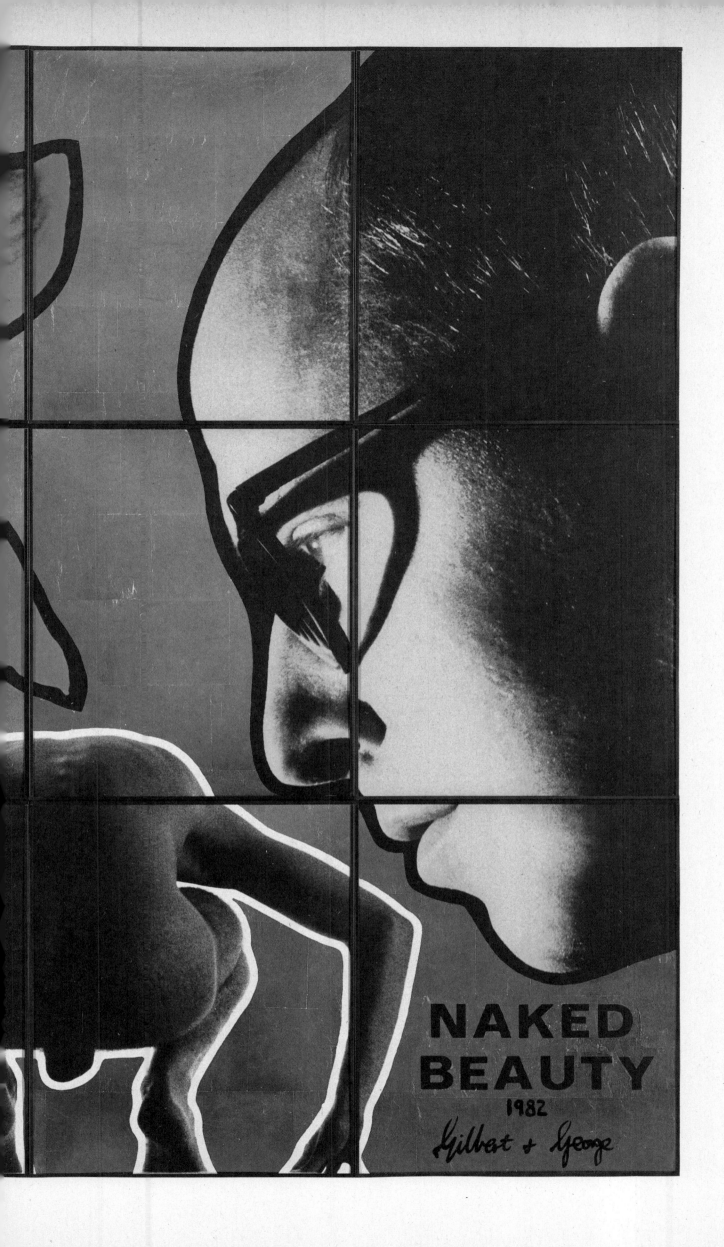

NAKED
BEAUTY
1982
Gilbert & George

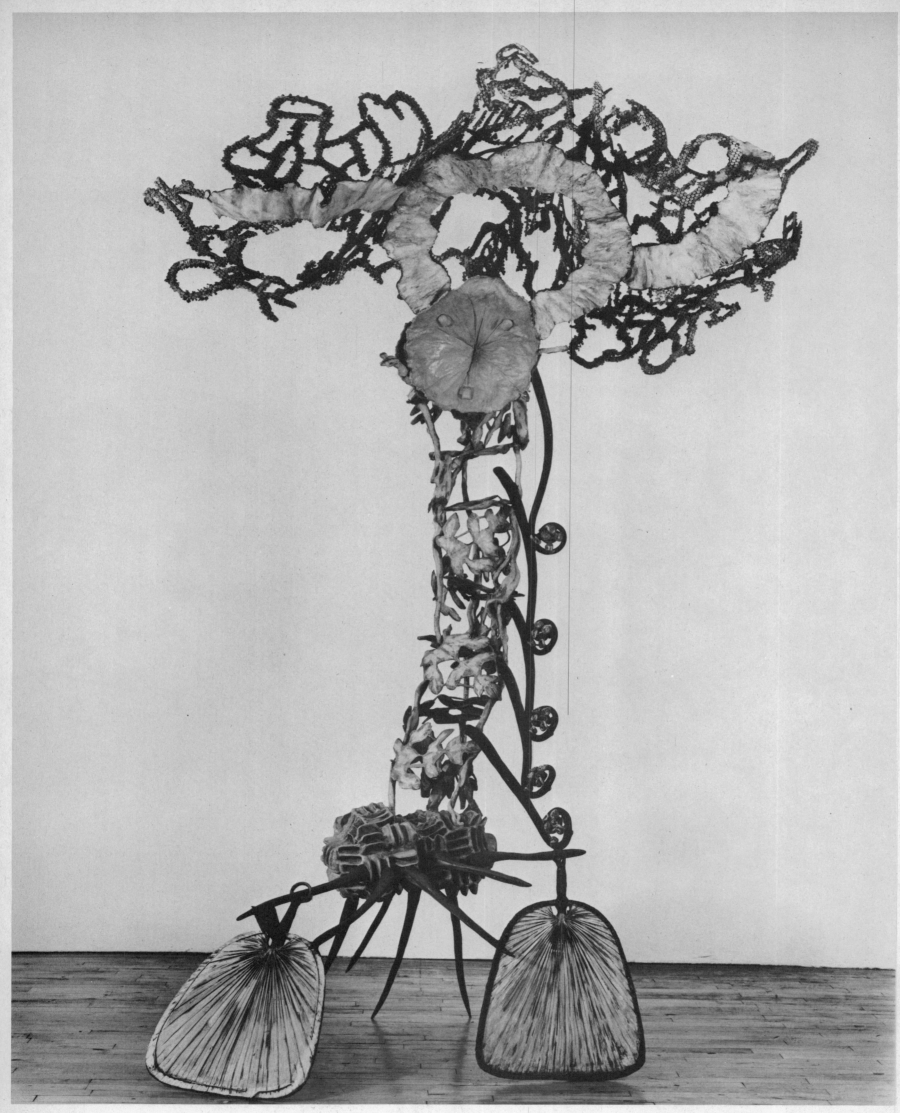

NANCY GRAVES
CANTILEVE. 1983
BRONZE WITH POLYCHROME PATINA, 98¾ x 67 x 55"
THE WHITNEY MUSEUM OF AMERICAN ART, NEW YORK
PURCHASE, WITH FUNDS FROM THE PAINTING AND SCULPTURE COMMITTEE

NANCY GRAVES

GREGORY GILLESPIE
SELF-PORTRAIT. 1980–81
COLLAGE, 12 x 10¾"
COURTESY FORUM GALLERY, NEW YORK

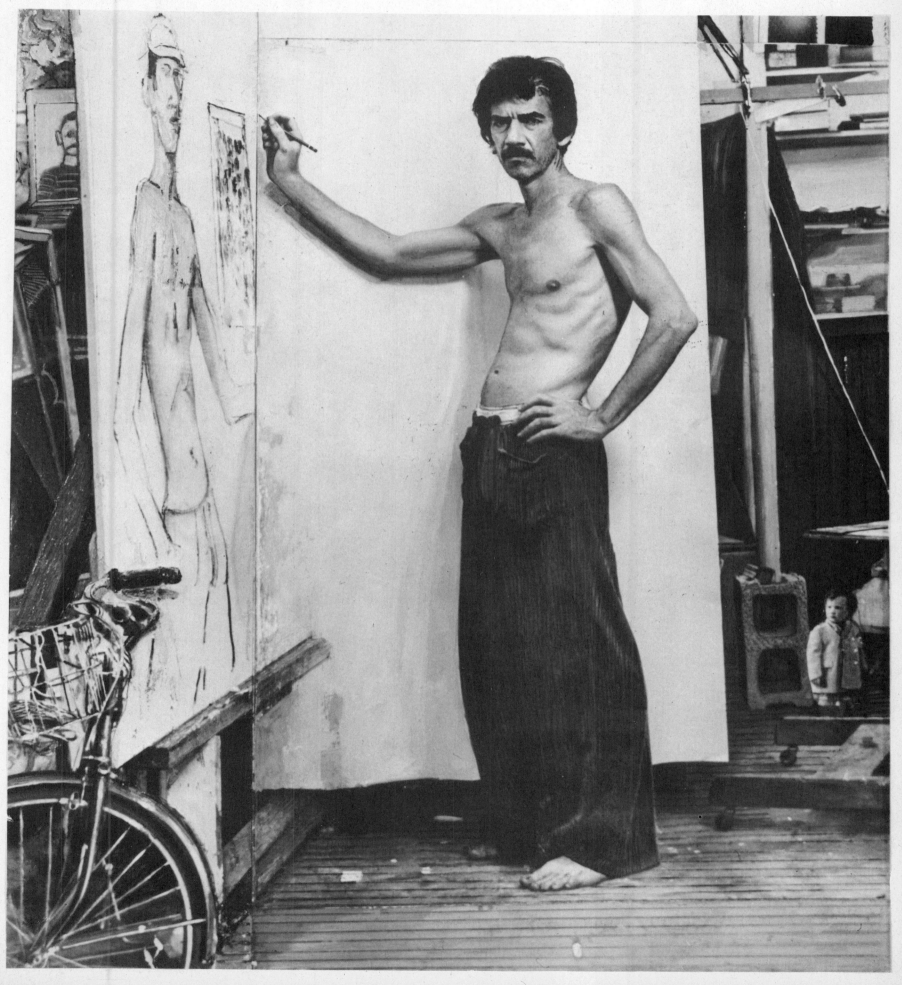

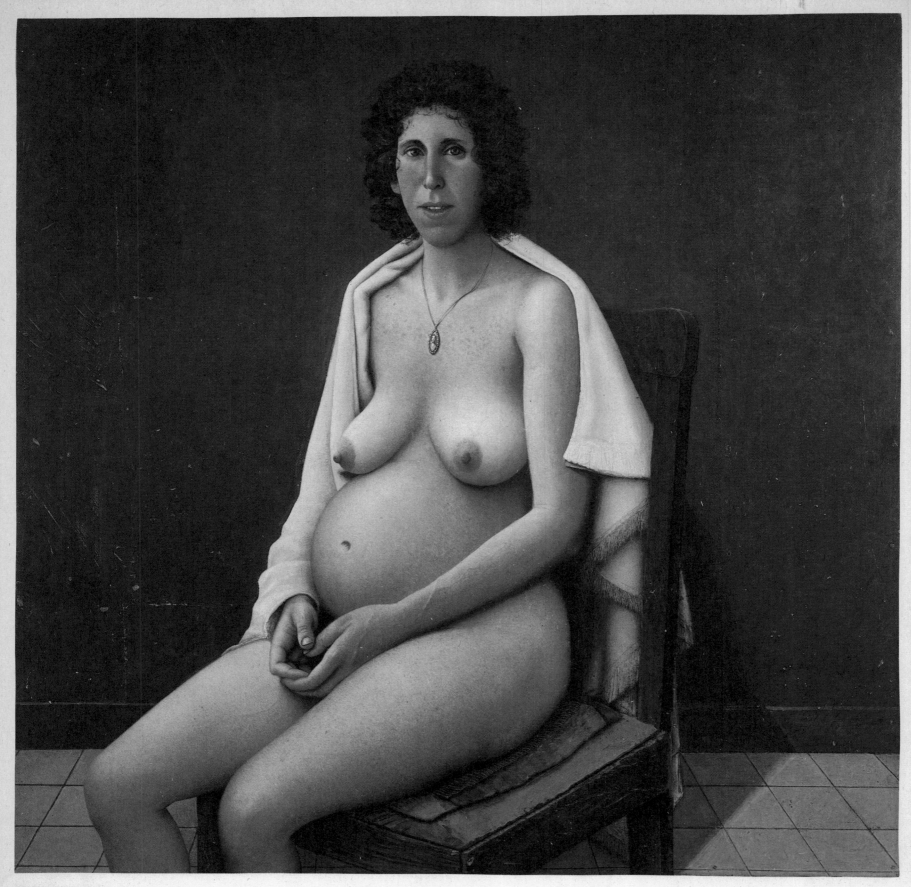

GREGORY GILLESPIE
PEG SEATED (AS IF PREGNANT). 1982–83
MIXED MEDIUMS ON BOARD, 46⅛ x 45⅛"
MUSEUM OF FINE ARTS, BOSTON. THE HAYDEN COLLECTION .

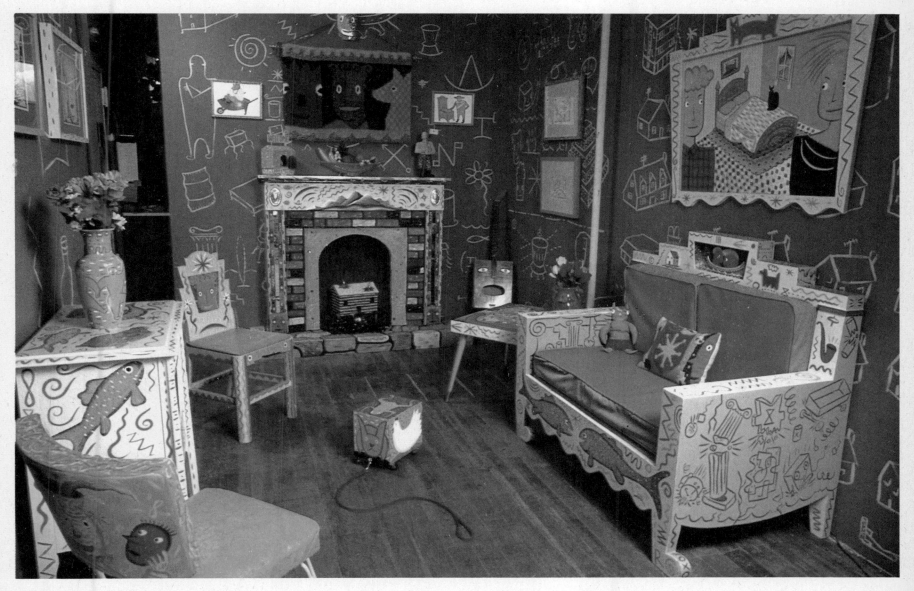

RODNEY ALAN GREENBLAT
INSTALLATION, GRACIE MANSION GALLERY, NEW YORK, OCTOBER–NOVEMBER, 1983
COURTESY GRACIE MANSION GALLERY, NEW YORK

JAN GROOVER

JAN GROOVER
UNTITLED. 1980
PALLADIUM-PLATINUM PRINT, 8 x 10"
COURTESY BLUM HELMAN GALLERY, NEW YORK

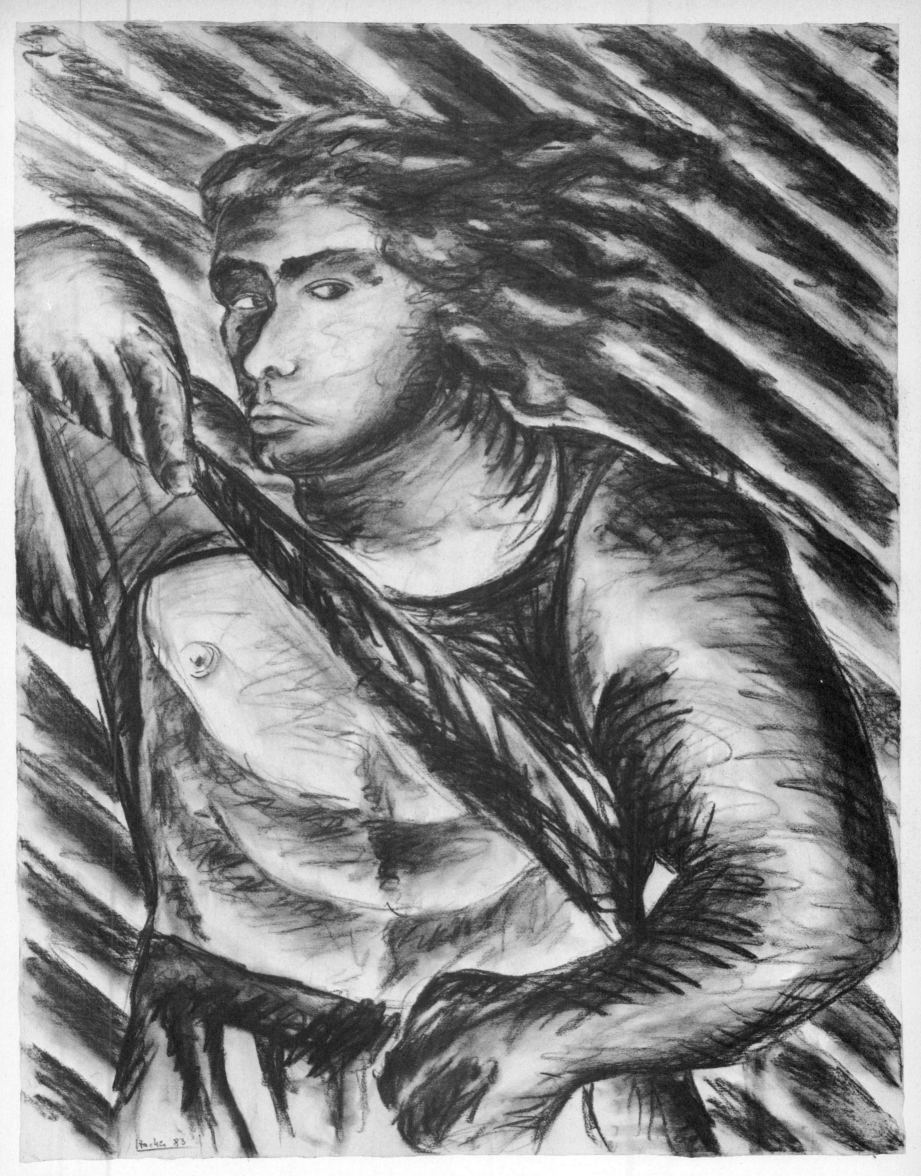

DIETER HACKER
MON DIEU 2. 1983
CHARCOAL ON PAPER, 41¾ x 30¾
COURTESY MARLBOROUGH GALLERY, NEW YORK

DIETER HACKER

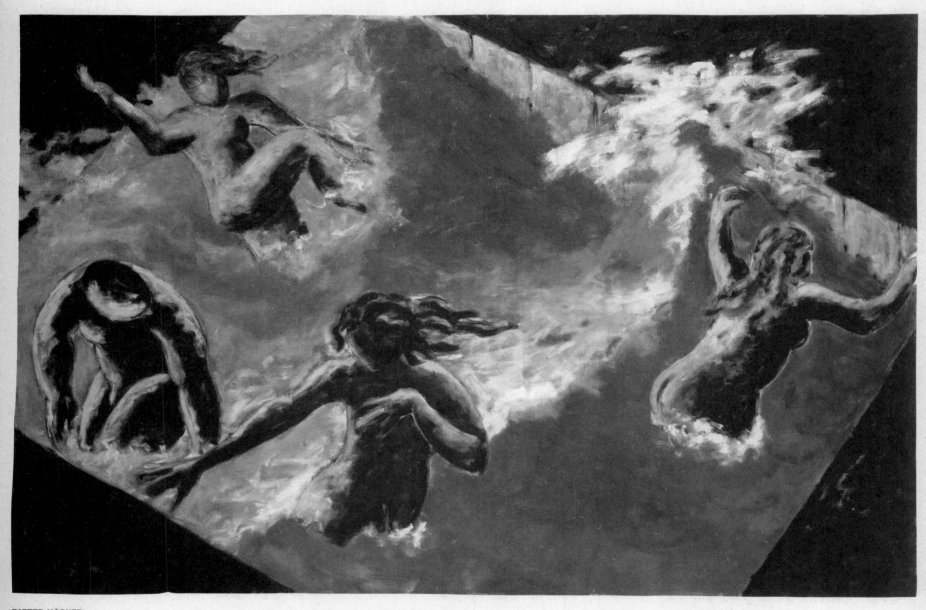

DIETER HACKER
BADENDE/BATHERS. 1983
OIL ON CANVAS, 75⅝ x 112⅝"
COLLECTION STEFAN EDLIS

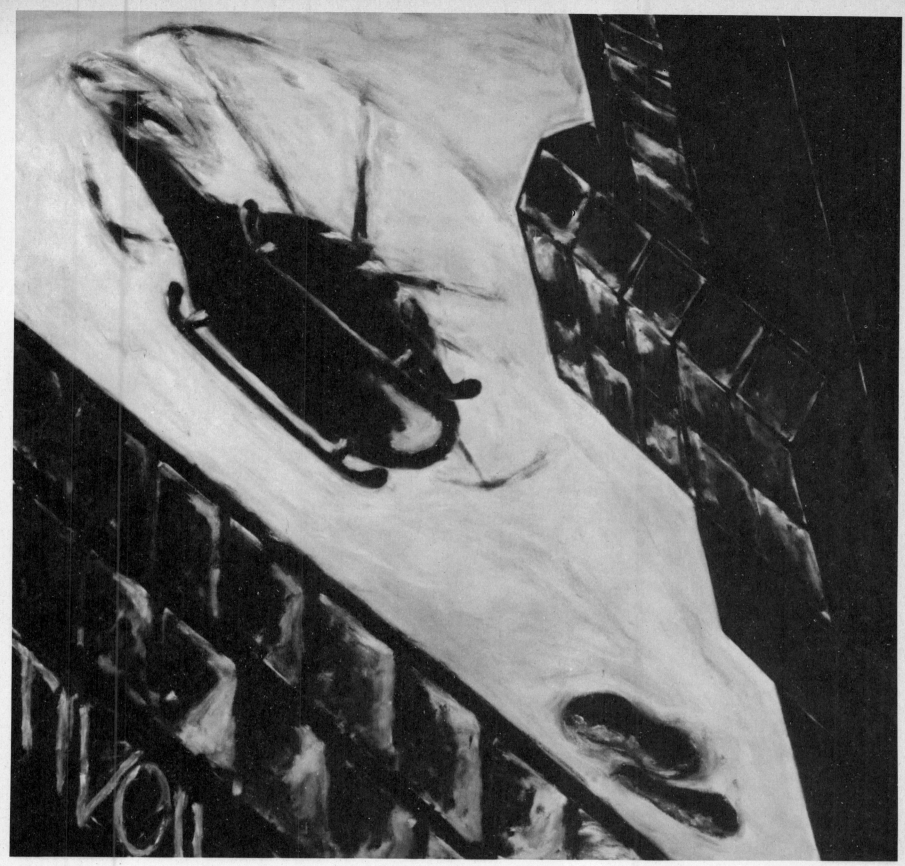

DIETER HACKER
TIVOLI. 1982
OIL ON CANVAS, 78¾ x 78¾"
COLLECTION DIANE AND STEVEN JACOBSON

RICHARD HAMBLETON

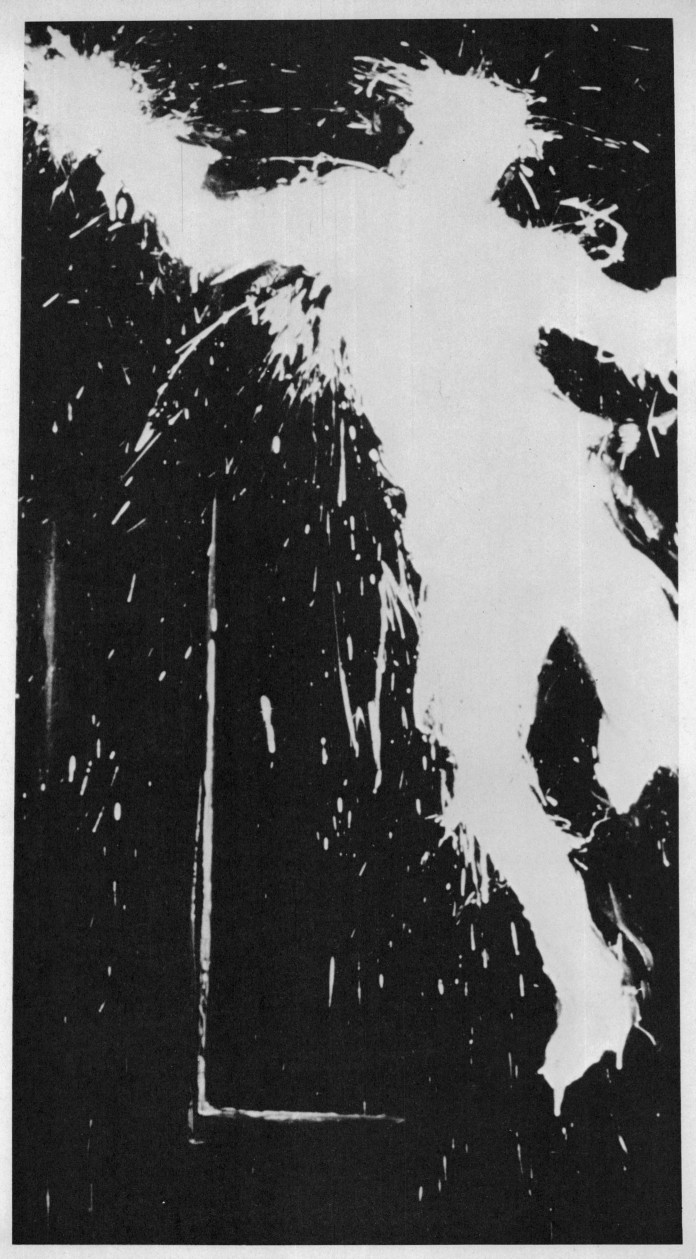

RICHARD HAMBLETON
YOU MADE ME DO IT. 1983
ACRYLIC ON CANVAS, 96 x 44"
COURTESY PIEZO ELECTRIC GALLERY, NEW YORK

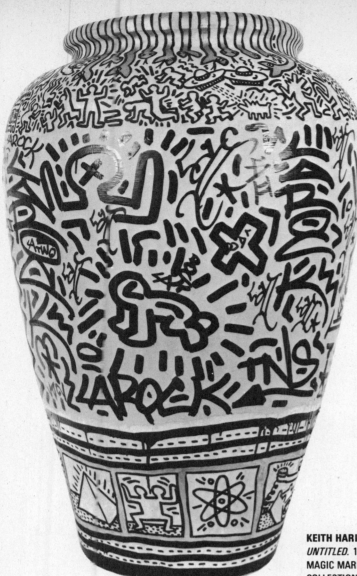

KEITH HARING AND LA II
UNTITLED. 1982
MAGIC MARKER AND ENAMEL ON FIBERGLAS VASE, 39" HIGH, 28" DIAMETER
COLLECTION MR. AND MRS. ARSLANIAN, NEW YORK

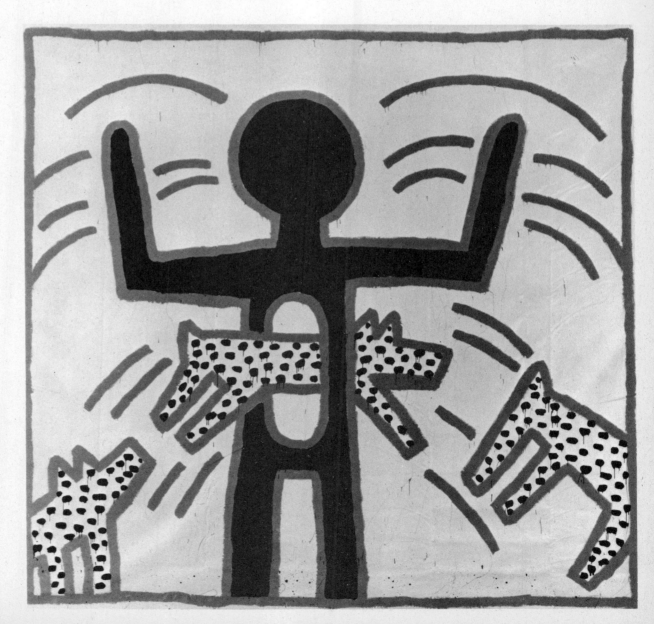

KEITH HARING
UNTITLED. 1982
VINYL INK/VINYL TARP, 12 x 12'
COLLECTION TONY SHAFRAZI, NEW YORK

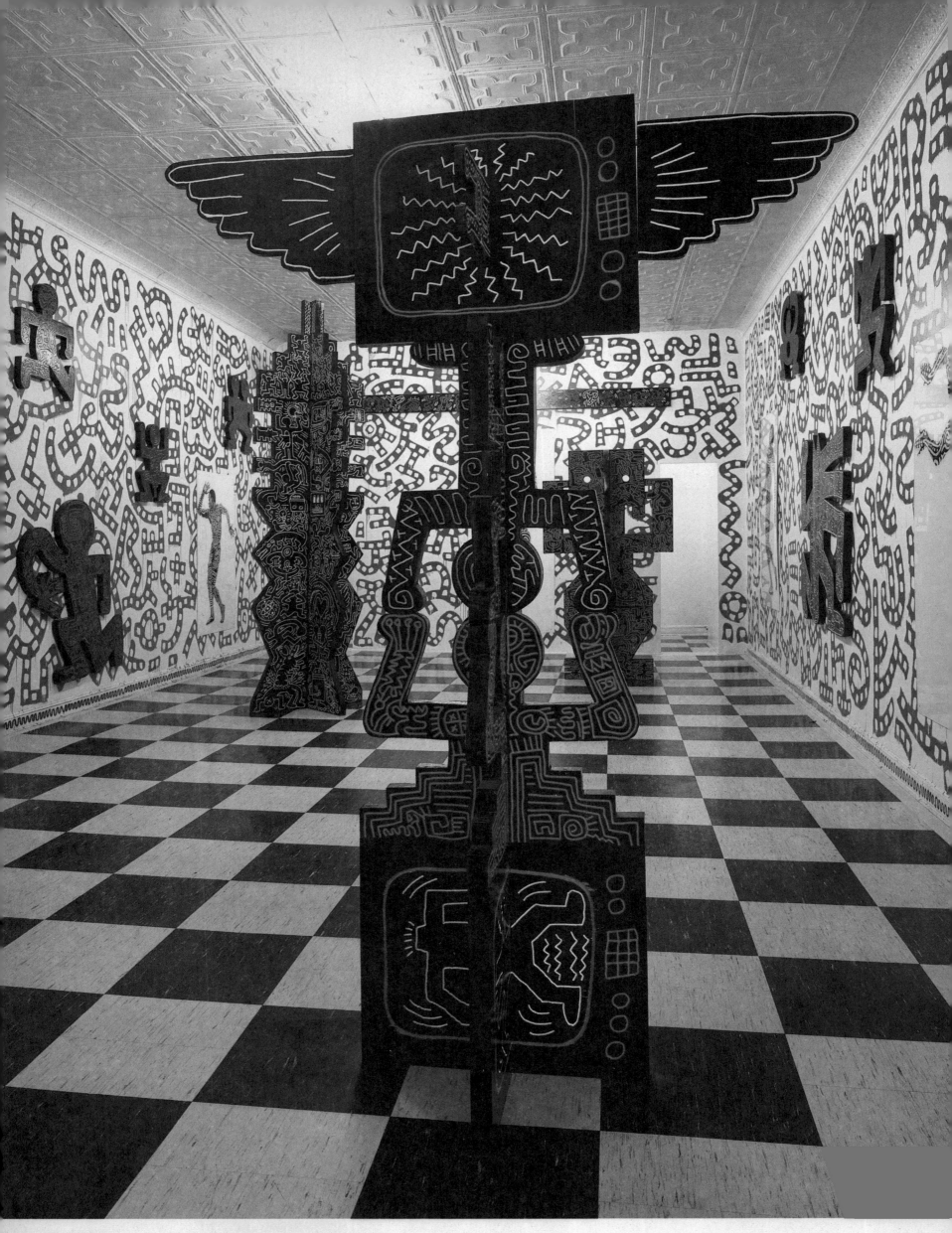

KEITH HARING
UNTITLED. 1983
ENAMEL ON WOOD, 120 x 42"
COLLECTION PHOEBE CHASON, NEW YORK

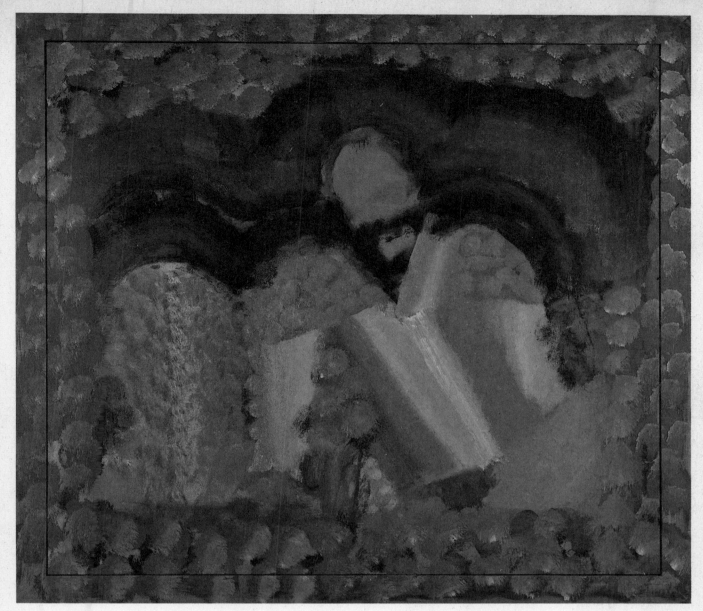

HOWARD HODGKIN
PORTRAIT OF TERENCE MCINERNEY II. 1981
OIL ON WOOD, 50½ x 55"
COLLECTION NAN AND GENE CORMAN, BEVERLY HILLS

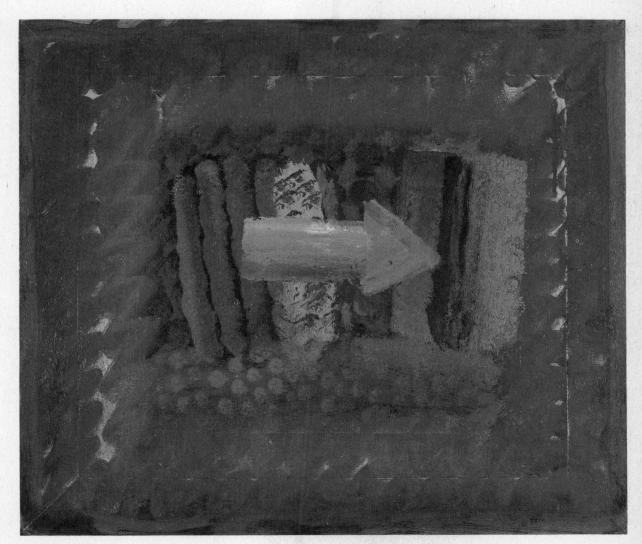

HOWARD HODGKIN
IN A HOT COUNTRY. 1979–82
OIL ON WOOD, 22½ x 25¼"
COLLECTION DON AND ANN BROWN, WASHINGTON, D.C.

JENNY HOLZER

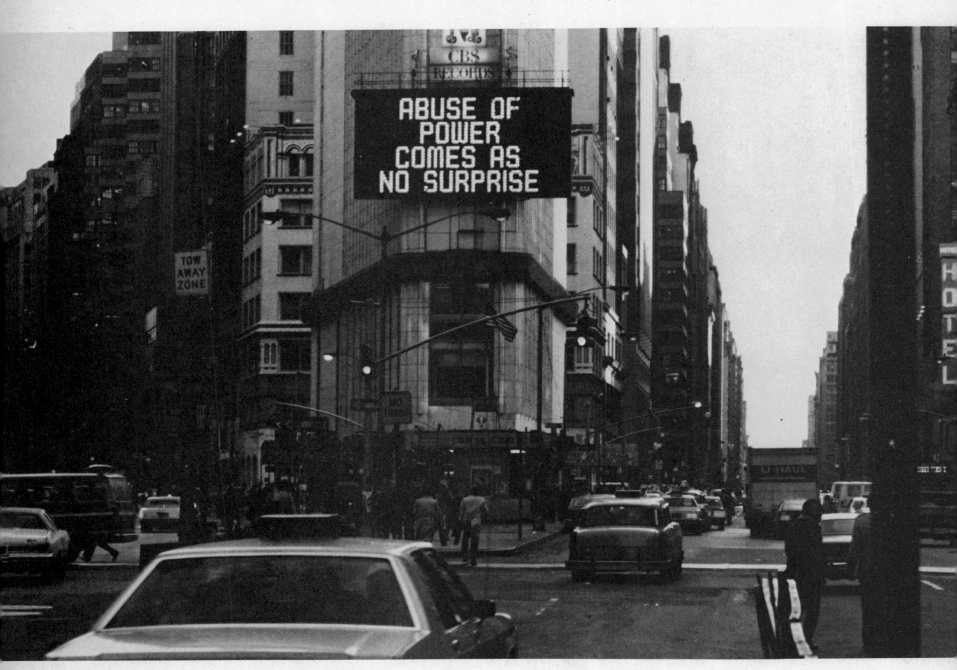

JENNY HOLZER
SELECTION FROM THE "TRUISMS" SERIES. 1982
SPECTACOLOR BOARD, TIMES SQUARE
COURTESY BARBARA GLADSTONE GALLERY, NEW YORK

LITTLE QUEENIE
ANY NUMBER OF
ADOLESCENT GIRLS LIE
FACE DOWN ON THE BED
AND WORK ON ENERGY,
HOUSING, LABOR, JUSTICE,
EDUCATION, TRANSPORTATION,
AGRICULTURE AND
BALANCE OF TRADE.

JENNY HOLZER
SELECTION FROM THE "LIVING" SERIES. 1981
BRONZE PLAQUE, 7½ x 10½"
COURTESY BARBARA GLADSTONE GALLERY, NEW YORK

BRYAN HUNT

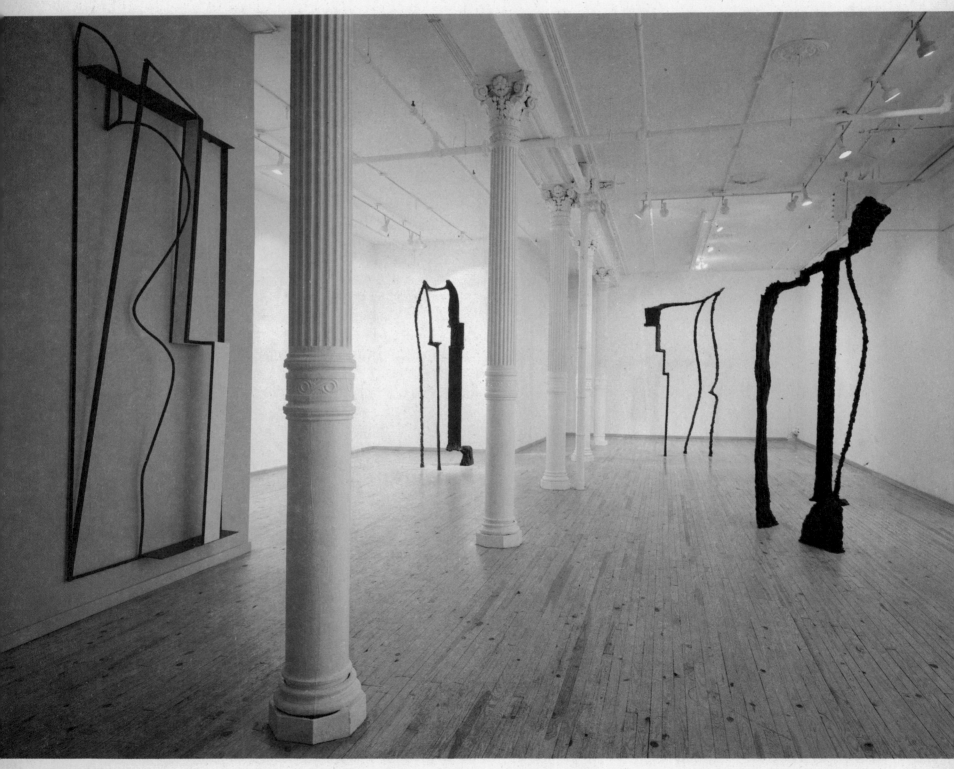

BRYAN HUNT
INSTALLATION, BLUM HELMAN GALLERY, NEW YORK, APRIL, 1983

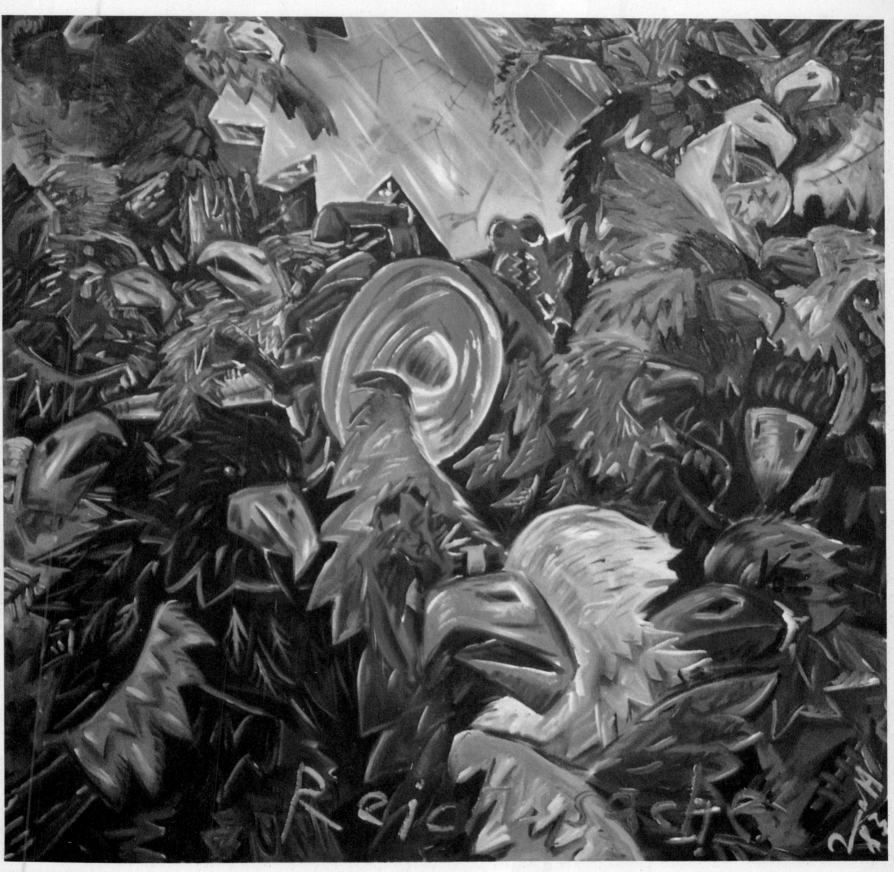

JÖRG IMMENDORFF
REICHSSACHE. 1983
OIL ON CANVAS, 98 x 98"
PRIVATE COLLECTION, NEW YORK

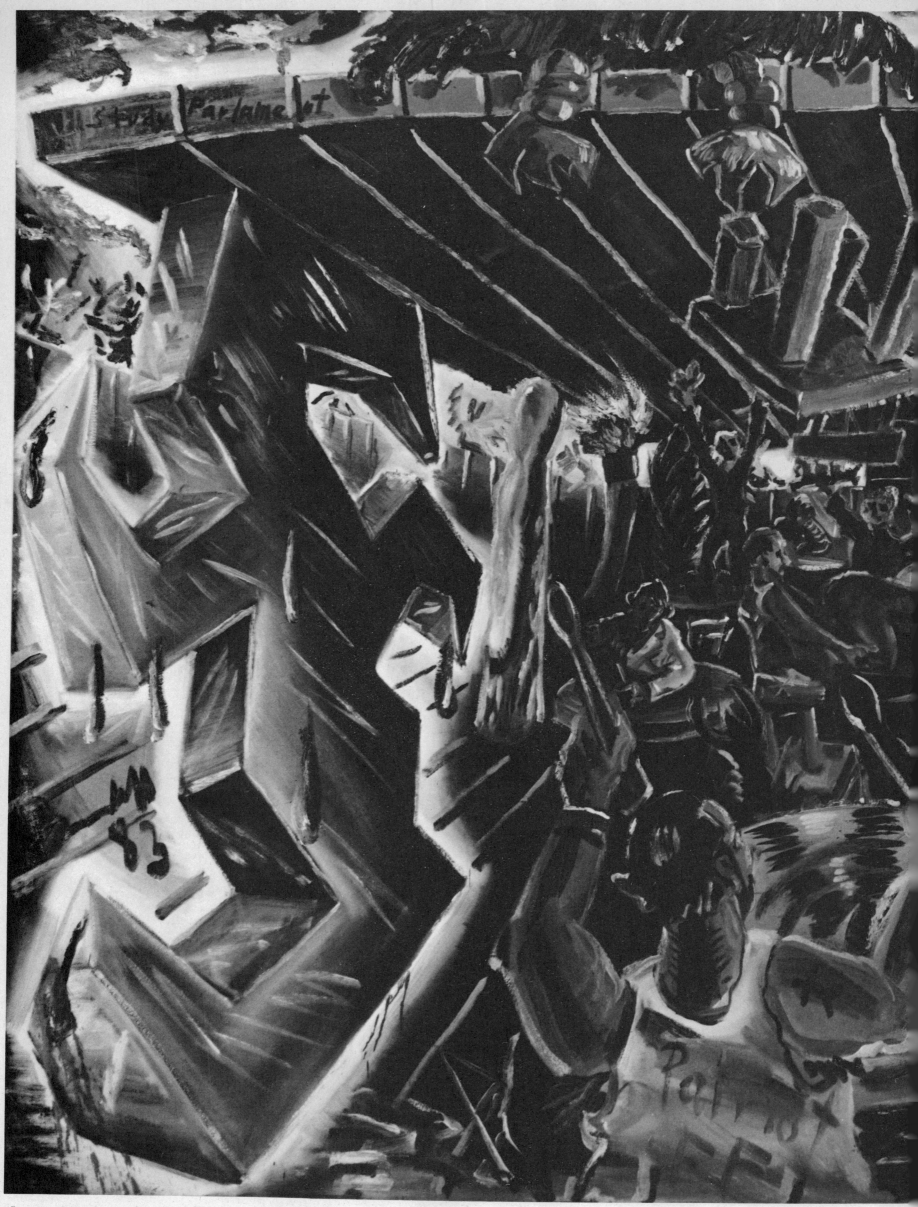

JÖRG IMMENDORFF. *C.D. 38 PARTEITAG.* 1983. OIL ON CANVAS, 78¾ x 118". COLLECTION ESTELLE SCHWARTZ

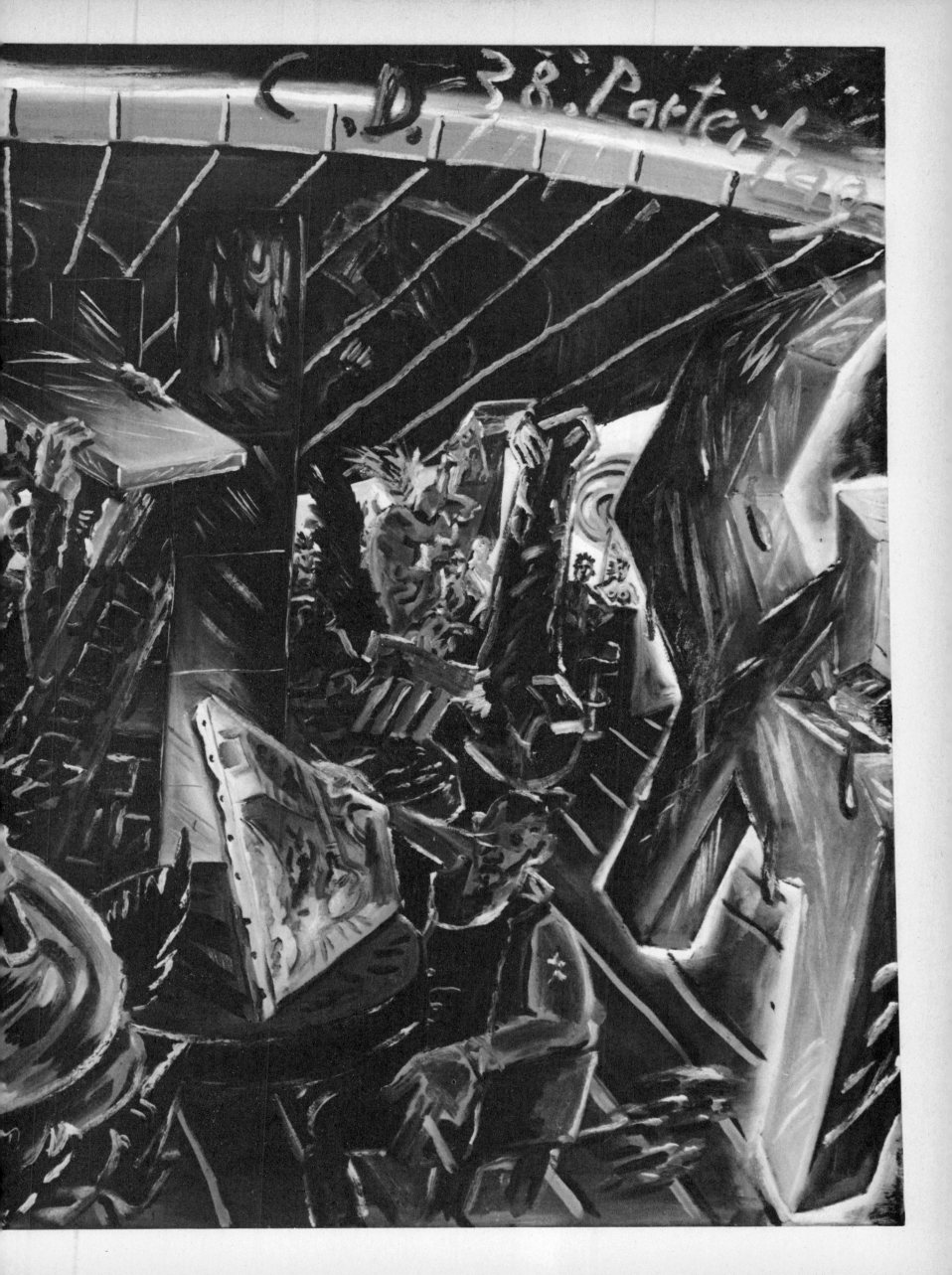

NEIL JENNEY

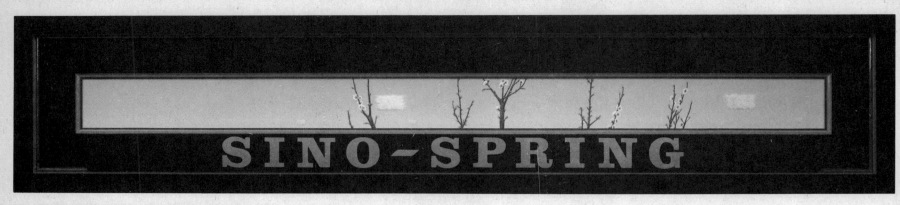

NEIL JENNEY. *SINO-SPRING.* 1981. OIL ON WOOD, 25¾ x 112½"
COLLECTION DALLAS MUSEUM OF ART. GIFT OF MR. AND MRS. BEN H. CARPENTER,
MR. AND MRS. JOHN W. CARPENTER III, LAURA L. CARPENTER, ELIZABETH C. CARPENTER,
BARBARA D. CARPENTER, ELLEN B. CARPENTER, AND BENJAMIN H. CARPENTER

NEIL JENNEY
THE BRUCE HARDIE MEMORIAL. 1978–82
OIL ON WOOD, 74 x 80"
COLLECTION THE ARTIST

BILL JENSEN

BILL JENSEN
THE MEADOW. 1980–81
OIL ON LINEN, 26 x 26"
COLLECTION THE WHITNEY MUSEUM OF AMERICAN ART,
NEW YORK. PURCHASE, WITH FUNDS FROM
THE WILFRED P. AND ROSE COHEN PURCHASE FUND

STEVE KEISTER

STEVE KEISTER *PHANTOM.* 1982. PYTHON SKIN, GUITAR PARTS, ENAMEL ON PLYWOOD, 48 x 55 x 24". COURTESY BLUM HELMAN GALLERY, NEW YORK

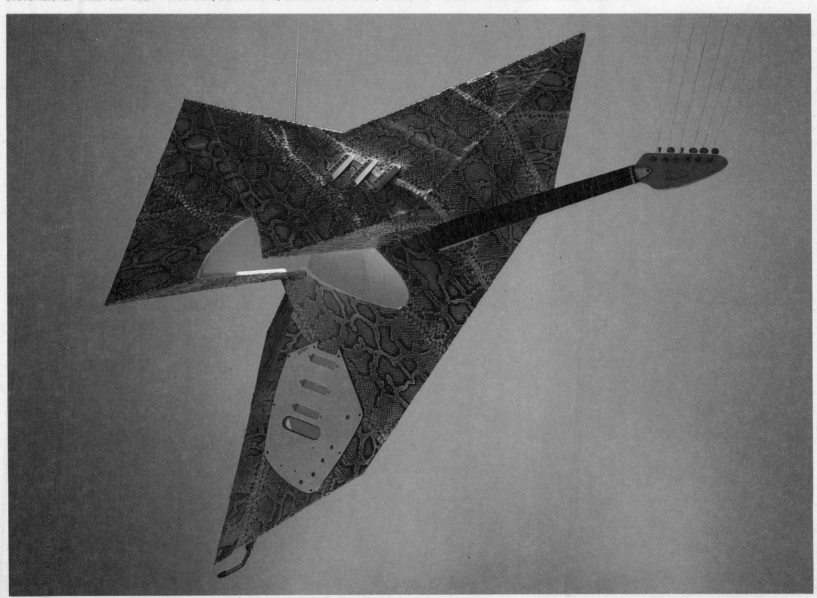

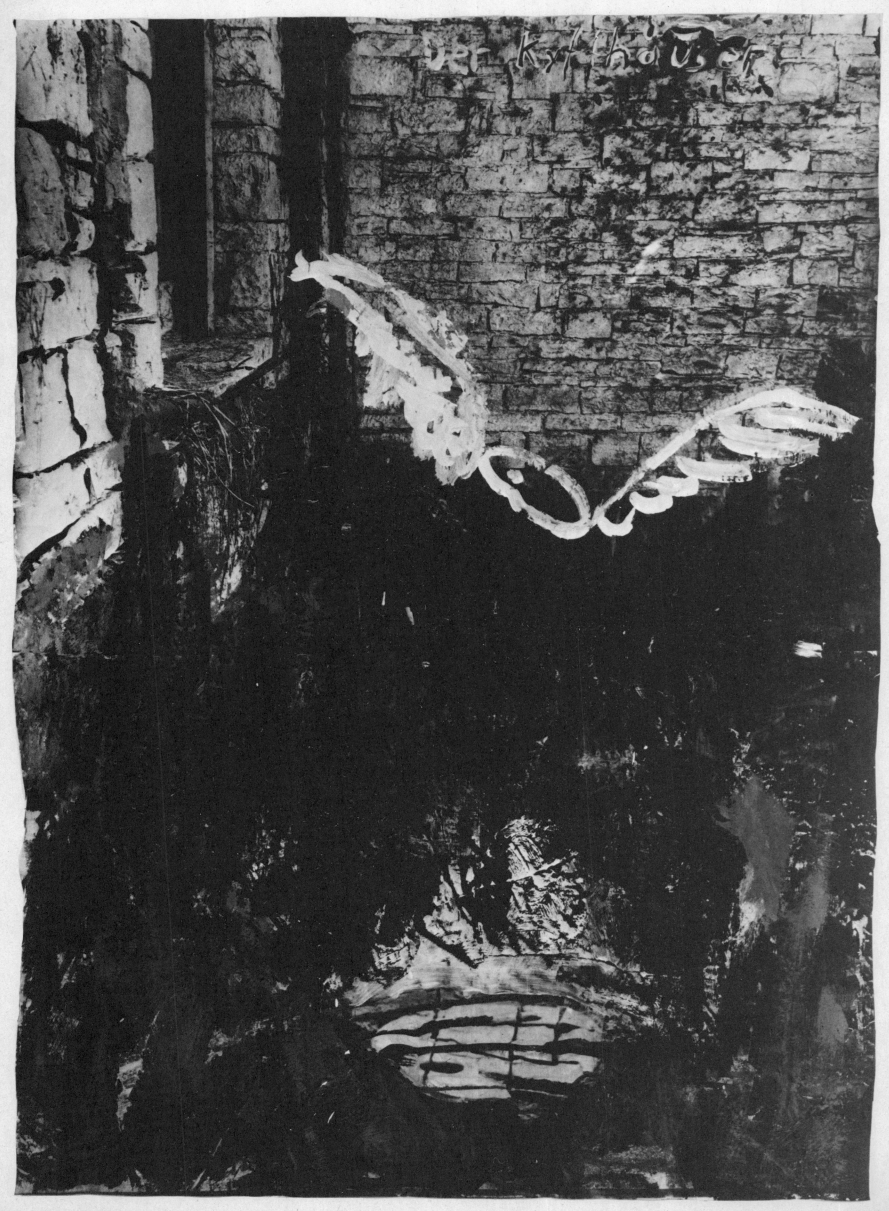

ANSELM KIEFER
GRAB DES UNBEKANNTEN MALERS. 1982
WOODCUT (UNIQUE), 68 x 93"
COLLECTION LOIS AND MICHAEL TORF

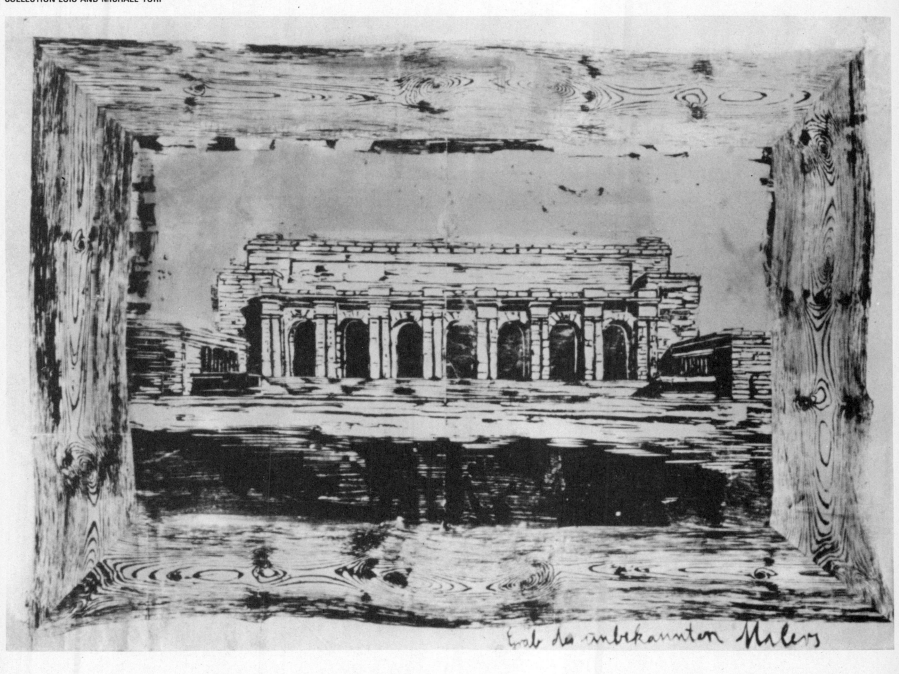

◄
ANSELM KIEFER
KYFFHÄUSER. 1981
OIL PAINT ON PHOTOGRAPH, 43 x 30"
CHASE MANHATTAN BANK COLLECTION

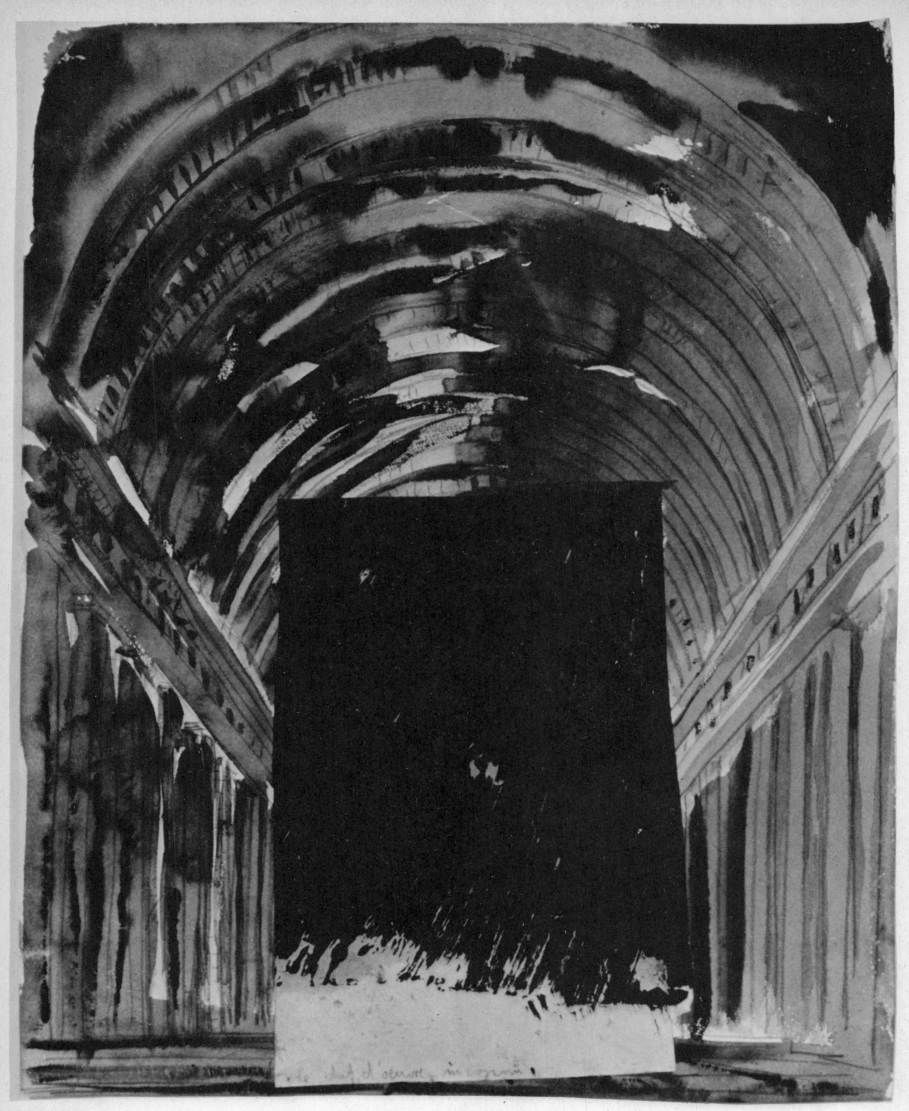

ANSELM KIEFER
LE CHEF D'OEUVRE INCONNU. 1983
MIXED MEDIUMS ON PAPER, 25 x 19½"
COURTESY MARIAN GOODMAN GALLERY, NEW YORK

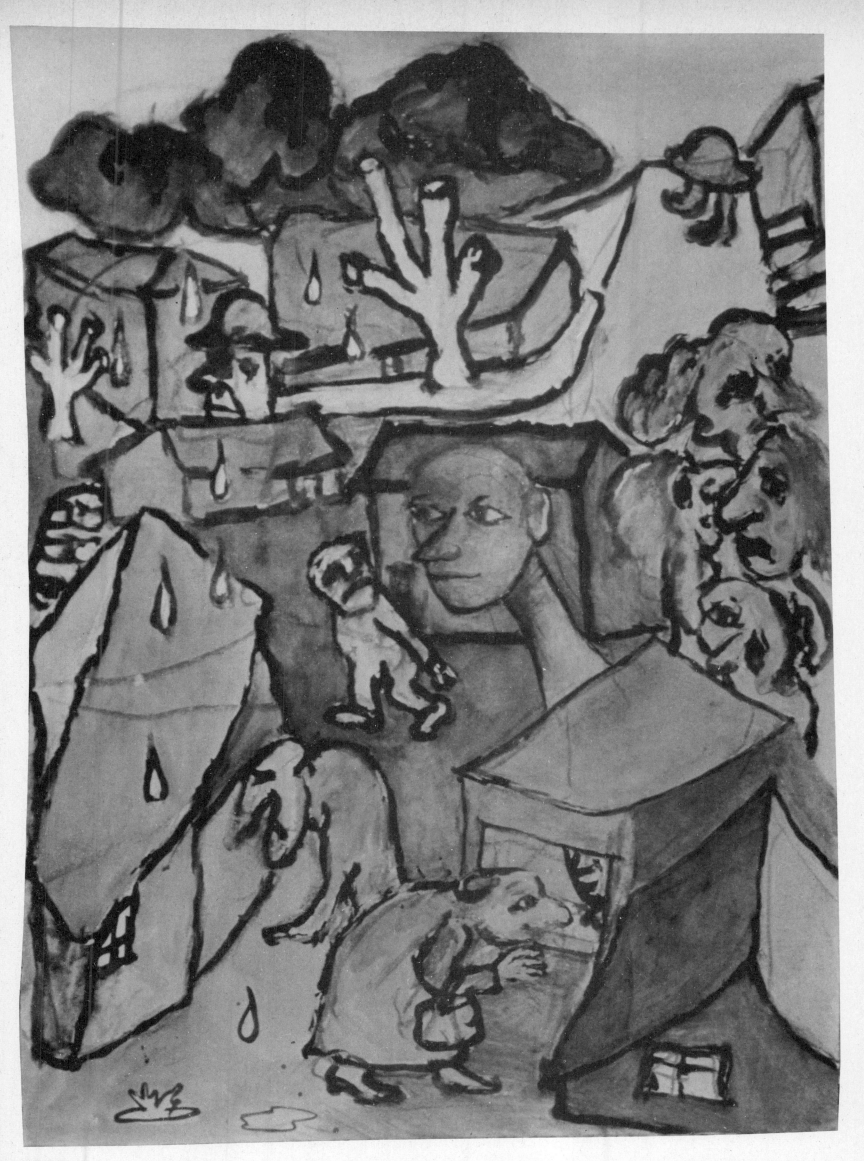

KEN KIFF
STREET WITH RAIN. 1982
WATERCOLOR, 21½ x 15½"
COURTESY EDWARD THORP GALLERY, NEW YORK

▶

KOMAR AND MELAMID
LOST PARADISE (SCENE FROM RUSSIAN LIFE). 1982–83
OIL ON CANVAS, EACH PANEL 72 x 47"
COLLECTION WILBUR, SARA, AND JASON PIERCE, BRYN MAWR, PENNSYLVANIA

KEN KIFF **KOMAR AND MELAMID**

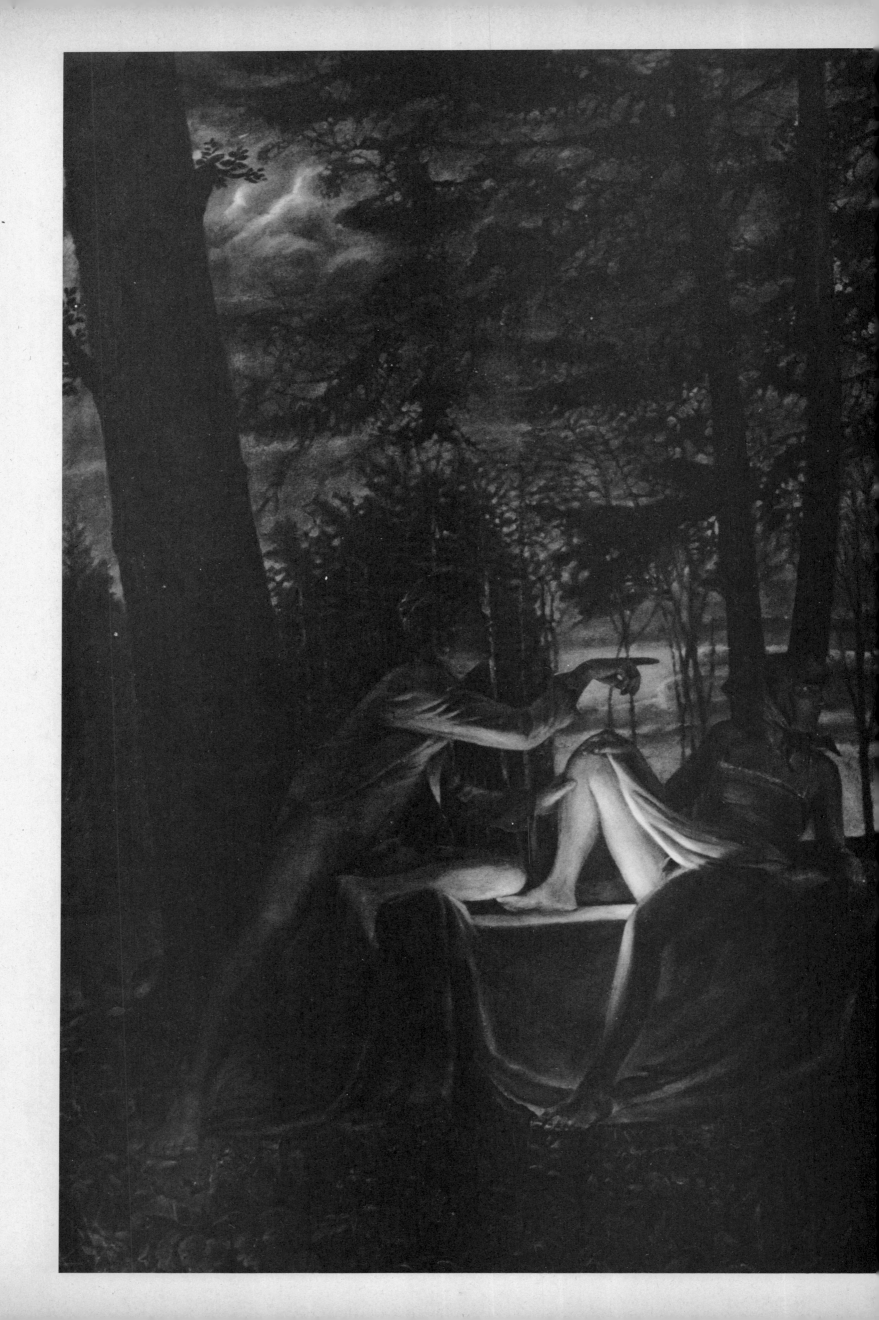

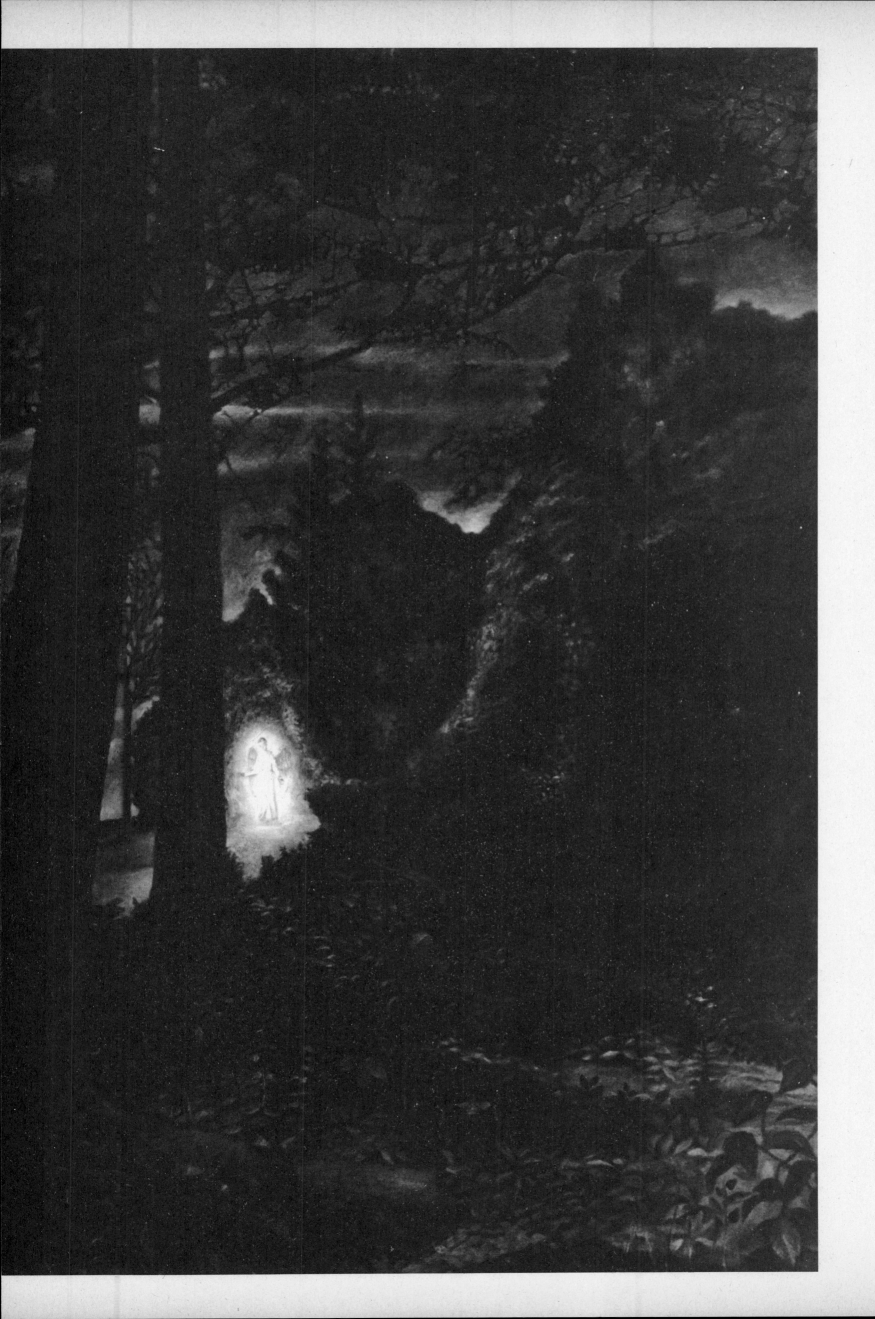

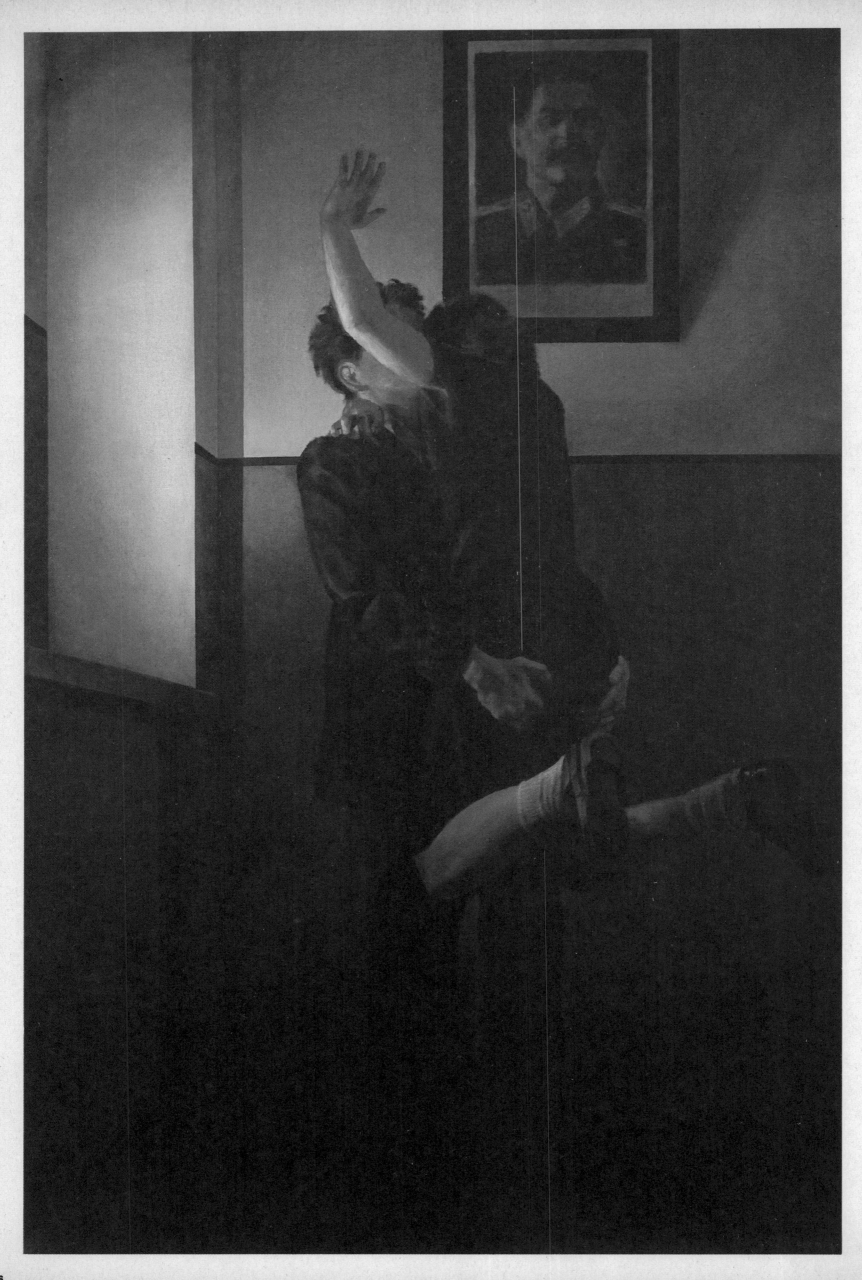

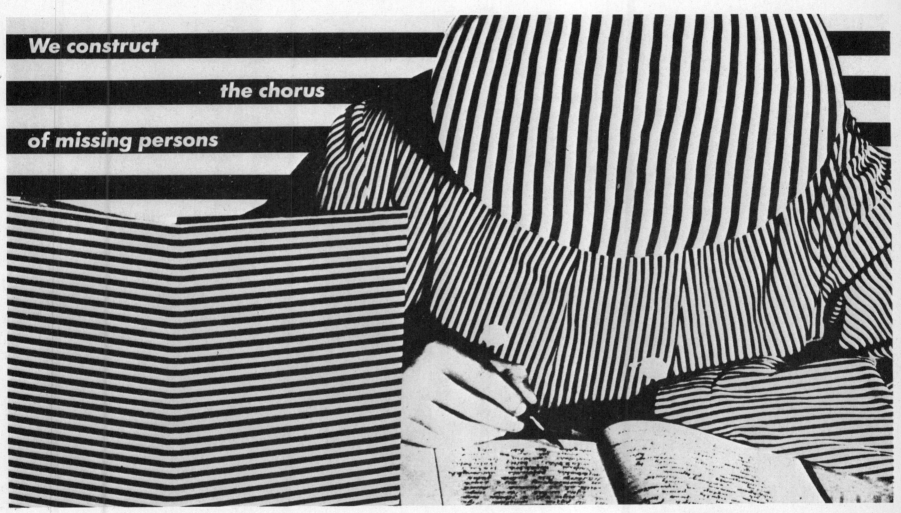

BARBARA KRUGER
WE CONSTRUCT THE CHORUS OF MISSING PERSONS. 1982
PHOTOGRAPH, 48 x 84"

◀
KOMAR AND MELAMID
THIRTY YEARS AGO 1953. 1982–83
OIL ON CANVAS, 72 x 47"
COURTESY RONALD FELDMAN FINE ARTS, NEW YORK

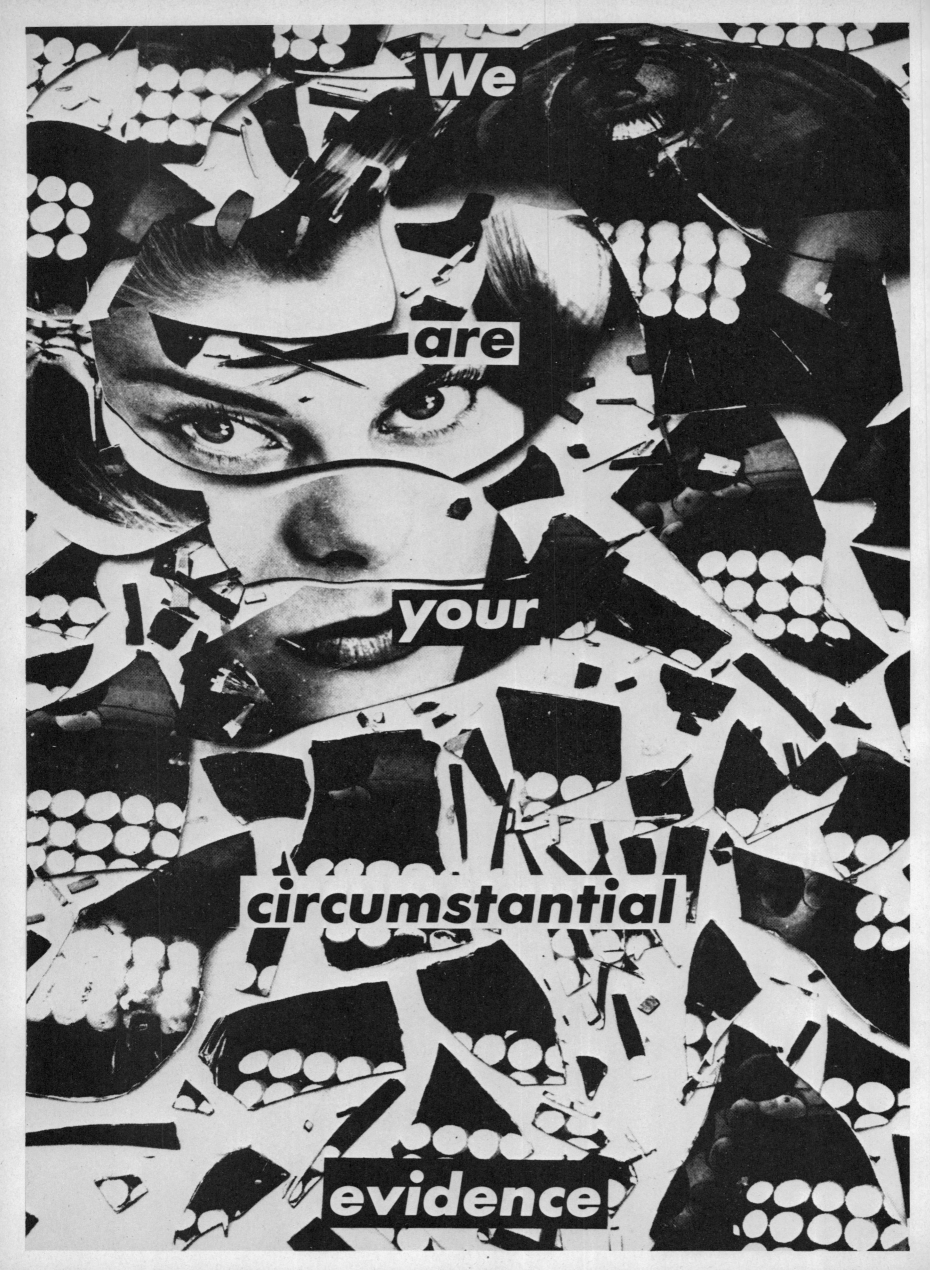

STEPHEN LACK
AMBASSADOR'S SON'S CAR BOMBED. 1983
ACRYLIC ON CANVAS WITH VINYL ON WOOD, 97 x 88"
COURTESY GRACIE MANSION GALLERY, NEW YORK

◄
BARBARA KRUGER
WE ARE YOUR CIRCUMSTANTIAL EVIDENCE. 1983
PHOTOGRAPH, 12 x 8'

STEPHEN LACK
PARTY GIRL (LITTLE LULU PARTY SLUT). 1983
ACRYLIC ON CANVAS WITH PAPER BAG,
VINYL/WOOD, 79 x 74"
COURTESY GRACIE MANSION GALLERY, NEW YORK

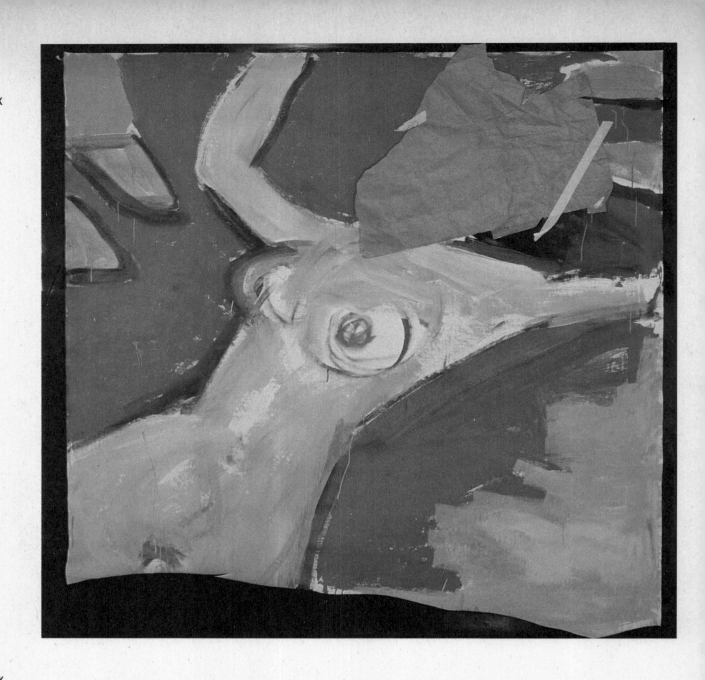

STEPHEN LACK
MEETING THE NEIGHBOR. 1982
ACRYLIC ON CANVAS, 10 x 6'
COURTESY GRACIE MANSION GALLERY, NEW YORK

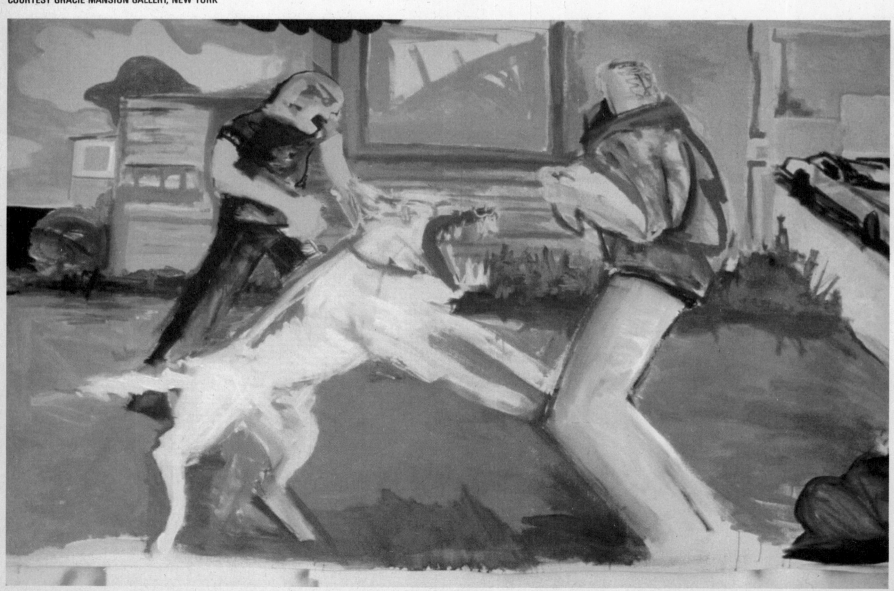

CHRISTOPHER LE BRUN
PROW. 1983
OIL ON CANVAS, 102 x 132"
COLLECTION PAINE WEBBER INC. COURTESY SPERONE WESTWATER, NEW YORK

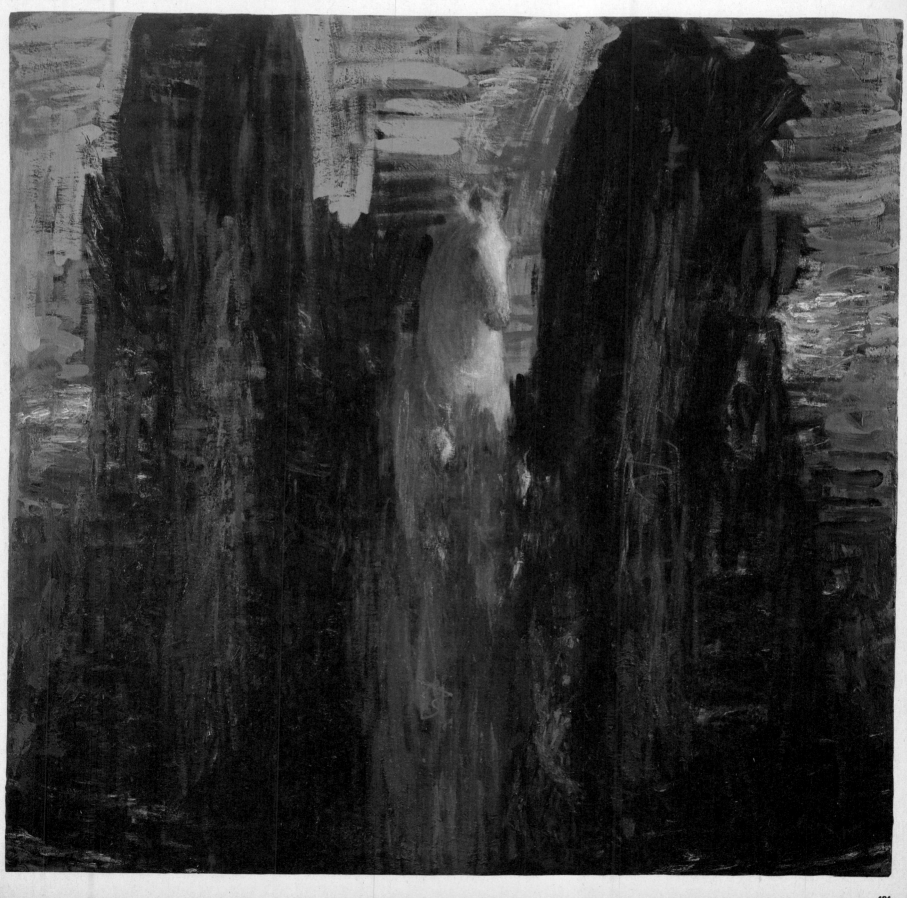

LOIS LANE

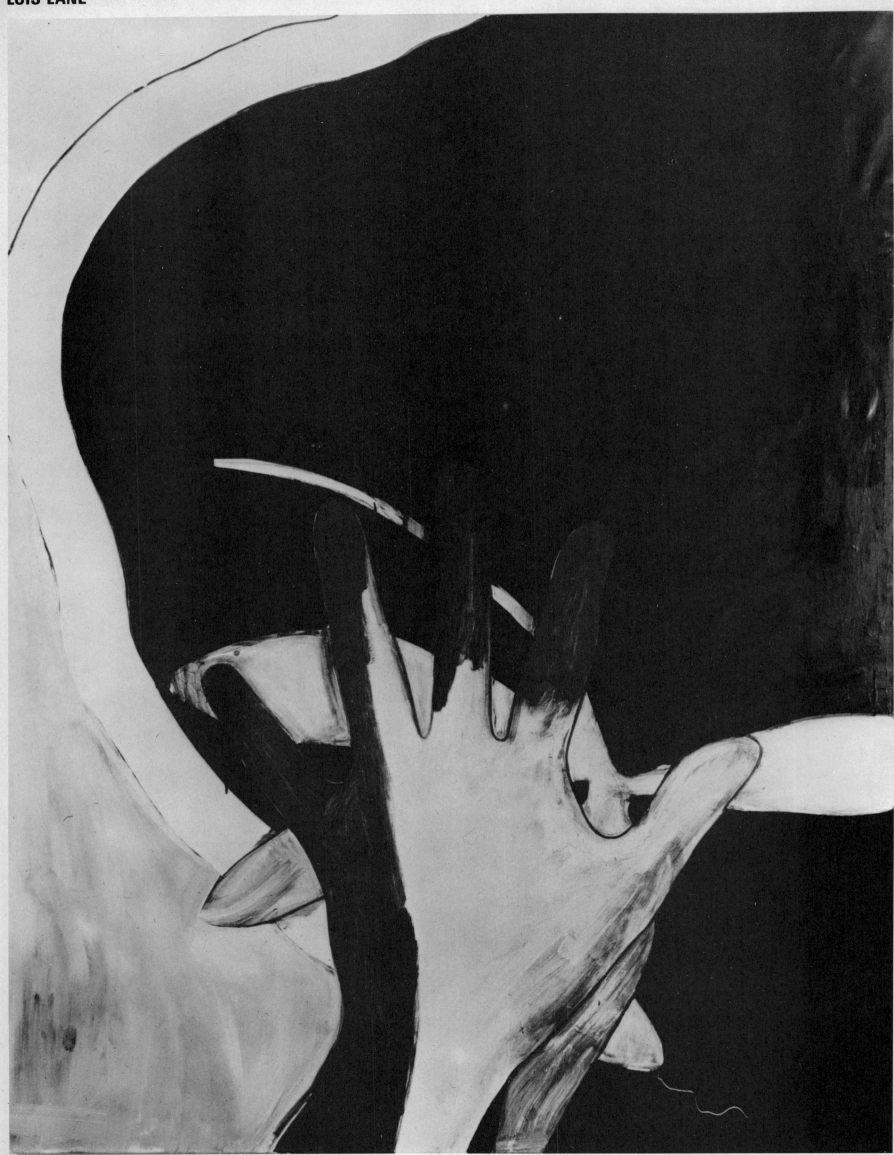

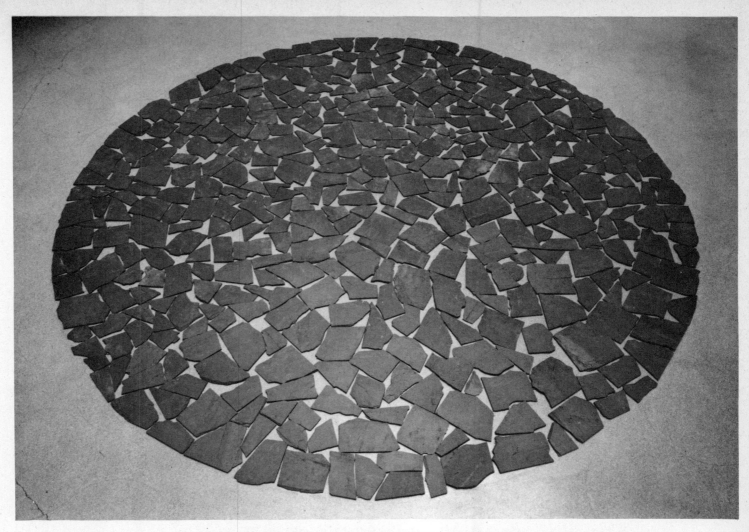

RICHARD LONG. *RED SLATE CIRCLE*. 1980. 28' DIAMETER. THE SOLOMON R. GUGGENHEIM MUSEUM, NEW YORK. COURTESY SPERONE WESTWATER, NEW YORK

RICHARD LONG. *RIVER AVON MUD NEW YORK*. 1982. MUD ON WHITE WALL, 10'10" DIAMETER. COURTESY SPERONE WESTWATER, NEW YORK

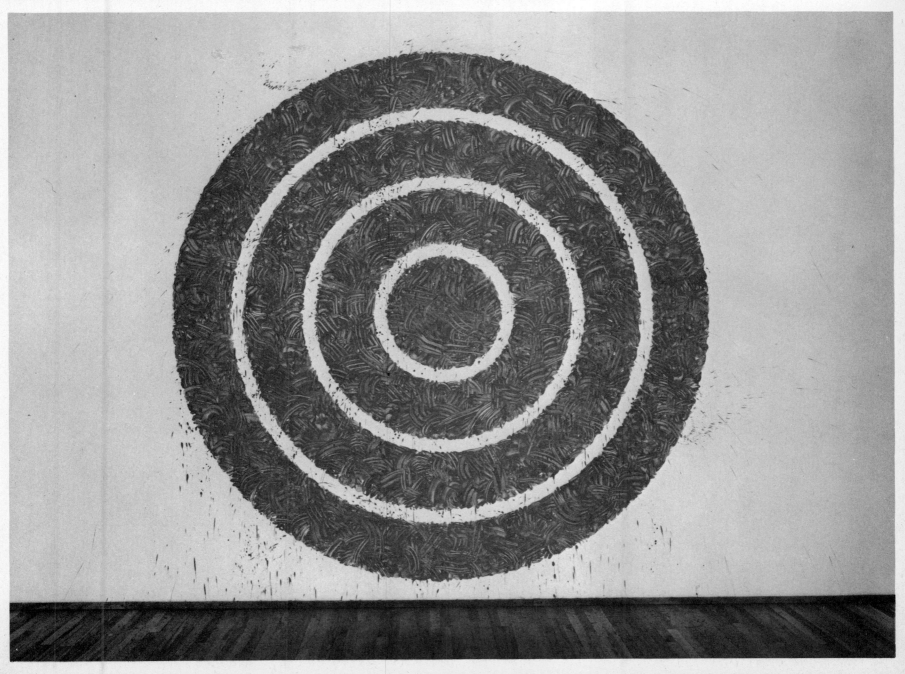

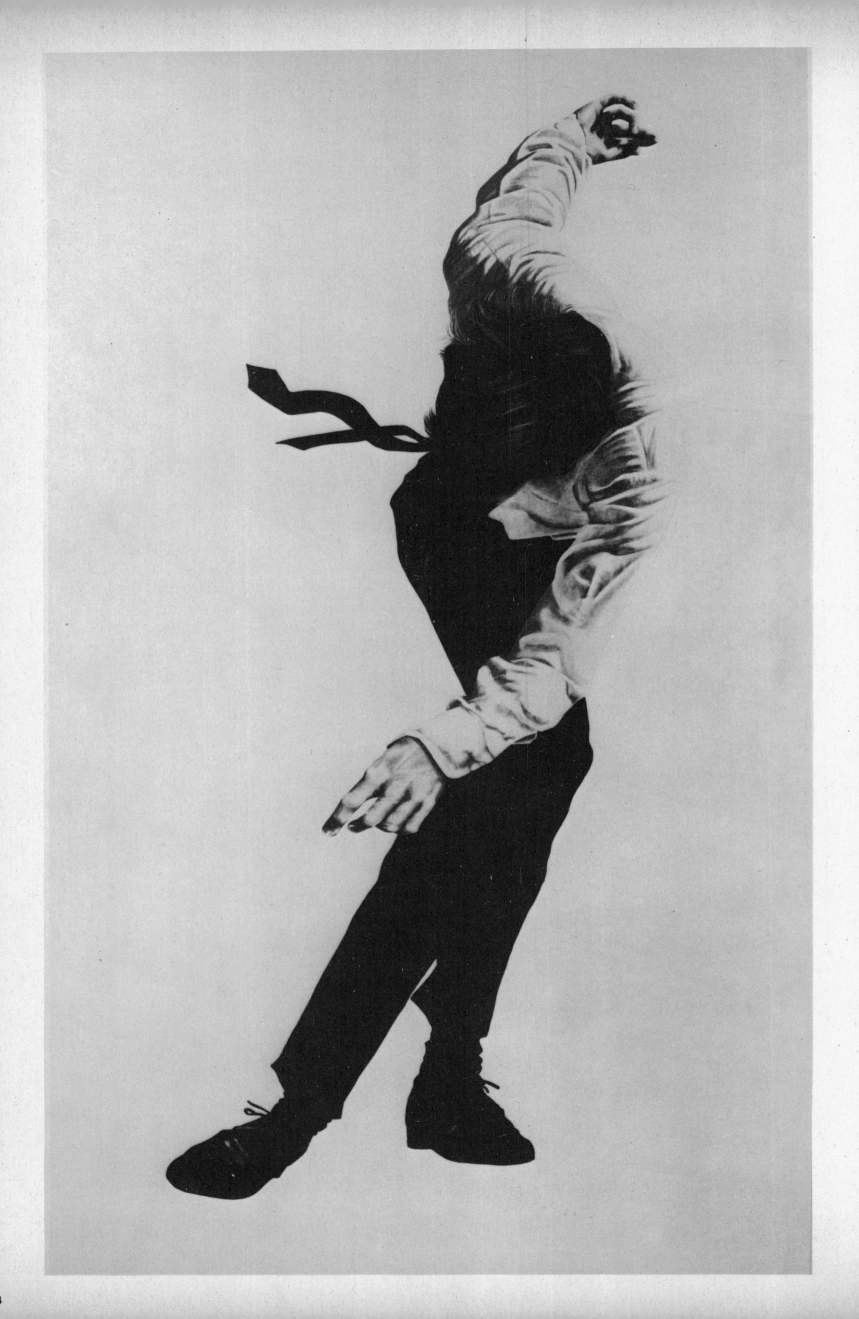

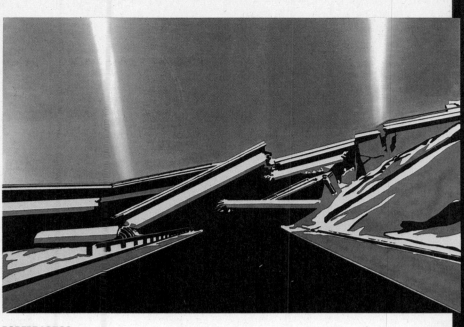
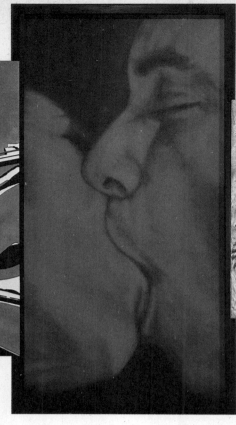
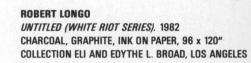

ROBERT LONGO
ORNAMENTAL LOVE. 1983
MIXED MEDIUMS, 101½ x 202"
PRIVATE COLLECTION

◀

ROBERT LONGO
UNTITLED (MEN IN THE CITIES SERIES). 1981
CHARCOAL AND GRAPHTE ON PAPER, 8 x 5'
COLLECTION METRO PICTURES GALLERY, NEW YORK

ROBERT LONGO
UNTITLED (WHITE RIOT SERIES). 1982
CHARCOAL, GRAPHITE, INK ON PAPER, 96 x 120"
COLLECTION ELI AND EDYTHE L. BROAD, LOS ANGELES

MARKUS LÜPERTZ

MARKUS LÜPERTZ
"DU WEIST NICHT VIEL," VERSETZTE DIE HERZOGIN (ALICE IM WUNDERLAND). 1981
OIL ON CANVAS, 39¼ x 31"
COURTESY MARY BOONE GALLERY/MICHAEL WERNER GALLERY, NEW YORK

MARKUS LÜPERTZ
"DU WEIST NICHT VIEL," VERSETZTE DIE HERZOGIN (ALICE IM WUNDERLAND). 1981
OIL ON CANVAS, 39¼ x 31"
COURTESY MARY BOONE GALLERY/MICHAEL WERNER GALLERY, NEW YORK

MARKUS LÜPERTZ
BEWOHNER: MITTAG (DAS COLLIER D. SIEGERS). 1983
OIL ON LINEN, 65 x 52½"
COURTESY MARY BOONE GALLERY/MICHAEL WERNER GALLERY, NEW YORK

MICHAEL MAZUR

MICHAEL MAZUR
THE MODEL. 1983
PASTEL ON PAPER, 58⅛ x 42"
COURTESY BARBARA MATHES GALLERY, NEW YORK

MICHAEL MAZUR
WAKEBY NIGHT STUDY II. 1983
PASTEL OVER MONOTYPE, 47½ x 62¾"
COURTESY BARBARA MATHES GALLERY, NEW YORK

MARIO MERZ

MARIO MERZ
PITTORE IN AFRICA. 1983
ACRYLIC AND OIL ON CANVAS WITH WOOD COLLAGE, 80 x 96"
PRIVATE COLLECTION, NEW YORK
COURTESY SPERONE WESTWATER, NEW YORK

MARIO MERZ
DAL MIELE ALLE CENERI. 1984
STEEL, BEESWAX, PINECONES, ANTELOPE HEAD,
AND MUSLIN ON ALUMINUM FRAME, 81" HIGH x 81" DIAMETER
COURTESY SPERONE WESTWATER, NEW YORK

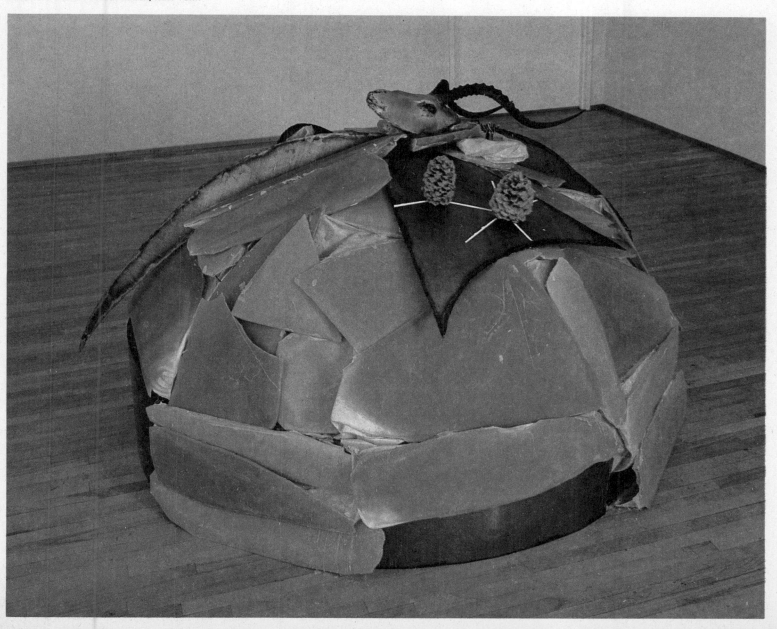

ROBERT MAPPLETHORPE
TULIPS IN A BLACK PITCHER. 1982
GELATIN SILVER PRINT, 16 x 20"
COURTESY ROBERT MILLER GALLERY

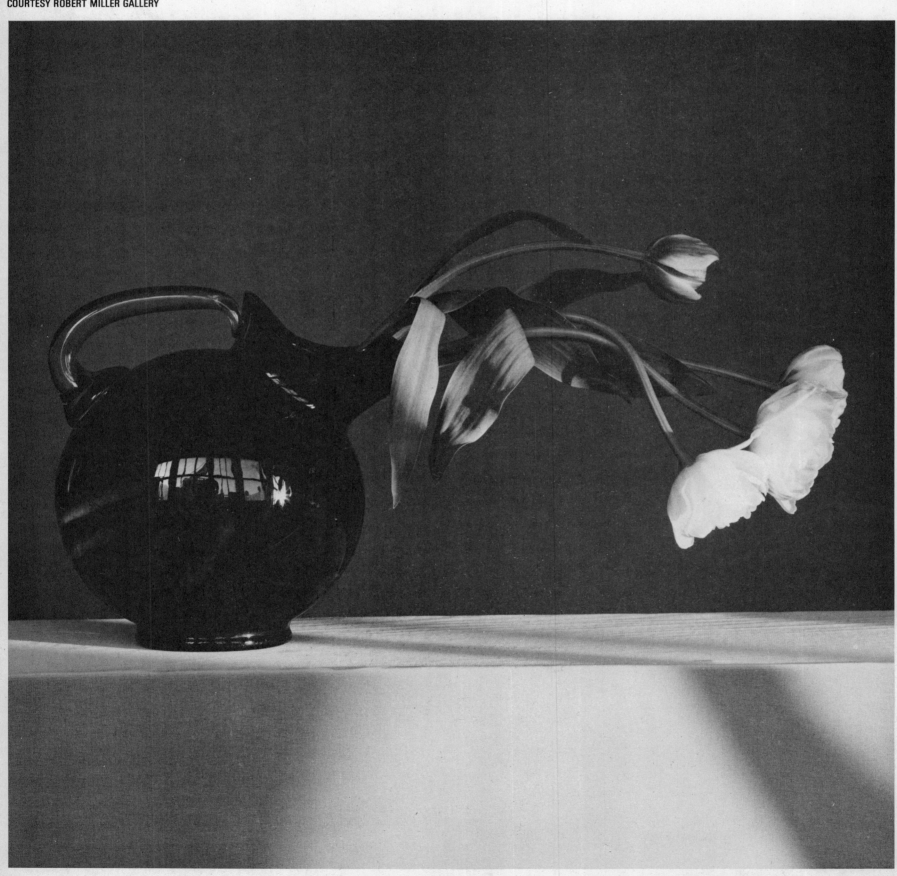

ROBERT MAPPLETHORPE
BRUCE, SAN FRANCISCO. 1980
PHOTOGRAPH, 16 x 20"
COURTESY ROBERT MILLER GALLERY

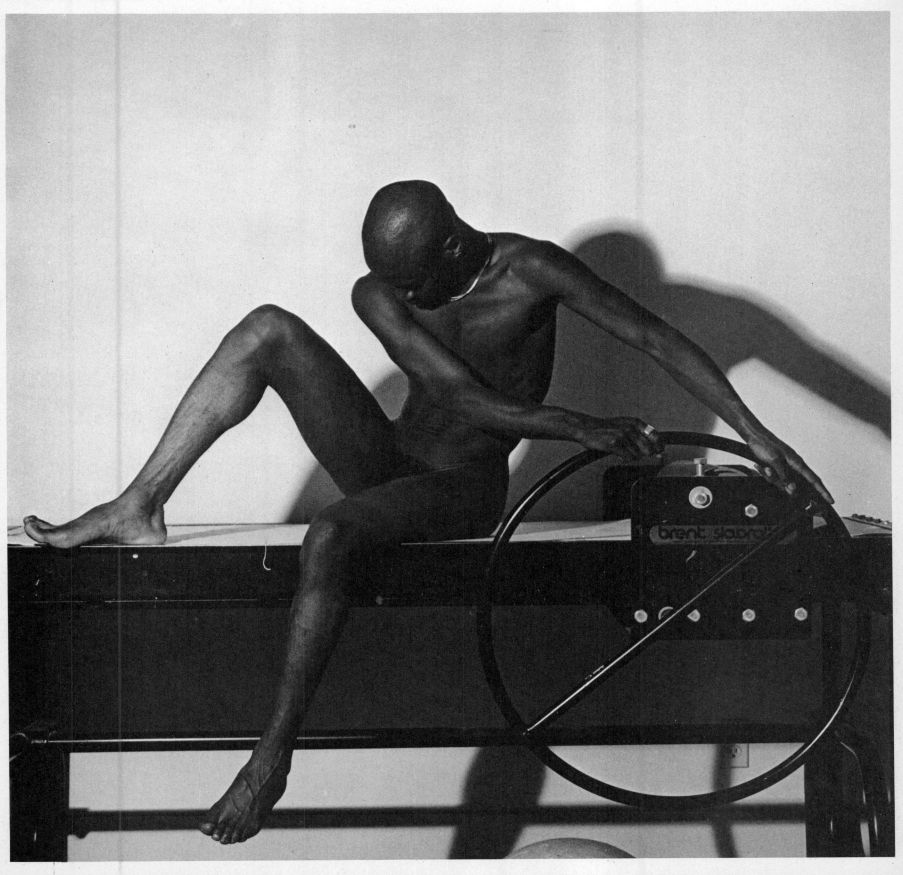

MELISSA MILLER

▶
MELISSA MILLER
STUDIES FOR THE ARK: EYE OF THE STORM. 1981
ACRYLIC ON PAPER, 24 x 30"
PRIVATE COLLECTION

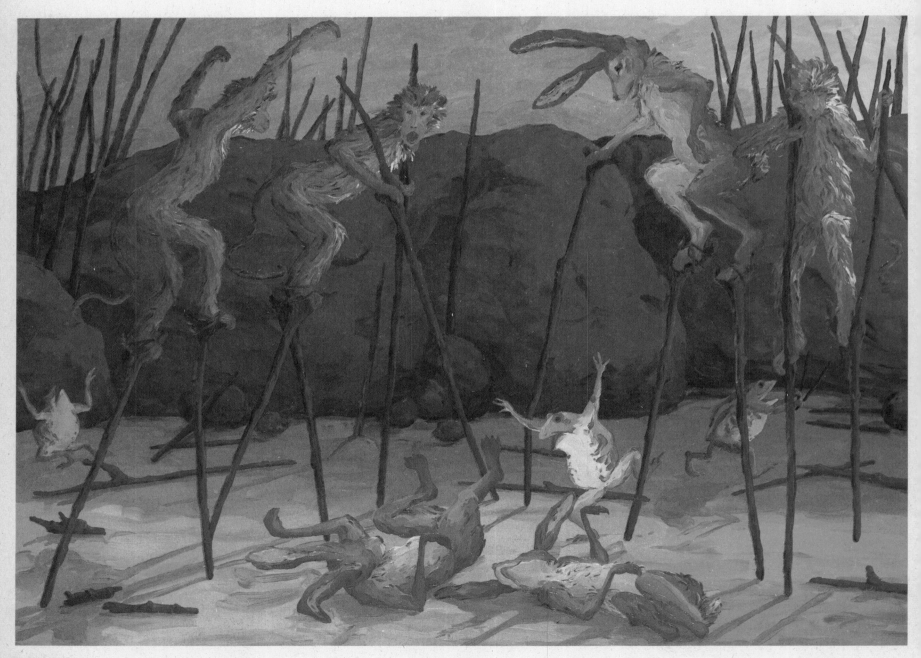

MELISSA MILLER
CLOWNS. 1983
OIL ON LINEN, 59 x 95"
COLLECTION MR. AND MRS. I. H. KEMPNER, III, HOUSTON

▶
MELISSA MILLER
FLOOD. 1983
OIL ON LINEN, 59 x 95"
MUSEUM OF FINE ARTS, HOUSTON

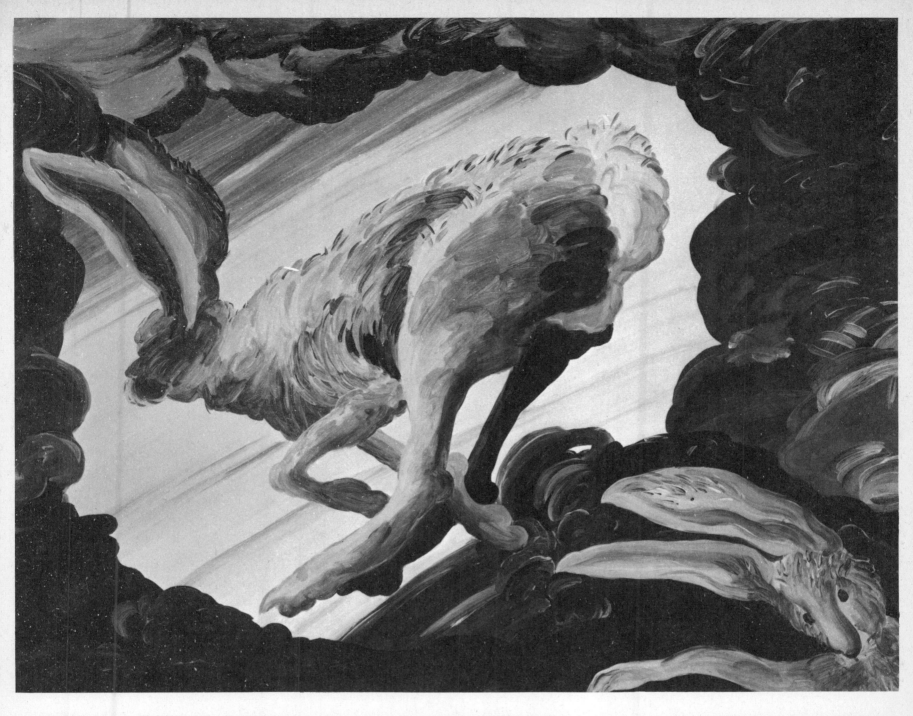

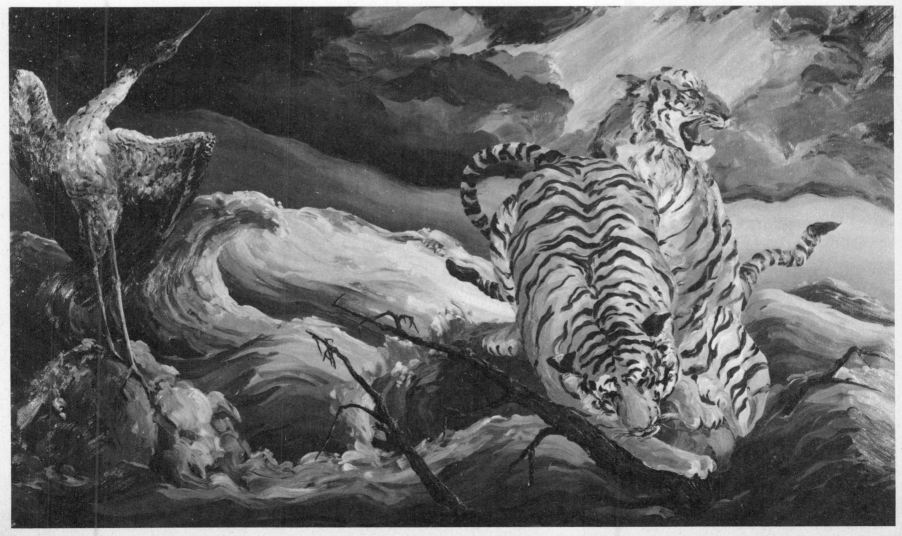

MARY MISS

▶
MARY MISS
FIELD ROTATION. 1981
CENTRAL STRUCTURE 60' SQUARE x 70' DEEP ON 4½ ACRE SITE
GOVERNORS STATE UNIVERSITY, PARK FOREST SOUTH, ILLINOIS

▶
MARY MISS
MIRROR WAY. 1980
WOOD, WIRE MESH, 42 x 20 x 32'
FOGG MUSEUM, BOSTON

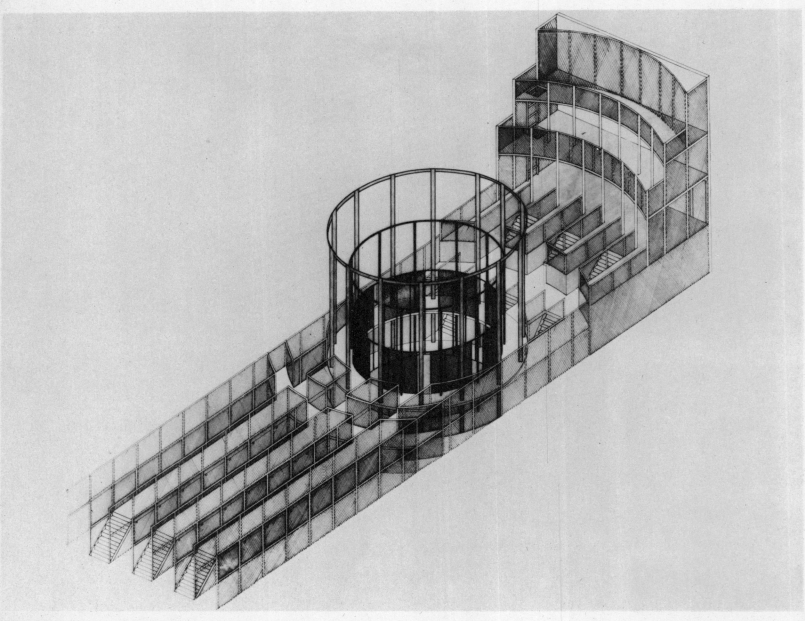

MARY MISS
42ND ST. PROJECT. 1981
INK ON MYLAR, 42 x 54"

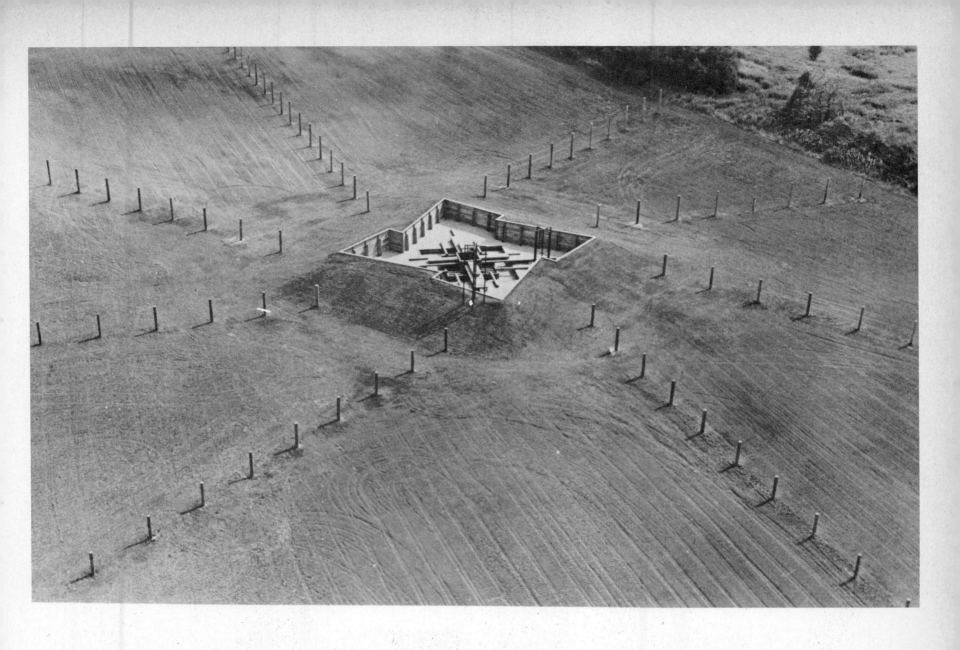

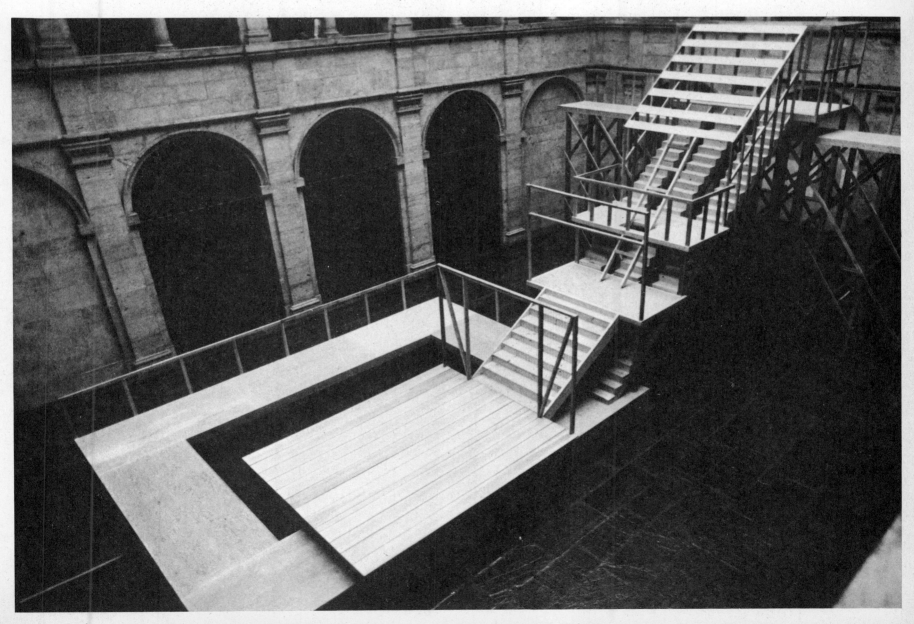

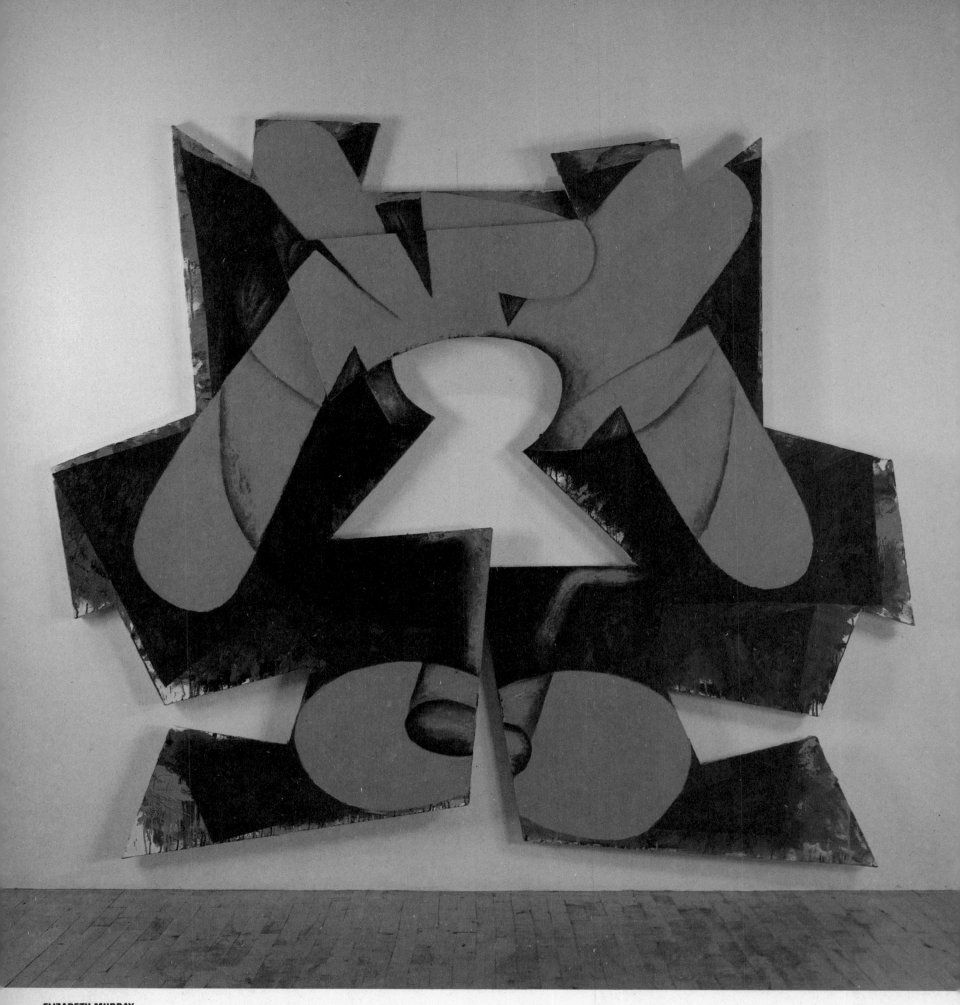

ELIZABETH MURRAY
KEYHOLE. 1982
OIL ON TWO CANVASES, 99½ x 110½"
PRIVATE COLLECTION

ELIZABETH MURRAY

MALCOLM MORLEY
CRADLE OF CIVILIZATION WITH AMERICAN WOMAN. 1982
OIL ON CANVAS, 80 x 100"
PRIVATE COLLECTION

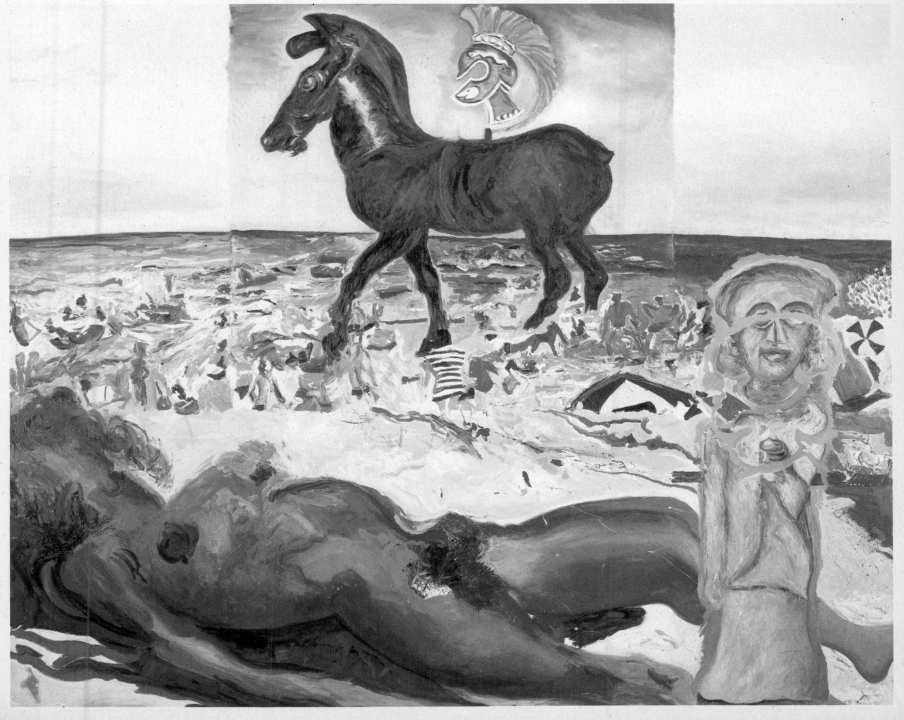

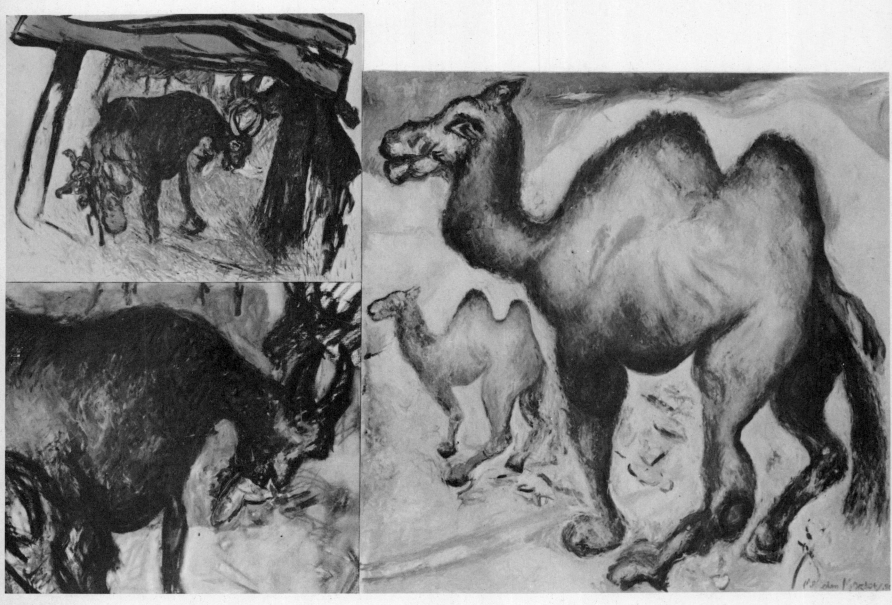

MALCOLM MORLEY
CAMELS AND GOATS. 1980
OIL ON CANVAS, 66½ x 100"
COLLECTION DORIS AND CHARLES SAATCHI, LONDON

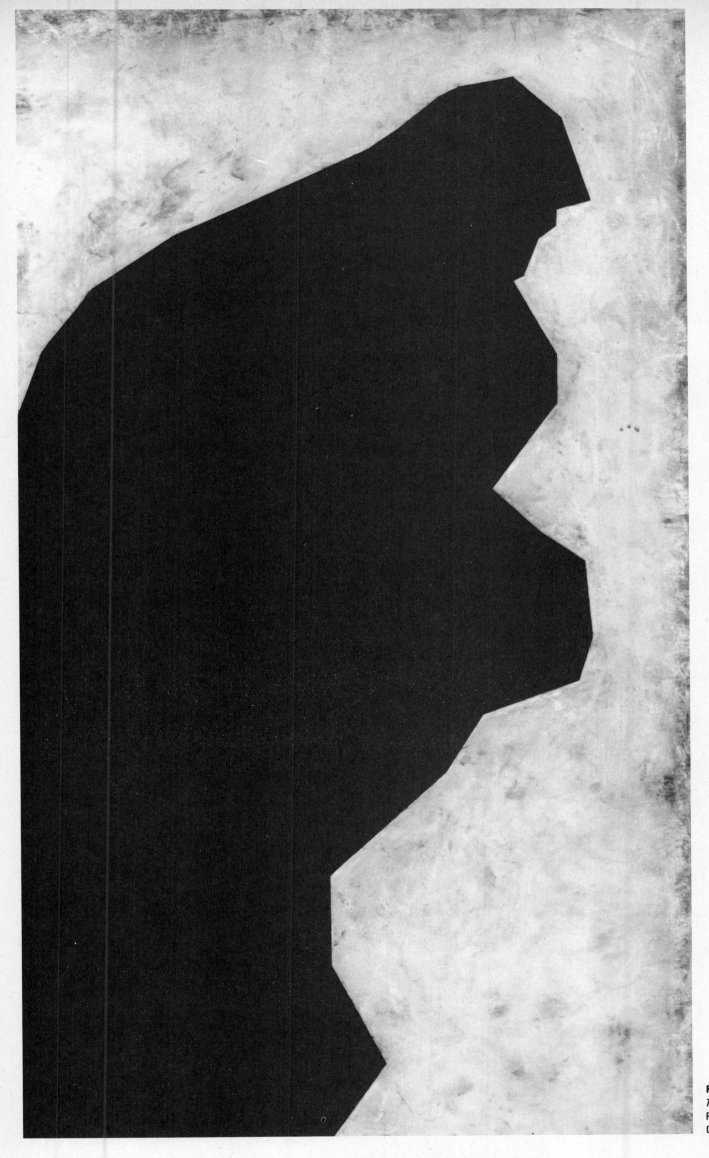

ROBERT MOSKOWITZ

ROBERT MOSKOWITZ
THINKER. 1982
PASTEL ON PAPER, 108 x 63"
COURTESY BLUM HELMAN GALLERY, NEW YORK

PAUL NARKIEWICZ

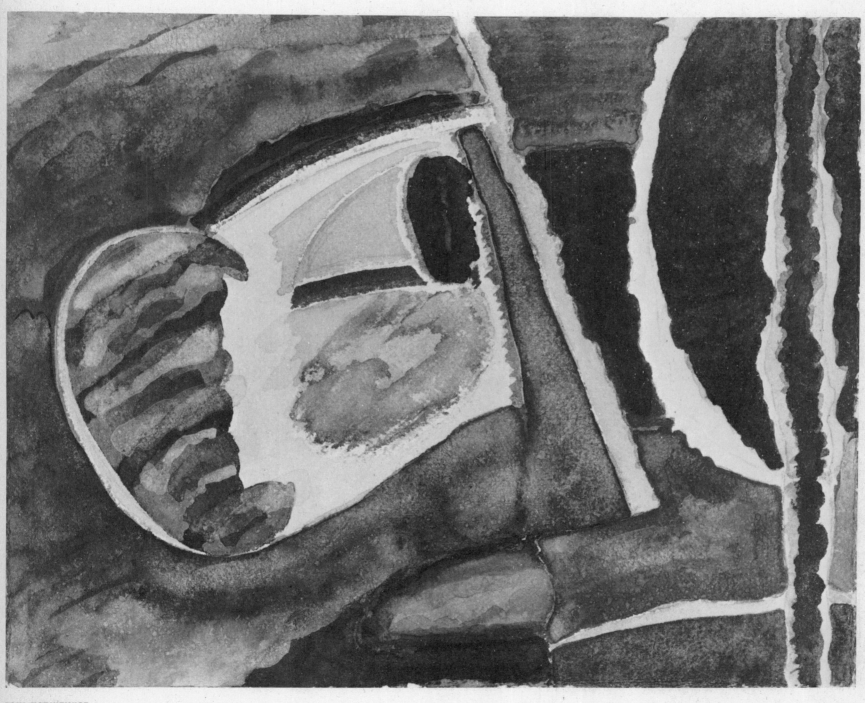

PAUL NARKIEWICZ
UNTITLED. 1983
WATERCOLOR ON PAPER, 14½ x 17½"
PRIVATE COLLECTION

NIC NICOSIA

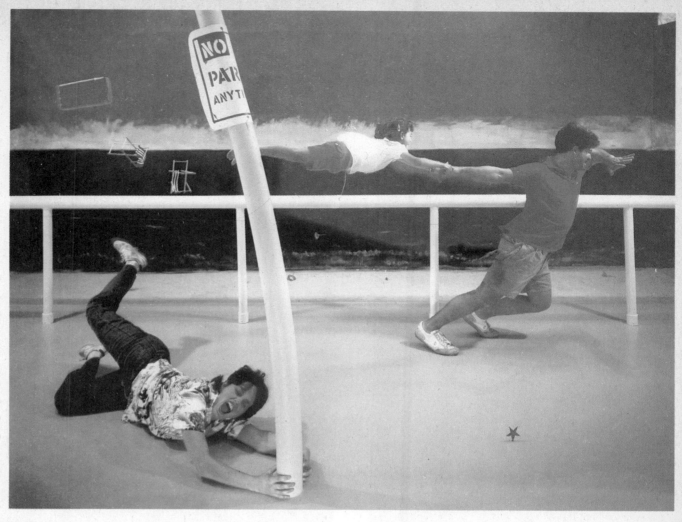

NIC NICOSIA
NEAR MODERN DISASTER #8. 1983
CIBACHROME, 40 x 60"
COURTESY DELAHUNTY GALLERY, NEW YORK/DALLAS

JIM NUTT

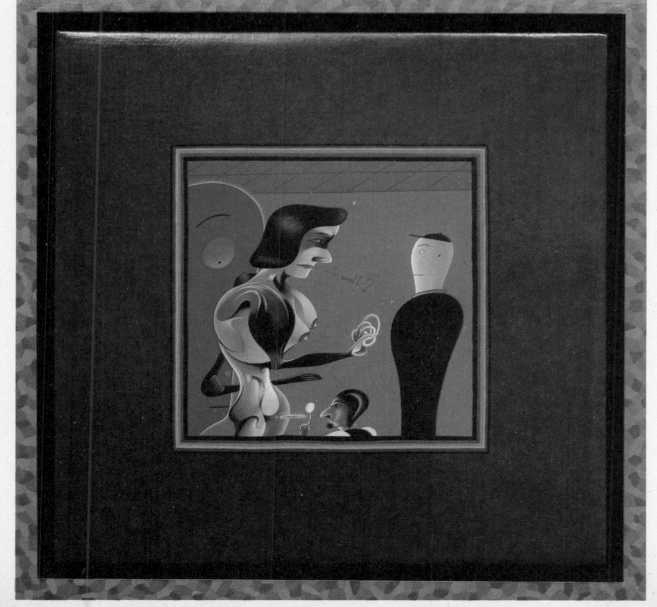

JIM NUTT
"TO THE POINT—A CLUE PERHAPS?" 1981
ACRYLIC ON CANVAS, 14⅝ x 14⅝"
COLLECTION THE ARTIST

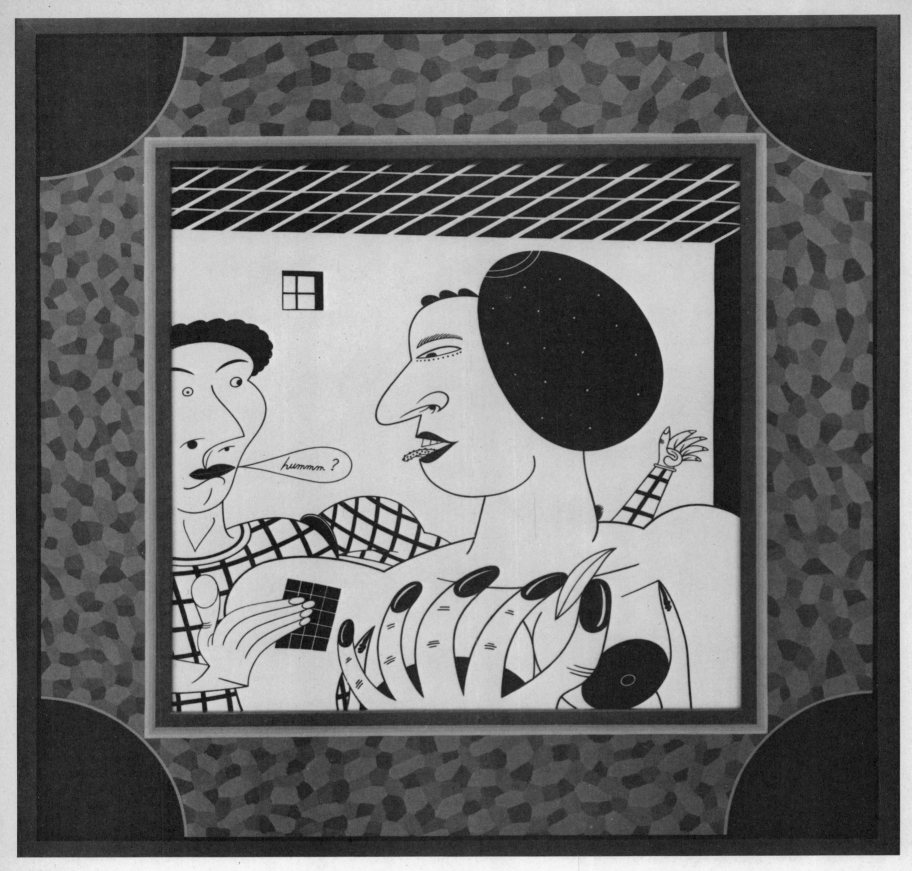

JIM NUTT
"SEEMS SIMPLE!!" 1982
ACRYLIC ON CANVAS, 22⅜ x 22⅜"
PRIVATE COLLECTION, CHICAGO

TOM OTTERNESS

TOM OTTERNESS
BABY. 1982
PAINTED CAST POLYADAM, 17½ x 16 x 16½"
COLLECTION WEATHERSPOON ART GALLERY GREENSBORO, NORTH CAROLINA

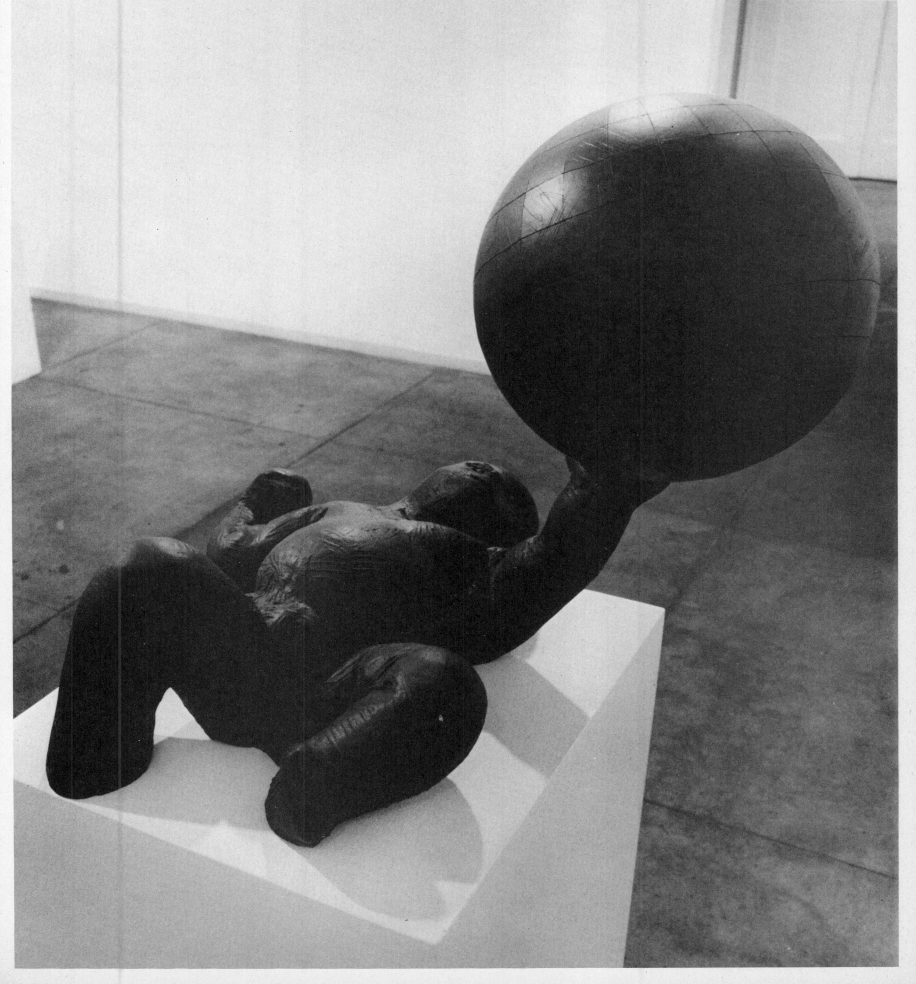

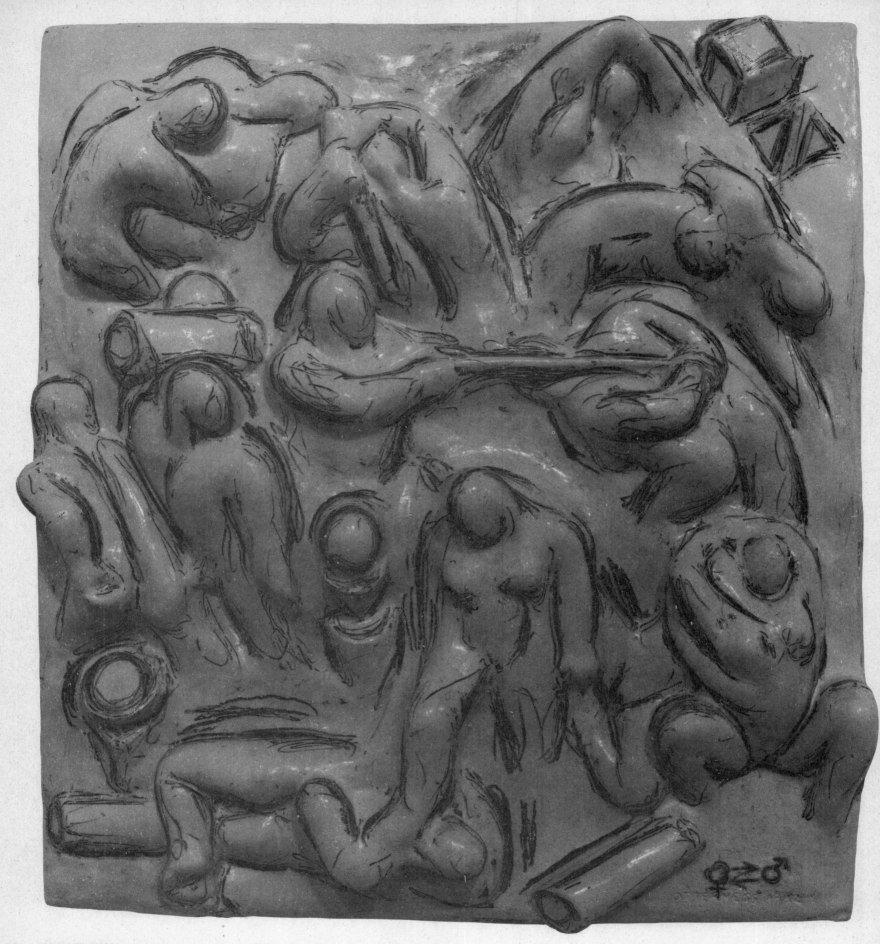

TOM OTTERNESS
BATTLE CARTOON. 1982–83
PAINTED CAST POLYADAM, 24 x 21 x 5"
COURTESY BROOKE ALEXANDER, INC., NEW YORK

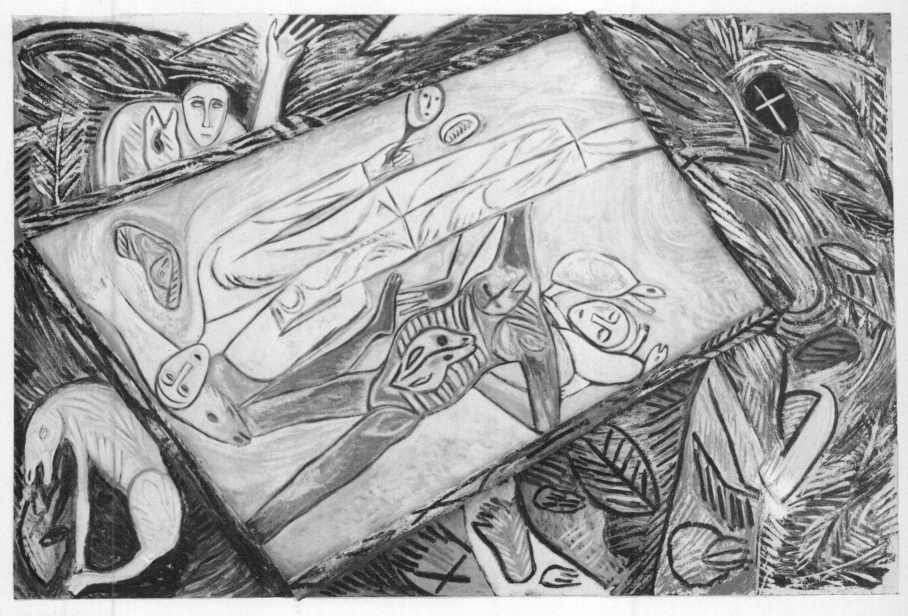

MIMMO PALADINO
POZZO DI EROI. 1983
OIL ON CANVAS AND WOOD COLLAGE, 81 x 120¼ x 42½"
PRIVATE COLLECTION. COURTESY SPERONE WESTWATER, NEW YORK

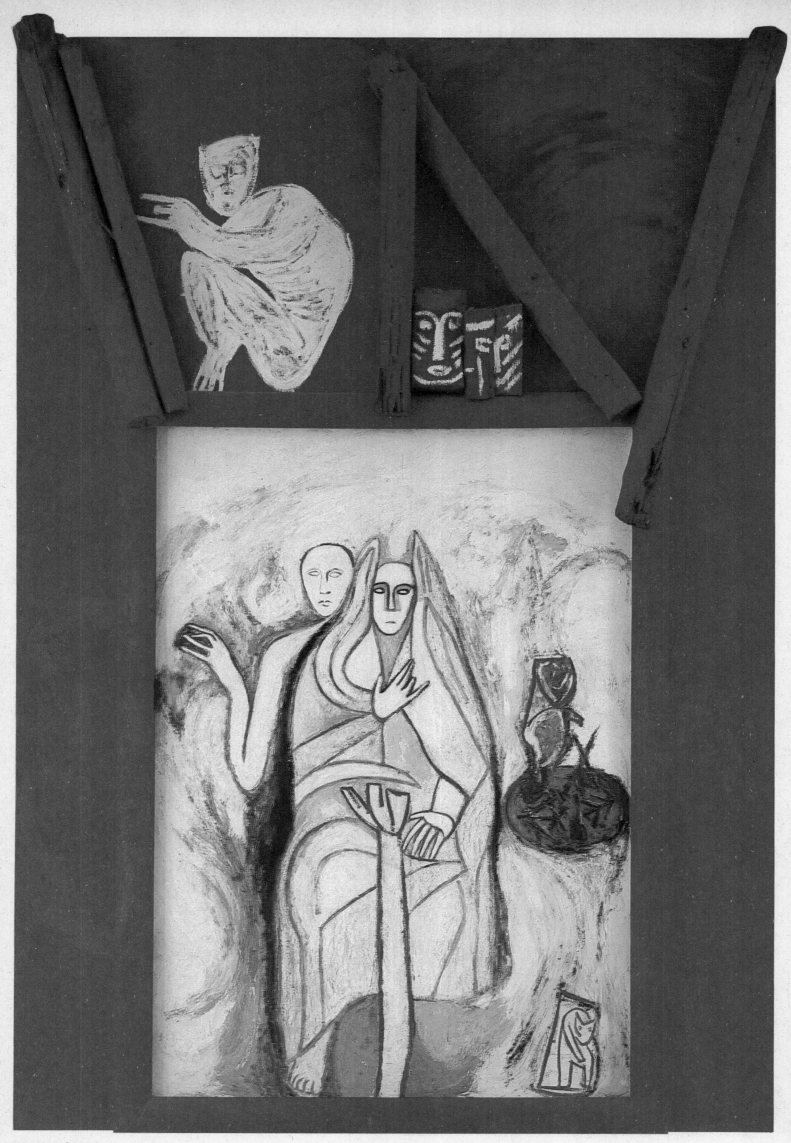

MIMMO PALADINO
UNTITLED. 1983
OIL ON CANVAS AND WOOD COLLAGE, 130 x 87"
COLLECTION MR. AND MRS. LEWIS MANILOW, CHICAGO
COURTESY SPERONE WESTWATER, NEW YORK

▶
ED PASCHKE
FERNSEHEN. 1981
OIL ON CANVAS, 42 x 84"
COURTESY PHYLLIS KIND GALLERY

ED PASCHKE
LE LIQUE. 1983
OIL ON CANVAS, 54 x 80″
PRIVATE COLLECTION, NEW YORK

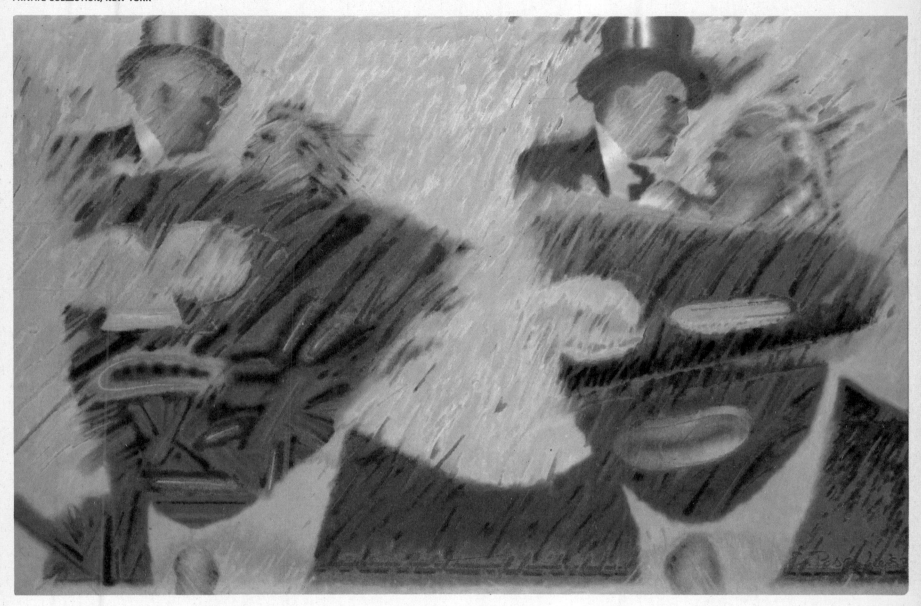

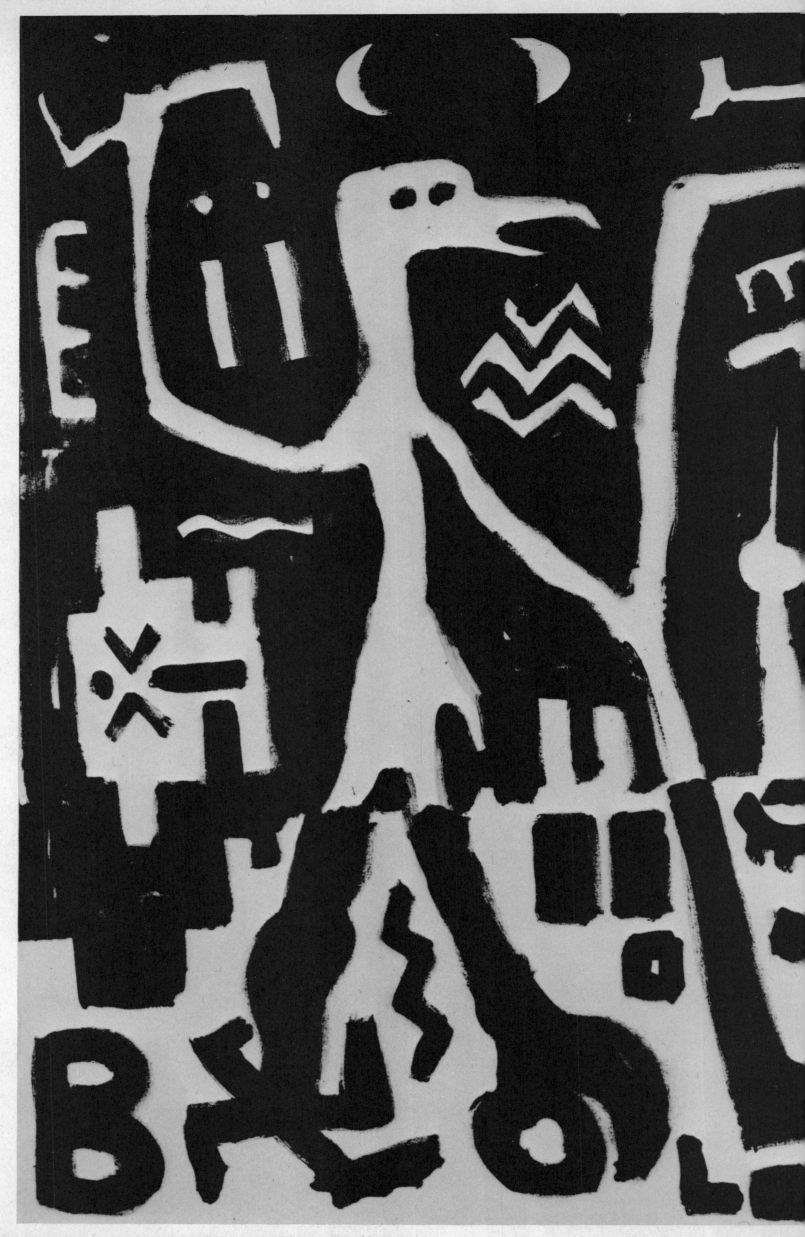

A. R. PENCK. *T.V.* 1981. ACRYLIC ON COTTON DUCK, 79 x 110". COLLECTION CAROL AND ARTHUR GOLDBERG, NEW YORK

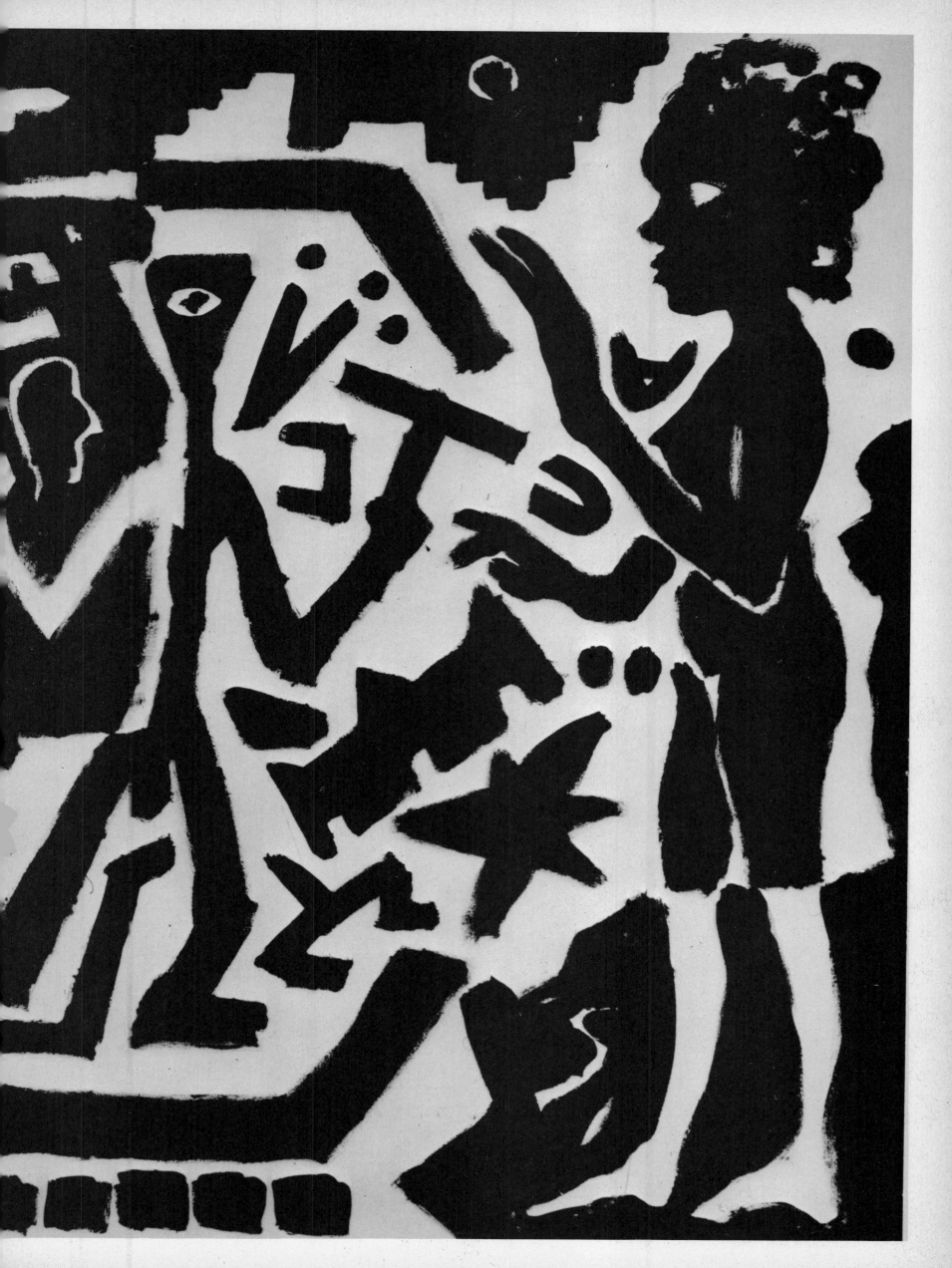

JUDY PFAFF

JUDY PFAFF. *STAGEFRIGHT.* 1983. MIXED MEDIUMS WALL RELIEF, 85 x 102½ x 29". COURTESY HOLLY SOLOMON GALLERY, NEW YORK

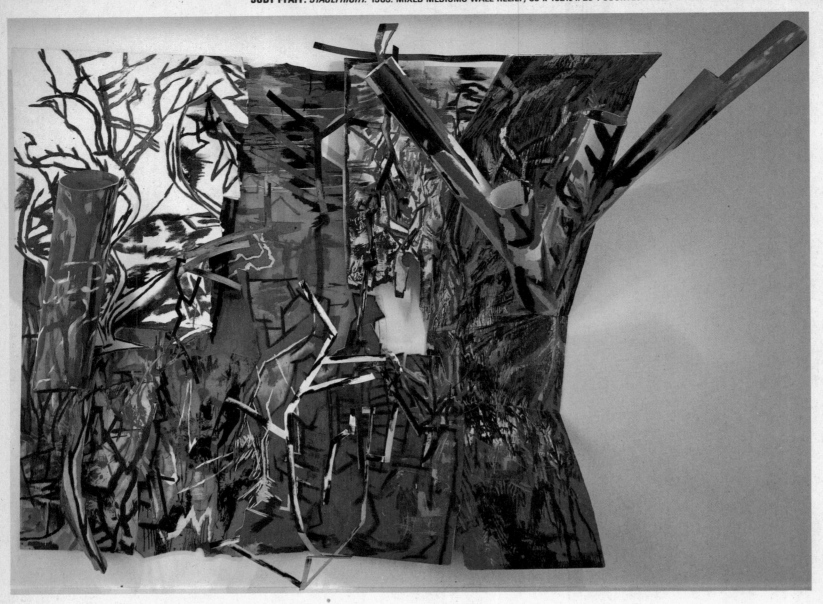

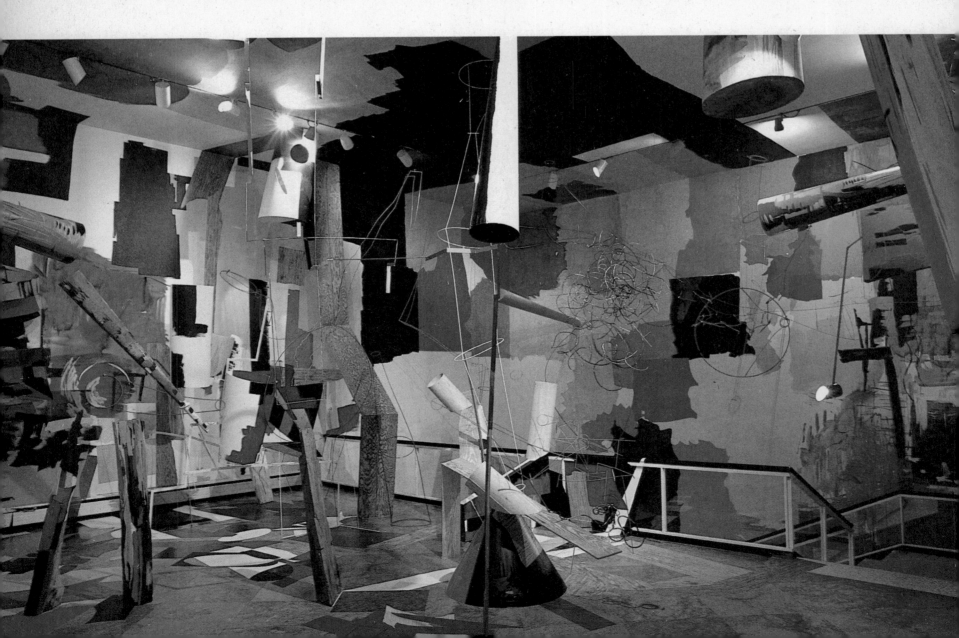

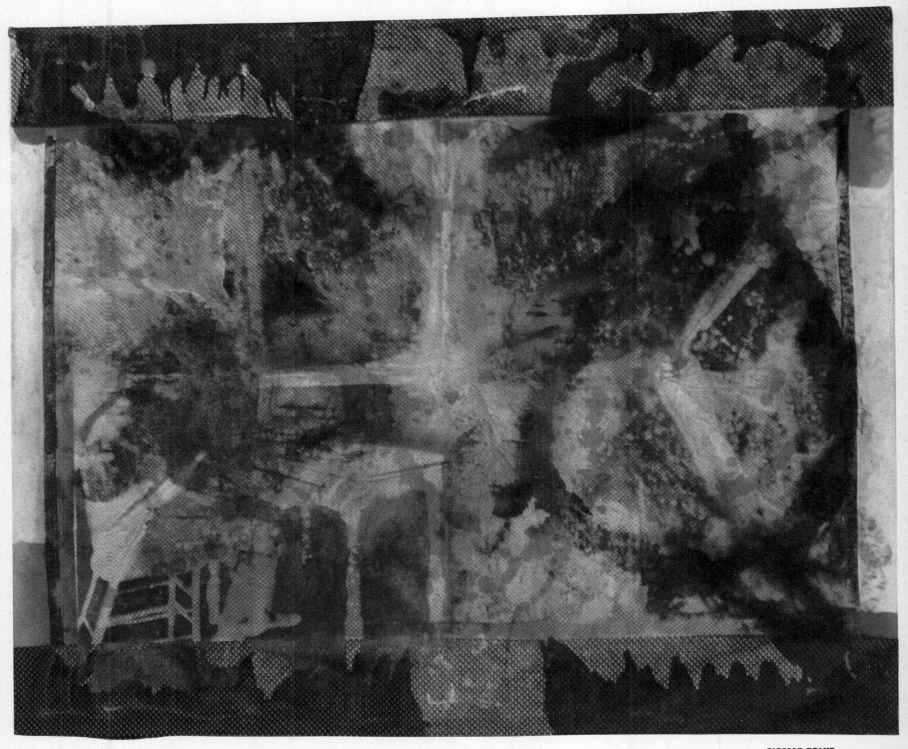

SIGMAR POLKE
COMPUTER PAINTING. 1983–84
OIL ON CLOTH, 9'2" x 9'2"
PRIVATE COLLECTION

◄
JUDY PFAFF
ROCK/PAPER/SCISSORS. SEPTEMBER 24, 1982–JANUARY 9, 1983
INSTALLATION, ALBRIGHT-KNOX ART GALLERY, BUFFALO, NEW YORK

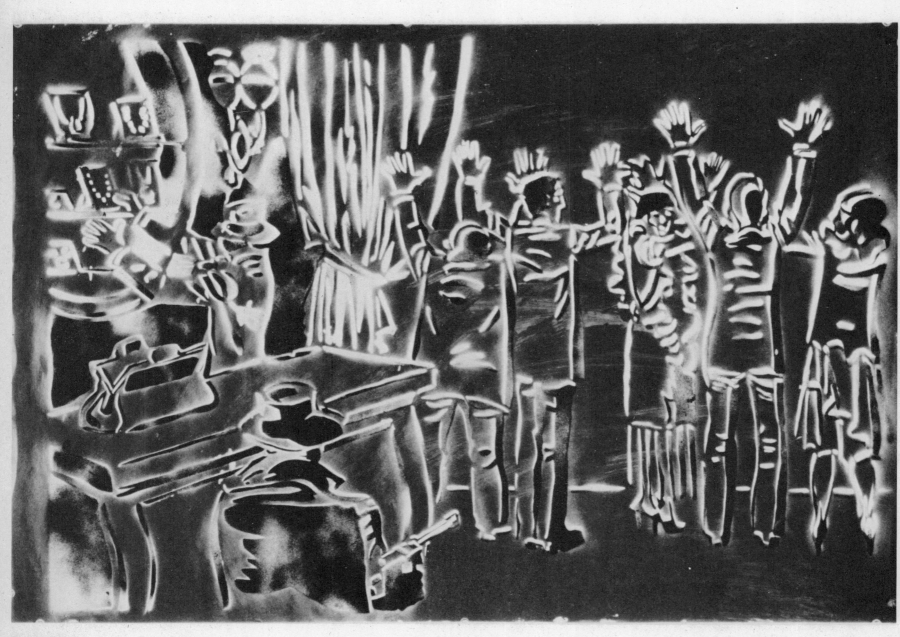

SIGMAR POLKE
UNTITLED. 1980
MIXED MEDIUMS ON PAPER, 30¼ x 42"
PRIVATE COLLECTION

KATHERINE PORTER. *ABANDONED CONVERSATIONS.* 1982. OIL ON CANVAS, 82 x 106". COLLECTION EDWARD R. BROIDA TRUST

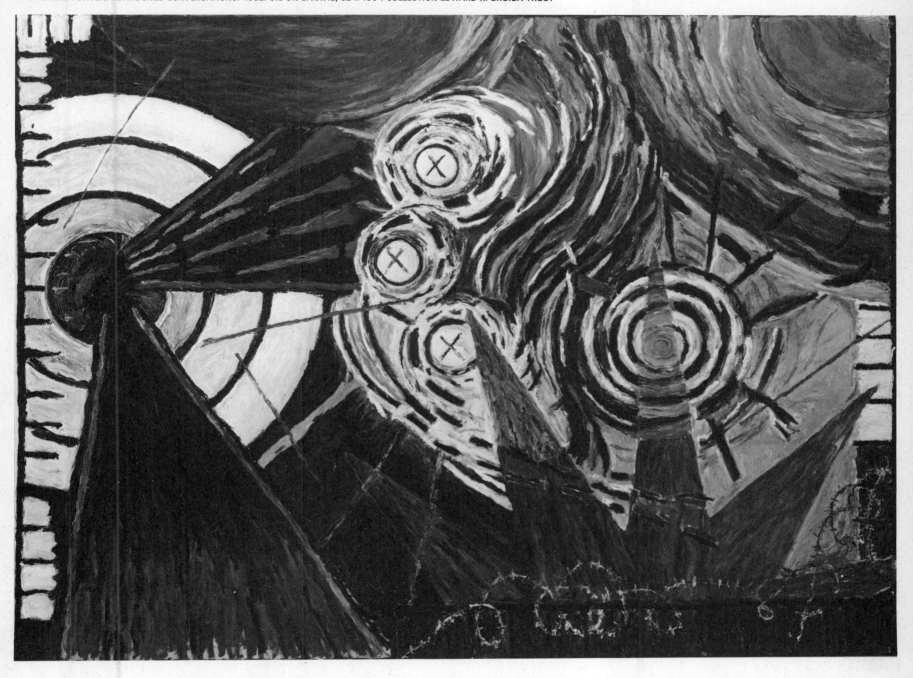

KATHERINE PORTER. *THE CITY.* 1982. OIL ON CANVAS, 84 x 175". COURTESY DAVID MCKEE GALLERY, NEW YORK

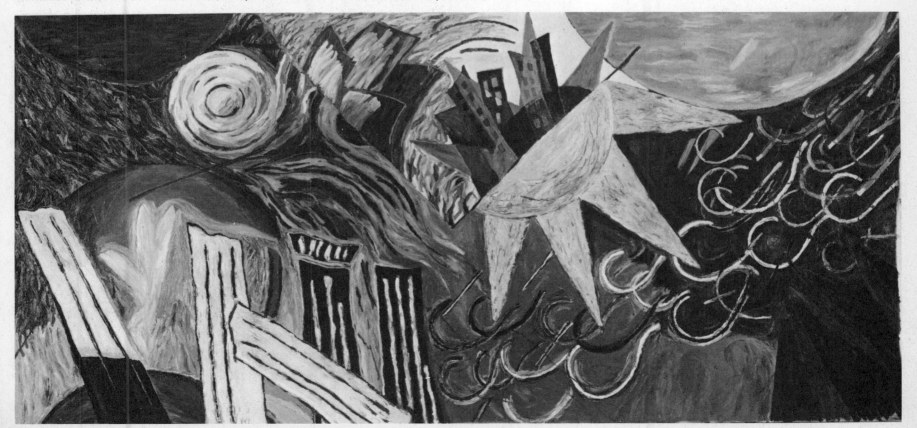

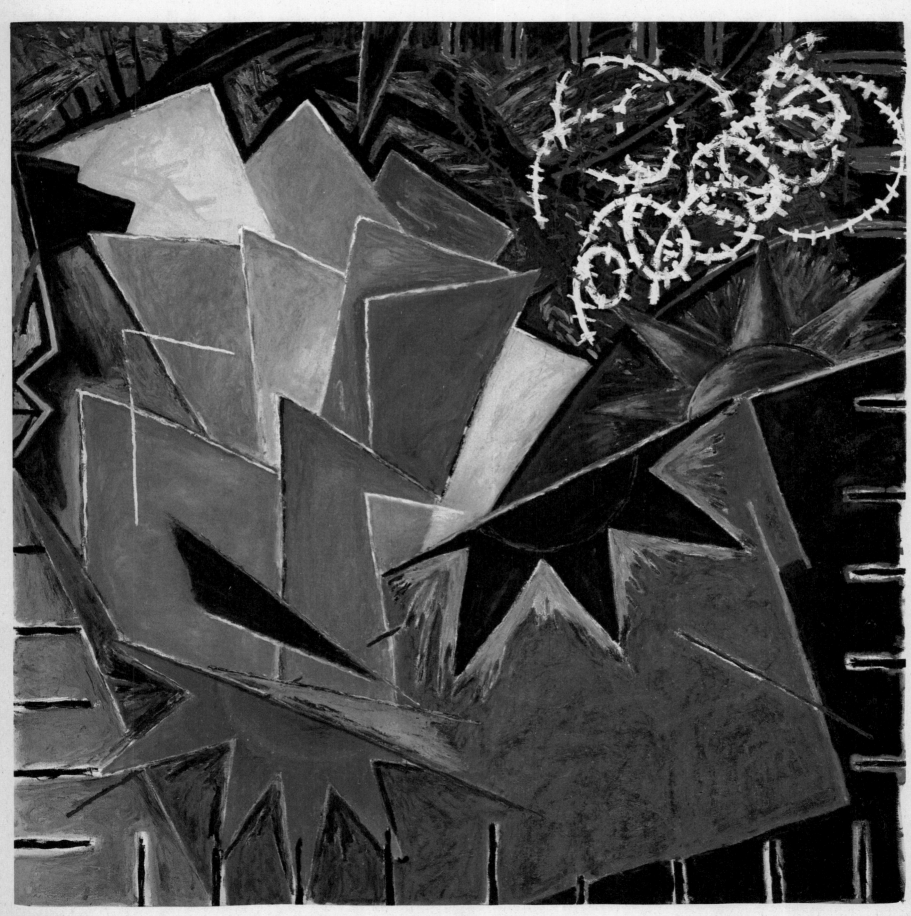

KATHERINE PORTER
UNTITLED. 1983
OIL ON CANVAS, 91¾ x 89½"
COURTESY DAVID MCKEE GALLERY, NEW YORK

LOUIS RENZONI. *TRAINYARD.* 1984. OIL ON LINEN, 56 x 72". COURTESY PIEZO ELECTRIC GALLERY, NEW YORK

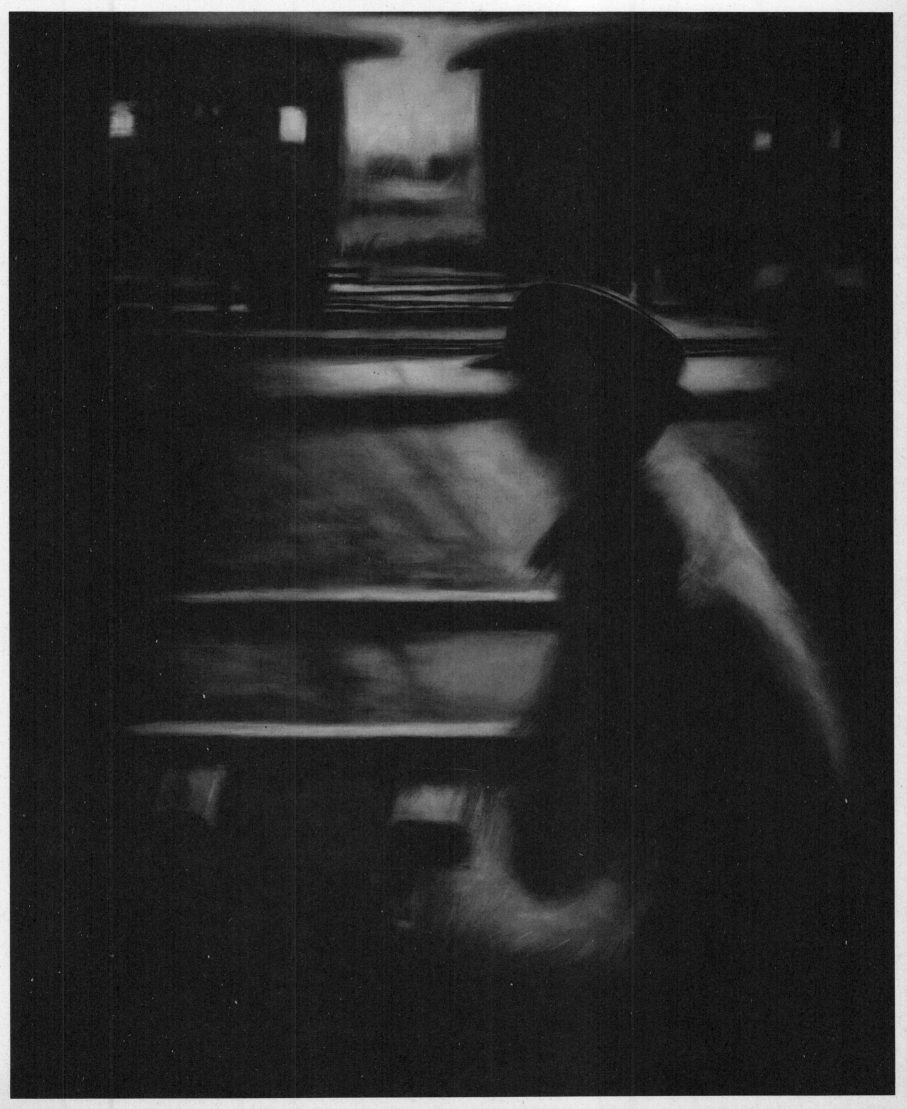

JUDY RIFKA

JUDY RIFKA
4A. MORE STORE. 1982
OIL ON LINEN, 102 x 190"
COURTESY BROOKE ALEXANDER, INC., NEW YORK

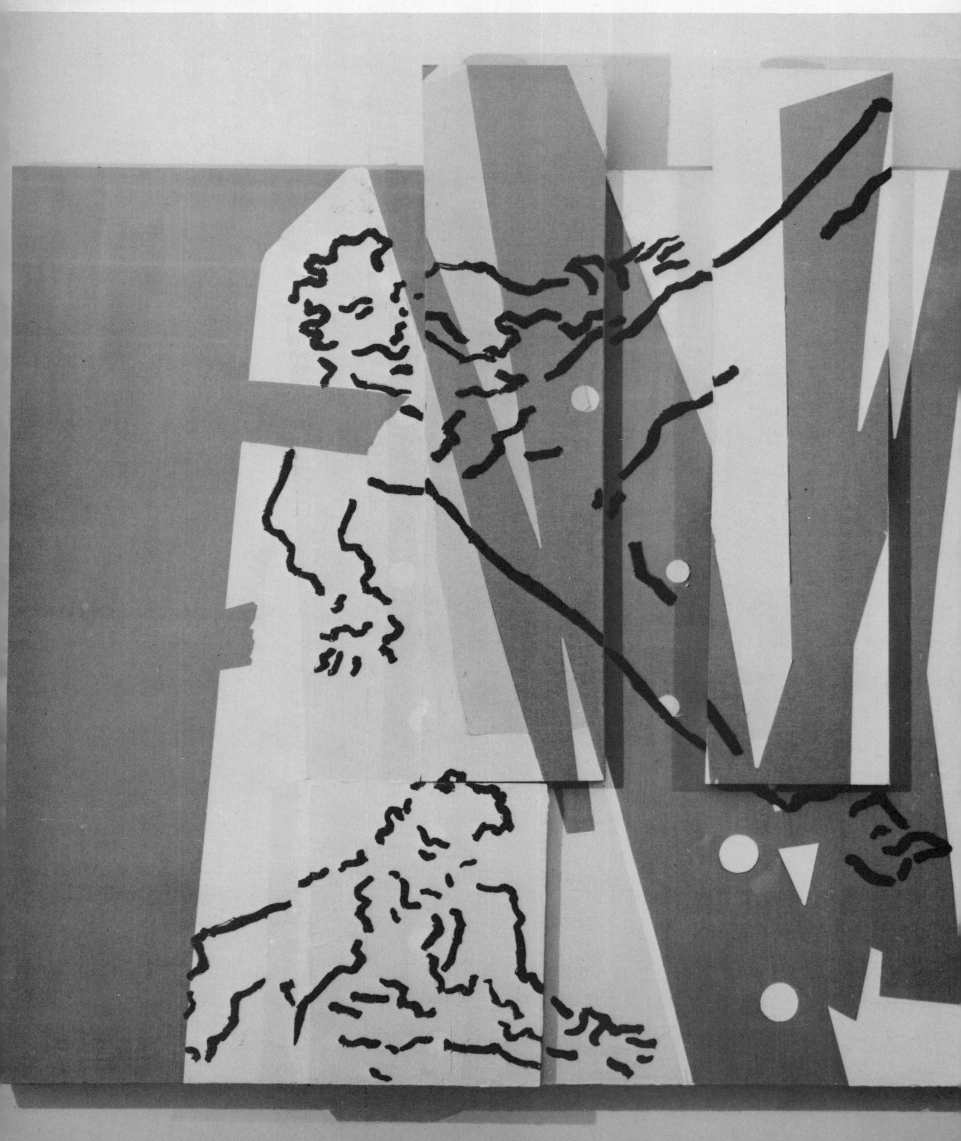

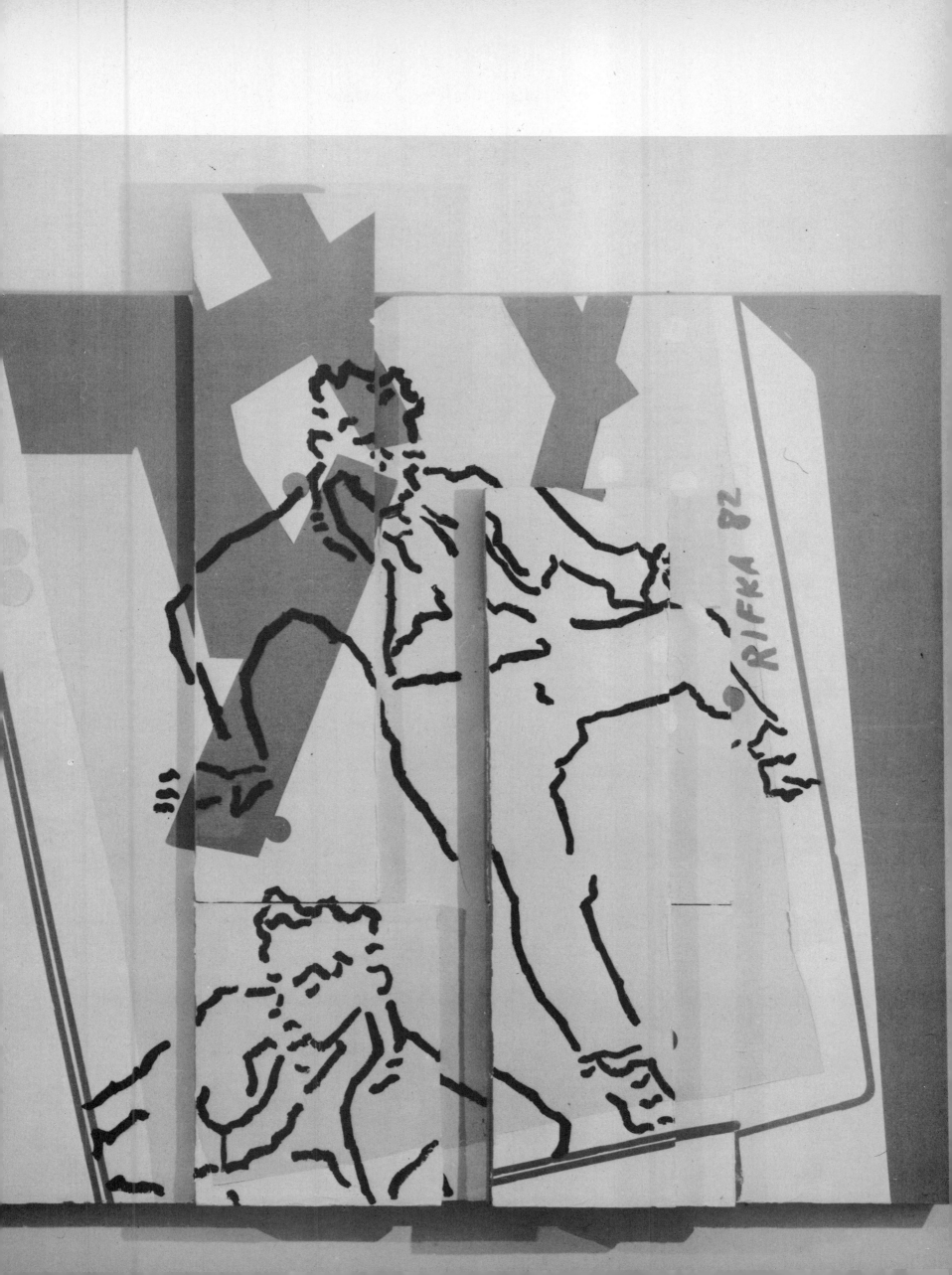

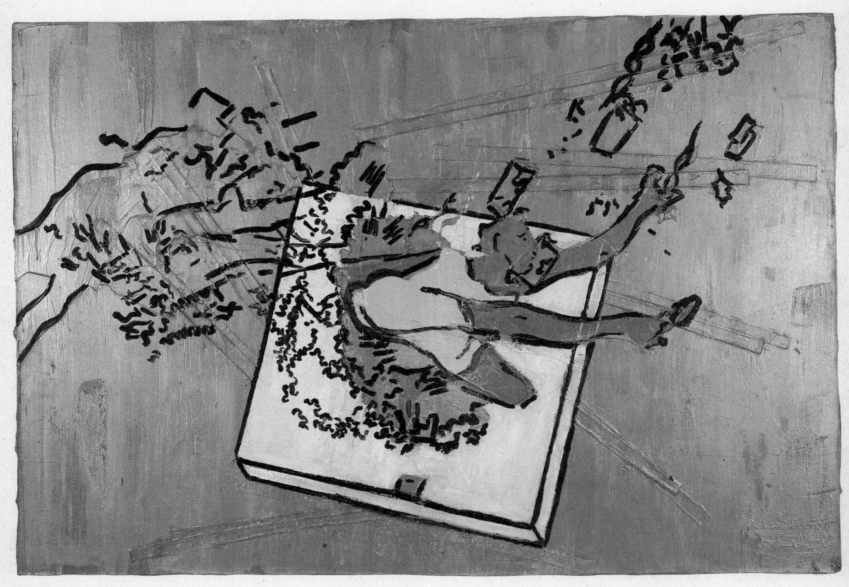

JUDY RIFKA
COMING THROUGH. 1981
ACRYLIC AND MODELING PASTE ON CANVAS, 72 x 102"
PRIVATE COLLECTION, NEW YORK

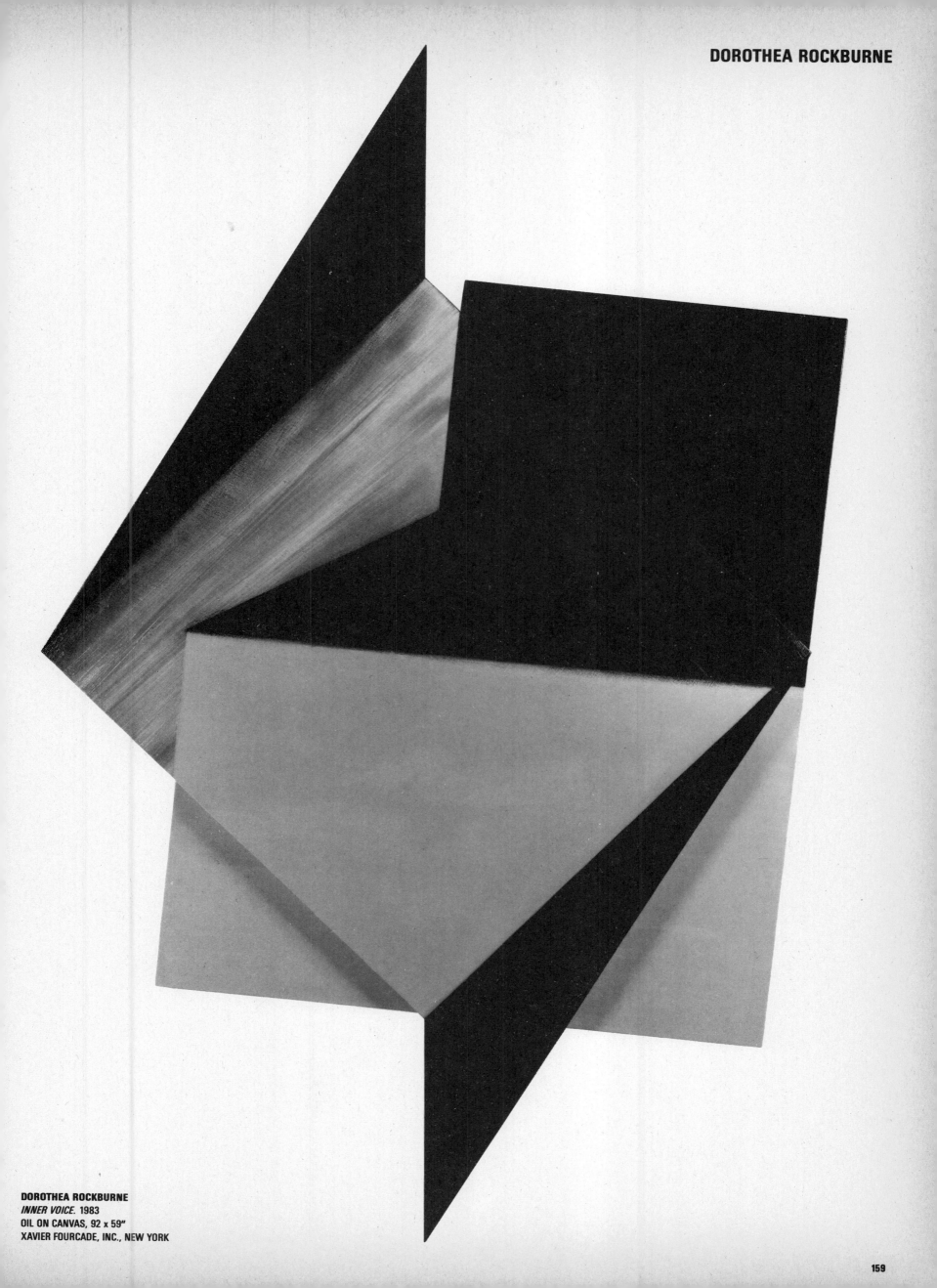

DOROTHEA ROCKBURNE
INNER VOICE. 1983
OIL ON CANVAS, 92 x 59"
XAVIER FOURCADE, INC., NEW YORK

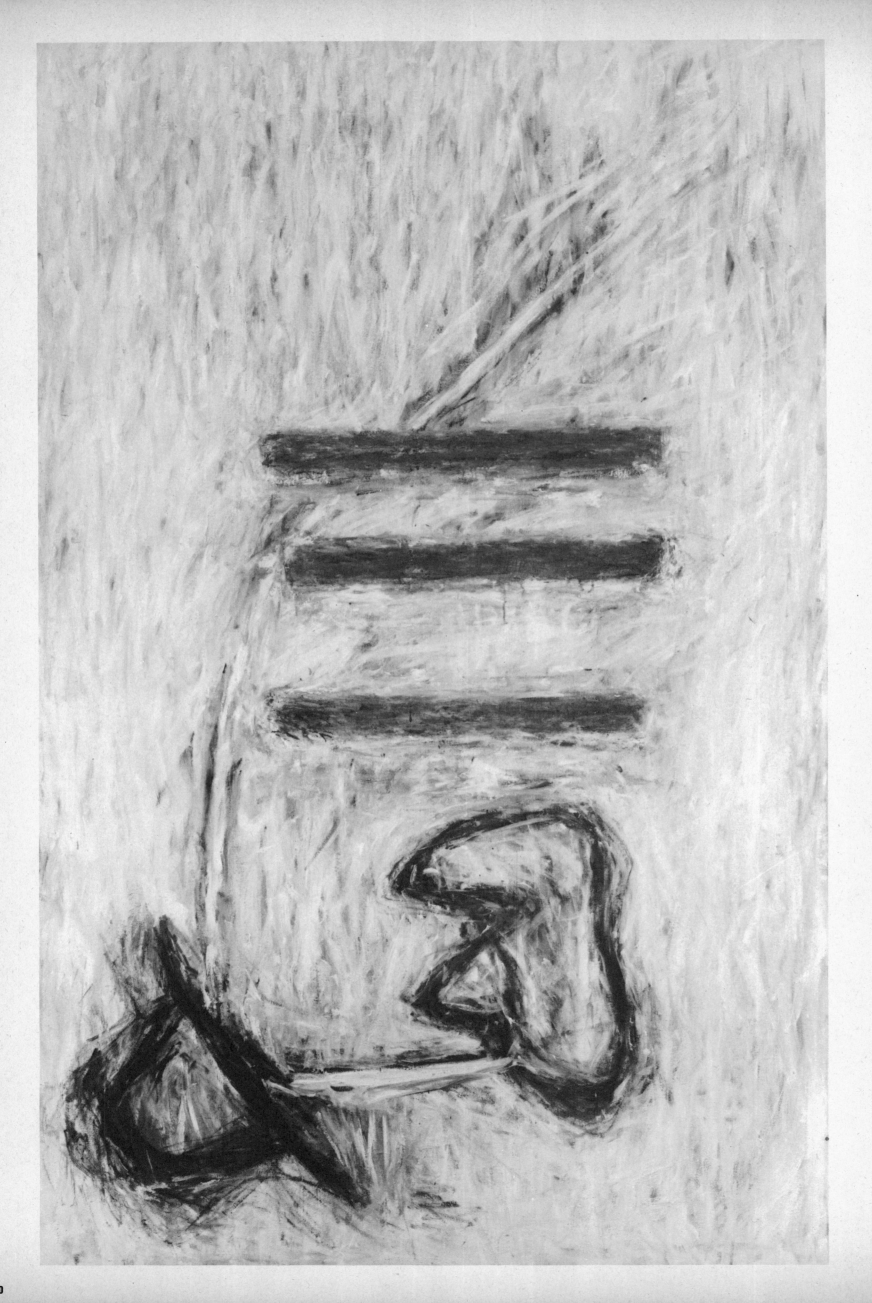

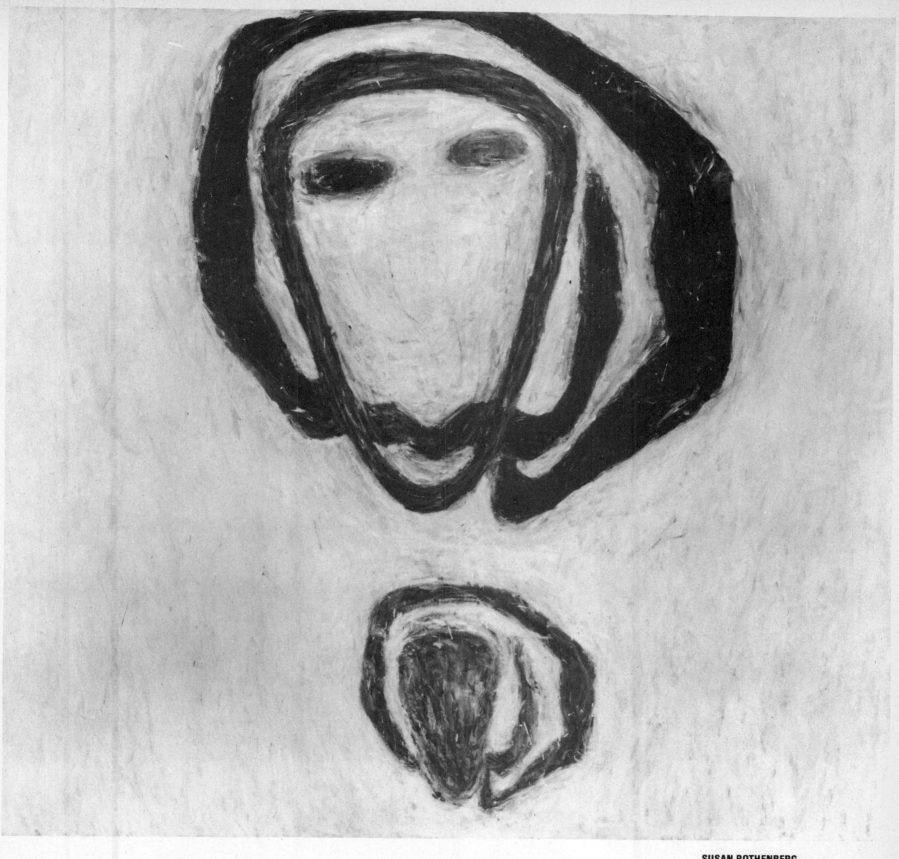

SUSAN ROTHENBERG
UNTITLED. 1980–81
ACRYLIC AND FLASHE ON CANVAS, 111 x 114"
PRIVATE COLLECTION

SUSAN ROTHENBERG

◀
SUSAN ROTHENBERG
BLUE BARS. 1982
OIL ON CANVAS, 87 x 52"
PRIVATE COLLECTION, NEW YORK

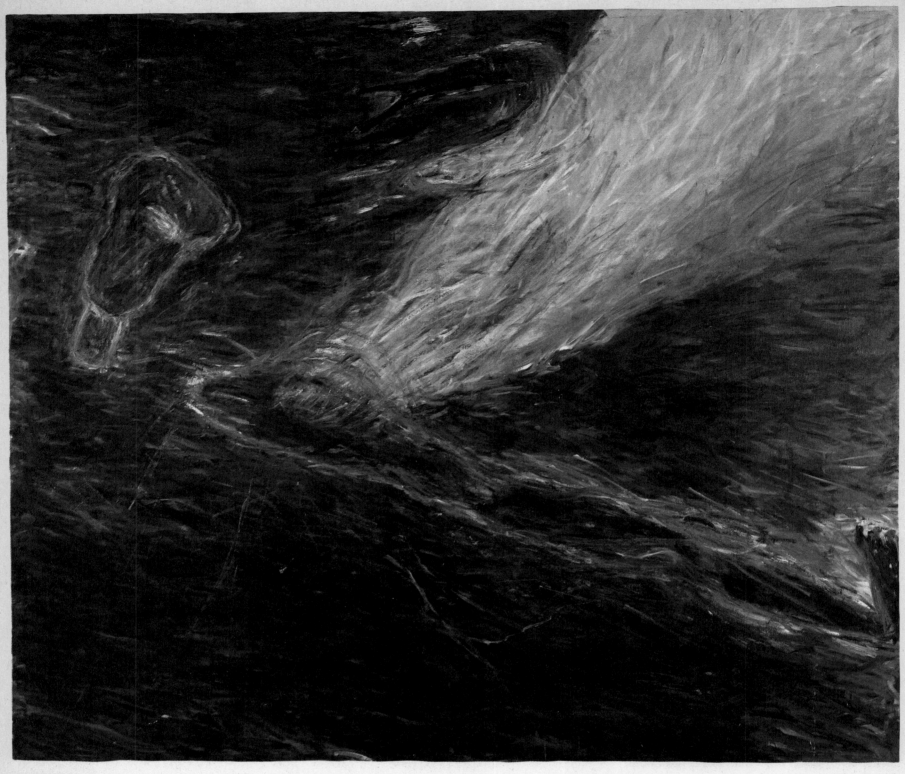

SUSAN ROTHENBERG
MIST FROM THE CHEST. 1983
OIL ON CANVAS, 78 x 89"
COLLECTION MILWAUKEE ART CENTER

DAVID SALLE
ZEITGEIST PAINTING #4. 1982
OIL AND ACRYLIC ON CANVAS, 156 x 117"
COLLECTION DORIS AND CHARLES SAATCHI, LONDON

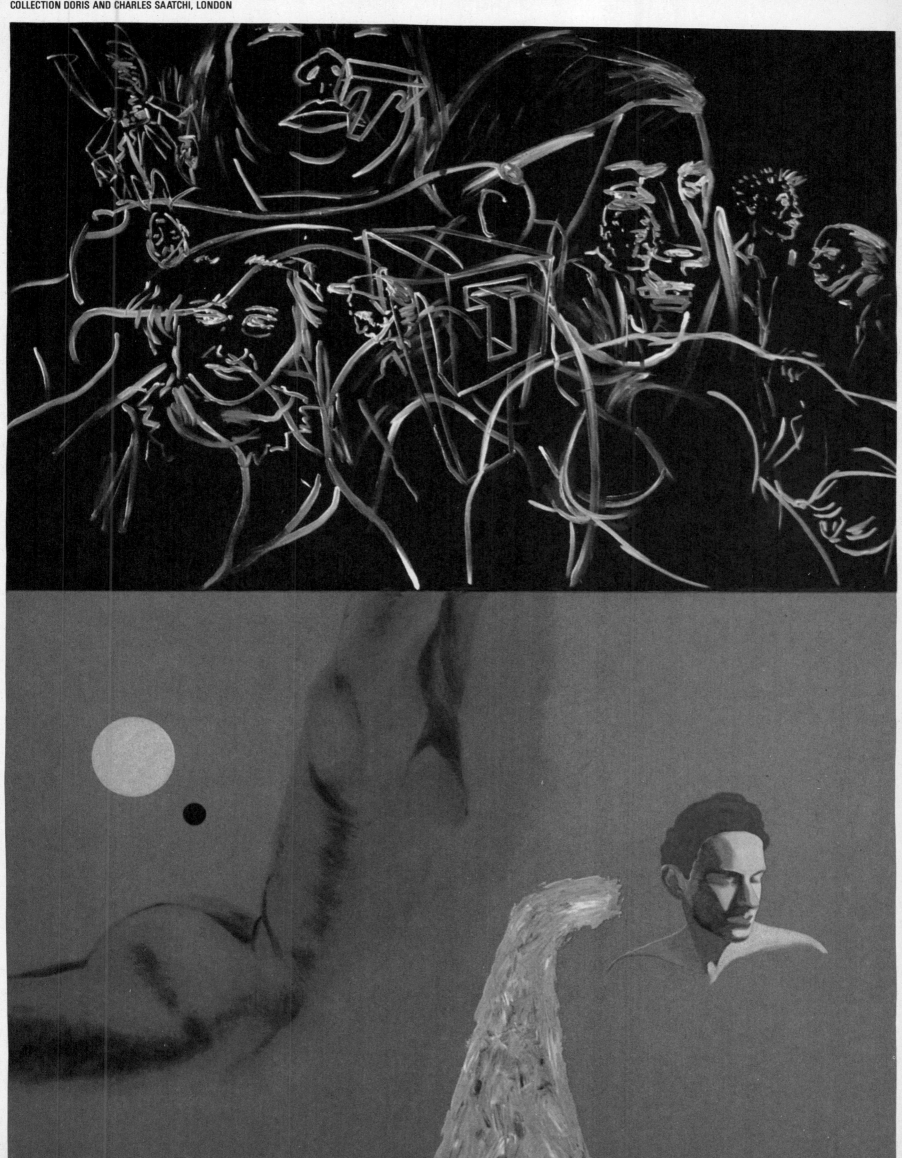

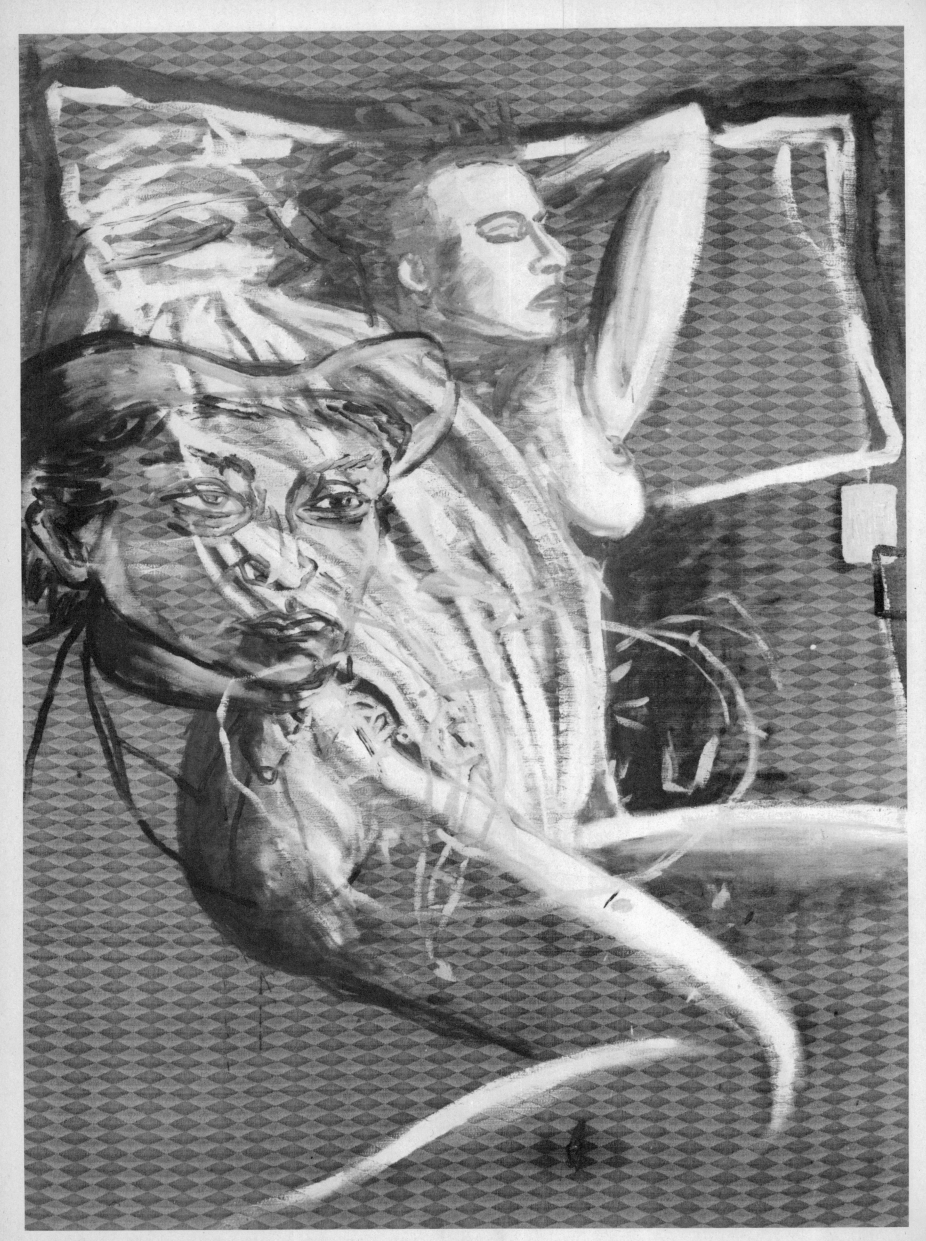

DAVID SALLE. *THE BULLFIGHTER AND THE JEW.* 1983. ACRYLIC ON CANVAS, 60 x 42". PRIVATE COLLECTION, PARIS

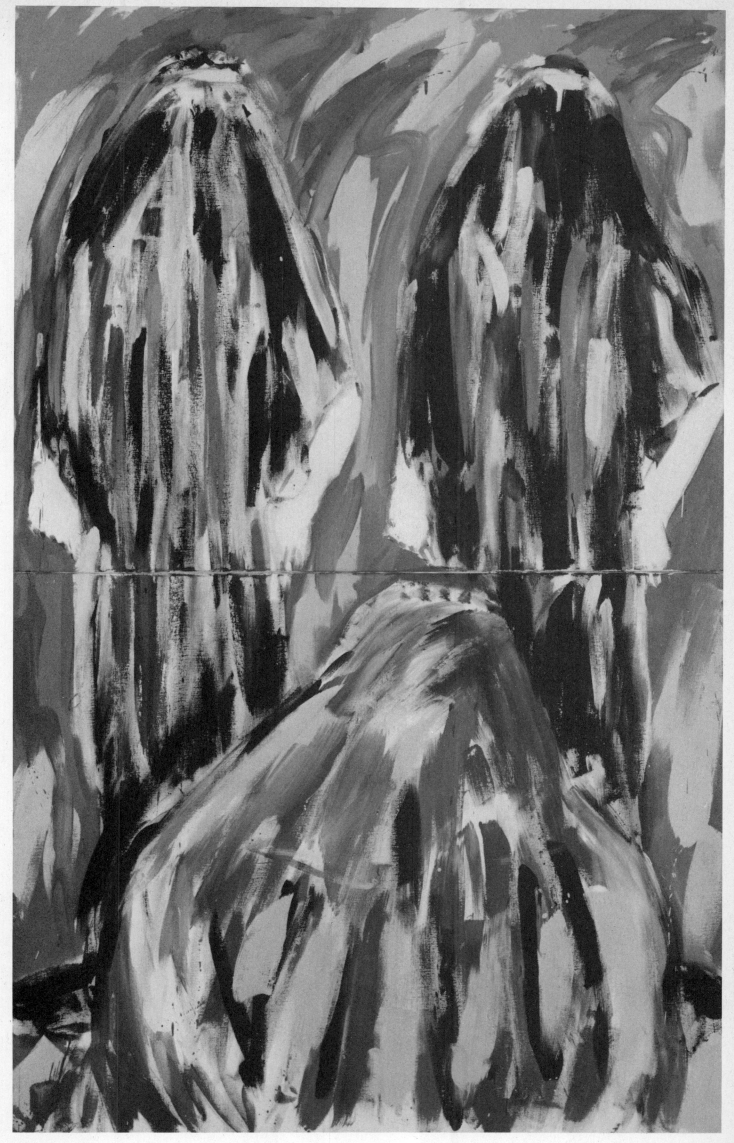

SALOMÉ
THREAT. 1981
ACRYLIC BASE PAINT ON CANVAS, 8' x 5'3"
PRIVATE COLLECTION, NEW YORK

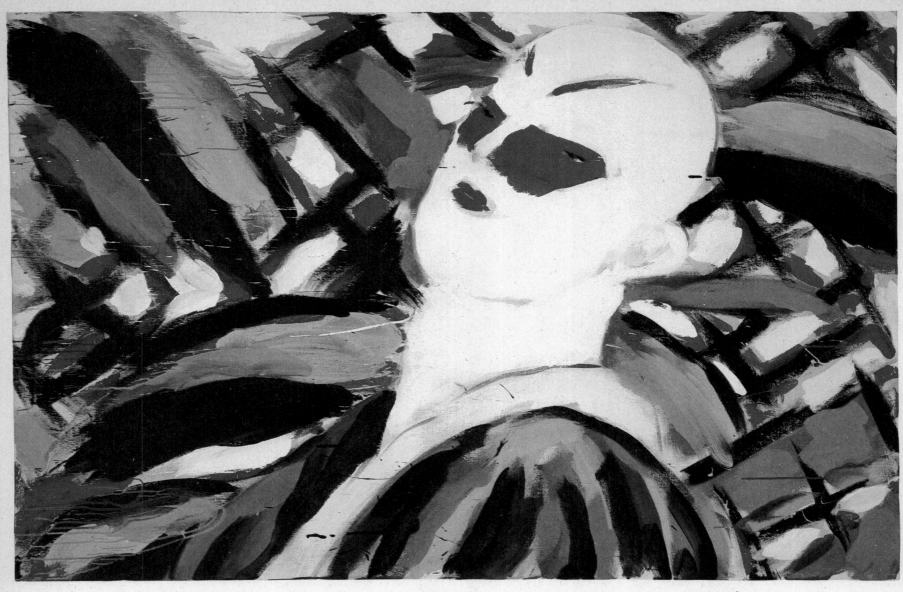

SALOMÉ
GROSSER JAPAN KOPF. 1981
ACRYLIC BASE PAINT ON CANVAS, 47¼ x 70¾"
PRIVATE COLLECTION, NEW YORK

JIM SANBORN

JIM SANBORN
LIGHTNING AND OTHER EARTHLY FORCES. 1982
SANDSTONE, COMPASSES, 25 x 25 x 3'

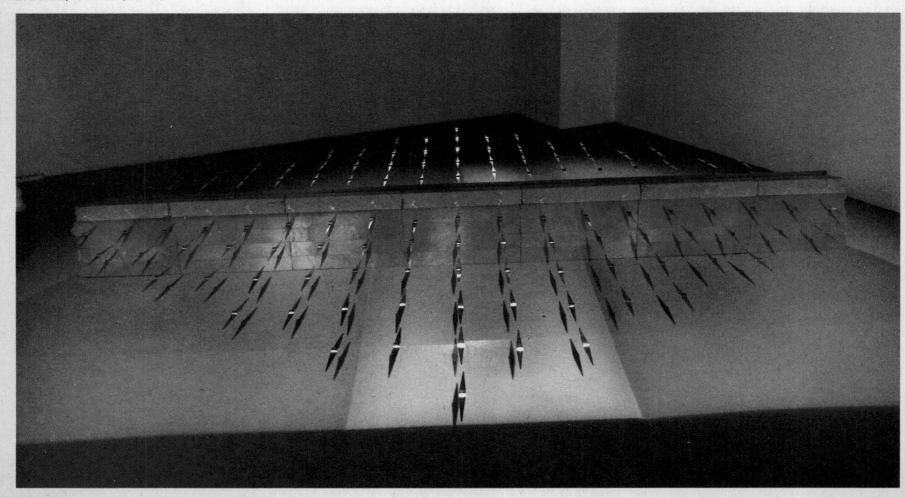

KENNY SCHARF

KENNY SCHARF. *THE FUN'S INSIDE.* 1983. OIL AND SPRAY PAINT ON CANVAS, 7'6" x 9'. COLLECTION TONY SHAFRAZI, NEW YORK

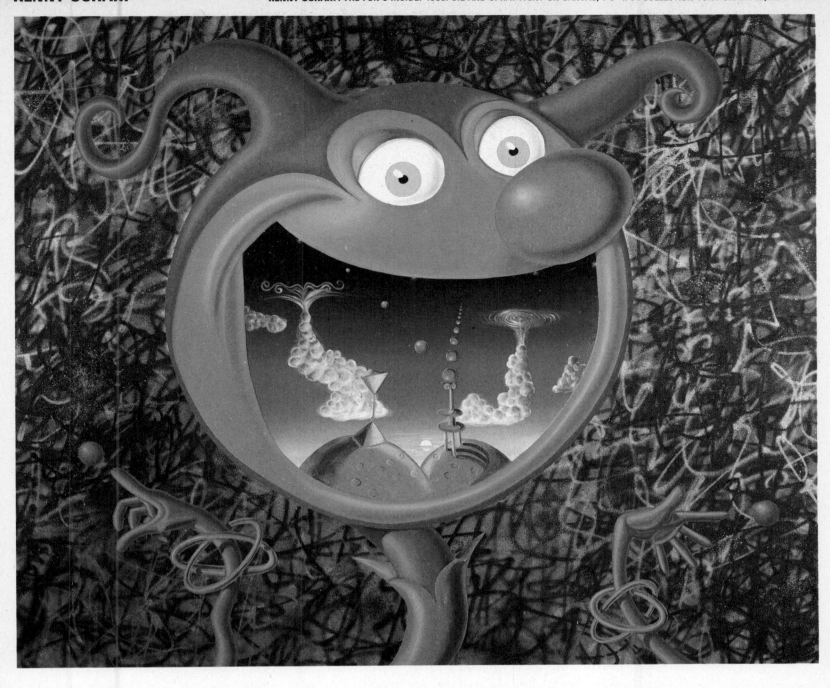

JULIAN SCHNABEL

JULIAN SCHNABEL. *THE STUDENT OF PRAGUE.* 1983. OIL, PLATES, BONDO ON WOOD, 116 x 228". COLLECTION JERRY AND EMILY SPIEGEL, NEW YORK

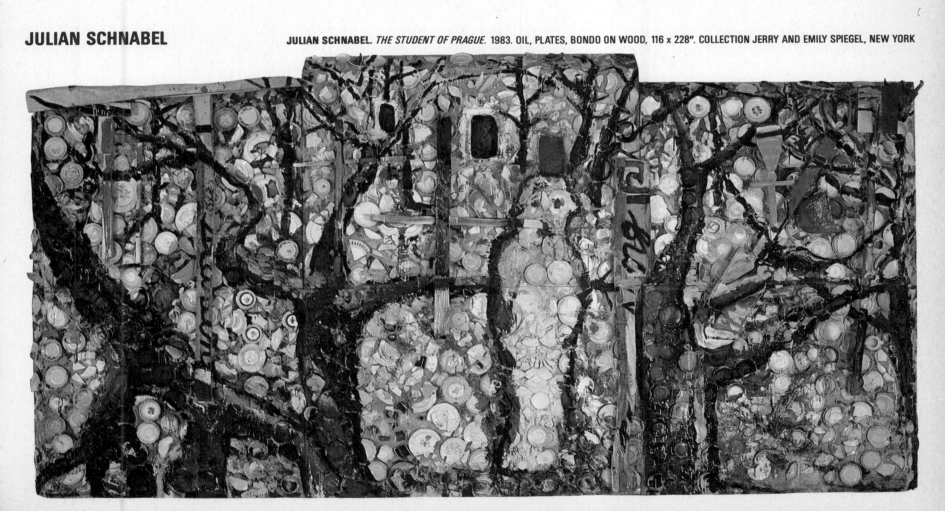

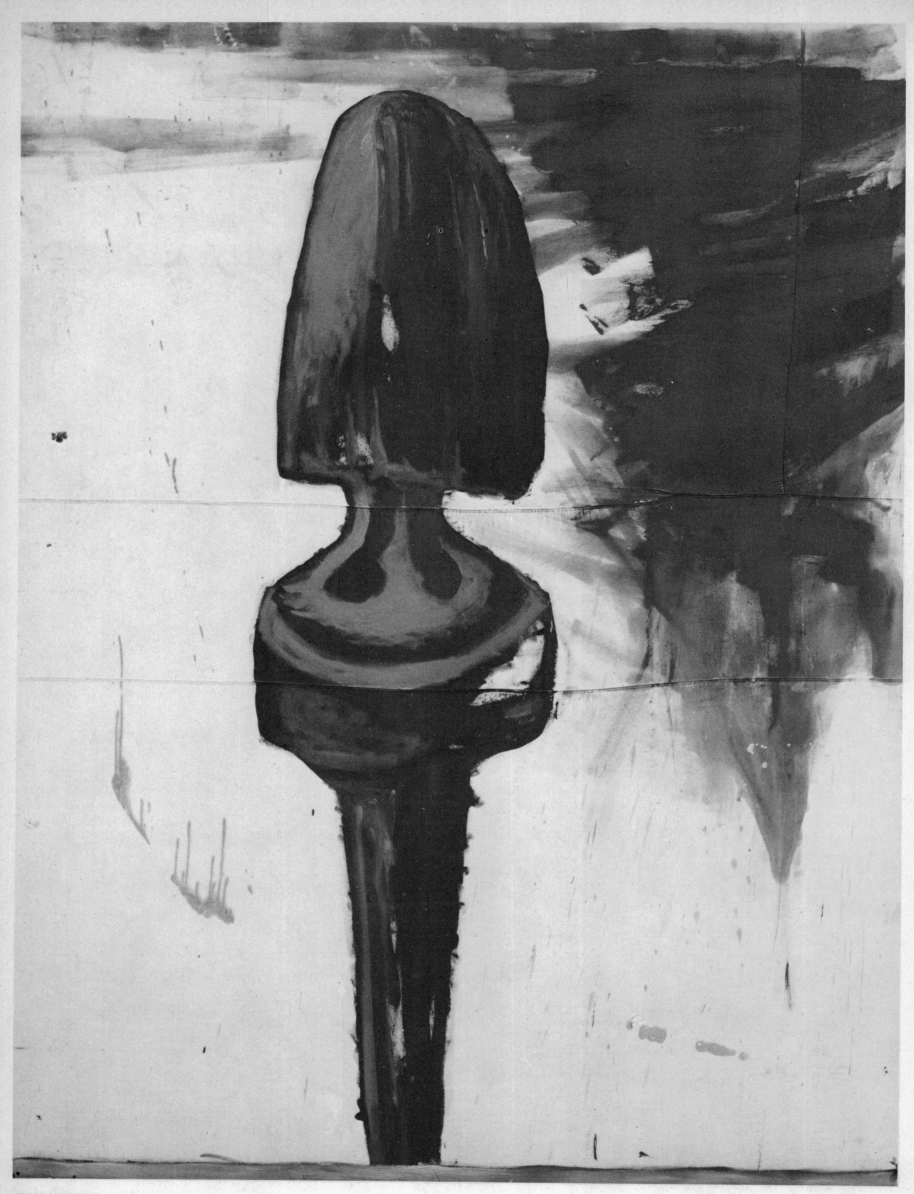

JULIAN SCHNABEL
PISTON FOR THE EPISTEMOLOGICAL (LITTLE SHEBA). 1983
OIL ON CANVAS, 132 x 96"
COLLECTION MARY BOONE, NEW YORK

RICHARD SERRA
ST. JOHN'S ROTARY ARC. 1980
COR-TEN STEEL, 12' x 200' x 2½"
COURTESY LEO CASTELLI GALLERY, NEW YORK

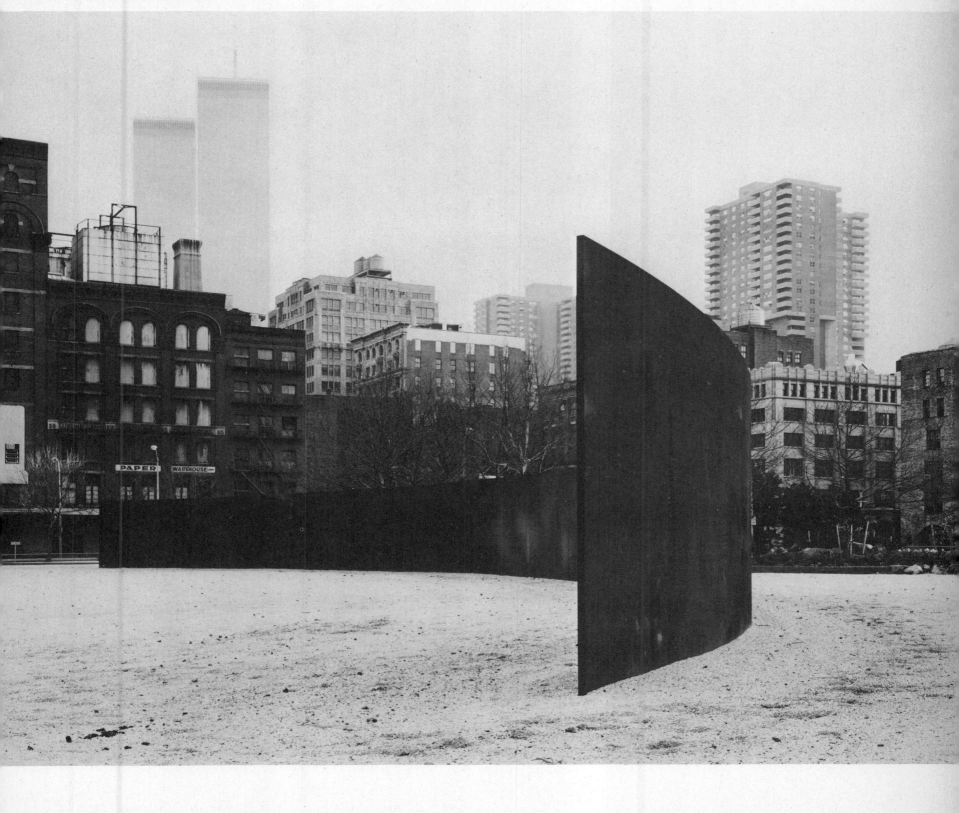

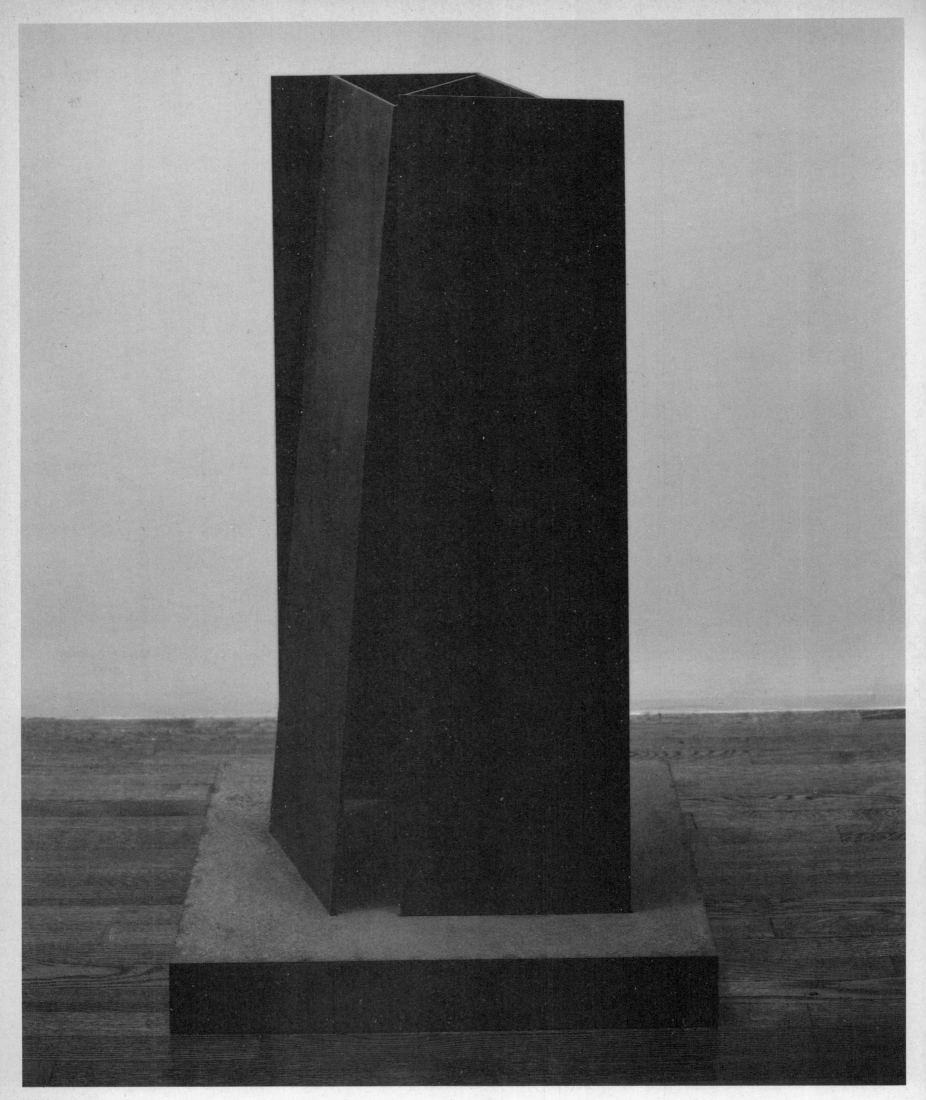

RICHARD SERRA
PARALLELOGRAM OF NEW YORK CITY. 1982
COR-TEN STEEL, 42½ x 24 x 24″
COURTESY LEO CASTELLI GALLERY, NEW YORK

JOEL SHAPIRO
UNTITLED. 1982–83
CAST BRONZE, 43 x 34 x 35¾"
COLLECTION THE TOLEDO MUSEUM OF ART. GIFT OF EDWARD DRUMMOND LIBBEY

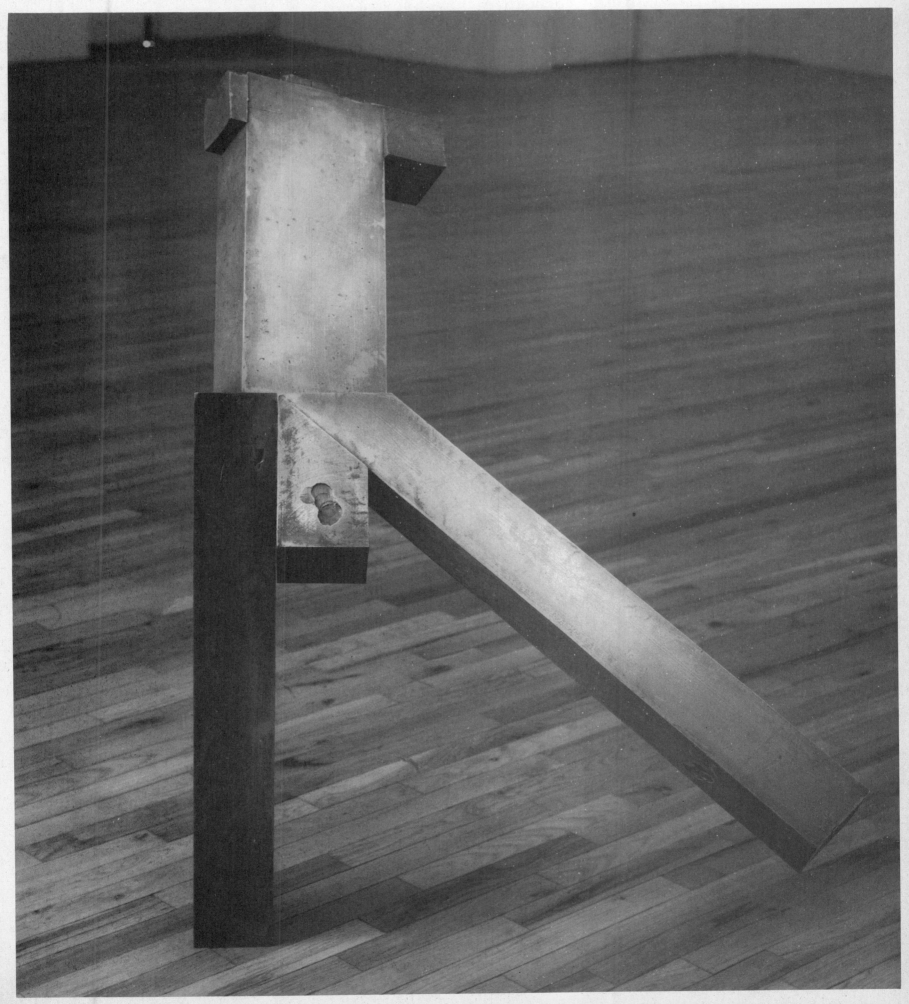

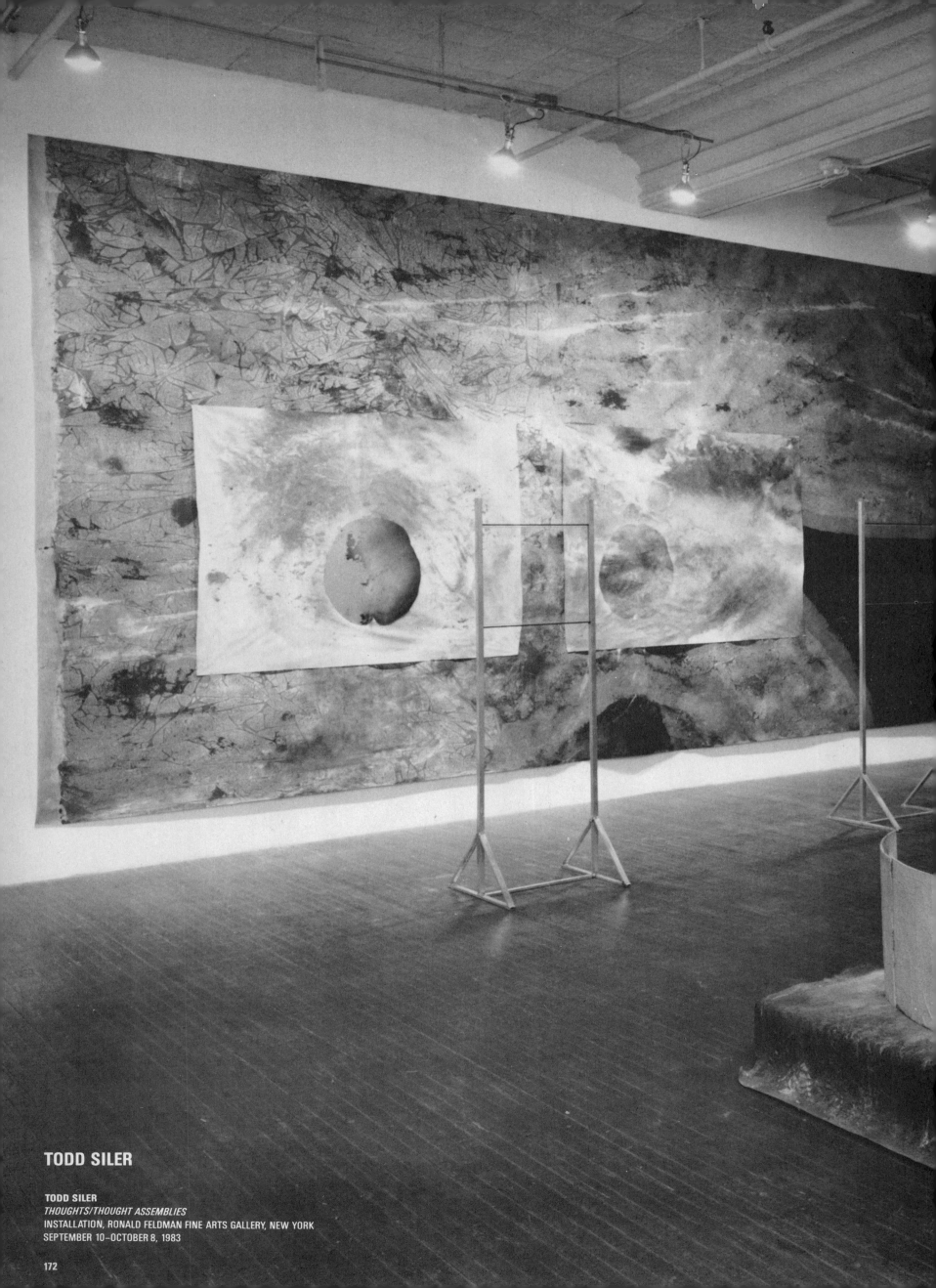

TODD SILER

TODD SILER
THOUGHTS/THOUGHT ASSEMBLIES
INSTALLATION, RONALD FELDMAN FINE ARTS GALLERY, NEW YORK
SEPTEMBER 10–OCTOBER 8, 1983

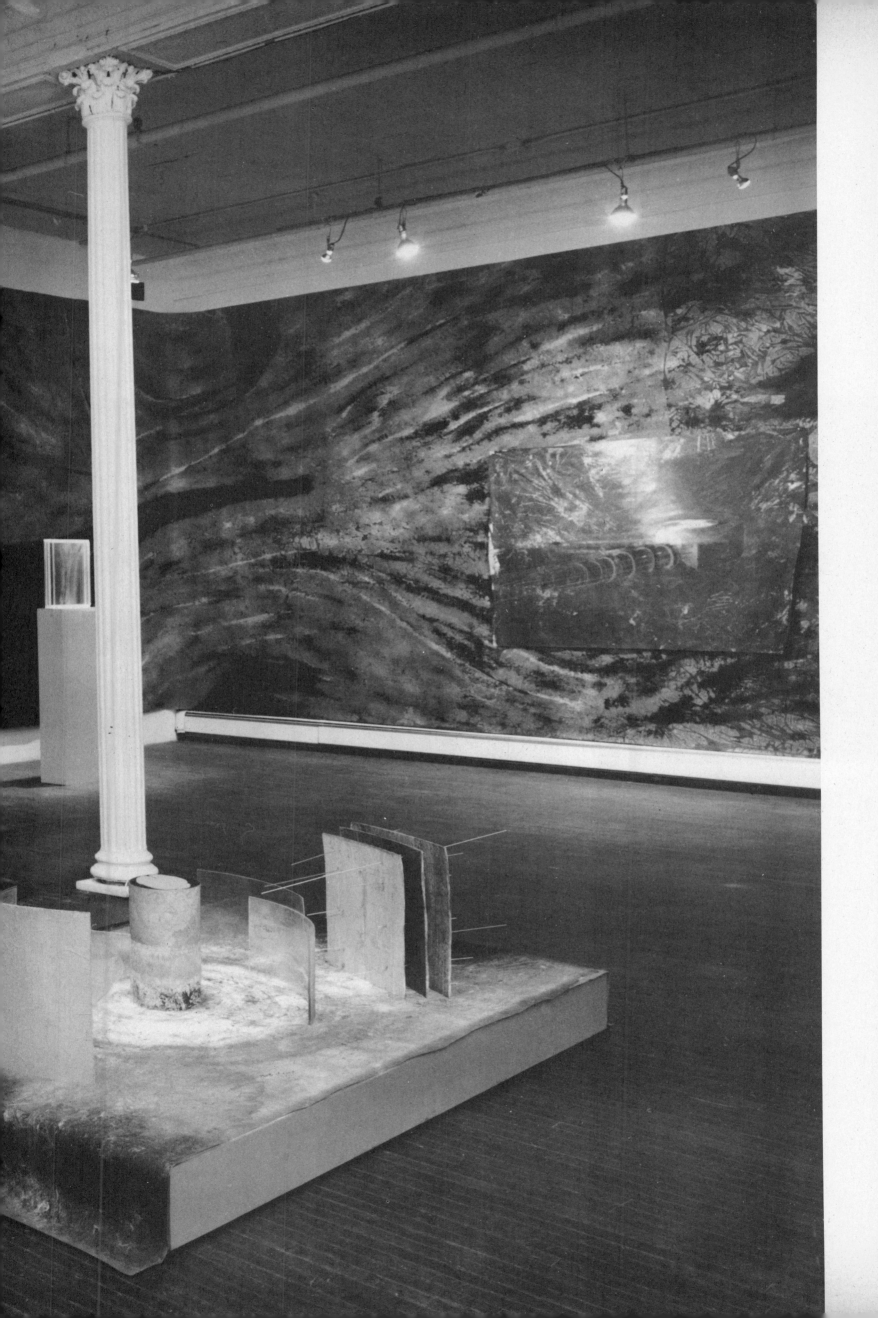

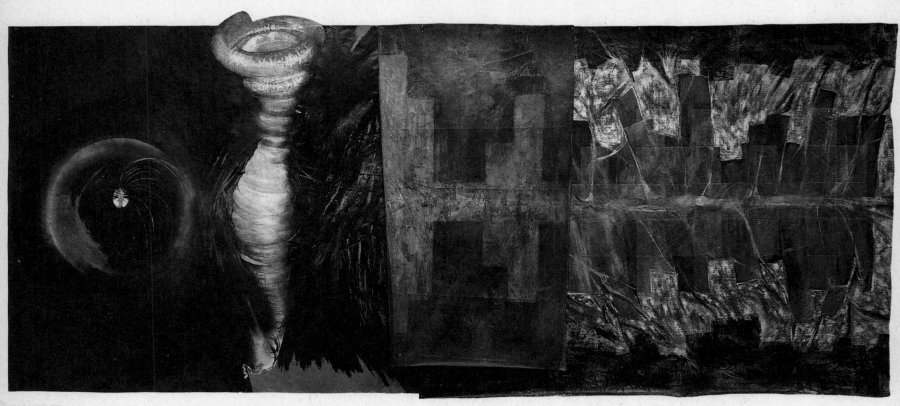

TODD SILER
EMERGING THOUGHT ASSEMBLIES. 1983
SPUNBONDED POLYPROPYLENE, WOOL, SYNTHETIC FABRICS
WITH INK, GRAPHITE, PHOTOCOPIED ELEMENTS,
COMPUTER-GENERATED DRAWINGS, ENAMEL, LATEX, AND PAPER
3 PANELS: 9' x 10', 8'2" x 4'7", 9' x 13'
COURTESY RONALD FELDMAN FINE ARTS, NEW YORK

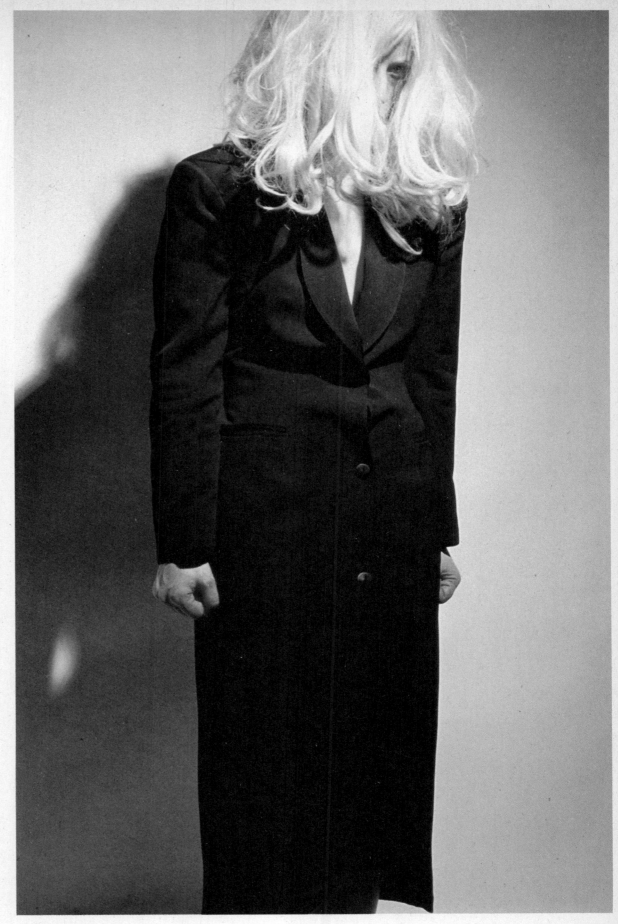

CINDY SHERMAN
UNTITLED. 1983
COLOR PHOTOGRAPH, 74½ x 44¾"
COLLECTION DORIS AND CHARLES SAATCHI, LONDON

CHARLES SIMONDS

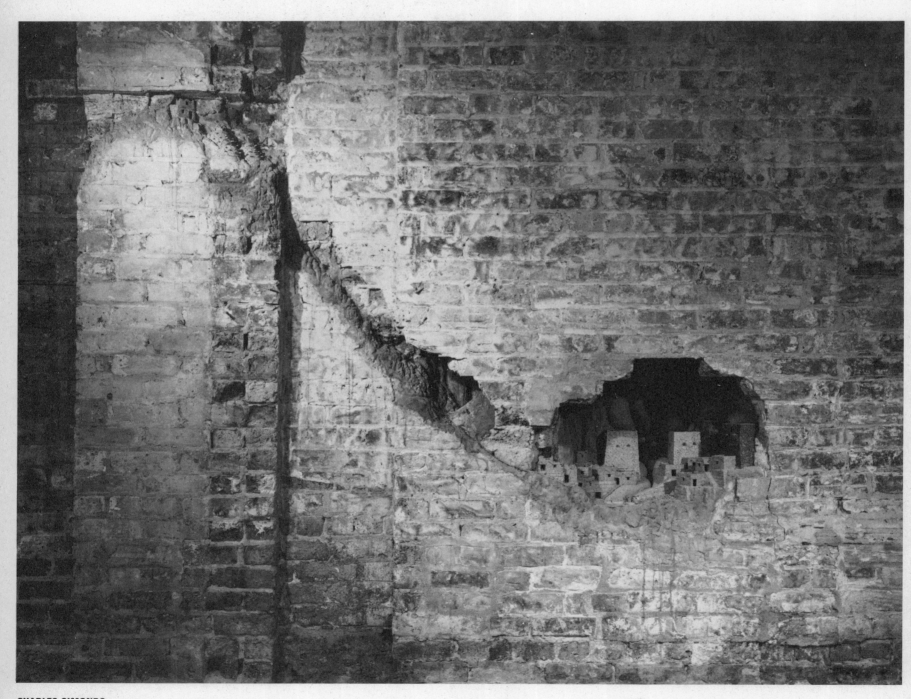

CHARLES SIMONDS
DWELLING. 1981
UNFIRED CLAY, 30' ACROSS
PERMANENT INSTALLATION, MUSEUM OF CONTEMPORARY ART, CHICAGO
GIFT OF CAROL AND DOUGLAS COHEN

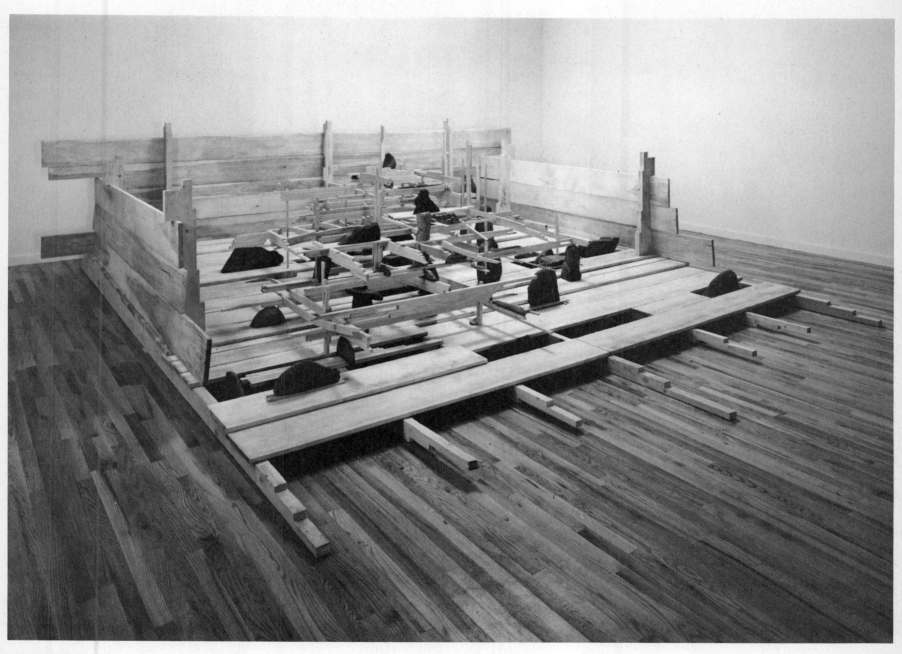

MICHAEL SINGER
CLOUD HANDS RITUAL SERIES 80/81. 1980–81
WOOD AND ROCK, 4'9" x 14'3½" x 16'9"
COLLECTION LOUISIANA MUSEUM OF MODERN ART, HUMLEBAEK, DENMARK
COURTESY SPERONE WESTWATER, NEW YORK

JOAN SNYDER

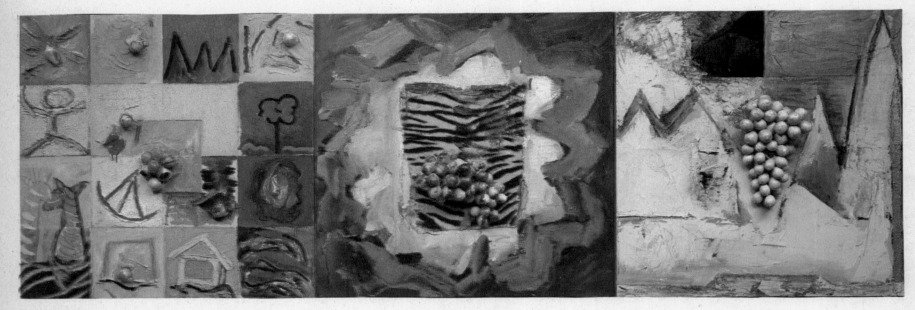

JOAN SNYDER
TRILOGY. 1982
MIXED MEDIUMS ON CANVAS, 24 x 72"
COLLECTION THE ARTIST

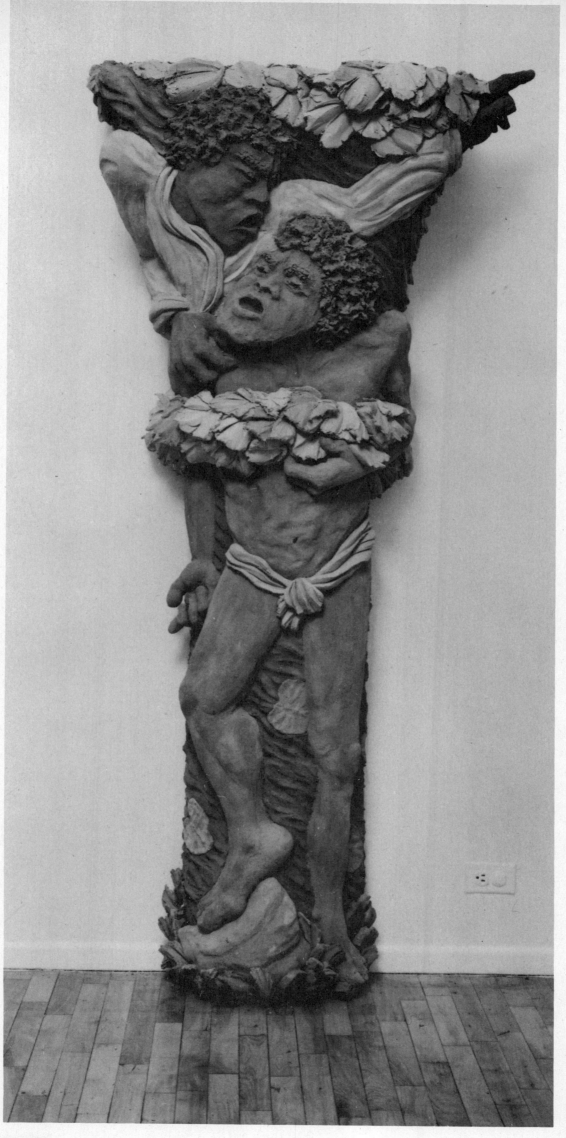

NED SMYTH
SIBLING RIVALRY. 1982
CONCRETE WITH PIGMENT, 82 x 36 x 14"
COURTESY HOLLY SOLOMON GALLERY, NEW YORK

KEITH SONNIER

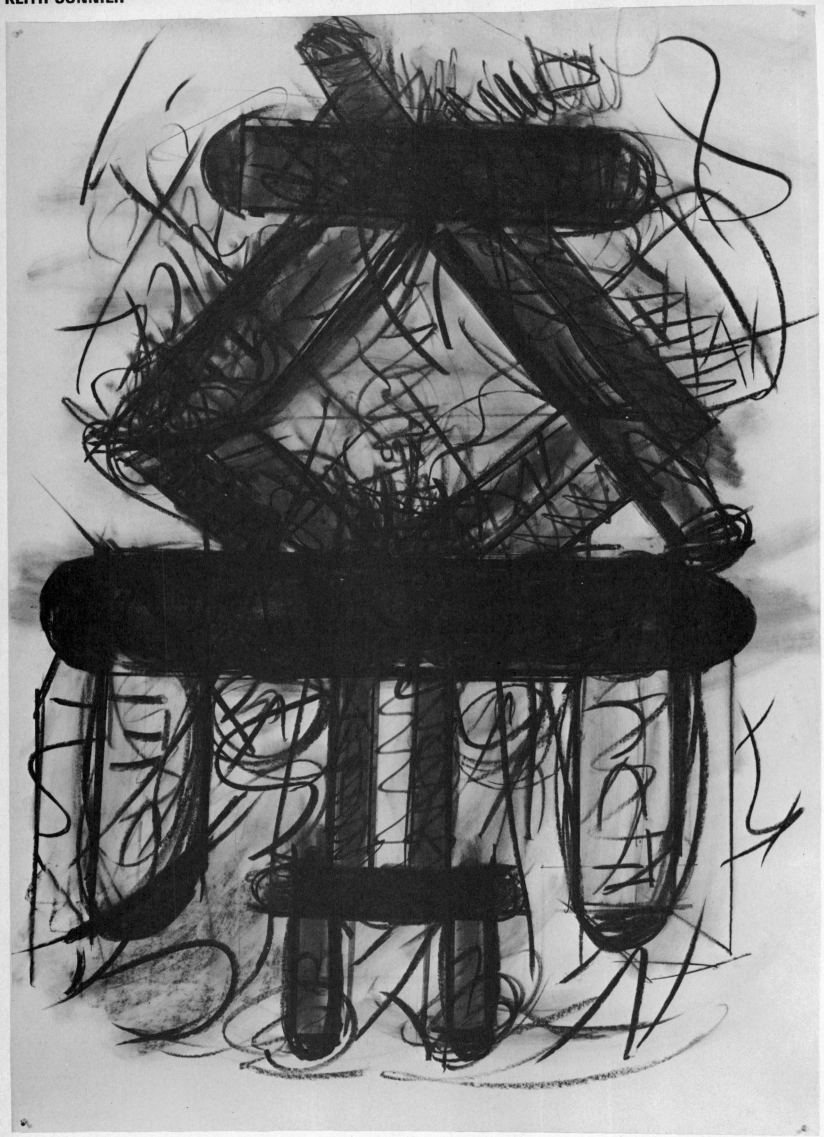

KEITH SONNIER
TRIMURTI. 1981
PERMANENT FELT TIP PEN, CHARCOAL, AND DRY PIGMENT ON PAPER, 73 x 50"
COURTESY LEO CASTELLI GALLERY, NEW YORK

GARY STEPHAN
OH YE OF MENTAL MEN. 1981
ACRYLIC ON CANVAS, 96 x 96"
COLLECTION EUGENE AND BARBARA SCHWARTZ, NEW YORK

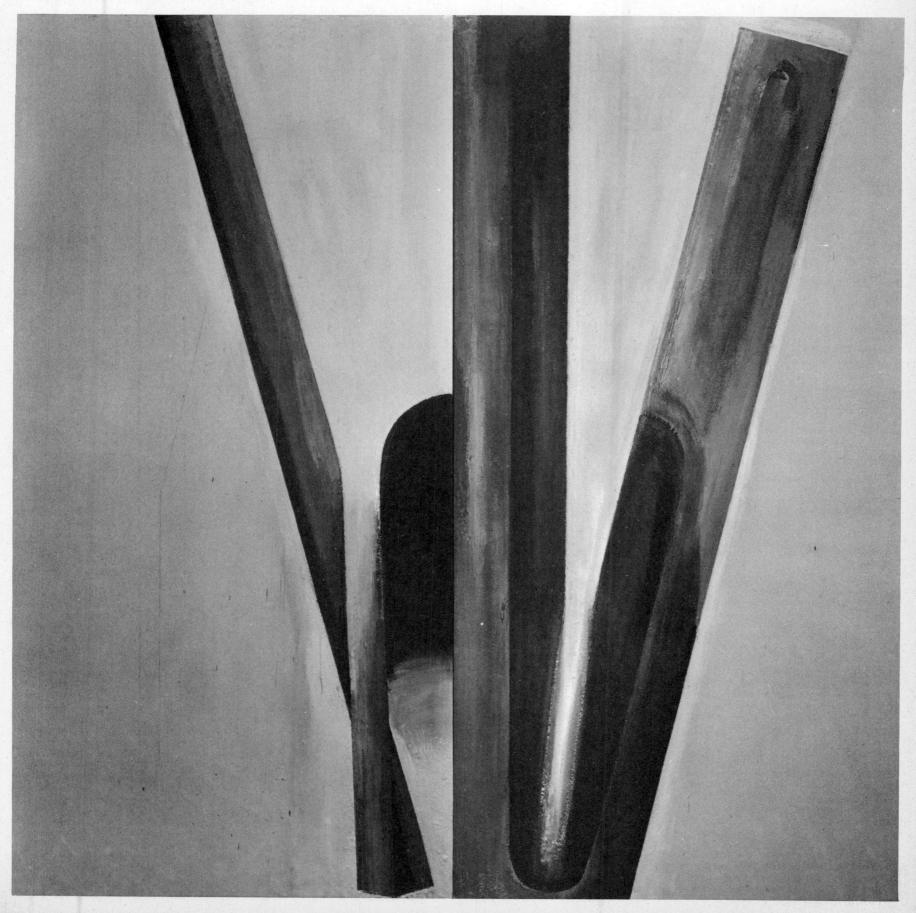

PAT STEIR

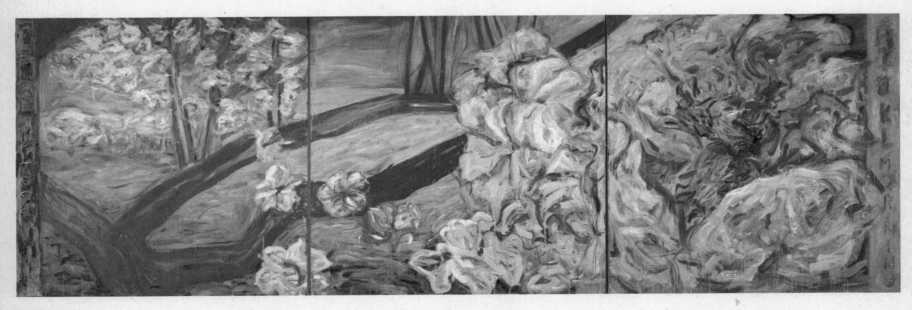

DONALD SULTAN

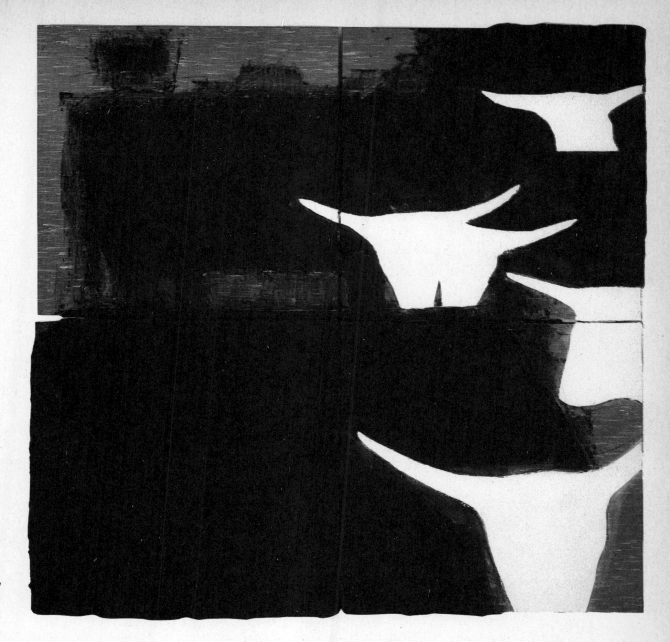

DONALD SULTAN
STEERS, NOVEMBER 18, 1983. 1983
PLASTER AND TAR ON VINYL TILE OVER WOOD, 98 x 99¼"
PRIVATE COLLECTION
COURTESY BLUM HELMAN GALLERY, NEW YORK

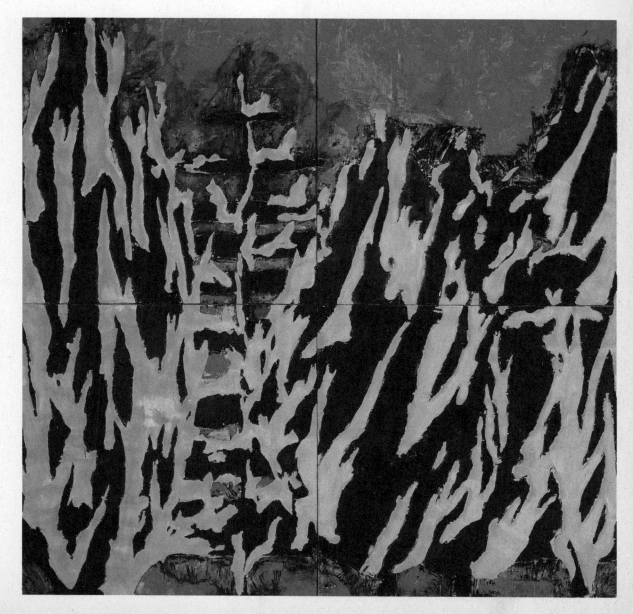

DONALD SULTAN
FOREST FIRE, OCT. 28, 1983. 1983
OIL, WATERCOLOR, PLASTER, AND TAR ON
VINYL TILE OVER MASONITE, 96¼ x 97"
PRIVATE COLLECTION
COURTESY BLUM HELMAN GALLERY, NEW YORK

MARK TANSEY

MARK TANSEY
HOMAGE TO FRANK LLOYD WRIGHT. 1984
OIL ON CANVAS, 32 x 85"
MUSEUM OF ART, CARNEGIE INSTITUTE, PITTSBURGH
MUSEUM PURCHASE: PAINTINGS ACQUISITION FUND 1984

MARK TANSEY
ICONOGRAPH I. 1984
OIL ON CANVAS, 72 x 72"
COURTESY GRACE BORGENICHT GALLERY, NEW YORK

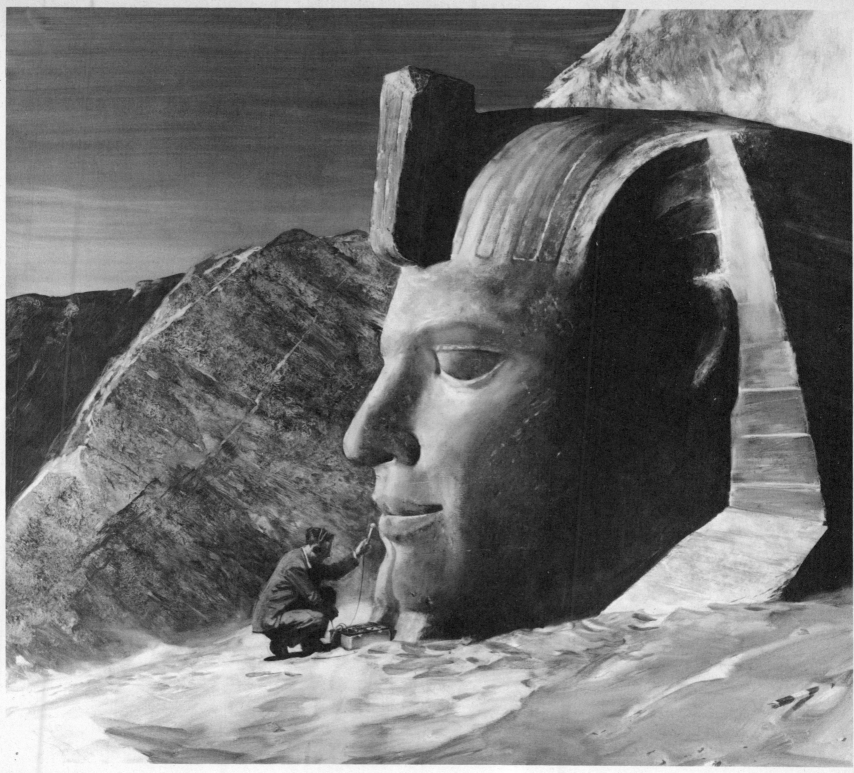

MARK TANSEY
SECRET OF THE SPHINX (HOMAGE TO ELIHU VEDDER). 1984
OIL ON CANVAS, 60 x 65"
COLLECTION MR. AND MRS. ROBERT M. KAYE, NEW YORK

RICHARD TUTTLE

RICHARD TUTTLE. *MONKEY'S RECOVERY I—#1.* 1983. MIXED MEDIUMS, 28½ x 42 x 9". PRIVATE COLLECTION. COURTESY BLUM HELMAN GALLERY, NEW YORK

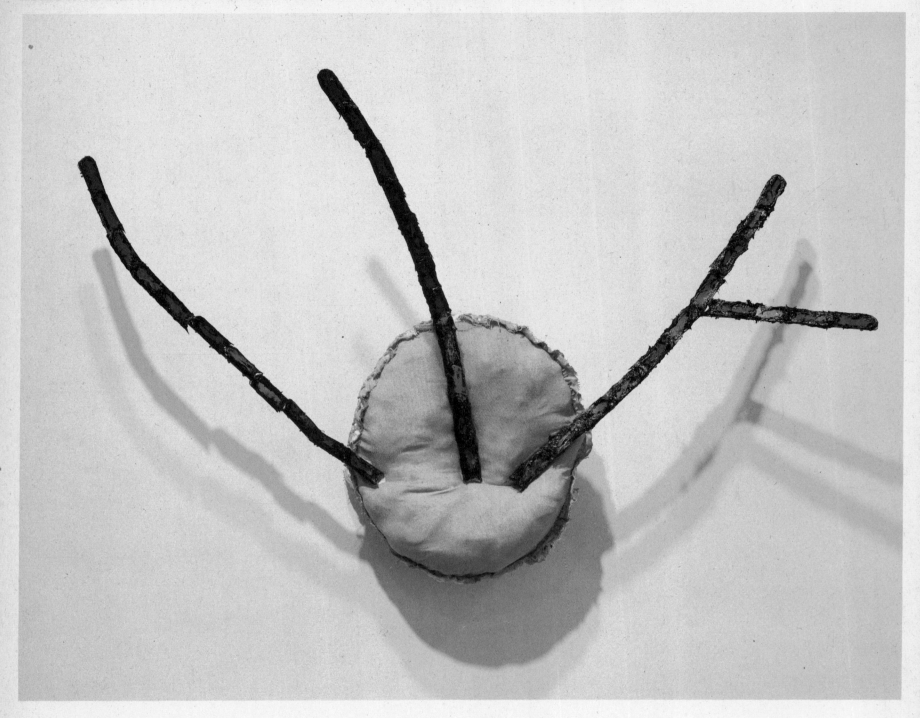

RICHARD TUTTLE. *MONKEY'S RECOVERY II—#6.* 1983. MIXED MEDIUMS, 7½ x 29¼ x 5⅛". COLLECTION PETER C. FREEMAN, NEW YORK

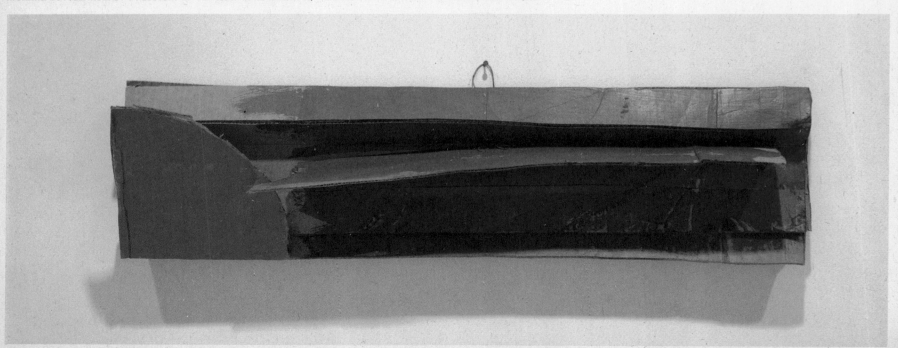

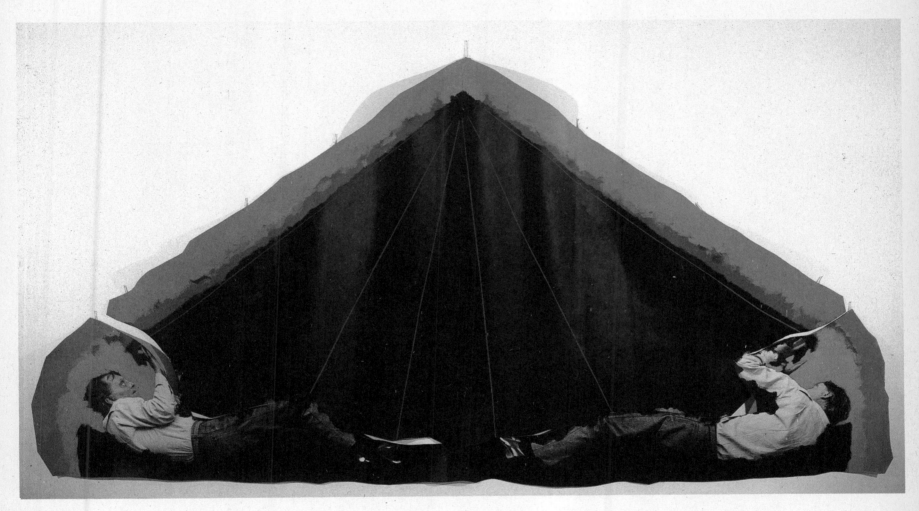

GER VAN ELK
PUSHING SCULPTURE. 1981
ACRYLIC PAINT ON PHOTOGRAPH ON SHAPED CANVAS, 6 x 9'
PRIVATE COLLECTION

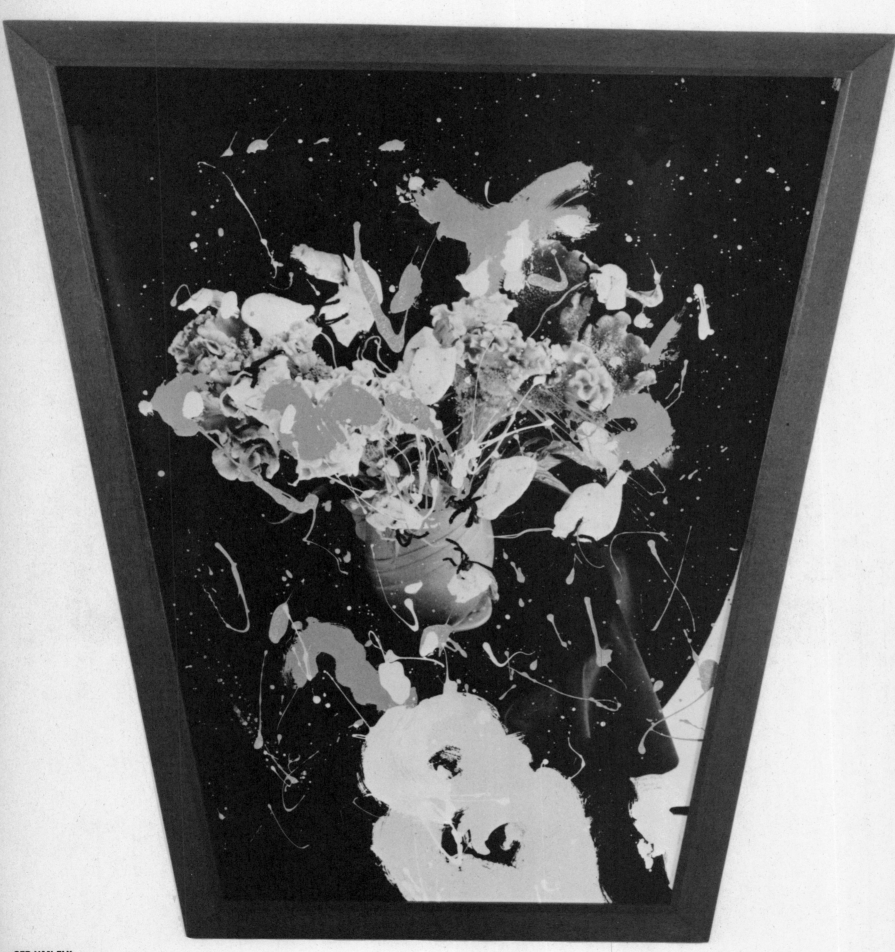

GER VAN ELK
PARROTS IN GREEN VASE. 1982
ACRYLIC ON PHOTOGRAPH, 48½ x 44¾"
COURTESY MARIAN GOODMAN GALLERY, NEW YORK

JOHN WALKER
OCEANIA IV. 1982
OIL ON CANVAS, EACH PANEL 84 x 66"
COLLECTION DR. AND MRS. W. JOST MICHELSON, GLOUCESTER, MASSACHUSETTS

JOHN WALKER

JEFF WALL

JEFF WALL
WOMAN AND HER DOCTOR. 1980–81
CIBACHROME TRANSPARENCY, FLUORESCENT LIGHT, DISPLAY CASE, IMAGE 40 x 60"
COLLECTION DR. JÖRG JOHNEN, COLOGNE

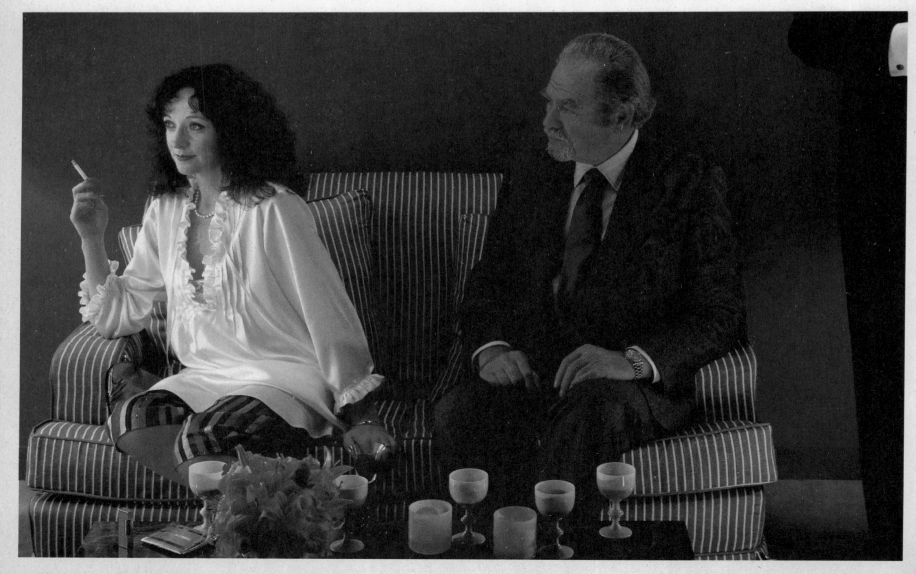

WILLIAM WEGMAN
DOG CABIN. 1982
PHOTOGRAPH, 14 x 11"
COURTESY HOLLY SOLOMON EDITIONS, NEW YORK

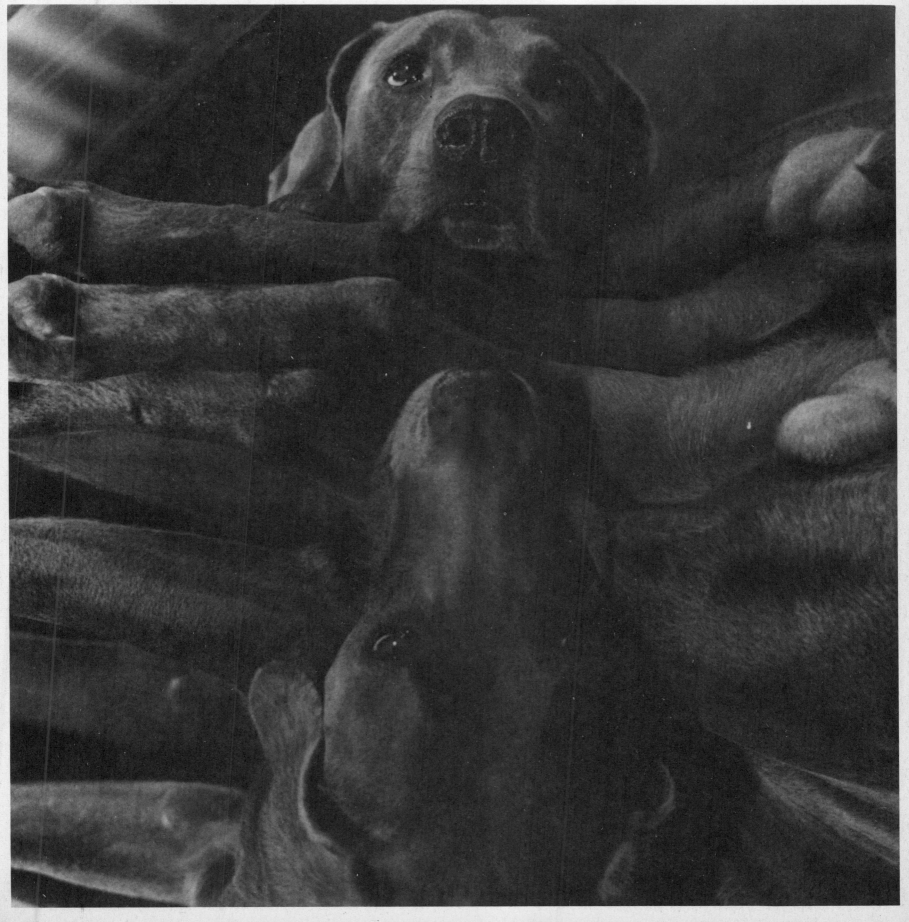

NEIL WELLIVER

NEIL WELLIVER
SNOW ON ALDEN BROOK. 1983
OIL ON CANVAS, 76 x 96"
COLLECTION NEWSWEEK

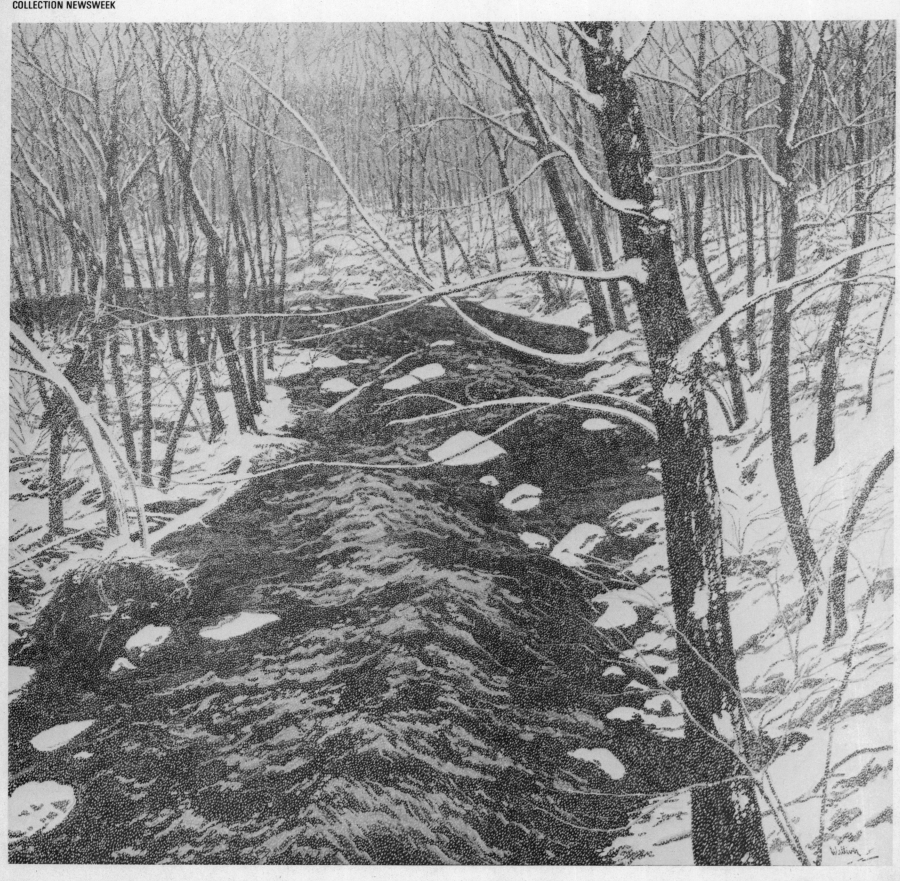

NEIL WELLIVER
MIDDAY BARREN. 1983
OIL ON CANVAS, 8 x 8'
COURTESY MARLBOROUGH GALLERY, NEW YORK

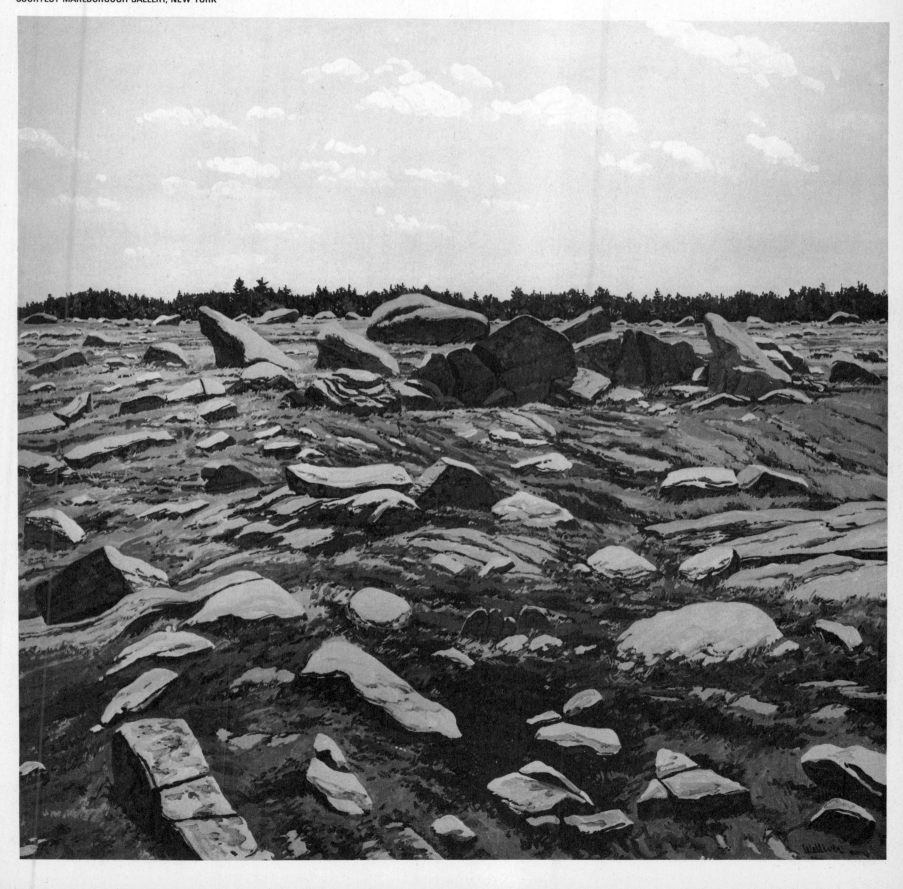

NEIL WELLIVER
DEEP POOL. 1983
OIL ON CANVAS, 96 x 96"
COLLECTION EXXON CORPORATION

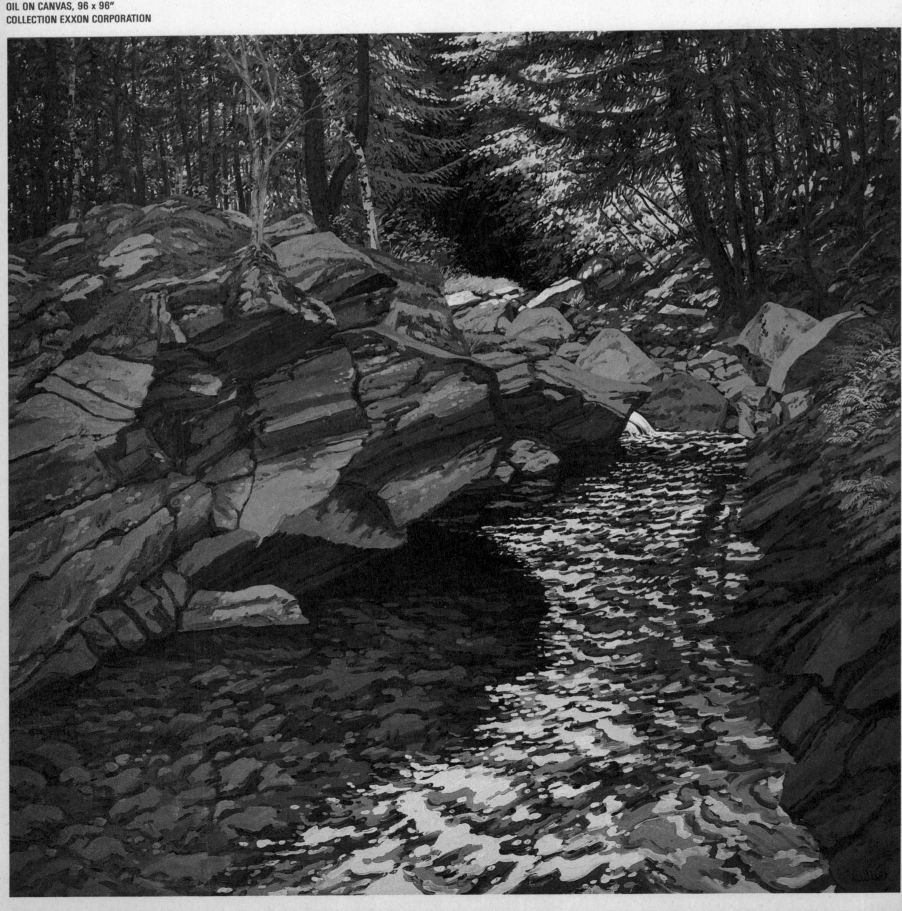

WILLIAM WILEY
BAD BALANCE II: FREEDUMB AND RIDICULE. 1981
CHARCOAL AND ACRYLIC ON CANVAS, 79 x 95"
COLLECTION MARTIN Z. MARGULIES, MIAMI

DAVID WOJNAROWICZ

DAVID WOJNAROWICZ
ACTION AND INSTALLATION AT THE PIER. 1983
A COLLABORATIVE PROJECT AT AN ABANDONED COVERED PIER ALONG THE HUDSON RIVER, NEW YORK

WILLIAM WILEY
CHARMS AND STRANGENESS FOR RUDE OFF. 1981
CHARCOAL AND ACRYLIC ON CANVAS, 71¾ x 95½"
COLLECTION CLAIRE ZEISLER

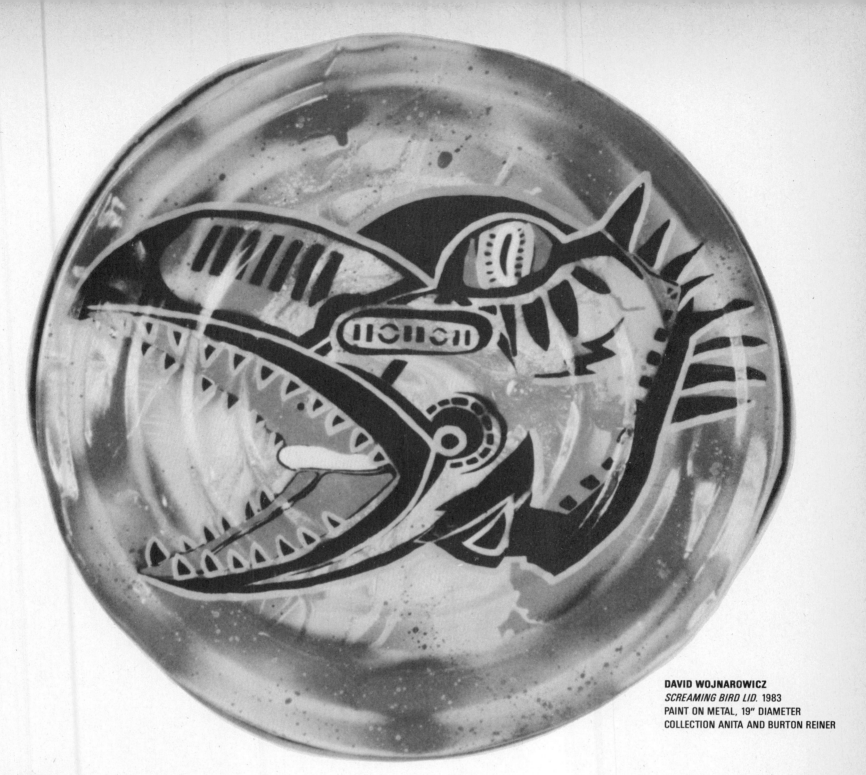

DAVID WOJNAROWICZ
SCREAMING BIRD LID. 1983
PAINT ON METAL, 19" DIAMETER
COLLECTION ANITA AND BURTON REINER

DAVID WOJNAROWICZ
THE BOYS GO OFF TO WAR. 1983
PAINT AND MAPS ON MASONITE, 4 x 8'
COURTESY HAL BROMM GALLERY, NEW YORK

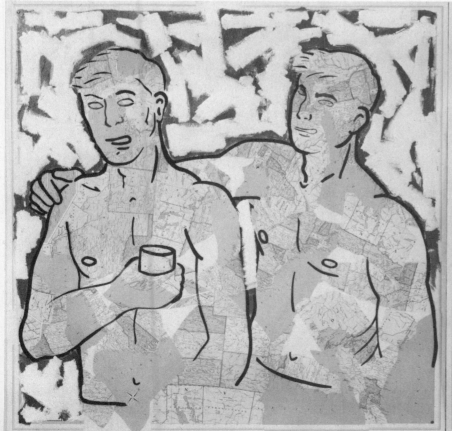
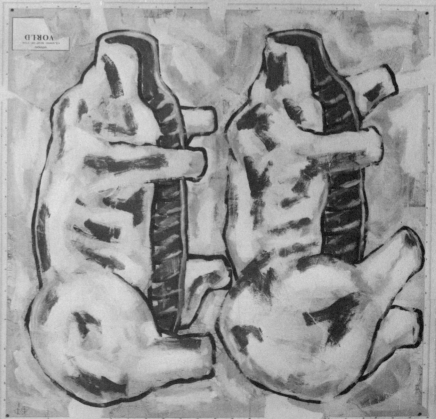

JACKIE WINSOR

RHONDA ZWILLINGER

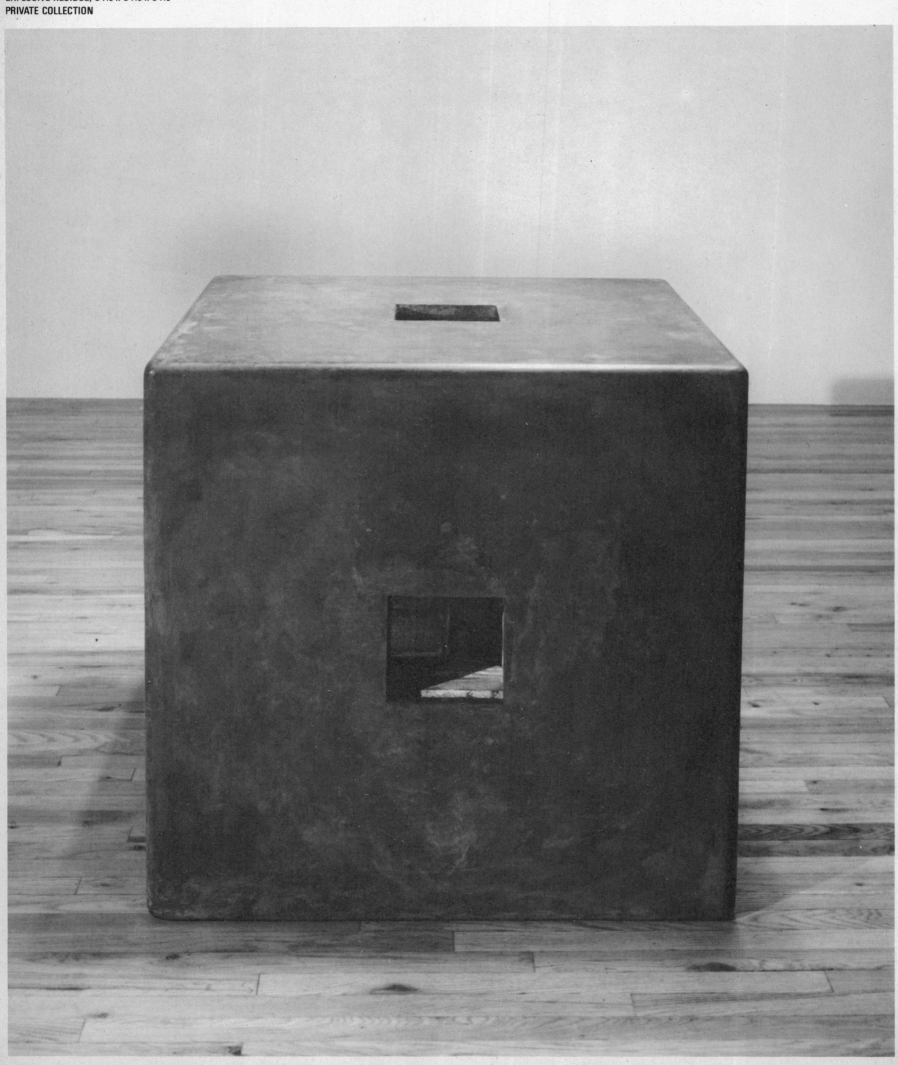

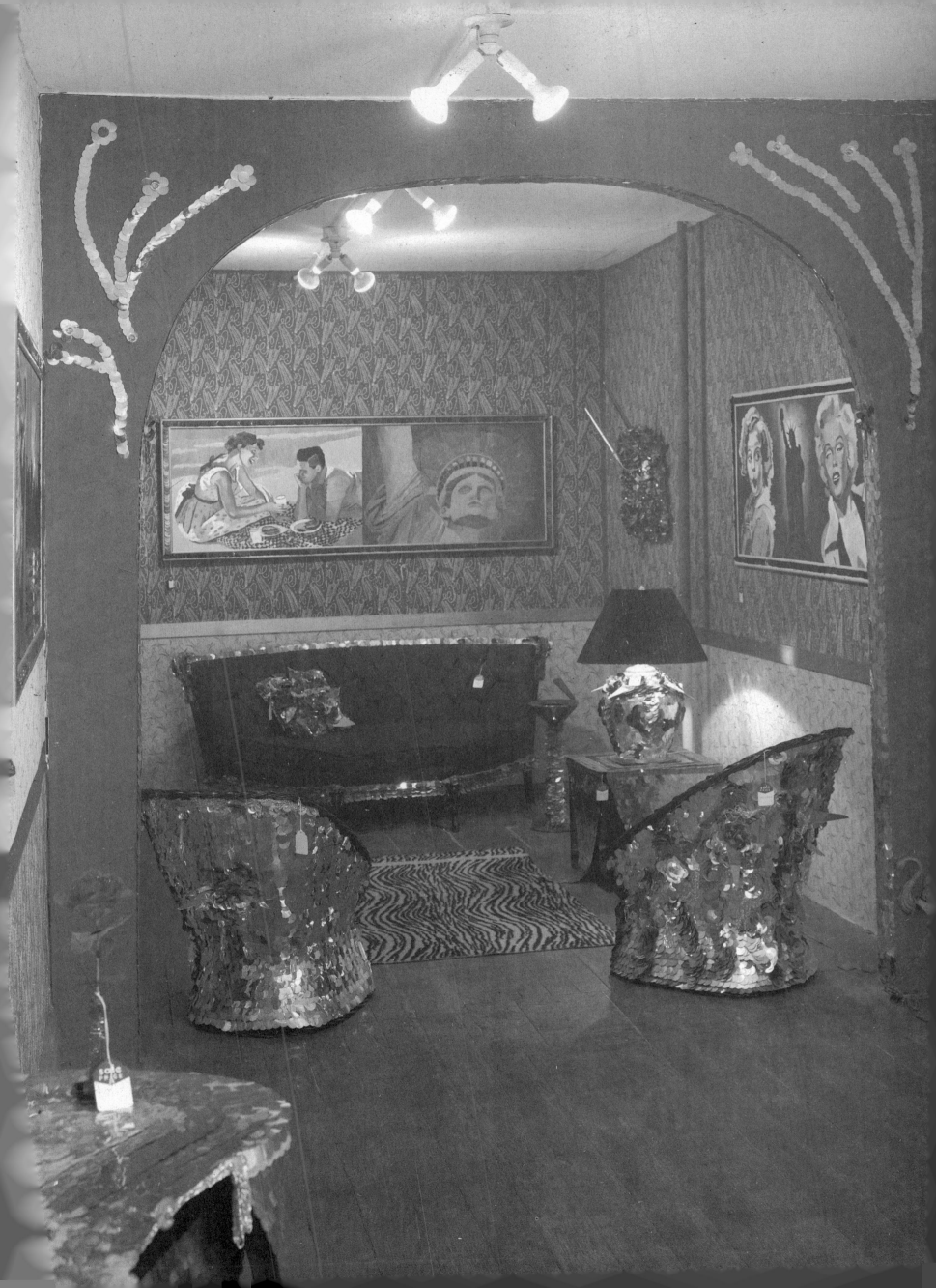

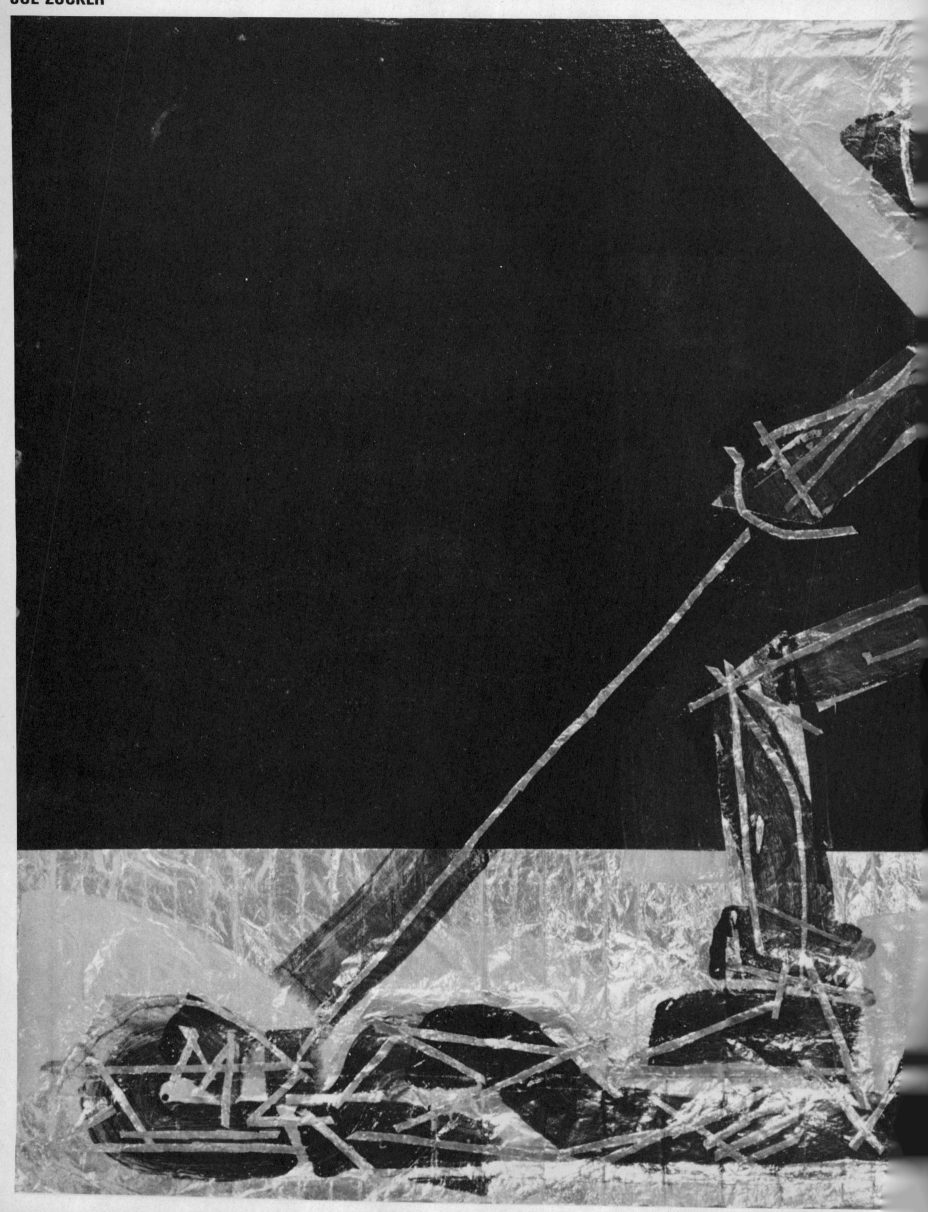

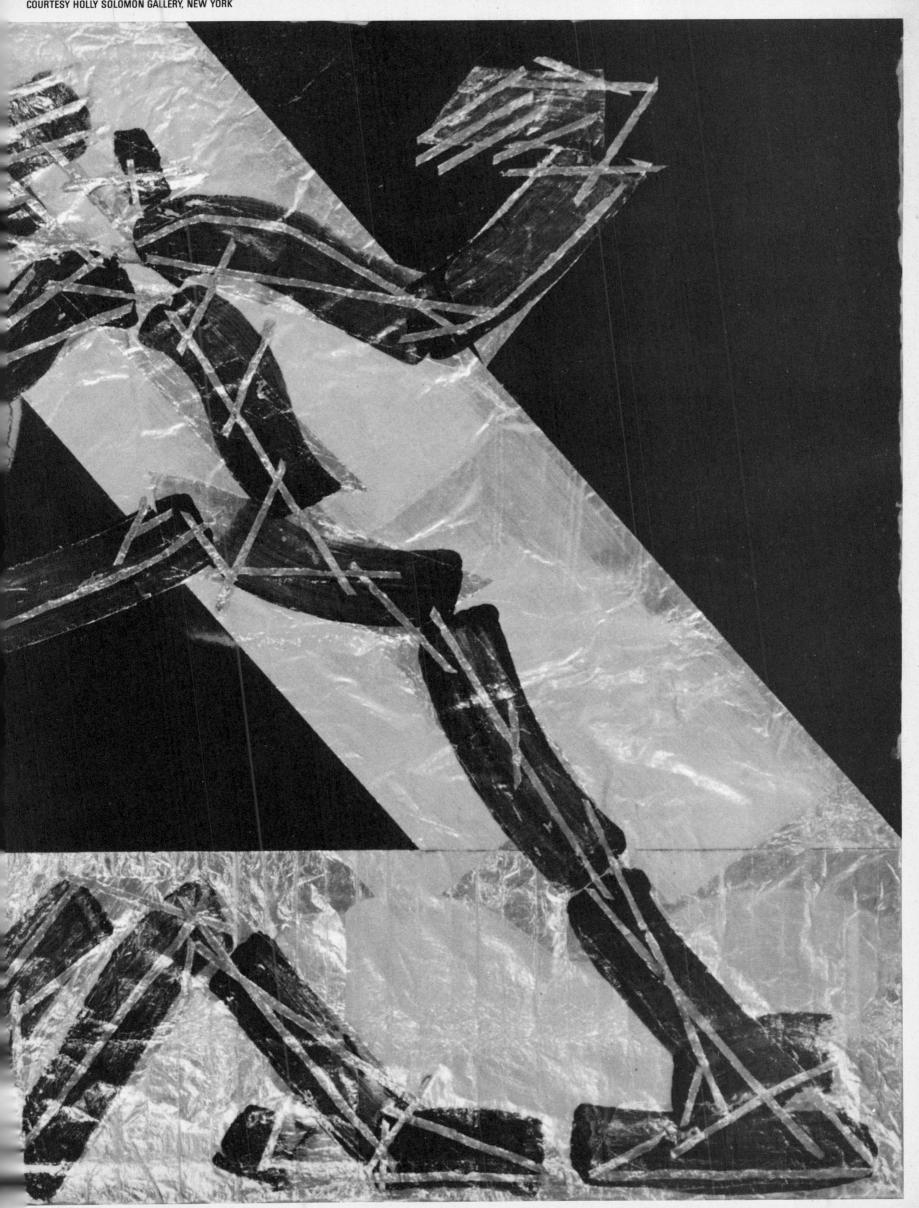

INDEX OF ARTISTS

NUMBERS FOLLOWING THE ARTISTS' NAMES
REFER TO PAGE NUMBERS.

LOIS LANE, 122
BORN: PHILADELPHIA, 1948
LIVES: WARWICK, NEW YORK

CHRISTOPHER LE BRUN, 121
BORN: PORTSMOUTH, ENGLAND, 1951
LIVES: LONDON

RICHARD LONG, 123
BORN: BRISTOL, ENGLAND, 1945
LIVES: BRISTOL, ENGLAND

ROBERT LONGO, 124, 125
BORN: NEW YORK, 1953
LIVES: NEW YORK

MARKUS LÜPERTZ, 126, 127
BORN: LIEBEREC, GERMANY, 1941
LIVES: KARLSRUHE, WEST GERMANY

ROBERT MAPPLETHORPE, 130, 131
BORN: NEW YORK, 1946
LIVES: NEW YORK

MICHAEL MAZUR, 128
BORN: NEW YORK, 1935
LIVES: CAMBRIDGE, MASSACHUSETTS

MARIO MERZ, 129
BORN: MILAN, 1925
LIVES: TURIN

MELISSA MILLER, 132, 133
BORN: HOUSTON, 1951
LIVES: AUSTIN

MARY MISS, 134, 135
BORN: NEW YORK, 1944
LIVES: NEW YORK

MALCOLM MORLEY, 137, 138
BORN: LONDON, 1931
LIVES: NEW YORK

ROBERT MOSKOWITZ, 139
BORN: NEW YORK, 1935
LIVES: NEW YORK

ELIZABETH MURRAY, 136
BORN: CHICAGO, 1940
LIVES: NEW YORK

PAUL NARKIEWICZ, 140
BORN: EASTON, PENNSYLVANIA, 1937
LIVES: NEW YORK

NIC NICOSIA, 141
BORN: DALLAS, 1951
LIVES: DALLAS

JIM NUTT, 141, 142
BORN: PITTSFIELD, MASSACHUSETTS, 1938
LIVES: WILMETTE, ILLINOIS

TOM OTTERNESS, 143, 144
BORN: WICHITA, KANSAS, 1952
LIVES: NEW YORK

MIMMO PALADINO, 145, 146
BORN: PADULI (BENEVENTO), ITALY, 1948
LIVES: PADULI (BENEVENTO), ITALY

ED PASCHKE, 147
BORN: CHICAGO, 1939
LIVES: CHICAGO

A. R. PENCK, 148–149
BORN: DRESDEN, 1939
LIVES: DUBLIN

JUDY PFAFF, 150, 151
BORN: LONDON, 1946
LIVES: NEW YORK

SIGMAR POLKE, 152
BORN: OELS, GERMANY, 1941
LIVES: COLOGNE

KATHERINE PORTER, 153, 154
BORN: CEDAR RAPIDS, IOWA, 1941
LIVES: NEW YORK AND MAINE

LOUIS RENZONI, 155
BORN: SUDBURY, ONTARIO, 1952
LIVES: NEW YORK

JUDY RIFKA, 156–157, 158
BORN: NEW YORK, 1945
LIVES: NEW YORK

DOROTHEA ROCKBURNE, 159
BORN: VERDUN, QUEBEC, 1934
LIVES: NEW YORK

SUSAN ROTHENBERG, 160, 161, 162
BORN: BUFFALO, NEW YORK, 1945
LIVES: NEW YORK

DAVID SALLE, 163, 164
BORN: NORMAN, OKLAHOMA, 1952
LIVES: NEW YORK

SALOMÉ, 165, 166
BORN: KARLSRUHE, GERMANY, 1954
LIVES: WEST BERLIN

JIM SANBORN, 166
BORN: WASHINGTON, D.C., 1945
LIVES: WASHINGTON, D.C.

KENNY SCHARF, 167
BORN: LOS ANGELES, 1958
LIVES: ILHEUS BAHIA, BRAZIL, AND NEW YORK

JULIAN SCHNABEL, 167, 168
BORN: NEW YORK, 1951
LIVES: NEW YORK

RICHARD SERRA, 169, 170
BORN: SAN FRANCISCO, 1939
LIVES: NEW YORK

JOEL SHAPIRO, 171
BORN: NEW YORK, 1941
LIVES: NEW YORK

CINDY SHERMAN, 175
BORN: GLEN RIDGE, NEW JERSEY, 1954
LIVES: NEW YORK

TODD SILER, 172–173, 174
BORN: NEW YORK, 1953
LIVES: CAMBRIDGE, MASSACHUSETTS

CHARLES SIMONDS, 176
BORN: NEW YORK, 1945
LIVES: NEW YORK

MICHAEL SINGER, 177
BORN: NEW YORK, 1945
LIVES: WILMINGTON, VERMONT

NED SMYTH, 179
BORN: NEW YORK, 1948
LIVES: NEW YORK

JOAN SNYDER, 178
BORN: HIGHLAND PARK, NEW JERSEY, 1940
LIVES: NEW YORK

KEITH SONNIER, 180
BORN: MAMOU, LOUISIANA, 1941
LIVES: NEW YORK

PAT STEIR, 182
BORN: NEW JERSEY, 1940
LIVES: NEW YORK AND AMSTERDAM

GARY STEPHAN, 181
BORN: NEW YORK, 1942
LIVES: NEW YORK

DONALD SULTAN, 183
BORN: ASHEVILLE, NORTH CAROLINA, 1951
LIVES: NEW YORK

MARK TANSEY, 184, 185
BORN: SAN JOSE, CALIFORNIA, 1949
LIVES: NEW YORK

RICHARD TUTTLE, 186
BORN: RAHWAY, NEW JERSEY, 1941
LIVES: NEW YORK

GER VAN ELK, 187, 188
BORN: AMSTERDAM, 1941
LIVES: HAARLEM

EMO VERKERK, 189
BORN: AMSTERDAM, 1955
LIVES: AMSTERDAM

JOHN WALKER, 190
BORN: BIRMINGHAM, ENGLAND, 1939
LIVES: MELBOURNE, AUSTRALIA

JEFF WALL, 190
BORN: VANCOUVER, B.C., 1946
LIVES: VANCOUVER

WILLIAM WEGMAN, 191
BORN: HOLYOKE, MASSACHUSETTS, 1943
LIVES: NEW YORK

NEIL WELLIVER, 192, 193, 194
BORN: MILLVILLE, PENNSYLVANIA, 1929
LIVES: PHILADELPHIA

WILLIAM T. WILEY, 195, 196
BORN: BEDFORD, INDIANA, 1937
LIVES: FOREST KNOLLS, CALIFORNIA

JACKIE WINSOR, 198
BORN: NEWFOUNDLAND, CANADA, 1941
LIVES: NEW YORK

DAVID WOJNAROWICZ, 195, 197
BORN: NEW JERSEY, 1954
LIVES: NEW YORK

JOE ZUCKER, 200–201
BORN: CHICAGO, 1941
LIVES: EAST HAMPTON, NEW YORK

RHONDA ZWILLINGER, 199
BORN: NEW YORK, 1950
LIVES: NEW YORK

PHOTOGRAPH CREDITS

NUMBERS REFER TO PAGES ON WHICH
ILLUSTRATIONS APPEAR.

JON ABBOTT, COURTESY SONNABEND GALLERY, NEW YORK, 88–89, 106–107; VITO ACCONCI, 10, 11; BRIAN ALBERT, 197 TOP; BRIAN ALBERT, COURTESY HAL BROMM GALLERY, NEW YORK, 195 BOTTOM; COURTESY ANNINA NOSEI GALLERY, NEW YORK, 166 TOP; WILLIAM H. BENGTSON, COURTESY PHYLLIS KIND GALLERY, 41, 42 BOTTOM, 141 BOTTOM, 142, 147 BOTH; LARRY BERCOW, 184 BOTH, 185; BRUNO BISCHOFBERGER, COURTESY MARY BOONE GALLERY, 28–29; CHAMBERLAIN/BC SPACE GALLERY, 45, 46; GEOFFREY CLEMENTS, 33, 171, 198; KEN COHEN, COURTESY M. KNOEDLER & COMPANY, NEW YORK, 90, 101 BOTH, 190 TOP; IVAN DALLA TANA, 13, 37, 40, 42 TOP, 99 BOTH, 100, 137, 159, 167 TOP; BEVAN DAVIES, COURTESY MARY BOONE GALLERY, NEW YORK, 181; D. JAMES DEE, 15, 179, 191; D. JAMES DEE, COURTESY ANNINA NOSEI GALLERY, NEW YORK, 66–67, 165; D. JAMES DEE, COURTESY RONALD FELDMAN FINE ARTS, NEW YORK, 43, 44 TOP; D. JAMES DEE, COURTESY HOLLY SOLOMON GALLERY, NEW YORK, 150 TOP, 200–201; EEVA-INKERI, 22 BOTH, 23 BOTH, 27, 32, 34–35, 71, 136, 197 BOTTOM; ROY M. ELKIND, COURTESY WILLARD GALLERY, NEW YORK, 161; JONATHAN ELLIS, 72 BOTH, 73; M. LEE FATHERREE, 195 TOP, 196; COURTESY FORUM GALLERY, INC., NEW YORK, 91, 92; LUIS FRANGELLA, 77; GENERAL ELECTRIC CORPORATION, COURTESY JOHN WEBER GALLERY, NEW YORK, 31; CHARLES HARRISON, COURTESY WILLARD GALLERY, NEW YORK, 122, 160, 162; LESLIE HARRIS, 182 BOTTOM; WILLIS HARTSHORN, 143; DAVID HEALD, 123 TOP; B. HUBSCHMID, COURTESY MARIAN GOODMAN GALLERY, NEW YORK, 70; BILL JACOBSON, 16, 17; COURTESY JOHN WEBER GALLERY, NEW YORK, 12, 20, 30; BRUCE C. JONES, 25, 26, 138; CASSANDRA KEITH, 93; COURTESY MARLBOROUGH GALLERY, NEW YORK, 96, 97, 192, 194; COURTESY MARIAN GOODMAN GALLERY, NEW YORK, 151, 152; COURTESY MARY BOONE GALLERY, NEW YORK, 76 BOTH, 163, 167 BOTTOM; COURTESY MARY BOONE GALLERY/MICHAEL WERNER GALLERY, NEW YORK, 105; ROBERT E. MATES, 153 BOTH, 154; COURTESY MAX PROTETCH GALLERY, NEW YORK, 47 TOP; ROBERT McELROY, COURTESY HOLLY SOLOMON GALLERY, NEW YORK, 150 BOTTOM; LUIS MEDINA, 12 BOTTOM; OTTO NELSON, 12 TOP; DOUGLAS M. PARKER, 109 BOTTOM; PELKA/NOBLE, 124, 125 BOTH; PELKA/NOBLE, COURTESY MARY BOONE GALLERY, NEW YORK, 39; EDWARD PETERSON, 78, 80; PHILIP POCOCK, 119, 120 BOTH, 199; ERIC POLLITZER, 14, 36, 38, 68, 108 BOTH, 144, 156–157, 158; COURTESY ROBERT MILLER GALLERY, NEW YORK, 52, 53 BOTH, 79, 81, 82, 83, 84; JOSHUA SCHREIER, 141 TOP; CINDY SHERMAN, 175; STEVEN SLOMAN, 178; STEVEN SLOMAN, COURTESY WASHBURN GALLERY, NEW YORK, 109 TOP; RICK STAFFORD, 135 BOTTOM; DAVID STANSBURY, 177; GLENN STEIGELMAN, INC., 18, 19, 180; COURTESY TEXAS GALLERY, HOUSTON, 132, 133 BOTH; JERRY L. THOMPSON, 69, 104, 170; WEBBER PHOTOGRAPHY, NEWTON, MA., 128; DOROTHY ZEIDMAN, 86–87; ALAN ZINDMAN, COURTESY SONNABEND GALLERY, NEW YORK, 24, 148–149; ZINDMAN/FREMONT, 54–55, 56, 61, 85, 113, 123 BOTTOM, 145, 146; ZINDMAN/FREMONT, COURTESY MARY BOONE GALLERY, NEW YORK, 75, 127, 164, 168; ZINDMAN/FREMONT, COURTESY SPERONE WESTWATER, NEW YORK, 63